TO AND FROM UTOPIA IN THE NEW CUBAN ART

TO AND FROM UTOPIA

IN THE NEW CUBAN ART

RACHEL WEISS

UNIVERSITY OF MINNESOTA PRESS MINNEAPOLIS · LONDON

The University of Minnesota Press gratefully acknowledges financial assistance provided for the publication of this book from the School of the Art Institute of Chicago.

Portions of chapter 2 were previously published as "The Pavilion's Dare," in Alexander Schmoeger, Lisa Schmidt-Colinet, Eugenio Valdes Figueroa, and Florian Zeyfang, eds., *Pabellon Cuba: 4D—Four Dimensions, Four Decades* (Berlin: b_books, 2008); and as "Performing Revolution: Arte Calle, Grupo Provisional, and the Response to Cuban National Crisis, 1986–89," in Blake Stimson and Gregory Sholette, eds., *Collectivism after Modernism: The Art of Social Imagination after 1945* (Minneapolis: University of Minnesota Press, 2007), 114–62. Portions of the Interlude were previously published as "After the Storm in Cuba: A Case of Withdrawal," ed. Rachel Weiss and Nicholas Lowe, special issue on censorship, *Social Identities* 13, no. 2 (Spring 2007): 183–99. Portions of chapter 3 were previously published as "Visions, Valves, and Vestiges: The Curdled Victories of the Havana Bienal," *Art Journal* 66, no. 1 (Spring 2007): 10–26.

Published by the University of Minnesota Press
111 Third Avenue South, Suite 290
Minneapolis, MN 55401-2520
http://www.upress.umn.edu

Library of Congress Cataloging-in-Publication Data
Weiss, Rachel
To and from utopia in the new Cuban art / Rachel Weiss.
p. cm.
Includes bibliographical references and index.
ISBN 978-0-8166-6514-3 (hc : alk. paper)
ISBN 978-0-8166-6515-0 (pb : alk. paper)
1. Art, Cuban—20th century—Themes, motives. 2. Art and society—Cuba—History—20th century. I. Title.
N6603.2.W45 2011
709.7291'0904—dc22

2010026334

Printed in China on acid-free paper

The University of Minnesota is an equal-opportunity educator and employer.

18 17 16 15 14 13 12 11 10 9 8 7 6 5 4 3 2 1

For Avrum and Ariel, who know where this comes from.

━━━━━━━━━━━━━━━━

Trying to think the revolution is like waking up and trying to see the logic in a dream. There's no point, in the middle of a drought, in imagining how to cross the river when the bridge has been swept away. When, half awake, I think about the revolution, I see it as the tail of a caged tiger, starting to lash out in a vast sweep, then falling back wearily on the prisoner's flank.

—JEAN GENET, *A PRISONER OF LOVE*

CONTENTS

ACKNOWLEDGMENTS

I am indebted to the many people who, in one way or another, helped me in writing this book. Any remaining mistakes, of course, are mine.

First and foremost, my thanks go to the many artists, curators, writers, and cultural administrators who graciously spoke with me (some at great length) about their own work and experiences: Francis Acea, Juan Carlos Alom, Beatriz Aulet, Tania Bruguera, Iván Capote, Yoan Capote, Alberto Casado, Marco Castillo, Sandra Ceballos, Ángel Delgado, Magaly Espinosa, José Manuel Fors, Carlos Garaicoa, Erik García, Luis Gómez, Magda González, Diango Hernández, Inti Hernández, Ernesto Leal, Glenda León, Jorge Luis Marrero, Corinna Matamoros, Ibrahim Miranda, Luis Miret, Gerardo Mosquera, Desiderio Navarro, Abel Oliva, Hanoi Pérez, Manuel Piña, Eduardo Ponjuán, Wilfredo Prieto, René Quintana, Fernando Rodríguez, René Francisco Rodríguez, Joel Rojas, Lázaro Saavedra, Esterio Segura, José Ángel Toirac, Ruslán Torres, Eugenio Valdés Figueroa, José Vincench, Cristina Vives, and the collectives DUPP, Enema, 609, and Punto (in Cuba); Flavio Garciandía and Marta María Pérez (in Mexico); and Alejandro Aguilera, Juan-Sí González, Glexis Novoa, and Leandro Soto (in the United States). It would have been impossible to address this subject without the knowledge, insight, and, in many cases, friendship that they extended to me, and I am enormously grateful. I owe a particular debt to Gerardo Mosquera, who was my introduction to the subject and to many of the artists; he has been a valued colleague for many years. Orlando Hernández and Glexis Novoa both pointed me to artists and works that I otherwise would never have known about.

I thank the many friends and colleagues who have been generous with their time, reading parts of the manuscript or discussing various ideas with me, in some cases across decades: Gregg Bordowitz, Mike Dorf, Cola Franzen, Nereida García, Vanalyne Green, Raja Halwani, Alan Henrikson, Orlando Hernández, Steve Jones, Terri Kapsalis, Judith Kirshner, Jules Kirshner, Magali Lara, Lou Levine, Bob Loescher, Peter Menéndez, Stuart Michaels, Desiderio Navarro, Laurie Palmer, Mary Patten, Claire Pentecost, Maureen Pskowski, George Roeder, James Rondeau, Jeffrey Skoller, Lisa Stone, Janos Szoboszlai, and Joyce Zemans. Conversation with and comments from Luis Camnitzer, who reviewed the entire text over the course of several iterations, and with whom I have argued

about Cuba since 1986, have been crucial to the development of my thinking. I am indebted to George Yúdice, who (along with Jean Franco and Juan Flores) responded so enthusiastically to the book and brought it to the University of Minnesota Press, where Richard Morrison—to my great delight—took it up. Adam Brunner at the Press was a strong ally in managing the details of the publication process. For help in obtaining images and the rights to reproduce them, I am grateful to Cristina Vives, Rafael Díaz Casas, Glexis Novoa, and Howard Farber. Cola Franzen translated Spanish material in the first chapter (with her unending enthusiasm and sharp insight), and Lucha Pérez Palacio and Mery Palarea completed the thankless task of transcribing dozens of hours of interview tapes. I am extremely grateful to the friends in Havana who provided hospitality during my stays there, who made me feel at home and who spent countless hours talking through the questions and confusions with which I ended each day: I do not name them here, for the sake of discretion, but they have my sincere appreciation.

Research for *To and from Utopia in the New Cuban Art* was concluded in early 2003, and the text therefore does not reflect subsequent events.

INTRODUCTION: TO BUILD THE SKY

By my count, there are twelve pairs of pants in the Museum of the Revolution. Three of them are bloody, although the blood, now decades old, doesn't look that vivid anymore. These fraying old clothes are neatly pressed and folded, as though tucked in the dark recesses of a bedroom drawer.

The Museum of the Revolution, occupying what was formerly Fulgencio Batista's presidential palace, incarnates the process at the heart of Cuba's history. Celia Sánchez, longtime companion to Fidel Castro and the first woman to take up arms in the guerrilla struggle, was instrumental in founding the museum. Raúl Castro, Fidel's brother and head of the country's armed forces since the beginning, established it by military decree on December 12, 1959: the museum was therefore one of the first institutions established after the revolutionary triumph. What one notices about the museum is that it holds the epic and the abject in continual oscillation: it is a museum of bits and tatters that lie alongside the armaments and campaign maps, an odd and poignant crescendo of history and sentiments. It is, in this sense, a relic of another time, when the Revolution itself was felt on such intimate terms.

The Museum of the Revolution's dirge recalls earlier sacred pauperizations. Like all relics the objects are authoritative by virtue of touch—owned, worn, washed, torn, bled or cried onto, died in—not entirely immune to the aura of kitsch that the enshrinement of bodily fluids, the consecration in blood, can confer. The most intimate residues of lives, like the oily wisps on the Shroud of Turin, the physical remains of an increasingly evanescent and remote subject. The Museum of the Revolution, abundant repository of traces of the absolute, celebrates immediate contact with it like in a Mass, exempt from the distance of symbolism or mediation. A system of "marvelous symbol–mirages," to use Hermann Broch's phrase, "bound in a magical unity by the heavenly–earthly, infinite–finite symbol of the Eucharist."[1] This kind of immediate relation, it must be noted, inherently claims a moral dimension.

The museum's narrative charts Cuba's long struggle for independence. It is a story full of tragedies and reversals, its text of utopian journey signaled by the meager yacht *Granma*, vessel of the 1956 revolutionary embarkation, enclosed in a glass pavilion on the museum grounds. Of course, the fact of the pants is

no accident (to be fair, there are three dresses—one of them bloody), and one pair even belonged to Fidel himself ("Trousers worn by Commander in Chief Fidel Castro"). The museum used to come to a close with the displays celebrating the Revolution's accomplishments, but in recent years more galleries have been added that chronicle the continuing battle: a suite of rooms addresses the tribulations of the "Special Period" of the early 1990s, and, following the 1997 return of the remains of Che Guevara to Cuba, a gallery devoted to his memory has been installed. Here we find locks of the martyr's hair and beard, scraps of the clothes he died in, the stretcher he was transported on from La Higuera to Valle Grande (where his body was publicly displayed and photographed),[2] and some of the instruments used to perform his autopsy. Also displayed are the diminutive coffins used to transfer Guevara's remains from Bolivia to Cuba, along with those of his compatriots, and a nocturnal, funereal videotape of the ceremonies upon his arrival.[3] Guevara, along with his cocommander Camilo Cienfuegos, is the subject of a large and startling "sculptural ensemble in hyperrealist style" about midway through the museum's displays, but it is with his return to Cuba (his resurrection), forty years after his death, that the museum's *récit* ends.[4]

The museum oscillates. It is archetypal, sacramental, auratic, and banal. It oscillates between history and theology, the one constituted through narrative straightening and the other by way of fierce illogic. It oscillates, and that is mnemonic in effect: the rhythmic reiterations, the concentration and endurance reverberate and drill until they are internalized. The museum's overall meter is intervalic, suspended, anticipatory: the Museum of the Revolution is a poem of loss as much as of triumph, in which the broken bodies and frustrated dreams are a Greek chorus, the voice that keeps returning. The museum is a discourse of the Revolution in the strongest sense of the term, with all of the specificity to location, context, and history that it implies, tracking the nation as asymptote. A magical function, *numen* and *tremendum*, baptism against the slaughterhouse. The museum's display contends with a past that is at once too palpably present to yield entirely to myth, but that is also too broken to persist in myth's absence. The (Museum of the) Revolution is a miniature, a diorama, a domestication: an act of faith, written across the everyday.

The Cuban Revolution dreamed, aspired, and dared, but it was also full of contradictions. Visions of justice and human fulfillment, of realizing, at last, a historic destiny, the audacity to proceed on its own terms, on the one hand; the inevitable gaps between a revolution of ideals and its regime of controls, on the other. "Within the Revolution, everything: Against the Revolution, nothing," Fidel

Castro had famously proclaimed in his 1961 *Words to the Intellectuals*,[5] setting the terms for both an expansive cultural mandate and concern about how and by whom the borders of "inside" and "against" would be determined.[6] Ten years later, the polysemous gesture of that dictum gave way to one declaring art a "weapon of the Revolution," and by the time a national constitution was finalized in 1976, "form" had been definitively split from "content," the better to hold the latter in thrall: this mirrored a split between political and cultural avant-gardes, and an increasingly contentious relation between them.[7]

The new Cuban art is generally understood to have begun—at least publicly—with the 1981 exhibition *Volumen Uno*. That exhibition and the sense of the event were in relation, reaction, and contrast to many things. Among the most important were the increasingly oppressive sovietization of culture on the island, the consolidation of political power and control, and the anathematizing of culture and especially of its critical vocation by the Cuban leadership. The 1970s, which began with a miserable process of silencing politely referred to subsequently as the *Quinquenio Gris* (Five Gray Years), was the proximate referent for the new Cuban art: generally dated between 1971 and 1976, both the length and hue of this interval could well be put more starkly (the writer Pablo Armando Fernández has applied the color to the entire decade, and later on the critic Osvaldo Sánchez shifted it from gray to black).[8]

In this sense the new Cuban art was a reaction to the prescriptions and proscriptions of official culture. But it was also, crucially, the dynamic entry of a group of young people, born around the time of the Revolution and formed not only by its encroaching orthodoxies but also by its poetic idealism and dedication to independence. For that matter, the new Cuban art has also been a mark of the continuity of Cuban cultural traditions—in particular those of the 1920s and 1930s vanguards (that shared with *Volumen Uno*, for instance, a certain relation of simultaneous apartness from and commitment to the political arena). It also recalled the 1960s cultural efflorescence and even the 1970s, when a role of "critical participation" in the revolutionary project was developed, and from an array of political positions, in the face of what one critic has called the "relative monologism dominant for years."[9]

It would be simplest, and it might even give rise to a more dramatic narrative, to sketch the contours of culture during the revolutionary period as alternating bands of darkness and light: initial revolutionary enthusiasm and charisma, ensuing corrosion and calcification, hydraulic eruption in reaction, self-occlusion. . . . This pattern, and its segments, could be attributed to the factors intrinsic to Cuba and its cultural life and also to outside forces that have significantly affected the

island, including the relentless hostility and aggression from the United States, the quasi-colonial impositions of the USSR, and the collapse of the leftist project in Latin America (for the moment, anyhow), to name only the most obvious. But the unitary nature of such darknesses and lights is mostly an illusion, and nowhere is this clearer than in the country's culture, which has always boiled with conflicting and cosanguinating tendencies. There was never a hegemonic institutional landscape, or a sole artistic proposal in the face of it. The new Cuban art squeezed through the many cracks between the various positions and factions with its own offering of desires, intentions, and approaches. Among other things, it has been an act against the institutionalized forgetting of inconvenient traditions and legacies that plagues all cultural processes, and especially those of a small, perennially beset island.

The new Cuban art has been notable not only for the nature of its objects but also for the energies that it has collected around itself and the energies that it has lent, in various moments, to sectors and questions that are "extra-artistic" in nature. The linkage of art with revolutionary politics is a key aspect of Latin American modernity, but a singular accomplishment of the new Cuban art has been its ability to generate mobility around not only the explicitly political situation but also the more daily and ordinary realities of the island.

But the new Cuban art was not a "movement" per se. It never had a manifesto. It was spontaneous in its eruption, more a phenomenon than anything else. It became consolidated on various levels—first among and by the artists themselves and by certain critics, until it fused as a recognizable entity. Eventually, and as a result of a complicated combination of factors (ideological challenge of the work and ideological crisis of Cuban and European socialism, economic opportunity afforded by art commerce and economic crisis of the nation, emigration of most of the "problematic" artists, maturation of others amid an effective erasure of the past, intense challenge and struggle at every juncture on the quotidian level, preoccupation with immediate and individual survival, exhaustion, disillusionment, cynicism, opportunism, anger . . .), Cuban art metamorphosed into something different, though apparently similar, solving or surpassing some of its traditional problems and reinstating others with renewed vengeance. But I want to insist that there is not a single, clean line of development: neither from utopianism to cynicism nor from naive optimism to pragmatism, much less from fantasy to reality. The new Cuban art is not a palindrome, falling symmetrically to either side of a catastrophic fold.

The new Cuban art grew up in the supercharged and conflicting currents of revolution, sometimes tracking to its optimism and at others scalded by it. But

even more than that it was an art with extraordinary relation and relevance to the life of the country across social, domestic, cultural, and psychological registers: aggressive, protean, and perennially restless within an extraordinary conviction about the possibilities of art.

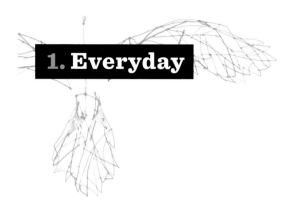

1. Everyday

Every Cuban is a mechanic.
—POPULAR SAYING

The everyday is the realm of the everyman and everywoman, and it is also, of course, the site of Cuban socialism's most important promises: housing, health care, education, and dignity. Art of the "everyday" can live more easily in the everyday, as all avant-gardes have dreamed: the novel everyday, whose range intersects the political, ethical, and ideological, the unlimited social field that lives in a permanent quarrel with the theological and metaphysical; the actual, which learns to correct the speculative's bad memory.

The everyday has been an enduring preoccupation in much of Cuban art during the twentieth century, a central trope for the figuring of self, nation, history, and the real, tracking closely to the volatile social scenarios that have housed it.[1] In the early 1980s the everyday represented a number of things, from the affirmative to the compensatory. It was a dense and rich space, full of human interaction, texture, tradition, and different forms of knowledge. A space of ethics understood, as in Michel Foucault, as "the conscious practice of freedom," "the reflective part of freedom."[2] A space of concern, "the care one takes for what exists and could exist," and therefore integral to the search for what it is to be human; "a casualness in regard to the traditional hierarchies of the important and essential," and thereby a counterpoint to the normative machineries of morality that hope to pass as ethical.[3] The everyday was valued on its own merits and was a refuge from the space of ideological treacle: subjectivity in the artistic everyday was one propelled out into the world not as a monad but utterly interpenetrated

with all that surrounded it. A promiscuous space, which could encompass kitsch exuberance and introspection, voluntarism and skepticism, curiosity, excitement, valor, longing and generosity, without forcing those into opposing and contradictory positions. Creole, historical, utopian (in the good sense). It tended to be a space of interiority, domesticity, and reflection, although the boundary at the time between public and private was not that strong.

In the latter half of the 1980s the everyday took on some different dimensions, especially with regard to the political temperature of the island. The gap between "official" and "everyday" had opened up to an unacceptable degree, and they had become opposites of a sort. This crisis was spurred partly by an erosion of conviction, which had grown brittle and hollow: the everyday acquired the sense of authenticity and candor missing in the other space. The everyday was the space of the open secret, what everyone knew and thought but dared not say in that other, official space, an important arena of choral complaint. The everyday became a root space of struggle and humor, the raw material of an aggressive, caustic, bull's-eye art. Artists, themselves part of that everyday conversation, realized that the special tropological properties of their language could be just the thing to bring that litany of whispers and sidelong jeers smack into the public face of the society, where it could not be ignored. As they were still perfecting their technique, the whole enterprise became too inconvenient, too insistent, too accurate, too well liked. And was, consequently, brought to an expedient end.

In the 1990s, again, a new situation arose. The decade began with the near-total collapse of the nation's viability, both economic and psychic: precipitous drops in food and basic goods, transportation, electricity, hope. There was a concurrent spike in rhetoric and the public performance of commitment, and a concurrent (triangulated) ascendance of the *doble moral*, the new gold standard that underwrote the new dollarized economy. The everyday was now (again) stealing, lying, pimping, hustling, deceiving, disbelieving, desperation, cheating, embarrassment, shame: survival. A clandestine universe of the everyday false, eroding inner space just as pomp and lies had eroded public space before it. Everyday mutuality now lay in this zone of *resolver*. Some artists retired to lick their wounds, assuaged by the new everyday that had opened to them—the "international" one—where they sold their works to buyers who found everyday Cuban angst charming and piquant. Some insisted that the battle to make the everyday a public one had been to blame—grandiose, egotistical, utopian (in the bad sense). Art's everyday became the "not that": not political, not ambitious, not collective, not optimistic, not modern, not invested.

The everyday has left its footprints all over Cuban culture, politics, history, psychology, location, and dislocation. How to map it? This everyday is related to, overlapping and contiguous with, the ordinary, intimate, lilliputian, interior, testimonial, background, novelistic, labyrinthine, contingent, private, routine, popular, prosaic, social, epistolary, experiential, spontaneous, amateur, provisional (especially in the case of Cuba), improvised (ditto), mysterious, evident, live. The everyday, as in . . .

. . . "Cuban"

The new Cuban art is a legitimate child of the Cuban Revolution—on the mother and on the father's side—and conceived in a night of orgasms.
. . . The new Cuban art takes notice and gets even.
—GERARDO MOSQUERA, "TRECE CRITERIOS SOBRE EL NUEVO ARTE CUBANO"

The question of local versus international is one that always gets asked of artists outside major metropolitan centers, and the Cubans have been no exception. In his interview with Flavio Garciandía, José Bedia, and Ricardo Brey for their 1985 New York exhibition *New Art from Cuba,* it is Benjamin Buchloh's first question. "I am not innocent of the avant-garde," replies Brey. "And still, I try to work within the context within which I function. . . . I am interested in my work being understood in the context I move in, in my country, my region."[4] The second inevitable question, this one more particular to Cuba, is about art under socialism. The answer, again (this time from Garciandía): "I try to make art influenced by what surrounds me, but I am open to any ingredients that may help me."

Supremely Caribbean, Cuban culture has been as voracious (maybe even more) as it is protective. In 1992 the critic Iván de la Nuez counted among the roots of *cubanía* the following ingredients: "religious syncretism, Marxism, pop art, surrealism, the counterculture, the Soviet manuals, the 1950s tradition of the U.S., marginality and, among others, a tropical Stalinism always lying in wait."[5] The various elements of Cuban national identity have always been in flux, alternately ascendant and scorned in successive moments depending on what was happening and who was talking. Fernando Ortiz and Jorge Mañach, making a case for *cubanía* early in the twentieth century, argued to free Cuba of foreign influence and, specifically, dependency on the U.S. sugar market. Ortiz metaphorized *cubanía* as *ajiaco* (a local stew in which the ingredients keep their individual flavors) and accepted not only indigenous but also African and Spanish influences on national identity in addition to the prevalent theme of the *guajiro.* For its part, the Los Once group's version of the authentically Cuban in

the 1950s rejected *tropicalismo* in favor of a more-internationalized abstraction.[6] Nonetheless, the writing of Cuban identity has been largely a process of writing across other texts—colonial (Spain), neocolonial (United States), pseudocolonial (USSR), to contest and conquer them.

Modernity has often meant a simultaneous inward- and outward-looking dialogue, and by the 1970s in Cuba both an insular/nationalist cultural identification— retooled as anti-imperialism—and a staunch internationalist stance, both of them chauvinist, had been consolidated. The national operated as a rhetorical condition of unity that, among other things, provided a "defensive wall in the face of actually existing socialism," as Fernando Martínez Heredia has contended, "and the colonization 'from the Left' that it implied."[7] The international thrust Cuba forth as a model and leader, asserted at the center of the periphery and not just another member of a club based somewhere to the north.

Havana maneuvered itself to center stage as host for conferences on global issues, including meetings on the Third World debt crisis and, in 1979, the Sixth Summit of the Non-Aligned Nations, over which Fidel Castro presided. Combined with its theatrical sense of isolation—the horizon-obsessed mentality of the islander and attendant provincial frustration, the recurrent images of a harshly besieged, tragically destined country—there has also been a countertendency toward not simply integration into the world map but also a quixotic level of international ambition. Underlying both tendencies, though, is an unshakable sense of Cuba as sui generis: as José Martí once wrote, "Graft the world onto our republics, but the trunk must be our republics."[8] Throughout the 1970s, the young revolution asserted an often archaic and agrarianist proposition, sentimentalized as the soul of *cubanía*. The ruralist image bank had a distinguished history in Cuba reaching back to the nineteenth century, and in the 1920s and 1930s the Cuban peasant had been used as a cult symbol, the "peasant-as-the-nation."[9] "To create a rooted form of painting, painting with roots in our land. Nourished by our sun, and our air, and our waters," Manuel Vidal rhapsodized in 1974.[10] "Is our landscape, full of light and greenery, and of such special national significance, unimportant? Of course it is not," affirmed Alberto Quevedo.[11] The origins of countryside as ne plus ultra lay in the historical struggle for independence: both the 1868–78 and 1895–98 wars of independence were fought mostly in the countryside, with many peasants joining the *mambises* (independence army), and the same pattern was repeated in the 1950s revolutionary struggle.[12] The "authentically revolutionary" art substituted revolutionized peasants for their otherwise mythified predecessors: artists such as Nelson Domínguez and Roberto Fabelo, who had been painting neo-expressionist monsters, took up the new catechism

of *milicianos,* campesinos, cane fields, machetes, sombreros, *mulatas,* and maracas, their subjects levitated to an order somewhere between prototype and archetype. Pastoralism and revolutionary virtue were highly compatible symbolic systems, and by around 1980 it had gotten to the point that White Udder, a Cuban cow that had set a world record for milk production, was the subject of both a monument and an exhibition, the latter receiving a favorable review by Manuel López Oliva in *Granma.*[13]

In light of all this, identity and *cubanía* were important topics of debate and dispute for the generation of artists who came of age around 1980—the first to be educated and socialized entirely "under the revolution"—who brought an allergy to the syrups and sureties of this heritage. The establishment of the Ministry of Culture under the direction of the liberal Armando Hart in 1976 was an important precondition in political terms for this break, creating an atmosphere more tolerant of the young artists' interests in connecting to currents in international contemporary art. "Our policy," Hart wrote in 1983,

> is to preserve our best cultural traditions and simultaneously stimulate new
> forms, artistic experimentation and the critical assimilation of contemporary
> artistic and literary currents—to which, in turn, we have made our own
> contribution, at least in Latin America. . . . They accuse us of "leaving" Western
> culture. Mr. Reagan has said that we should "rejoin" the West. That's really a
> serious problem, because we can't return to where we already are; as far as I
> know, the island of Cuba hasn't moved. We are in the West, and our ideological,
> political and cultural debate takes place in our world, in the West.[14]

Cuba had had cultural links to Europe for centuries, but that tradition had been stigmatized by the growing institutional phobia about "borrowing" from foreign influences, derived mostly from the growing need to restrict the development and circulation of ideas that might depart from the Communist Party's own. Information and ideas from the world beyond Cuba (and the USSR) were tightly rationed and eagerly sought,[15] and by the end of the 1970s the bureaucracy's tendency to an increasingly rhetorical and constipated version of *cubanía* had come to prove the general principle that when something is repressed on the physical plane, it bursts forth in the imagination. In the 1960s Raúl Martínez had already dispatched with this xenophobia, importing pop art and converting it into an uncannily celebratory and skeptical vehicle for revolutionary portraiture. The journal *Criterios,* from its first issues in 1973, undertook a parallel importation by publishing theoretical texts not included on the Revolution's reading list, from

Umberto Eco to Mikhail Bakhtin to the antidogmatic socialist theory being produced by Yuri Lotman's School of Tartu.

What Hart was suggesting was a sense of Cuban *mestizaje* that was pointedly historical—not just a blend of ethnicities but a blend of historical epochs in the Cuban experience. His suggestion that it was U.S.—not Cuban—ideologues who divorced the island from the hemisphere was a clever end run, rejecting the dogma that viewed those connections as counterrevolutionary and neocolonial. Cuba's ideology was by definition internationalist, he pointed out, and therefore the attitude toward culture should be as well. His liberalism drew heavy fire just a few years later from powerful advocates of a more orthodox position, but during the first years of his tenure Hart's views were a relief for young artists.[16]

The exhibition *Volumen Uno* was the opening salvo of the "new Cuban art."[17] It opened on January 14, 1981, at a gallery in one of the liveliest parts of Havana and immediately caused a scandal. The participating artists, most of them still in school, filled the space with a fresh, eclectic mix filtered through informalism, pop, minimalism, conceptualism, performance, graffiti, and Arte Povera, reconfigured and reactivated in the name of an art that worked to be "critically, ethically, and organically Cuban."[18] An affinity for the everyday and popular, and "sense of joy and human affirmation," was pervasive.[19] *Volumen Uno* had no overall theme and no unifying stylistic tendency: the works followed the interests, inclinations, aesthetics, "peculiarities," and talents of eleven individual young people with no use for the marshaling injunctions of schools and manifestos. The show was not just a break in formal terms but also in content: the works' substitution of Indians, popular religions, and the kitsch aesthetic of popular home decoration for the revolutionary dramatis personae was as significant as its refusal of the tonalities and compositions of that patriotic imagery. In place of the responsible, organized, and normatizing figures of revolutionary modernism, the artists' highly individualized eclecticism was a vertiginous "acceleration of imaginative reach," as Gerardo Mosquera, probably the most important critic of the period, commented. "Emotionally, the response [was] a sensation of possibility."

The artists had been trying to stage the show for months without success: ironically, it was due to the intervention of state security that the gallery's doors were finally opened to the youngsters, in a classic case of the anomalies, parabolic reactions, and paradoxes that typify political life in Cuba. Having been rejected over and over by public galleries (which were universally state-run under the socialist system), the artists decamped to a group member's home in an outlying area of the city and first installed the show there, sans curators, deliberators, or authorizers.[20] The invitation list for the opening included not only friends but also

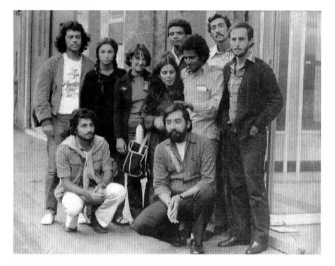

Some of the *Volumen Uno* artists, 1981. *Standing:* José Bedia, unidentified woman, Lucy Lippard, Ana Mendieta, Ricardo Brey, Leandro Soto, Juan Francisco Elso, and Flavio Garciandía. *Kneeling:* Gustavo Pérez Monzón and Rubén Torres Llorca. Photograph by Gory (Rogelio López Marín).

the various officials charged with responsibility for the country's visual arts, and word got around quickly.[21] For the institutions, as Garciandía recounted in 2003,

> that was impossible! And that, an exhibit in a private home? And those guys, what? . . . I was working in the office of plastic arts of the Ministry of Culture. And the minister of the interior was the one who said to my boss, to the director of the plastic arts division, you have to give a place to those guys to exhibit, there cannot be one more exhibit in a private home. So it was the minister of interior who got the gallery for us. . . . they gave us this place, somewhat to relieve the tension in that sense.[22]

("The police," says Tom Stoppard, "are the realists.")[23]

At the Centro de Arte Internacional, *Volumen Uno* was an instant phenomenon, attracting over ten thousand visitors in two weeks. The minister of culture showed up. The artists did their own promotion ("we never trusted the official systems"), and they set up loudspeakers that blared rock music into the busy street.[24] "It was a party," recalls Mosquera, "lively, youthful. . . . A renovating energy and enthusiasm bubbling there. One felt that that event was bringing a change."[25]

Three of the eleven artists (Garciandía, Tomás Sánchez, and Gory) were already rising stars in Cuba's visual art scene, but the rest were largely unknown, and the exhibition catapulted all of them into high visibility and vitriolic controversy. The reviews poured out, damning the artists. Formalists. Abandoners of the values of Cuban national identity. Faux-vanguardist copiers. Facilists. Puppets of imperialism. Ideological diversionists (an extremely Soviet, and serious, charge).[26]

The day after the opening, a conference was held at which the exhibiting artists were given the opportunity to explain their work, and established artists such as Alberto Jorge Carol (known for tropicalist landscapes and portraits of Che Guevara) and César Leal (a pop/utopian realist) took the opportunity to attack.[27] Neither Domínguez (agrarianist, the sublime in the everyday) nor Fabelo (kitsch caricaturist, oneirist of the theatrical everyday) liked it either, and the confrontation had the clear marks of one generation fighting the obsolescence cast on it by another. The minister of culture himself arose, full of grandiloquent claims—it was Thanks to the policies of the Revolution; Thanks to the system of free education, that such a fresh moment could ignite—to which one of the artists replied: No. It was against all odds. They gave us the space because there was basically no other option left and if there is anything good here it is thanks to nobody but us.

Volumen Uno was organized by a group of friends bound together by a conviction about artistic creation as a committed, intellectual, and ethical process of reflection. They shared no particular aesthetic or ideological platform: their idea of art was conceived not within the strictures of a national art or identity but in a simultaneously expanded, international field of contemporary practice and a more interior universe, psychological and personal in nature.[28] As Garciandía has described it,

> We did things as a group that functioned at a specific moment, and there was
> still a sort of utopic idea that we might have some impact on the wider cultural
> and social level. . . . for us it was not so much a matter of being Cuban or a matter
> of nationalism, but simply a matter of adapting to the circumstances and acting
> accordingly. . . . we were very much imbued by that spirit.[29]

In rejecting the orthodoxies of *cubanía,* the *Volumen Uno* generation was interested in opening that definition to include new possibilities. According to Mosquera, the theme of national identity was also adopted at least partly as a strategic maneuver, since it gave a little more room for expression: many things indeed could be justified under the banner of searching for identity.[30] In any case, perhaps the radicality of their generational preoccupation with identity lay in its rejection of the Revolution's insistence on the rupture with the past, and the loss of historical continuity that ensued. Everything, everyone, was "new" as of 1959: the Revolution's first amputated, and then enforced, history eventually channeled a search for identity that encompassed a more ample set of historical antecedents.[31] The young artists' sense of "Cuban" therefore meant both more, and less, than what the high scribes had put forth.

On April 1, 1980, eight months before *Volumen Uno* opened, twelve Cubans crashed a bus through the gates of the Peruvian embassy in Havana and requested asylum. The ambassador announced that any Cubans wishing to defect would be allowed to enter the embassy, which about 10,000 people subsequently did. U.S. president Jimmy Carter announced that his country's borders were open to "freedom-loving Cubans." On April 22 *Granma,* the newspaper of the Cuban Communist Party, announced that anyone wishing to leave the island could do so via the port of Mariel. The ensuing exodus included about 125,000 people, some leaving voluntarily and some under pressure.[32]

The ugliness of Mariel was stunning. "Let my people come," railed Miami's radios, while on the other side of the straits the "working people," as Castro intoned,

> are of the opinion: "Let them go, the loafers, the antisocial and lumpen elements, the criminals and the scum!" . . . As always, Cuba gladly opened the doors for them, as it had done before with all the rabble that opposed socialism and the Revolution.[33]

"We need not worry if we lose some flab," he said a week later. "We are left with the muscle and bone of the people. We are left with the strong parts."[34] It cannot be overlooked that the new Cuban art took off in the downdraft of this national trauma. Mariel occasioned a loss of political innocence for many, but the harshness of the experience for the young artists was mixed with the mounting excitement about their work and its reception. But the massive, desperate emigration was an embarrassment for the Cuban government, and so even if artists' reactions were muted, the government's was not. Culture assumed new prominence in the post-Mariel strategy of rehabilitating the regime's image, and the new art was incorporated into that effort. Osvaldo Sánchez has even argued that, despite the controversies it gave rise to, the new art "could easily be accommodated without many theoretical pressures to the new official strategy centered on the political reinsertion of Cuba—after the guerrilla movements and the pro-Cuba committees of the seventies—into the mainstream of Latin America and the Third World, but on this occasion under the guise of the new professional clichés of identity, periphery, popular urban culture, anthropology, cultural roots, etc."[35] And so in turn, if not in return, the artists put a fresh, earnest, and cultured face on the Cuban situation, refiguring it for an increasingly numerous and enthusiastic international viewer.

The *Volumen Uno* generation's internationalizing project remapped the America to which it belonged, drawing an arc extending from local, popular cultural, and

spiritual influences through contemporaneous New York art (Kenny Scharf, David Salle, Keith Haring, graffiti art), to pre-Columbian and especially Mesoamerican cultures. This latter interest responded to the other historical amputation—of Cuba from Latin America—that had been performed over time under the relentless pressure exerted by the United States. None of these sources or references was viewed as particularly foreign or exotic by the artists, but rather was felt to be somehow a part of their own heritage and contemporaneity. A desire for dialogue with artistic and intellectual currents in the rest of the world outgrew the revolutionary apparatus and started its own, larger conversation.

The young artists' internationalized expression of a local content was also what made their work interesting and accessible to an audience outside Cuba. *Volumen Uno* coincided with the East Village art scene in New York, which also suddenly became visible around 1981 and which, though quite different in many ways, shared a do-it-yourself and antiestablishment ethos and a tangent improvisational aesthetic. The Cuban work could easily be understood within the rubric, and the spirit, of what was happening at the fashionable fringes of the mainstream art system. Reflecting on a question that had become a central concern in the discourses surrounding Latin American art, and taking a relatively dim view of the phenomenon in his classic essay "Access to the Mainstream," Luis Camnitzer points to it as one imposed on "peripheral" artists as a condition for entry into the "mainstream": only by adopting an "acceptable formal repertoire," and with "ethnicity and/or nationality . . . confined to content," could these artists hope to enter the market.[36] Although their focus was very much on the Cuban situation and public, and although it was not yet necessary for any of the young Cuban artists to sell work to survive (the state guaranteed basic needs),[37] still the growing international attention to their work was developing its own importance: we need only look at the impact of their friendship with Ana Mendieta, who was esteemed for being both Cuban and more than that. While for Mendieta her displacement from Cuba was the source of a lifelong wound ("I felt a lot of anger, I still do," she wrote in 1983. "My art comes out of rage and displacement."),[38] for her contemporaries in Havana it had provided her with the invaluable gift of being able to see Cuba both from within and at a distance. "To know Ana was a bombshell for us," Juan Francisco Elso once said:

> It was discovering how the world could see us and how we could become
> conscious of what we were making. . . . it was really my first contact with
> someone who sees your production with a different eye, not ruminating within
> your own relations. . . . In some of us, a more universal, more ambitious capacity
> in the process of creation was established. We took all the proposals of the

Revolution, of the guerrilla war, of Che, of all that inspired dreams in the people, and we made of it also a goal in art. It was like appropriating what was ours, and yet we had been looking at it all the time as something put in a book and that we would have to wait for permission to make ours. It was like an awakening in that sense.[39]

Inevitably, the new Cuban art has been as entangled with how and where and by whom it has been read as with what it, itself, reads or does. Since that first eruption in January 1981, the movement of contemporary art in Havana has been acutely aware of this multiple vigilance—vigilant of the vigilance of foreign curators, dealers, and collectors, of state security, of the Communist Party, of local critics of a slightly older generation for whom the movement was the realization of a long-sought dream, or people in the neighborhood whose secretive complaints the art made public. And it has composed its own set of propositions about how to look at Cuba, and at the art, in place of all the habitual narratives of revolution and utopia, on one side, and dictatorship and communism, on the other. Aesthetic and ethical languages were transformed from a force for identity and assertion into a means for challenge, transgression, and disruption, for overturning each and every one of those habitual versions in favor of a state of constant agitation—marking, in the process, the changing space for culture in Cuba.

In place of instrumentalization or moralizing, *Volumen Uno* had proposed that ethics lie at the core of art, and that such ethics were situational rather than metaphysical, derived from their work and from the affiliations and obligations the artists had to each other rather than from grand claims. The "nation," as proposed in the rosary of folklorized heroes, had been construed as a moral community but was probably not, as *Volumen Uno* seemed to suggest, an ethical one. The show's delight in kitsch, poor materials, and eclectic subject matter rejected the entire arsenal of imagery and method that the Revolution had come to insist on.

Volumen Uno's importance lay not in any particular statement but for what it signified through absence—apologetic patriotic realism—and for its displacement of the artwork's content into its form, contrary to the cultural theory of the national Constitution ("Artistic creation is free, always when its content is not contrary to the Revolution. The forms of expression in the arts are free.").[40] As Garciandía has explained,

When we did *Volumen Uno* we were very, very conscious of the fact that the "state of the arts" in Cuba was just awful, precisely because of those ideas of programmatic contentism [*contenidismo prográmatico*]. We knew that *Volumen Uno* was a political exhibition . . . very polemical, precisely because we were positioning the problems in another part, not in the "content"—we

had a completely distinct focus and in that moment this was practically
a political challenge.... Given the circumstances of the context, it was an
exhibition that was proposing ... art as a totally autonomous activity, not
as a weapon of the Revolution as the Constitution says. No, art is a totally
autonomous entity with its own discourse and its own directions.... it is
in no way a weapon of propaganda, nor can it be directed by anybody, nor
channeled by anybody.[41]

Volumen Uno's call for an autonomous art was in part a rejection of the massified
conception of both the producers of and audience for art.[42] If that massification
had roots in democratic aspiration, its co optation in the service of governing
tasks had sharply diminished its currency as a means to empowerment. *Volumen
Uno* defined aesthetic autonomy against sociological programs for culture and
against the enveloping institutional surround. In the context of a highly central-
ized, bureaucratic environment, the use of "nonart" materials allowed artists
to work outside the official supply chain, and by organizing their own shows
they undercut the centrality of the institutional apparatus. Perhaps even more
decisively, their close and vigorous dialogue with sympathetic critics created a
parallel circuit of discussion that undercut the hegemony of official discourse.

A core ingredient of their shared purpose lay in a conceptualist framework.
More than a decade of narrowing had deracinated Cuban art's operations, valoriz-
ing its ideological and emotional capacities and (in order to) incapacitate its more
analytic properties vis-à-vis social, economic, political, cultural, philosophical,
and aesthetic questions. Conceptualism was an antidote to the *contenidismo* that
had dictated what could (or, mostly, could not) be "thought" by art. A conceptual-
ist approach allowed the rejection of symbolic space as an end in its own right,
of figuration as fundamental to the treatment of "reality," and facilitated the
desired realignment of art's relation with reality and with the spectator. It was a
less mediated, and therefore more egalitarian, exchange, antidote to the false pop-
ulism of official art, all within a potentially limitless range of tonality, from the
analytically cool to the increased proximity of the performative and live. A con-
ceptualist approach dispatched the dilemma of how to arrive at a revolutionary
art through one or another diet of representation, and it allowed the idea of revo-
lutionary to open back up to include earlier dimensions that had been sloughed
off, especially the centrality of ethical practice.[43]

Two main convictions fueled the new Cuban art: first, the belief that it was
possible to have a critique of socialism from within socialism, and second, the
belief that art could change something in the reality.[44] Feeling themselves

to be a part of the society that they sought to change was key: as Leandro Soto explained,

> I thought if you acted from an honest position believing in the Revolution, they would respect you. I thought that if I acted within the principles of the Revolution with all that implies, including freedom, why would they not accept me? If I believe in this project . . . I had no other sympathy except for my family, then, for me, well, I thought I was acting from within the Revolution, from a basic revolutionary position.[45]

. . . the orishas

I refused to paint the chá-chá-chá.
—WIFREDO LAM

"Cubanness" not only reverberated against identity and the Revolution and extended beyond the island's shores, it also excavated the island's popular religious traditions. The spiritual was employed by artists such as Elso, Bedia, and Brey as curative against the epidermal art of exemplifications and exhortations. A spiritual focus acted as an overall amplifier of meaning, selecting, framing, and displaying fragments to open more general questions and observations about identity and culture. The scale of cosmological narrative was appealing, able to encompass the demand that, as Elso formulated it, art belong to both a micro- and macro-narrative: unlike many faiths, theirs did not make light of the world to emphasize the weight of the spiritual. An anthropological approach responded to their interest in reformulating ideas of identity, but offered a more "organic" set of tools than the schematized precepts of official ideology. The artists' interest was less with the specifics of practice and ritual than with a general philosophical–gnoseological perspective exploring universal ideas about the human condition, continuing in the vein of Ortiz's "social anthropology" in the early decades of the twentieth century. Theirs was a kind of tightrope anthropology, balancing between a certain allusive and resonant abstraction and a localized, highly legible narration. Afro-Cuban religious culture and ritual, Native American spirituality, and Mesoamerican cultural traditions were all part of a lost identity that became of great interest to artists of the *Volumen Uno* generation. Perhaps most important, they were enthusiastic researchers, contrary to the anti-intellectual inclinations that Mañach and others had decried early in the twentieth century as part of the Cuban character. Their work was based in an unapologetic intellectualism that,

coinciding with their popular origins, constituted a new persona for artists that was a truly revolutionary social/cultural phenomenon.

Elso, Bedia, and Brey opted for an aesthetic of ephemerality and "poor" materials, analogous in many ways to Julio García Espinosa's idea of "Imperfect Cinema," which articulated an aesthetic and ethical position from the reigning poverty of means to better reflect the context within which the works were being made. For visual artists, poor materials, together with an anthropological frame, could also invest the works with the possibility of magical or supranormal function.

The three artists were drawn to the universe of Afro-Cuban religious practice—Brey was born into the tradition, while Bedia and Elso were initiated in 1983—and it constituted an important part of the close friendship between them. Since colonial times, popular spirituality has been the selvage of the Cuban everyday. Afro-Cuban religions (primarily Santeria, *palo monte, abakuá,* and *Arará*) permeate Cuban society—white, black, and creole—and intersect with everything from music to politics to gossip. Completely noninstitutional, these religions have always functioned through personal networks at the margins of the society's structures. Since colonial times they have had a checkered relationship with the political authorities, variously suppressed, tolerated, and rehabilitated according to the complicated calculus of power in various historical epochs.[46] Their ubiquity, though, meant that when the young artists turned to popular religion, that anthropological gaze was as much an exploration of self as of other, an avenue into the heart of the Cuban world.

A pronounced lyrical and subjective tendency permeated Brey's work, which contrasted sharply with the epical, objectivizing tendencies of the official pantheon. Between about 1982 and 1985 he produced a series of tender works that proposed an imaginary journey accompanying the great nineteenth-century German naturalist Alexander von Humboldt through the Americas, by way of his diary: "a way," as Brey explained, "of examining who we are through the meanings of history: looking at ourselves through the eyes of the Other."[47] In his quietly defiant poetics, Brey unveils his interest in restructuring and retaking ownership of the myth of America. The work's botanical–historical method is a sophisticated play on fact as fiction and fiction as fact, the explorer's notes and drawings reappearing "by unorthodox conceptual means, paraphrasing Jorge Luis Borges rather than Joseph Kosuth,"[48] to register the European's amazement at the exuberance and otherness of the "new" world, the scientist's eyes stunned by it. Brey's work is full of fascination with, and affection for, the flora of "América," understood within the myths that have variously identified that name.

In subsequent work Brey switched to a more sculptural, installation format, accentuating the quality of oneiric rebuses, of stories told in fragments with potent, mysterious, poignant, and sometimes menacing passages. That quality was nascent in Brey's telling of Humboldt's story and seems related to a pervasive sense of loss in his work. His continual resort to discarded, worn-out, and patinated materials flirted with but evaded a romance of the ruin, in an apparently rueful attachment to the sacred. In 1992 Brey was invited to participate in *Documenta IX*: one of only two Latin Americans included in that megashow, his work strained almost to exemplify and hyperbolize an unspecified otherness.[49] In 1994, several years after having left Cuba, Brey returned to install a suite of works on the occasion of the fifth Havana Biennial. The works in that show, *Tocar la otra orilla,* recaptured the poetic compression that the enlarging symbolic generalities of the *Documenta* work had dissipated. The Havana installations seemed to mirror the intense symbolic passages of Afro-Cuban ritual, a very specific intonation that generated great emotional density.

Although they are often lumped together for their interest in spirituality, the "primitive," and the Afro-Cuban, Brey and Bedia took very different positions with regard to those subjects. Brey, always somewhat overshadowed by Bedia the charismatic raconteur, was more introverted both in temperament and in visual language: perhaps as a corollary to that, his work seemed to operate from within a spiritualized condition, while Bedia's work maintained a more expository tone.

By 1982 Bedia had already developed a keen interest in anthropology and indigenous American cultures, and an attachment to myth and the ancient world. Much of his work was a kind of time machine that located the "primitive" and the contemporary in proximity, looking for echoes and overlaps between them in a ritualized space. Bedia's 1983 exhibition *La persistencia del uso* (The persistence of use) was perhaps the first mature statement of those investigations, as well as a signature statement of the period. The title referred to cultural implements—the knife, ax, hoe, and lance—whose basic structures have remained more or less the same throughout and across human development. As Bedia saw them, those tools had a metonymic function in the material and spiritual–symbolic vocabularies of survival. The persistence of these objects positioned Bedia as equally within the ancient and the contemporary world, creating a bridge and reducing the cultural contradictions usually seen as dividing tradition from contemporaneity. The spirit world becomes visibly present in Bedia's compressed and spare language, no longer ascribed to ancient status but actively present in the unfolding conflicts of modernity.

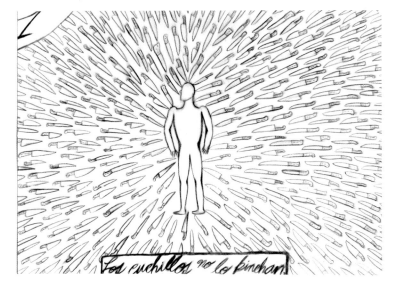

José Bedia, *Los cuchillos no lo pinchan* (The knives don't prick him), ca. 1985. Crayon on paper; approximately 22 x 28 inches. Courtesy George Adams Gallery, New York.

In the mid-1980s Bedia made a series of ideogrammatic black-and-white drawings that stand as a high point of his work. Immaterial presences loom in human and urban space, humans take animal forms and conversations ensue. By this point, *palo monte* was central in Bedia's life, and the work's abbreviated pictorial code delineated a world in which animals, knives, people all vibrated with spirit: "symbolic territories," "zones of force."[50] Bedia's simple, stark graphic style often incorporated handwritten captions into the image, increasing the anthropological, field note feel of the work. *Autoreconocimiento* (Self-recognition), in which men see themselves reflected in a small pond as wolf, bird, and deer. *Venado pensándose* (Deer thinking itself). A man protected by an invisible force, in *Los cuchillos no lo pinchan* (The knives don't prick him). *La habitación no está vacia* (The room is not empty) reads one image of a space filled with spirits swirling above a sleeping man. The organic, informal aesthetic of the works corresponded to the materiality of the cultures that Bedia was studying and positioned the work as "inside" them, both as a result of Bedia's great erudition and his absorption of their cosmoview and ethos into his own, even while holding them in suspension: he acknowledged that he was "neither a scientist nor an aborigine," but rather an artist working in "an ambiguous situation."[51]

Bedia's immersion in the Afro-Cuban quickly became magnetic for curators in the United States and Europe working under the rubric of multiculturalism, and he was a frequent participant in blockbuster surveys such as *Art of the Fantastic* and *Magiciens de la terre*.[52] The works Bedia showed in these international

José Bedia, *Juguete para niño africano* (Toy for an African child), 1989. Crayon, cinder block, tree branch, homemade toy; approximately 6 x 20 x 3 feet. Courtesy George Adams Gallery, New York. Photograph by Luis Camnitzer.

platforms made only indirect reference to his viscerally critical opinion of the Cuban regime, keeping "politics" sotto voce underneath the work's "enigmatic clarity."[53] *Juguete para niño africano* (Toy for an African child), an installation from 1989, enthroned the eponymous toy on a makeshift altar pierced by *garabatos,* forked branches used in Afro-Cuban ritual. The ensemble recalled the story of the simple toy, made for a child by his Angolan father who had nothing more than a scrap of wood and an archive of symbolic structure to work with. Only hinted at was Bedia's side of the story, which began with his forced conscription by the Cuban military for service in Angola and concluded in his angry memories of that war's utter corruption and brutality.

The third close friend was Elso. For Elso, the modes of investigator and believer were not demarcated, and the few works that he produced before his death from leukemia at the age of thirty-two have, consequently, an ambiguous status somewhere between art and belief. To understand Elso's work, Orlando Hernández in his excellent 1995 essay *Map (incomplete) of Por América* looks to Milan Kundera for a sense of what distinguishes the "novelistic essay."[54] It is, he says,

> very different from usual ones because they work not only with systematic, rational, logical material but also with visions, dreams, intuitions, moments of enlightenment, the imagination, and where ideas and appreciations of the philosophic, moral, religious, and political order never appear attached to the general discourse of a work as alien elements, but are from the very first integrated and welded to the general body of the discourse.[55]

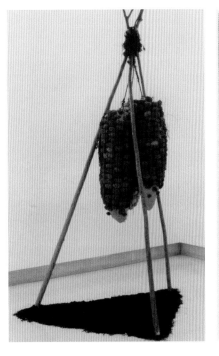
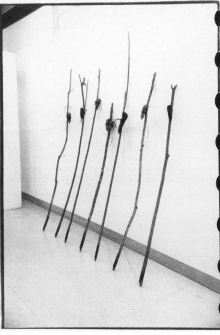

An incredibly tall order for an artwork, and for an artist, since he can never have the satisfaction—the consolation—of completion, in a process that can only "attempt," to "experiment," to open one question out from another.

Elso grew up with his mother and grandmother in a marginal neighborhood of Havana. He had an introspective and defiant personality, tended to melancholy, and seemed to be tortured by incessant ethical and moral questions that, for others, were probably "just a matter of politics." He had attended the San Alejandro Academy of Fine Arts and graduated to the Escuela Nacional de Arte, coinciding there with Brey, among others. By then, purges in the visual arts had accomplished their task, and the great teachers (Antonia Eiriz, Raúl Martínez, Servando Cabrera Moreno) were all gone. The young students, made restless by the surrounding mediocrity, began to look more and more to each other, and less and less to the school, meanwhile seeking out the maestros on their own. This was the genesis of the close community between them that was to become one of the period's hallmarks. They were reading everything they could (Elso's modest library included Alfredo López Austin, Mircea Eliade, Marie Louise von Franz, Ortiz, Claude Lévi-Strauss, James Fraser, Calixta Guiteras, and Laurette Sejourné),

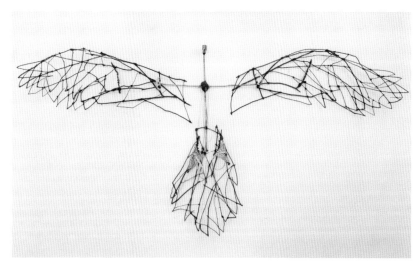
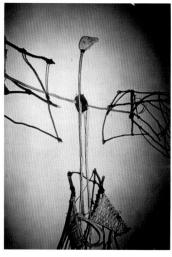

LEFT Juan Francisco Elso Padilla, *Pájaro que vuela sobre América* (Bird that flies over America), 1986. Branches, jute, sisal, wax, dirt, wood; approximately 6 x 9 x 1 feet. Courtesy Reynold C. Kerr. Photograph by Gory (Rogelio López Marín).

RIGHT Juan Francisco Elso Padilla, *Pájaro que vuela sobre América,* 1986, detail. Courtesy Reynold C. Kerr. Photograph by Gory (Rogelio López Marín).

listening to all kinds of music, and watching the eclectic array of movies screened in Cuban theaters and on TV.

Elso's developing interest in anthropology, archaeology, and indigenous American cultures gradually began to overtake "art" as a model for his work. He was increasingly inclined toward the popular, improvised, and handmade, an aesthetic based on the personally commemorative and significant, and drawn to the objects that carried the residues of peoples' lives. Elso's modest output, fashioned mostly of branches, twigs, clay, *amate* paper, twine, wax, dirt, bits of cloth, and vegetable fibers, exuded an attentive and fragile sense: the works are ruminative, with a hidden quality. The materials were not poor so much as specific, minimal, frail ("fragility as consistency," as Cuauhtémoc Medina understands it), and intimate. There are many aspects of Elso's work that could be taken up, but it is his idea of América that seems most relevant to the present discussion. A range from botany to ritual to history was his braided idea of América, a continent, destiny, history, biography, and ethic. Eventually Elso set out to describe the geography of América from Cuba to the edges of the great Mesoamerican empires; to enter myth via Quetzalcoatl and St. Francis; to learn and perform the rituals of Elegguá; and to meditate on how all of this fused into the world and moment he lived in: another magnitude of the continent.

Elso's early exhibition *Tierra, maíz, vida* (Land, corn, life) revealed his cosmological approach to thinking America. It was essentially a love poem to corn, the basic food and mythical origin of the peoples of the continent. Ritual elements radiated into the installation's spare display, focused on a rough tripod hanging

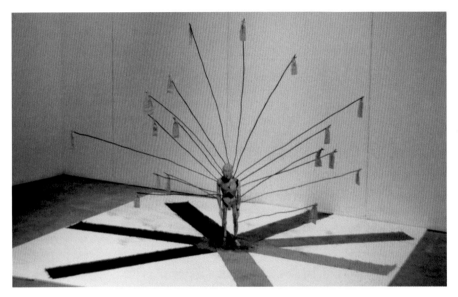

Juan Francisco Elso Padilla, *La fuerza del guerrero* (The force of the warrior), 1986. Wood, fabric, branches, wax, gesso; approximately 6 x 8 x 8 feet. Courtesy Reynold C. Kerr. Photograph by Gory (Rogelio López Marín).

with huge *mazorcas,* an icon of maize.[56] Not long afterward, Elso began working on the quartet of pieces that comprised *Ensayo sobre América* (Essay about America), and with that project his imaginary began to be more concrete and historical until, in 1986, his América had become, like that of Martí, an ambitious, generous, and critical vision.

It was also a vision of unity, which hinged on the great historical dreams: *Pájaro que vuela sobre América* (Bird that flies over America) referred to a myth repeated in cultures across the continent, concerning legendary birds whose flight bridged the distances between all her shamans.[57] Elso's rendition was sized precisely to his own body and, in the post-Mariel imaginary, brought connotations of longing and escape to the legendary flier's horizon. *La fuerza del guerrero* (The force of the warrior), another part of his essay, was a small figure bearing a gigantic halo of names that evoked the legacies and reach of the continent: "Martí. Bolívar. Che. Quetzalcoatl. Watauinaina. Manco Capac. Kukulcan. Gonzálo Guerrero. Toqui Caupolican. Lautaro. Makandal. Ganga Zumba. Pachan Mama. Udla'hä. San Martín (?). Miranda (?). Toussaint L'Ouverture (?). Zapata (?). Tupac Amaru. Toro Sentado," read his notes for the work. Elso's warrior was naked and anonymous, diminutive beneath his corona: he, like the bird, performed a linking function, between men and their heroes and gods, and between historical dreams and the reduced social space of the island.

Arming the figure: Juan
Francisco Elso Padilla and
La fuerza del guerrero, 1986.
Courtesy Reynold C. Kerr.
Photograph by Gerardo Suter.

. . . a spy of floors

Oh, how they sing upstairs! There's an apartment upstairs in this house with other
people in it. A floor upstairs where people live who don't know there's a downstairs
floor and that all of us live in the glass brick. And if suddenly a moth lands on
the edge of a pencil and flutters there like an ash-colored flame, I look at it, I am
looking at it, I am touching its tiny heart and I hear it, that moth reverberates in
the pie dough of frozen glass, all is not lost. When the door opens and I lean over
the stairwell, I'll know that the street begins down there; not the already accepted
matrix, not the familiar houses, not the hotel across the street: the street, that busy
wilderness which can tumble upon me like a magnolia at any minute, where the
faces will come to life when I look at them, when I go just a little bit further, when I
smash minutely against the pie dough of the glass brick and stake my life while I
press forward step by step to go pick up the newspaper at the corner.
—JULIO CORTÁZAR, *THE INSTRUCTION MANUAL*

"The struggle took on a popular character, and gained military control," declares
the section of the official guide to the Museum of the Revolution dedicated
to 1958 (*popular,* which in Spanish indicates less about being well-liked than
grassroots), and then, soon after, the triumphant guerrillas, "accompanied by
the people's gigantic clamor during the entire route from the eastern zone, made
[their] entrance into the capital of the republic."[58] *Popularity* in both senses of the
term has special political capital in a socialist country, and just as it was essential
to establish the popular credentials of the revolutionaries, it has been the same
with the artists. Aside from providing bona fides, however, popular origins have
also encouraged an aesthetic preoccupied with the ordinary, an art of the kitchen
and neighborhood rather than of the Nation.

An "interiorist" side has long been attributed to Cuban culture, for example,
in the figure of Amelia Peláez (painting in the "creole microclimate of her house")
and the others who clustered around Lezama Lima (who "lived the experience
of the world in the distance he went from the living room to the kitchen of his
house").[59] In 1943 Guy Pérez Cisneros wrote of the group around the painter
Mariano in the 1930s that "little by little . . . [they] had abandoned heroic subjects,
the concept of power, the search for the national essence, in favor of sheer joy,
delight in color, and a baroque struggle with form. Great, ambitious murals gave
way to intimate, delicious canvases on easels."[60]

Much has been made over the years of the new Cuban art's absorption within
the quotidian, which is understood to be a prophylactic against estrangement
or alienation. There is truth to this, but it is a truth too easily extended into a

romanticized claim for "authenticity," as though their very specialized training, with all of its resonances, had done nothing to set them apart. A more accurate representation of the relationship might be of a "participatory contradiction,"[61] speaking both for and from a popular base: an interiorized belonging to the everyday life on the island was a point of departure, which was then overlaid with the formal resources of contemporary art. Most important, probably, was the fact that the works carried a special feeling for real (Cuban) social space, thanks to the thematics and the often makeshift and improvisational materiality, making the work part and parcel of that social landscape. Although often eclectic, it remained attached to matters close at hand and deeply felt, never suffering from ethereality or stranded by the loss of historical moment. The unfolding of the Cuban work thus protagonized that very social space, pulling it from the background by virtue of its correspondence with it. "I am interested," wrote Mosquera,

> in the capacity of art to go beyond art. . . . I am interested in art as a very
> complex provocateur, stimulant, sometimes enigmatic and mysterious social
> comment, understanding the social in its widest dimension, not talking
> about it in its sociological sense, but as a fascinating way of giving us light, of
> illuminating our lives, our society, our culture, about very complex phenomena
> in which we find ourselves wrapped. . . . I am interested in the art that helps me
> to orient myself, because it illuminates for me complex areas of life through
> the strength of the metaphor, through the strength of the tropological language
> that allows me to immerse myself and shed light in certain sectors, where the
> more exact sciences or social sciences have difficulty entering because they
> are areas that are linked to the perceptive, to the psychological, to the cultural,
> to the symbolic.[62]

Tomás Sánchez's "antitouristic, anti-picturesque, anti-tropicalist" landscapes were a kind of indirect meditation on everyday Cuban life.[63] As the critic Manuel Vidal noted, while "the majority of landscape painters painted the landscape as it looked on Sundays, Tomás Sánchez paints the landscapes of Mondays, Wednesdays or at most of Saturdays."[64] A contemporary of the 1970s genuflectors, Sánchez had developed a serious interest in yoga, and his exquisitely rendered landscapes of garbage and puddles reflected an Eastern philosophical preoccupation with the centrality of small truths. Largely scorned at the end of the 1970s and fired from his teaching job at the Escuela Nacional de Arte under accusations of "religious proselytizing,"[65] Sánchez was rehabilitated only after winning the Joan Miró International Drawing Award in Barcelona in 1980. His presence in *Volumen Uno* therefore "highlighted the transitional tone of this event."[66]

In 1978 Mosquera had remarked of Elso that he was, "like children, . . . a spy of floors and walls,"[67] and it was that habit of close seeing that had grounded even his most celestially scaled works. His first subjects rested in the patina of the Cuban everyday—coins worn smooth with use, ceiba tree trunks polished by the hands of beseechers, pocked *guardacantónes,* the colonial relics still embedded in the old city's doorways. Federico García Lorca once compared the crescent moon to a fermata, a held note interrupting the harmony of the surrounding night. Elso's work—laboriously, painstakingly, ritualistically worked, was that kind of pro-longed tone, hanging over the small presences of the ordinary day to open them into other meanings. As he gradually came to suggest, it was precisely in the space where the private intersects with the public, the historical, and the religious—in the selvage between them—that aesthetic experience accumulates its power.

The work—or, better, nonwork—of Gustavo Pérez Monzón comes to mind in this regard. His early production had been a kind of mathematical poetics, a beautifully structured micro-universe tangent to his interests in tarot and astrol-ogy. The work's apparent systematicity was hermetic: strings formed grids that became mazes in an evident but uncrackable code. The works had a visual deli-cacy and a deliciously pensive mien, with a numerological obsession somewhere between Alfred Jarry and Sol LeWitt, and cosmological shifts in scale like the night skies of Vija Celmins.

After his successful "launch" along with the others in *Volumen Uno,* it was, then, strange to many when, not long afterward, Pérez Monzón decided not to make art anymore. His withdrawal from the scene, at precisely the time when his friends were gaining so much attention, inevitably became shrouded in rumor and legend. Whatever his reasons,[68] it seems likely that, for the artist, such a sharp distinction between making art and not making art missed the point. His artistic withdrawal was not the bruised one of Eiriz and the others who stopped working in the 1970s: among other things he began to work as an art (and not craft) teacher, with extraordinary results.[69] Working in the remote parklands of Jaruco, Pérez Monzón and the children made drawings with pigment in the run-ning streams and antlers out of fallen branches. "They did things with leaves that would disappear," a friend recalled, "or they would draw pictures on the surface of the lake with watercolors, then watch them disappear, or they would use the form of the rocks to draw animals."[70] Camnitzer also remembers a visit to Pérez Monzón's house around 1989, for which Pérez Monzón had created an elaborate spider web that spanned the tiny house's doorway, welcoming his guest with that everyday replacement for art.[71] The wonderful imagination and creativity of these

Gustavo Pérez Monzón, work with children in Jaruco, ca. 1981. Courtesy of the artist.

projects, marked by Pérez Monzón's characteristic sensitivity, made clear that he had not stopped making art, only perhaps stopped making art objects.

Pérez Monzón's teaching demystified art, without severing it from mystery. There was no guru persona and no system, but instead the offer of something more like the actual experience of life. The process was less deconstructive than a simple recourse to the possibilities that the moment and circumstance offered, parsed in the patterns of play, imagination, creativity, and awareness.

Pérez Monzón seems to have lost interest in the "scale" offered in the art world itself—its scale of ambition or lack of it, its scale of social meaning or lack of it, its scale of poetics. Some years later, in the very different moment of 1989, he was invited by the younger artists/curators José Ángel Toirac and Tanya Angulo to do an exhibition. They were fascinated with his disappearance from the scene and even more fascinated with the way it had accumulated into myth and with what that inflation signaled.

> In an artistic context in which grandiloquent attitudes and pretentions of transcendence seem to predominate, the idea of relaunching Gustavo Pérez Monzón has that aura that is acquired by works that propose to achieve the impossible. Our proposal—to do a solo exhibition of Gustavo's work—inserted

No matar, ni ver matar animales.

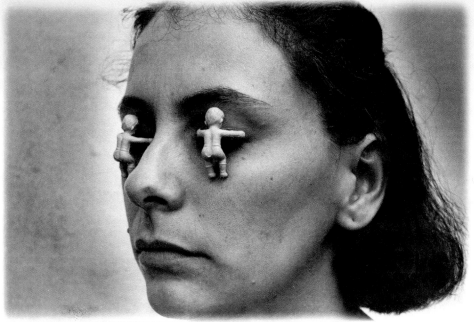

in this context and valued on the basis of the myth that exists regarding his
"artistic inactivity" becomes a demythification of his image.[72]

Pérez Monzón's "artistic inactivity" was, for them, the mark of his refusal within
the increasingly professionalized art circuit of 1980s Havana, and the "exhibition"
was an elliptical debunking of it: "Many people's views about Gustavo are per-
meated by this myth," they noted in the exhibition brochure. "The expectations
for this show demonstrated that." The show consisted of pretty much anything
but artworks: there were several events organized by the artist and his friends,
screenings of music videos, films, performances, parties, dances, free drinks: it
was an "oasis," evading the classificatory impulses of an "art" that had begun to
take itself too narrowly and self-importantly.[73]

Around the same time as Pérez Monzón was disappearing, Marta María
Pérez produced *Para concebir* (To conceive, 1985–86), works that stand as some
of the most explosive of the new Cuban art and all the more so for their sharp ric-
ochet off vernacular belief. Pérez had her husband (Garciandía) photograph her
own nude and pregnant body in tableaux that are chilling even for those ignorant
of the specific taboos that the images defy. Probably the most memorable image
shows her in profile wielding a butcher knife over her huge belly: it is an image
of almost unbearable suspense and savagery. "Do not kill animals or see them be
killed," reads the caption, as though sounding some kind of atmospheric social
text. Throughout the series Pérez's face is cropped out of the frame, and her body
appears in a deadpan, flat space, something like a mug shot in which the identity
is withheld: their moderate contrast and the repetitive, blocky compositions cre-
ate a sense of studied neutrality.

Pérez's figure is haloed by nothingness, enveloped and isolated by either a
black or a white void that deprives her of both company and immediate context:
the beliefs and fears hang suspended in that separate space, supplanting that
other social space with its other exhortations. Pérez's photographs opened a
new front in the departure from an ardent and reliquary role for photography
in Cuba. As early as 1965 the Revolution's use of photography in the service of
heroization had come into question. Inspired by Edmundo Desnoes's essay "The
Photographic Image of Underdevelopment," the exhibition *Photo-Lies* attempted
to strip photography of this naturalized and romanticizing role. Desnoes, writ-
ing in the catalog, attacked the regime's pervasive, rhetorical illusionism: "They
have created a false myth of photography as mirror, as mechanical reflection of
reality. . . . Everything is a hoax, a mystification: photography is a lie."[74] Pérez's
work stripped the photograph of its documentary mission, and in place of the
performance of public virtue, "history," "truth," or "victory," it recorded a private

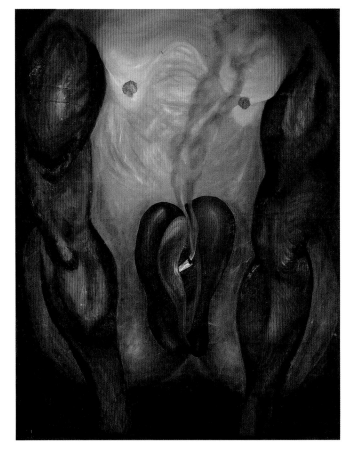

Ana Albertina Delgado, *¡Estás completa!* (You are a beast!), 1989. Oil on canvas; 50 x 40 inches. Courtesy of the artist.

realm, totally subjective, fascinated with prohibitions and filled with anxieties: a shadowy and silent universe.

The work is generally read mostly as an explicit contravention of the taboos of popular Cuban superstition, and that challenge is undeniably at play. But beyond that, the work's interiorized, psychologized space seems in some sense a decision *not* to inhabit or take on the public as historical or political arena, and to instead locate its communicative space more privately, in the semiclandestine realm of the taboo. It is not to debunk superstition, I don't think that the artist so deliberately shocks us but to register a vein of intrapsychic anxiety, violence, and dread—certainly not an element in the proclaimed constitution of Guevara's New Man. This became more explicit in her next series, *Recuerdos de nuestro bebé* (Memories of our baby): the tone of fearful consequences suggested in *Para concebir* becomes even more unsettling after the birth of Pérez's twins, who

begin to appear as tiny baby dolls in images that she construed as a version of the family photo album. The "girls" point sharp pins at their mother's eyes; they pin them shut. Pérez's fantasies violate the feelings that she is supposed to have as a mother: with brutal candor she reveals the relation of mother–child as terrifyingly fraught, visualizing not popular belief so much as an abyss of psychological self-doubt and estrangement. Pérez's work evokes a commonplace that is fearsome, in large measure because it is so intimate.

Pérez was one of very few women whose artistic visions were routinely included under the rubric of the new Cuban art. It does not seem coincidental that she, along with her contemporaries María Magdalena Campos Pons, Consuelo Castañeda, and the slightly younger Ana Albertina Delgado, tended to work with themes pertaining to domestic as opposed to political space, interior rather than ideological modes of identity. Campos's work, for example, articulated a central metaphor of female sexuality and contraception. In both small- and large-scale works her exuberant, vivid floral forms and fruit-vulvas suggested an eroticism "free of traumas, Freudian theories, subservience and passivity," as Mosquera noted at the time, but also with a darker underlying feel of aggression.[75] Delgado also located her work in a domestic context, playing with the realm of everyday fantasy in canvases painted with a playful naïveté and garnished with enigmatic titles. Castañeda, breaking the pattern, did stylish, cool works playing with themes of postmodern appropriation, exploring what those procedures might mean in a setting in which the *post* prefix arrived in advance of a complete modernization process.

... minor

What art should we make then? More conscience, that it shall not be avoidable, and that one should be unable to bear that conscience. The more massive and present, the better. Present, like my shoes, but with one being too big and the other one being too small...

—RICARDO CARREIRA, "COMPROMISO Y ARTE"

The great paradox of this autonomous art lay in its deep connection to social reality: rather than a return to individuality and interiority, or a disavowal of the political, it followed from the basic fact that people always, in some way (except autistics) negotiate their inner lives with the outer world, and so does art. Cuban art has had an enduring concern for the everyday public sphere and its practices, languages, and objects, a space that belies the false opposition of interior (formal) and external (political) expression.

A strong quotidian current, reformist in nature, ran through much of the Cuban visual art of the 1980s: the everyday and commonplace as legitimate public domain, a supplementary, real social space. Gilles Deleuze and Félix Guattari described something kindred that they called "minor" literature, which reclaims agency from a power that wants to make of the street a simple place whose politics and sentiments are in unison.[76] The Cuban everyday was reclaimed as space of observation and inquiry, and placed at the center of artistic process: it was anti-monumental, -empyrean, -mythic, -heroic, -hectoring, and -ecclesiastical (because by then it was clear that Revolution and the church were in some ways contiguous). It was a tangled space, both shared and private.

The thread returns us to the allegation that *Volumen Uno*'s challenge had been "merely formal," to which Deleuze and Guattari retort that, while

> in major literatures . . . , the individual concern (familial, marital, and so on) joins with other no less individual concerns, the social milieu serving as a mere environment or a background . . . minor literature is completely different; its cramped space forces each individual intrigue to connect immediately to politics. The individual concern thus becomes all the more necessary, indispensable, magnified, because a whole other story is vibrating within it. In this way, the family triangle connects to other triangles—commercial, economic, bureaucratic, juridical—that determine its values.[77]

Soto's contribution to *Volumen Uno* had consisted of documentation of earlier "plastic actions," open, largely unscripted events staged on the streets of his hometown Cienfuegos. Public performance, in a setting in which the streets are as animated as those in Cuba, does not have the abrupt quality of "intervention" that it tends to have in the U.S. context: Soto's actions tended to be popular affairs, attracting the curious and blending into the general urban energy. He is widely recognized as having been the first in Cuba to do performance art, and his work moved with great fluidity between painting, installation, performance, and theatrical design, all of which he has made a mark on. Although his first work exhibited an anthropological tendency parallel to Bedia, Brey, and Elso, he soon switched to the subject of the history and legend of the Revolution.

Soto had already made something of a name for himself in Cienfuegos by the time he left for Havana to study at the Escuela Nacional de Arte in 1972. At ENA he worked with Tomás Sánchez, who had a great influence on him: Soto had similar interests and explored theosophy, Santeria, Hinduism, yoga, and Catholicism in an effort "to see reality from another point of view." He began to have serious political problems early on in his career, despite the fact that he was a self-defined

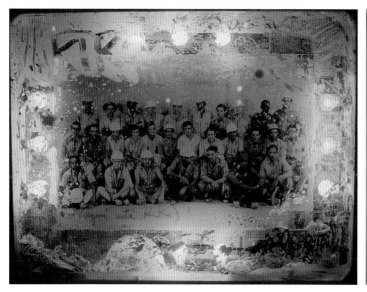

LEFT Leandro Soto, *Kiko constructor* (Kiko the builder), 1984. Photograph and mixed media; 100 x 131 x 20 cm. Courtesy of the artist.

RIGHT Leandro Soto, *Retablo familiar* (Family altar), 1984. Photograph, light bulbs, mixed media. Courtesy of the artist.

militant and a member of the Union of Young Communists: for Soto, there was no contradiction between his wide-ranging philosophical interests and his revolutionary belief, but from an official perspective it was not possible, as he was told, to believe in materialism, Marxism, and yoga at the same time.[78]

After finishing school, Soto returned to Cienfuegos to teach, as was common practice for art school graduates. He was soon fired for "ideological problems," and so began working in stage design, a field not only closely related to his training but also, crucially, a profession that had recently been "cleansed," leaving it more "open."[79] In 1983 Soto presented his work to the International Conference of Young Creators organized by the Ministry of Culture and received a standing ovation,[80] and shortly thereafter his 1984 exhibition *Retablo familiar* marked a high point in the acceptance of his work: not only had the 1983 incident helped rehabilitate him, he had also made the strategic decision to base his work in an evocation of the Revolution as personal history. As Soto explained in the exhibition catalog,

> One day in 1962 in the very midst of the October [missile] crisis my father had the idea of having a family superphoto made "for posterity since each of us was to wear the uniform showing the work he or she was doing when the country is in danger." . . . Dressed that way we walked to "La Madrileña" studio in Cienfuegos. For a long time the photo presided over the living room until more recent ones gradually covered it up until it disappeared. I've enlarged the photo,

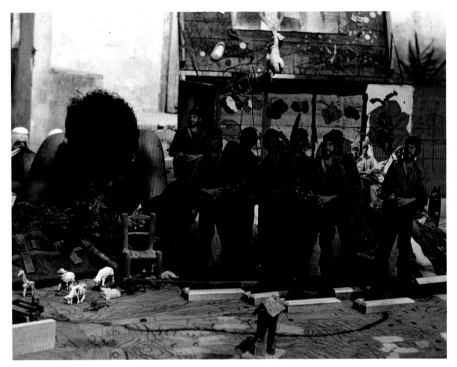

Leandro Soto, *Campamento miliciano*, 1984. Installation and performance, mixed media; dimensions variable. Courtesy of the artist.

feeling as my parents did that day, wanting to show my social commitment and to proclaim it outside the familial territory. I consider my father's "action" to be very original.[81]

Soto's father and uncles had fought against counterrevolutionary "bandits" in the Escambray mountains, and they reappeared in *Campamento miliciano* as toy soldiers.[82] Soto and three boys played with small bands of cutout fighters lined up on a camouflage dropcloth strewn with toy debris in front of toy mountains, all shrouded under a mosquito net, "like a child's dream."[83] The installation had both a playful, spontaneous and a mournful quality, its knee-high view enhancing the sense of a vulnerable, private world. Soto recalled that as a child he had played with the adults' military gear in order to be and feel like them—"heroic and mythic": his resurrection of the warrior cult as children, as imaginary friends, heightened the aura of their magico-military stature. "This was," he wrote, "the privilege of those of us who were children then."

Even though in Soto's hands the revolutionary images became ambiguous, nonetheless his pedigree granted him immunity from criticism: "They couldn't say anything to me," he explained in 2003,

because ours is a completely revolutionary family and began with my great-grandparents who fought with Antonio Maceo's troops, my father, my mother, everybody integral parts of the revolution. And so what I wanted to say with *Retablo Familiar,* somewhat, to the establishment was, This is not going the way you said it would. . . . You are veering away from the original plan of the revolution, this is not moving in the direction you said it would. That is, it was a little like reminding the establishment of the first years of the revolution because I felt that it was betraying its own project. I made them see that it was a family thing. . . . This is family and these are the memories of my family.[84]

Soto rescued the epic narrative of Revolution with family anecdote and memorabilia, replacing the stentorian tone with children's fantasies and play, the heroic horizon with a child's-eye view of the world, the masculine Iconic of beards and blood with the borderline kitsch of handmade dolls, the stolid dignity of the portrait and frame (the Museum of the Revolution's hushed, rehearsed tones) with a *schmutz-* and scatter-art sensibility that echoed the popular altars of threadbare living rooms and neighborhood shop-window displays. The Cuban Revolution had been personally lived by the entire population as real experience, excitement, and intimate hope, but had somehow gotten hijacked into the puffery of gray men. Soto, in these generous works, defrocked the official version of the story but reinstated, on the quotidian and anonymous level, the capacity for wonder: "I wanted," he said, "that when the spectator entered this room he would feel he was in a very well known place, a place that he had visited sometime in the past and it now appears before him by surprise."[85] Soto's work of the period struck a note so precise, complex, and deeply seated that it reopened a possibility for thinking revolution and ethics and self all in the same phrase. The works were an early expression of nostalgia for the lost revolution, mourning what until then had mostly been felt as continuous and alive.

A minor literature is set up from within a major language, not external to it. Pérez's photographs had nestled deep inside the popular imaginary and "torn away" from it, became "a nomad and an immigrant and a gypsy in relation to [it], "interiorize[d] relations of force."[86] Soto had done the same thing to the official (major) history when he tore it from its myth and "reterritorialized" it in dialect and patois; the *here* of vernacular insisted on over and against the *everywhere,* the *over there* and the *beyond* of the governmental, the referential, and the mythic.[87] *Cubanía* was once again and suddenly deliberately minor, revolutionary, dangerous.

Garciandía has been an axis for much of the length and breadth of the new Cuban art, and his 1982 *Vereda tropical* (Tropical footpath) exhibition was a watershed.[88] Garciandía grew up the son of militants in the fishing town of

Flavio Garciandía, exhibition poster for the series *Vereda tropical* (Tropical footpath) at Galería Habana, 1982. Ink and collage on silkscreen, edition numbered and signed by artist. Courtesy of the artist and Cristina Vives, Havana.

Caibarién, a place renowned for its exuberant carnival floats: "One year it's tritons and mermaids who pose drinking beer in the ultramarine inertia of the Atlantida," notes Osvaldo Sánchez. "Another year it's geishas, Mongol princes and the entire court of the great Khan receiving Marco Polo. Confetti, paper streamers, glitter, cellophane, silvery enamel paints, assembled plywood, banners, ornamental plants."[89] Garciandía began working with "the immense sea of kitsch that surrounds us" in 1981, interested, as he put it, in expressing

> certain visual elements generated by people who, despite a lack of knowledge of plastic arts and formal training, have felt the need to handle forms and colors. Nobody can ignore them because they are everywhere: [in] living rooms, shop windows, cafés, TV studios. . . . there can be found these aggressive, grating, irredeemably "bad" forms. Within their intrinsic poverty—in themselves they have no visual prestige at all, they are "bad forms"—such elements are of an extraordinary variety. I do not approach

Flavio Garciandía, *Todo lo que Ud. necesita es amor* (All you need is love), 1975. Oil on canvas; 150 x 250 cm. Collection of Museo Nacional de Bellas Artes, Havana. Courtesy of the artist and Cristina Vives, Havana.

them because I like them, but simply because they are a visual subject susceptible for re-elaboration. Why this and not something else? Because these forms are the ones that abound in our universe and as for me myself they impress me.[90]

Garciandía is an especially peripatetic artist, intellectually restless and constantly on guard against his own technical virtuosity. His kitsch work came shortly after the faux sentimentalism of a photorealist period, which had triumphed in his 1975 *Todo lo que Ud. necesita es amor* (All you need is love). The painting, a fatuous, soft-focus parfait of a pretty young girl lying in the grass was, along with being lovely, also just maybe (though this was never made explicit) a parody of socialist realism's pearly optimism, its superfidelity conjuring a questionable reality, a dreamy or bizarre exaggeration that also debunked the "realist" pretenses of heroic photography.[91] Nonetheless the picture had, as Mosquera noted, "left all of us quite content," in large measure for its romantic susurrus.[92]

An early assault on the cyclopean officialist aesthetic of the glorified peasant took place, improbably, in the form of photorealism. Cuban cultural policy from

the outset had accorded a special importance to photography, as the most direct and determinative medium of "reality" and, thus, the most utile as propaganda. This paralleled the photojournalistic tradition that had been so important to other liberation movements elsewhere in Latin America and in Africa, burning whole archives of struggle and triumph into the popular memory and laying the groundwork for a new construction of identity based on them. Cuba had a golden age of documentary photography in the 1960s and into the 1970s, with the work of Alberto Díaz Gutiérrez (Korda), Raúl Corrales, Enrique de la Uz, Mario García Joya (Mayito), Osvaldo Salas, María Eugenia Haya (Marucha), José A. Figueroa, and others. Art, on the other hand, with all of its ambiguities and multiple meanings, was seen as more problematic, although it was also, luckily, less reproducible. As Cristina Vives notes, the Cuban state "gradually set a course for art and photography—separately, as it were—from the beginning of the 1960s. The press took charge of the photographic image, and cultural institutions assumed responsibility for establishing the 'necessary' borders of art in their exhibition circuits."[93]

Luminous photographs of leaders, martyrs, campesinos, cane cutters, *rumberos, compatriotas, centenarios,* and *pioneros* (not to mention Che and Fidel playing golf on the expropriated grounds of the Havana Country Club) were widely circulated by the Revolution and played a vital role in establishing an inspirational image of victory in the public's mind. Against that set of conventions, a few artists began working in a hyperrealist style around 1973.[94] Although it was the formal antithesis of the expressionism that had been viewed so darkly, and of the nonfigurative work that had come to be seen as insufficiently forthright, excessively ambiguous, and impossible for the nonspecialist to understand, and despite its relatedness to the mannerist vérité favored by the political establishment, the photorealist work nonetheless came under attack.

But the complaint lodged against it was not concerned with its truth content but with its bastard roots in the photorealism that had prospered in the United States not so long before. The paintings "copied" from photographs, a practice decried as "Westernizing," "counter to Cuban traditions," "uncreative," "decadent," and "bourgeois."[95] As Garciandía explained, "When I did the hyperrealism, it was the big moment of hyperrealism in the U.S. That is to say, I was copying the enemy in a way, in the eyes of the ideologues and the politicians; it was a sort of copying the enemy. And the painting was titled after a Beatles song. The guy who was in charge of cultural affairs in the Union of Young Communists questioned me about that. . . . Those of us who were making hyperrealism, we were questioned severely on a political level."[96]

The 1976 Constitution's separation of form from content had evidenced a marked suspicion of the latter. The photorealists made clear that form was not so easily distinguishable from content and that form, consequently, was not "free." The artists had generated an unavoidable question around the Constitution's odd and illogical provision, and in that basic insight lay the first radicality of the new work. This photorealism, as it turned out, displayed an ambivalence more typical to the documentary than journalistic mode, functioning as a repertoire of filter, slow motion, zoom, and jump cut: techniques void of objectivity, all making the apparently familiar scenes somehow not right (truth, said Jacques Derrida somewhere, is something that declares itself in the structure of fiction).

Photorealism was used as tautology: This is a *painting,* it declared, And nothing more. It is not a mouthpiece for or extension of or evidence of the Revolution. To the "academic cramps" of the court painters the artists retorted with banalities,[97] in Garciandía's case, or odd, intimist juxtapositions in Gory, or with cryptomystical visions in Tomás Sánchez. Just how much of a departure this really was becomes clear in the installation of the contemporary Cuban galleries in the national museum: after filing by portraits of Che and Amilcar Cabral, coming upon Garciandía's *Todo lo que Ud. necesita es amor* is actually shocking. The photorealist work, predictably, set off a polemic in the press, but it was to be the first time, as Mosquera notes, "in which the artists could respond publicly to the opinions of the officialist critics."[98]

In the 1980s Garciandía began to develop a clean, graphic style, with a vocabulary of forms silhouetted against flat planes of color and embellished with glitter, enamels, and flamboyant, flaring biomorphic contours. By 1985 he had worked his way into a full-blown, glorious trumpeting of schlock with the room-sized panoply of *El lago de los cisnes* (Swan Lake). Garciandía's kitsch, like his earlier hyperrealism, was a bastard child of the inherent romanticism of revolution, both in terms of its propensity for the florid (here reappropriated and redetonated as an ironic, critical usage) and also in its insistence on immanence—on phenomenological facticity, rather than transcendence, as the baseline for defining value.

Garciandía's kitsch dialecticized a complicated battery of resonances. At the same time that he was reveling in that sea of bad taste, lending his work a populist whiff, he was also poking fun at the official populism that valorized the "culture of the masses" while erasing its disruptive dimensions: "The popular absurd is recovered as a confrontational discourse," noted Osvaldo Sánchez,[99] much as Bakhtin might have as well. Garciandía also played on the fact that, despite the extolling of the masses and their (bad) taste, nonetheless their taste remained excluded, even under socialism, from the still "high-culture" socialist institutions—while, of

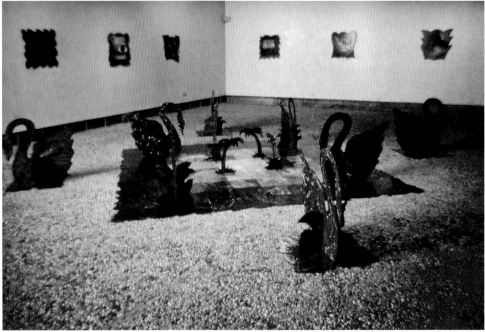

course, invoking what was undeniably a prerevolutionary and bourgeois identity. The Tropicana imagery of swans and palm trees, "perverse decorativism" as he called it, was decidedly not part of the revolutionary cortège.

Refranes (Proverbs), a series executed in similar manner, completed fragments of popular maxims spelled out in words with the corresponding image: the literalness of the image shifted the proverb's metaphoric language into nonsense. Not long afterward, and at a time when a more directly political and critical art was being made by a younger cohort (many of whom had been Garciandía's students), his references moved from domestic interiors and folk sayings to phallicized hammers and sickles penetrating each other ("turning the communist symbol into a body cleaved by its titanic cock").[100] These heroes paraded across canvas after dense canvas, the claustrophobic staccato compositions echoing Cuban socialism's own transit from spontaneous and free form to rationalistic and scientific hand-me-down. The new canvases teemed with suggestions of tropical foliage not polite enough to leave a little breathing room around the edges, veiled by fields of mannered Pollockesque drips. The mostly easel-sized canvases, though, confounded the original cranky angst of the expressionist–existential project by trading "being in the painting" for a much more quizzical, phenomenological distance.[101] In *Tropicalia* Garciandía used much the same repertoire of sparkly communist knick-knacks, though with a palette shifted to the classic revolutionist's red and black—also the colors of Elegguá. Kitsch, these works declared, was not only the bastard child of high art but also the stuff and soul of the revolutionary (any revolutionary) mise-en-scène. These symbols had never been absorbed into Cuban revolutionary iconography, and Garciandía's use of them, elaborately installed along with houseplants and lacquered chinoiserie

Flavio Garciandía, Untitled, 1988. Polyptych: acrylic on canvas; four panels, each 200 x 147 cm. Collection of Claire and Phillipe Coutin, Madrid. Courtesy of the artist and Cristina Vives, Havana.

trelliswork, neatly coincided with the growing expectations in Cuba prompted by news of Mikhail Gorbachev's reforms in the USSR and the no-news political situation at home.[102]

Sculpture is itself an act of Uncanny, always other than the expected, material object, and when familiar things or people are its explicit subjects there is a paradoxical doubling, displacement, and unsettling. The Revolution was not only excessively epic, it was also excessively metaphoric and transitive. Elso's project of reclaiming the heroes back to the tiny room he worked in on one of Marianao's dilapidated streets had touched the spirit of Cuban history in its most idealistic humanism. Those heroes reappeared a few years later—Martí, Guevara, Simón

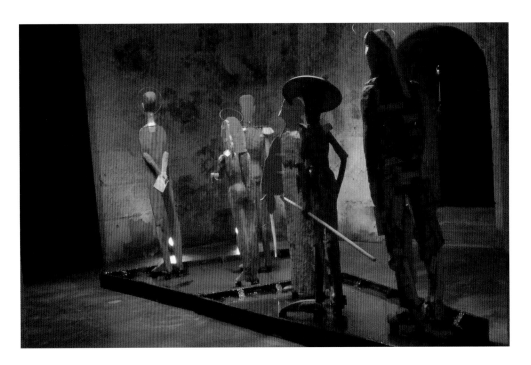

Bolívar, Father Bartolomé de las Casas, Don Quixote, and Jesus, in Alejandro Aguilera's *En el mar de América* (On the sea of America, 1989). Aguilera worked the likenesses roughly from scrap wood and metal, placing them in a somber line atop of a shallow pool of water. The great visions processed across Aguilera's work—independence, continental unity, revolution, humility, dignity: once more, an uncomfortable reading of American ideals and their destiny gathered, in an even more complicated echo chamber.

The ensemble fended off its own heraldic imagery, bringing a visual lexicon of scrap wood and used nails to bear on the heroic themes, bending and resizing them, bringing them to rest within the impoverishment of the material everyday. Around the same time, the Havana Biennial organized an exhibition consisting of popular renditions of Bolívar, filling the Casa Benito Juárez with hundreds of small dolls, handwrought in daily homage to the Great Liberator. Unlike that project's tribute to the act of tribute, Aguilera's piece generated a question around itself. Martí, little more than a silhouette, led the ragtag procession and a battered Guevara brought up the rear, giant but broken, "half man, half crucified guerrilla": Guevara haloed. Bolívar without his horse, Las Casas (who, as Aguilera noted, launched a Western anthropology founded in remorse),[103] Jesus before he is anointed as the Christ, a Quixote "lost in the forest of Cervantian ironies."

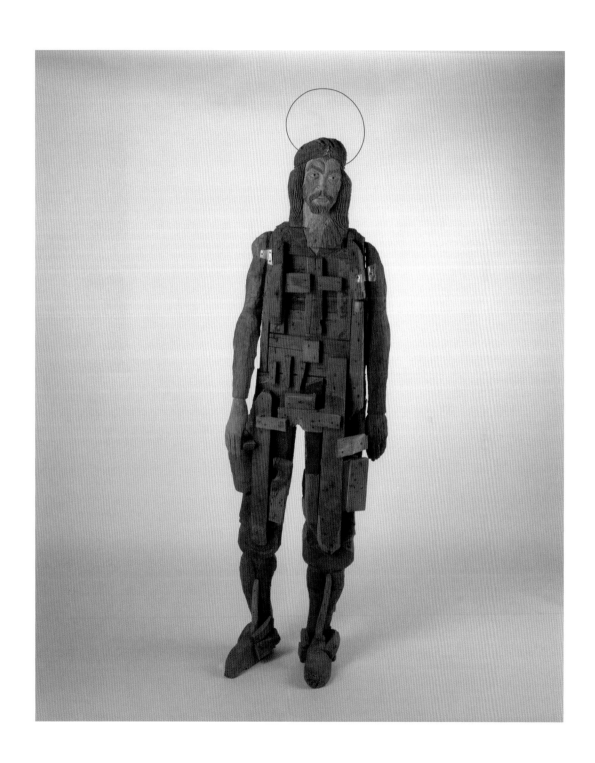

There exists behind all of these images, as Aguilera tells us, "more than biographical histories, rivers occasioned by words. Oceans of feelings."[104] The figures walk across a shallow, makeshift pool: dis-placing, as it were, the hyperterritorialized landscape of heroes and martyrs. The everyday, immanent: the *here* and not *over there*: "the dismantling of all transcendental justifications."[105] The work is a struggle against myth, against History ("rendered fraudulent, made unlivable").[106] The primary dynamic set up by this very apparently religious work, its intensity, has to do with a resolute refusal of ecstasy or release: Aguilera's rendering suggests the complexity of the continent's history, inclined on so many planes and crossing so many dreams in an eternal battle both against, and within, the impulse to faith and belief.

Aguilera's invocation of history was a return performed in order to question, a "eulogy to anxiety, curiosity and experimentation. Indiscreet questions posed to fatigue and indifference."[107] It was not a simple doubling of history but an obviously fictional anamnesis that sets up a parallax view: the figures repeat, and dissociate from, their "proper" meanings, just enough of a displacement to show the familiar for the strange that it really is. Aguilera's procession embodied more properly the process of historicizing, or mythifying: the long process of imagining America, the nightmare aspect and delirium of it.

This persistent doubling is a funereal return and, in that, a struggle to overcome. The repetitions proliferate and vibrate: doppelgänger, schizo, mirror, echo, backscatter, reflux. Memory work as mourning work, restoration and redemption through a violent sensation of loss. The ensemble marches across an odd stillness: the history it charts is blocked in its own impasses, a narrative unable to requite itself. The doubling, it seems to hope, will be symbolic, dialectical rather than traumatic (literal), will pull History back into continuity with real time. Cuba's Revolution had been held up so often as the realization of fervent desires, but by 1989 Aguilera was reassessing that history from the vantage point of a Cuba on the verge of collapse. Profoundly disappointed with its outcome, his work attempts, and then darkens, a compensatory remystification.

. . . scarecrow

I nailed vertigo. [Je fixais des vertiges.]
—ARTHUR RIMBAUD

The withdrawal from grand themes into the everyday is in interesting relation to the earlier genre of the testimonial, which sought to represent the experience of the everyman, directly and without the mediations of high art. Testimonial

literature, which was highly regarded within Cuban cultural officialdom of the 1960s, sought the neutral registration of the everyday, fueled by a belief that it was exactly what merited artistic attention, the "actual," rather than the flights of imagination (ego) of the artist or what one critic has ironically referred to as the "onanistic detours of fiction and language."[108] There are related desires in the 1980s art, which often reached for a prosaically materialist register in which an intimate image resonated chorally.

A slight but early manifestation of this spirit can be found in the exhibition *Sano y Sabroso* (Healthy and tasty), organized a few months after *Volumen Uno* in 1981.[109] According to the exhibition announcement, Bedia showed "2 or 3 sheets," Brey "1 bath," Elso "1 window," Fors "15 drawers," Garciandía "¿¿¿???," Gory "1/2 dining room," Pérez Monzón "a few quotidian dialogues," Israel León "2 or 3 domestic implements," Soto "1 closet," and Rubén Torres Llorca "1 television." Altogether a recipe, wrote Mosquera, for "reflecting a little on some aspects of that peculiar universe of the home and domestic life." The works ranged "from irony to nostalgia, from love to mystery, from banality to poetry. . . . But the principal effort of this show is to try for a language of greater popular reach, which allows a more direct and natural communication between the artist and the people. The ambition of these exhibitors is that the visual arts one day manage to convert themselves into something so normal, fresh, and quotidian and— why not?—as healthy and tasty as one of Nitza Villapol's good recipes."[110]

The ideal of a commentary-free, vérité record of life as it is has long inspired various genres. Of course such a transparent, vacant author, while perhaps attractive as antitoxin for artistic egotism and elitism, is necessarily a hoax: documentary's (re)presentation of reality puts it slightly awry, reloads its significances, shifts it, varies it, and sets it in motion. Consequently, cultural forms have turned a more and more attentive eye precisely to the author's own footprints and to representation's uncanny effects. In his discussion of the uncanny, Mike Kelley quotes Hans Bellmer's observation that "an object that is identical with itself is without reality."[111] The simple production, or reproduction, of the real, or everyday, is a void gesture. This makes Kelley think of Marcel Duchamp's readymades,

> without doubt, the most important sculptural production of the 20th century, precisely because, in the simplest and most concrete package, they present reality as impossible to concretize. . . . He [Duchamp] performs the sin of literalism and demands that it *is* art. . . . On the one hand, they go against the accepted notion of art as being the arena of façade, concerned as it is with representation, by presenting a "real" object as art. On the other hand,

Adriano Buergo, *Al final de este viaje* (At the end of this trip), 1990. Graphite on Canson board; 20 x 28 inches. Courtesy of the artist.

they reduce the Modernist idea of art as a materialist self-referencing to an absurdity, for it is impossible for these "real" objects, once presented in the context of art, to maintain their "real" status. As "art" these objects dematerialize; they refuse to stay themselves and become their own doppelganger.[112]

Now slightly other, they can work to illuminate what had been obscured by its own familiarity. In Cuba it was the everyday that reappeared as not exactly itself, engendering new readings and rereadings of the nearby and habitual.

Adriano Buergo's everyday lay in the nexus with improvisation and lack. His 1988 paintings had doubled the icons of the Cuban vanguard—Peláez's *medio puntos*[113] and wrought iron railings, Mariano's rooster (doubled as Eiriz's papier-mâché), Portocarrero's harlequin and *diablito,* his Flora, his interiors, all gone wild. In 1989 Buergo's magnum opus *Roto Expone* doubled a broken-down old fan from every angle: surrogate for the Cuban home, where the leftovers from before 1959 are the support for a daily activity of repair, refunctionalization, and reimagination. The fan, full of nostalgia for its earlier life inside an air conditioner, marks its own life cycle as analogy to that of the Revolution and is ultimately reincarnated as the Sun, shining on the white sands of Varadero beach.[114] Buergo's

ode to the patch and splice not only sang but bit, its observation of the material poverty of the Cuban household, and of its position in the shadows of a resurgent tourism, at once utterly obvious and caustic. (A decade later, a more straightforward pessimism animated the *Taller de reparaciones* [Repair workshop], René Francisco Rodríguez's contribution to the sixth Havana Biennial. In it, an incessantly unanswered telephone sounded the installation's lament: everything is broken, it tolled, and the disrepair might be funny [a smashed bicycle wheel mounted on a stool], or it might not. Like a broken-down version of Tinguely or Dieter Roth, the *Taller* was a place where even invention no longer suffices.)

Buergo was a member of Grupo Puré that, in its 1984 debut exhibition, had made even *Volumen Uno* seem august and dignified: the show was like a giant centrifuge spewing ridicule and wonder, a *Ruckus Manhattan* for Havana.[115] Puré's puree incorporated equal parts of Jonathan Borofsky (whom they cited as an influence) and John Cage (whom they did not). Like the former, their work coincided with a shift in the international art world away from "dry" conceptualism and "back" toward object making and "visuality." Their visuality, however,

was a wild one, eclectic, messy, vivid and immediate, full of games and jokes. A rambunctious extension of the Havana street, Puré "manhandl[ed] . . . delicateness until it becomes merciless irony, bad painting, revenge."[116] Like Cage, Puré's was an art of *Entgrenzung*, erasing boundaries between art, as traditionally defined, and the racket of everyday life's shouts, whistles, and rusted-out mufflers. Slovenly exuberant, very close to play, it was a kind of productive slippage whose critical agency came from rubbing up against daily life.

As Puré declared, the group "was born of the need to make a collective statement," to "express a critical and judgmental view of [Cuban] society and times."[117] The preoccupation of the group's members with the popular and quotidian linked them to their predecessors, but they felt that they were pushing the question further:[118] the observations were more pointedly situated within the daily tensions of life and stood as a kind of "critical empathy" expressed as scatological funhouse.[119] Their work ranged from Buergo's sarcastic ode to disrepair, to reveries of self, illogic, and dysfunction by Delgado, Lázaro Saavedra's malignant little observers, and Ciro Quintana's elevation of comics to art and debasement of comics-as-art to kitsch.

Puré's work opened the way to a more expressly political critique that began about a year or two later, mining the depth charge latent in the registration of Cuban quotidian reality.[120] While *Volumen Uno*'s treatment of materiality (especially in Elso, and also Brey and Bedia) was related to Arte Povera, in which the *povera* had some sense of ennoblement, Puré's installations really were materially impoverished ("squalid," in the words of Tonel [Antonio Eligio]), a brazen, disorienting agglomeration—a "demystifying Bronx cheer" that had an element of aggression in it that had been mostly absent in the gentler and more pleasing aesthetic of much of the earlier group.[121] Puré also foregrounded what had been a tendency among some in the *Volumen Uno* generation (especially Castañeda) toward a postmodern pastiche and appropriation, and which later became a primary methodology for the collective ABTV.

Puré considered itself a group in a more definitive sense than *Volumen Uno* ever had, but its members continued to each make their own work: the body, or substance, of the collective emerged in the form of their exhibitions. In a Puré exhibition the works of all the different artists intermingled and interpenetrated: as Saavedra remembered it almost twenty years later, "When you went into the space of Puré, you did not go into an architectural space where objects were hung, you went into a space of virtual reality, into a three-dimensional world where you found a work on the floor, on the ceiling, on the walls, wherever."[122] Puré cared neither for the edges of a particular artwork nor for the limits of the space of

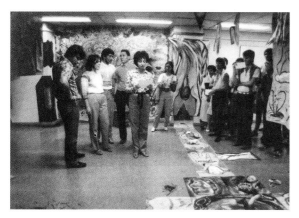

art itself, and in fact *Puré expone,* their first exhibition, straggled out from the gallery into the street by the time the artists had finished installing it. These comminglings were central to Puré's identity as a collective and opened a fuller consideration of the group itself as a form of artistic production. Puré was no longer a collection of individuals talking and showing together; it was more cohered internally, and the works—the final works, as it were, being the exhibitions as totalities—were a collective product. Or to put it another way, in challenging the formal properties of the exhibition, Puré reframed its own collectivity.

Puré's space overlapped everyday space, making active use of it while sounding the clandestine or even unconscious side of social life. It was a different kind of social knowledge than Cuban art had played with before, much closer to stream of consciousness, and in this Segundo Planes was king. Planes brought a graphomaniacal obsessiveness to the group's production, a profusely absurdist "jungle of images."[123] Intricate and amazingly inventive, Planes's work was a violently charged reverie on the Cuban everyday, a torrential self-portrait by an artist who signed his name "Nobody": "Je est une autre" (I is somebody else), Rimbaud had written over one hundred years before in expressing his own inner discrepancy, and "Crossed-out with the hope of being someone who never was," echoes Planes: "Author: was. Year: was. Title: will be." "I am an imbecile with a small 'I' (essence of the circle)," says the other side of the page.[124]

Planes's paintings, with their festive disorder, their "savage" baroque and kitsch, were inextricably rooted in Cuban popular culture, riddling the tradition of the everyday observation into a gonzo psychorealism overflowing with an unlimitable fantasy full of slips of the tongue and double entendres of everyday life. Flayed heads, bodies floating spread-eagled in a horrifying Chagall sky, sharp-toothed leers, all rendered in tender and luscious hues, at gigantic, vociferous

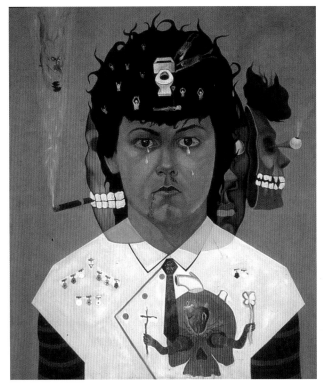

scale: the ghosts and lizards dwarf the small Segundo, a bystander in his own invention (in one canvas, he has a toilet in his brain, his teeth have escaped from his head, and he is crying). Even when the sky is blue, even when the sun refrains from exploding into flames, the figure riding the flying palm is a black, winged demon and the land is littered with eyeballs. Rapid-fire, percussive grids, fiendish faces with an operatic range of expressions: ferocious, beguiling, quizzical, devilish, snarling, and bizarre.

The paintings slid down the walls and across the floor and dangled from the ceiling, anchored and spanned with heavy ropes. A Planes installation turned the gallery space into a helter-skelter obstacle course, a physical as much as a visual assault. In comparison, the drawings were relatively calm and pensive, a resort to absurdist poetry for refuge from the clamor of the painted acrobatics. As with the paintings, they issued forth in a torrent: Planes was known to polish off a block of thirty sheets of paper in a single night's session. "Walking through the darkness," one drawing begins,

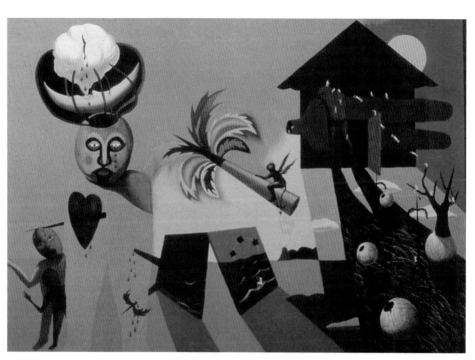

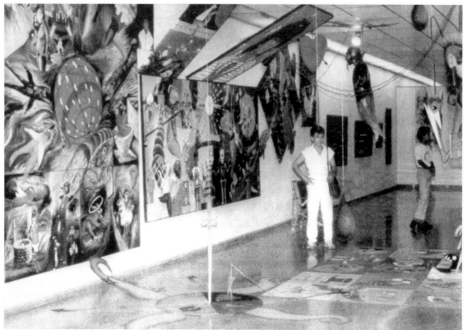

I entered the node of the immensities
Time, perpetuating the instant
of never through the black trees, smiling at hope, kept walking toward
 the same point.

Walking toward "the light" I found a dark door at each step, when I got to
the "sun" I stuck my head out and saw that everything was a well
(the earth) such that, when the light falls, the sun is its own
shadow; on the road I saw a false horizon (maybe an illusion) full
of silvered cathedrals, flies of gold and other things I won't say
here.

From the window of the abyss, the motivation to conclude the summary
 dissipated and went and made its own world.

Planes's theatrical surrealism shared social space with Tomás Esson's catalog of beasts and organs, which itself was not unconnected to Eiriz's traumatic monsters. From the first it had been clear that Esson was a ferociously good painter with a taste for gigantism: he was also, yet again, a young man of quintessentially popular origins and impeccable revolutionary credentials. The popular is often understood (especially in relation to the ranks of aristocracy and power) as a libidinous zone, a space of desire, and indeed Esson, unlike Planes, did not hide his anxieties in the ambiguity of hallucination.

Esson's 1988 show *A tarro partido* (The cleft horn) was a turning point for everyone. Installed in a gallery at one of the busiest corners in Havana, it filled the entire space, floor to ceiling, with a bestiary of Gargantuan and Pantagruelian monsters, inflamed vulvas, shit, and great, smoking farts. In Esson's hall of fame the bars of the national flag were cut down to bloody stumps, the national hero baseball player lifted a leg to expose a gigantic black ball, and a pair of corpulent monsters copulated enthusiastically under the watchful gaze of a mulatto Che. It was too much. "The scandal went from mouth to mouth," says Osvaldo Sánchez. "Soon, many nonphilosophers, those that after punching their exit cards at work go inside a gallery searching for an effervescent aspirin, scribbled furiously in the signature book demanding the suppression of such great filthiness."[125]

The complaints against the work ranged from counterrevolutionary to sexually aberrant, and the show was closed before it opened, amid a tempest of emergency meetings and rumors. During many meetings with various officials, Esson argued that "extra-artistic" criteria were being applied to the work and fought to have the evaluation take place at the level of specialists in art. High officials were included at various points, including Alfredo Guevara (who sug-

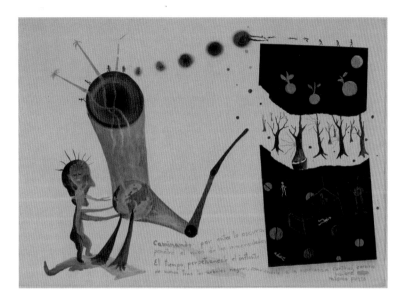

Segundo Planes Herrera,
untitled drawing, 1989.
Approximately 22 x 30 inches.
Courtesy of the artist.
Photograph by Clements/
Howcroft, Boston.

gested to Esson that if he were to agree to remove the offending paintings, "he could help the Revolution"), and even the minister of culture himself. One remarkable feature of the interchange was the fact that these high-ranking officials were trying to convince Esson to remove certain of the works, so that the show could be allowed to open. Eventually, Communist Party ideology chief Carlos Aldana overruled Hart, and the show did not open.[126] De la Nuez has explained the rift as follows:

> This faction [e.g., Hart, Haydée Santamaría, and Alfredo Guevara] supported patronage in the traditional middle-class manner. It might even be said that their style came from that middle class that during the 1950s was never able to implement its own cultural program and practically used the Revolution as a platform for carrying it out. . . . Now at last . . . anti-Soviets but devoted to Fidel and Che Guevara, eager to connect with Latin America and Europe, this group was offered the chance to further cultural policy in the "Cuban way," which had raised such high hopes among leftist intellectuals in the West and in the Third World as a whole. While this faction took its mainly institutional positions, and the orthodox group took its mainly party or ideological positions, the artists censored by one or another faction sought comfort and support in the rival camp, although taking care that their "failings" stayed within the bounds that both factions subscribed to.[127]

Esson toned it down in his next big showing at the third Havana Biennial, retaining the grid-as-sewer-system format and the carnal impudence, but "talisman," a character who in the earlier work was a bit player resembling a horned turd, was now the star. Late in the following year, after a nasty encounter with customs police at José Martí Airport, the artist took advantage of an exhibition in the United States and decided he had had enough.

Esson's raucous voluptuary was, yet again, the Cuban everyday, doubled, tripled, smeared across every inch of the walls. The sexual and scatological, so typical in the Cuban imaginary, the humorous grotesque, the pumped-up iconicity, the febrile, tropicalized vision, was the Havana street's evil twin. Louis Marin reminds us that, while repetition's production of difference has an uncanny knack, at times it does a very different work. Repetition, he says,

> is one of the basic characteristics of an ideological formation. Better, it
> is through repetition that a discursive formation acquires its ideological
> stance, that the dominating discourse, by the endless presentation of its
> signs . . . operates and maintains its domination as if it possessed a "natural"
> obviousness and contained ahistorical evidence.[128]

Esson's repetition of the eternally repeated national symbols pushed that naturalizing cycle so far over the top that it imploded into the carnivalesque. With the idea of carnival there begins to be an intimation of things happening in public space, and as a matter of fact it was precisely because of this that Esson's exhibition had caused such consternation: out in the open like that it could, the officials contended, be horribly confusing and upsetting to a (hypothetical) viewer unfamiliar with the ins and outs of contemporary art, and thereby misunderstood as counterrevolutionary. (The fact was, Esson's neighbors loved the pictures.)[129] By the late 1980s, Cuban life in some ways had become one big Uncanny, stuck in the split between an everyday that was increasingly harsh and repressed, and a rhetorical everyday that, while ubiquitous, existed nowhere. In Esson's carnival the everyday frustrations, degradations, and humiliations assumed wickedly new, retributive forms; translated into an assaultive grotesque, they were the pervasive underbelly of experience.

As in: No more lies

Wearing a leotard painted blue with cloud shapes on it. And I was like twenty or thirty minutes, there in Vía Blanca and Octubre, spinning around, and it was really

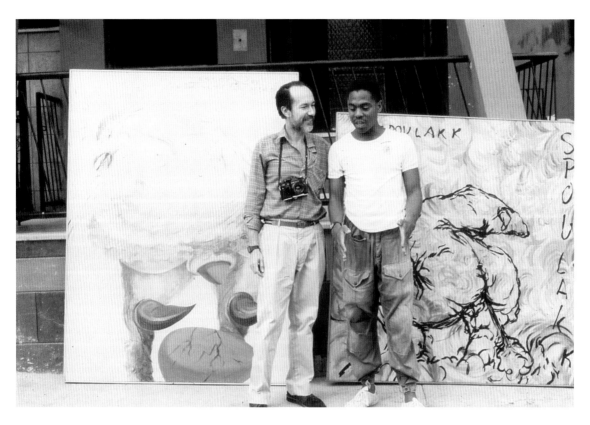

Gerardo Mosquera and Tomás Esson in front of Esson's home in Marianao, Havana, with paintings, ca. 1989. Photograph by the author.

heavy there. . . . there, spinning and screaming, screaming and screaming and everybody completely alarmed.
—JUAN-SÍ GONZÁLEZ

Works in a series by Carlos Rodríguez Cárdenas:

IDEAS GO FARTHER THAN LIGHT Against a pale blue sky, a godhead (we know him by his beard) thunders. The sun peeks out from the opposite corner, beaming into four little mirrors lined up in the sky. Down below a man walks with a top hat (he is a gentleman) and a cane (he is blind): four beams angle back from the empty place above his cheek ("Fight between ideas and the sun," the lush plains confirm).

FOR THE CORRECT PATH A radiant sky, a mountain landscape of the richest green: ascending paths snake in and out of each other's way. The hapless traveler plants one foot each on two as they slide apart.

TOP Carlos Rodríguez Cárdenas, *Las ideas llegan más lejos que la luz* (Ideas go farther than light), 1989. Oil on board; approximately 10 x 10 inches. Courtesy of the artist. Photograph by Clements/ Howcroft, Boston. Collection of Howard Farber, New York.

BOTTOM, LEFT Carlos Rodríguez Cárdenas, *Por el camino correcto* (For the correct path), 1989. Oil on board; approximately 12 x 10 inches. Courtesy of the artist. Photograph by Clements/ Howcroft, Boston. Collection of Howard Farber, New York.

BOTTOM, RIGHT Carlos Rodríguez Cárdenas, *Te protegen contra el arte* (They protect you against art), 1989. Oil on board; approximately 12 x 10 inches. Courtesy of the artist. Photograph by Clements/ Howcroft, Boston.

LEFT Carlos Rodríguez
Cárdenas, *Rectificar es crear, es
buscar lo nuevo* (To rectify is to
create, to search for the new),
1989. Oil on board; approxi-
mately 12 x 10 inches. Courtesy
of the artist. Photograph
by Clements/Howcroft, Boston.

RIGHT Carlos Rodríguez
Cárdenas, *Construir el cielo*
(To build the sky), 1989. Oil
on board; approximately
12 x 10 inches. Courtesy of the
artist. Photograph by Clements/
Howcroft, Boston. Collection of
Howard Farber, New York.

THEY PROTECT YOU AGAINST ART The man is safe against the grayness: helmet, goggles, earguards, respirator, boxing gloves, boots, all keep his flesh-brick body safe (there is no art in sight).

TO RECTIFY IS TO CREATE, TO SEARCH FOR THE NEW The familiar bearded face, a bust atop a simple plinth. He faces a vertical phalanx of profiles across the page: "to rectify . . ." they all affirm.

TO BUILD THE SKY An absent mason has been laying beautiful bricks of robin's-egg blue: the sky-wall rises steadily, stolidly, between the island's lush hillocks and a flat, black void.

This is Kafka's daylight: a sunny day bricks off the darkness, black and blue skies block out themselves and each other. (A lustrous blue sky: usual symbol of the state in socialist realism. "Heart of the sky," a wobbly black mark had pro-claimed in one of Planes's drawings, and then another page, torn and scribbled, "Mutilated skies.") The saturated colors, vivid hues, flat compositions and ren-derings exude a festive mood like in a tourist postcard, and in fact the images are

all diminutive, inviting the intimacy of a close-up view like the miniatures that chronicled the interiors of Persia or the orgies of India in another time. Their scale inverts the voice that they double: nobody has to be told that their first author is the language of the billboards, the radio, the huge rallies in the hugest public squares on the hugest and smallest of occasions, since they march to exactly the same, trim cadence. The lacuna between the image and its explanatory caption is a gaping space that, with utmost delicacy, simply pulls aside the curtain of the lapidary phrases to reveal the vast emptiness that lay behind it: to build the sky, indeed. "His work poses as a sophisticated version of the children's story of Crying Wolf about the status of the individual in daily life," says Osvaldo Sánchez. "Anyone who has lived through a revolution knows beyond the jubilation of the loudspeakers that it's in the daily life that the fissures between utopia and *café con leche* are resolved."[130]

Cárdenas's "cobblestones" were prepared for his 1988 exhibition *Artista de calidad* (Quality artist) in the Castillo de la Fuerza fortress/gallery at the mouth of Havana's harbor. The show, however, like six others in the planned series of twelve, never opened.[131] Later on, a foreign curator arranged to show them as part of an exhibition in the United States.[132] Arriving in Havana, she is told that policy dictates that they cannot be shown outside the country, since they have "not yet" been shown within it. (As it turned out, they had just been shown in the *Kuba ok* exhibition at the Städtische Kunsthalle in Düsseldorf and sold, along with most of the show, to the chocolatier and collector Peter Ludwig.) And even later on—this time in 1997—an art student in Havana repeats the image of Cárdenas's protector for an exhibition coinciding with the sixth Biennial, using it on an improvised pup tent hung off the gallery wall: *Mi casa soy yo* (My house, I am), he called it. The student, it seems, knows little of the image's origin or history.[133]

As the public space of the everyday became more and more relentlessly a space of control, the multifarious aesthetic of everyday echoes and doublings gradually turned in on itself until the everyday inscribed a dimension of withdrawal. Saavedra, witnessing the censure of friends' exhibitions and then suffering the drama of being himself proscribed, decided he no longer wanted to be an artist and joined a construction brigade. There were practical reasons for his decision: volunteering for one of the *microbrigadas* was pretty much the only way that he was ever going to get a house of his own.[134] Resolving the personal problem of housing (one of the most ubiquitous and intractable in Cuban society) also meant an exit from what had become the dead end of a frontal confrontation between artists and the state, an exit from the dead end of an explicitly political and critical expression. So Saavedra left Havana and entered a distanced, more

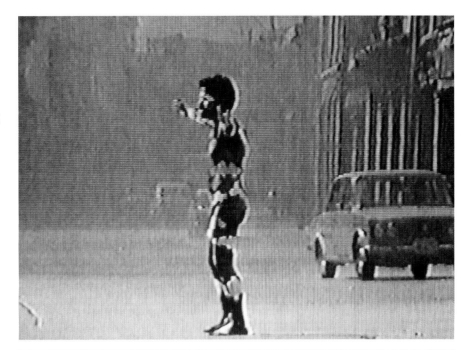

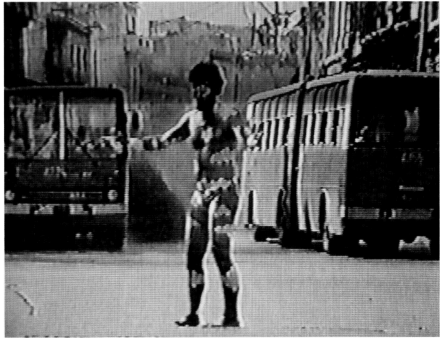

TOP Juan-Sí González, *Ritual,* 1988. Street performance at the intersection of Vía Blanca and 10 de Octubre, Havana. Courtesy of the artist. Video still; photography by Santiago Yanes and Marco Abad.

BOTTOM Juan-Sí González, *Ritual,* 1988. Courtesy of the artist. Video still; photography by Santiago Yanes and Marco Abad.

introspective and isolated zone where his new everyday was an endless cycle of labor, exhaustion, and insects.

One day in 1989 Juan-Sí González walked to the corner of Via Blanca and Diez de Octubre—an intersection that had once been a center of urban activity, now marginal and bankrupt—his body painted as a cloud. His existential street performance that afternoon was a kind of last-ditch effort to have art and the everyday coexist: not a "political" work, it was a work of "catharsis, fear, rage, frustration and hate, of oppression. And yes, also the reaction of a youngster, exactly."[135]

The everyday is at once an objective, subjective, and aesthetic fact of life. All social capital streams from it; it is the structure that makes sense to a community of people. The everyday was the supreme dialectical space of Cuban culture, constantly made up of its own past, of redigestions, reworkings, refutations, and overcomings of it, constantly revealing unapparent linkages in the great, sweeping picaresque of everyday life. This eventually produced an expanded idea of art, often anti-emphatic in temperament, imagining a more horizontal relation between art and the general culture and a productive opposition between the everyday and iconic. That art's elaborate and crisscrossing doublings were means through which the Cuban everyday was funneled, translated into an intense play of interference patterns.

In 1997 copies of the recently passed Foreign Investment Law went on sale in the Museum of the Revolution's gift shop, equal in their symbolic voltage to the baleful melody of the Guevarian resurrection upstairs.[136] Art is, after all, a descendant of the sacred, and so the effort toward effectively quotidianizing it is, on some level perhaps, a losing battle. "No work of art is absolutely truthful about life," says Richard Foreman, "but is a strategic maneuver performed on coagulated consciousness."[137] Nonetheless, in its dogged, wily attention to the everyday, the work of the new Cuban art had been able to condense and, however imperfectly, to model just how manifold the "typical" actually is, how replete with fundamental significances and mysteries.

The everyday constituted and contained the ambiguity between unity and multiplicity that was so fundamental to the Cuban conception of socialism and its blooming contradiction between the ontological and ethical. The idea of an aesthetic linked to an ethically superior position is tricky, and it was its endogenic relation to the everyday that had cushioned the new Cuban art against that particular irrelevance. Increasingly, the work had become a way to lodge critique in the society, hiding it in the plain sight of the everyday space. As everyday experience became more and more brutal and estranging by the end of the 1980s, being *in* it posed even more problems than providing a belated or elevated response to

it. The space of community began to yield, for artists along with everyone else, to competition and survival. This was part of what was lost as the Cuban everyday slipped from art's grasp.

Unfinished America

*When I made the Martí, I thought: "Why not? Let's give this a shape and a name."
In this case for me it is like taking that out of the local context and putting it into a broader one, one that is more Latin American. It will [then] become something about a myth where there is a creator who will make a world starting from an ethical principle of relations. That is what my understanding is of socialism, or better, how I understand my understanding of socialism.*
—JUAN FRANCISCO ELSO, INTERVIEW WITH LUIS CAMNITZER

With the piece of Martí, . . . I frightened myself: it was a risk I had to run, but also a responsibility. . . . For me it was a moral, political, and even religious dare.
—JUAN FRANCISCO ELSO, CONVERSATION WITH GERARDO MOSQUERA

Seen in terms of the similitude with his friends, it might escape notice that, for all the echoes between them (the anthropological, mythological, spiritual curiosity), Elso was alone in trying, daring, to "give it a name." Elso, for all his interiority and cosmological speculations, was willing, even compelled, to directly encounter the dark romanticism of the revolutionary myth: Orlando Hernández even detects a note of "patriotism or nationalism," probably the riskiest emotional territory that he could have entered.[138] In 1986 Elso left off with myth and distance and syncretic shapes, and made *Por América,* his Martí.

Por América is Elso's Martí, and it makes sense to refer to it as such because with this work the artist placed himself and his subject in close proximity. Martí left Cuba at the age of eighteen for exile in Spain and elsewhere, and only returned twenty-four years later, about five weeks before his death on a battlefield near Dos Ríos in Oriente province.[139] His *War Diaries* stand as one of the most peculiar and touching testimonials in the country's very considerable national literature. Hernández finds Elso's Martí to be the Martí of the *Diaries,* who "moves in an exotic more than strange world, . . . touches, interrogates, strays, seeks whomever might orient him, hides who he is, has no one with whom he can be frank." It is "Odysseus, returning to his homeland after twenty years of absence, changed into an old, decrepit, indigent man."[140]

In this sad and beautiful narrative, somewhere between stream of consciousness and reportorial finitude, Martí's attention moves constantly and indissolubly

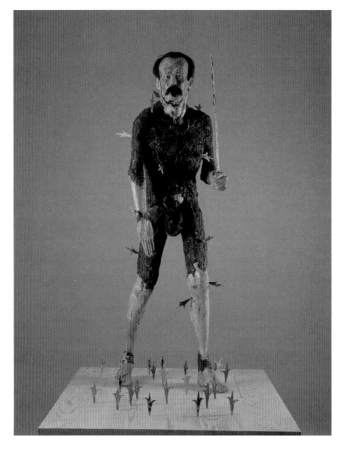

between observations of different orders: people, plants, landscapes, politics, battles, love. There is no analogizing of one to another; they just occupy the same lived space. Elso's affection for the Apostle (as he is sometimes known) recalls Martí's own rapture on returning to Cuba:

> The breast swells with quiet reverence and powerful affection before the vast landscape of the beloved river. We go across it near a ceiba tree and after greeting a *mambí* family who are overjoyed to see us, we enter the bright woods, with gentle sunlight, widely-spaced trees, dripping leaves. The grass is so thick the horses move as if over a carpet. The bromeliads above us look up into the blue sky, and the young palm, and the dagame, which has the finest flowers, beloved of bees, and the guacimo, and the *jatía*. All is festoon and fronds and through the clearings to the right a pure green can be

seen on the other side, sheltered and dense. Here I see there the *ateje,* its high, sparse crown full of parasites and bromeliads, the courbaril, "the strongest wood in Cuba," the stout *júcaro,* the gumbo-limbo, with its silken skin, the broad-leafed genipap, the sagging calabash tree, the hard sabicu, with its black core for making canes and its bark for tanning, the *jubabán,* or axe-handle tree, with its light foliage whose leaves, layer upon layer, "make tobacco smooth," the rough-barked mahogany, the break-axe its striated trunk opening out into the strong branches near the roots, and caimitillo, copey, canella and the *yamagua,* which stanches blood. We found Cosme Pereira along the path, and with him one of Eusebio Venero's sons, who turns back to announce our presence to Altagracia. Still to be found in Altagracia is Manuel Venero, progenitor of patriots, whose beautiful daughter Panchita was killed by the machete of Federicón, the Asturian, for refusing to yield to him. Gómez was very close to the Veneros; he made a fearsome guerrilla leader of their daring Manuel and had a deep friendship with Panchita, which rumor called love. . . . I'm surprised, here as everywhere, by the affection I'm treated with, and the unity of soul, *which will be diluted and ignored and dispensed with only to the detriment of the revolution, at the very least the detriment of delay, in the momentum of its first year.* The spirit I sowed is the spirit that has taken hold, the spirit of the Island, and with it, guided by it, we will triumph quickly, for a better victory, and for a better peace.[141]

Regarding *Por América:* first, there is the fact of the artist choosing the national hero, complex enough in itself as a task. As often happens with heroes and prophets, claim to Martí's mantle has been laid according to sharply conflicting ideological lineages, including the one that presently rules Cuba: this generally requires a strict and zealous image- and message-management.[142] Elso's Martí, unlike virtually every other one on the island—and they are as uniform as they are ever present (white, calm, and pensive, with the possible exception of Jorge Arche's 1943 portrait—safely tucked in the national museum—in which the figure is clothed in a *guayabera*)—is this almost impossible portrayal. It is meticulous: Elso referred to a measured drawing of Martí made by the Dominican tailor Antonio Almonte in Dajabón, Santo Domingo, in 1895. It has also been noted that the Martí, like the few other figures that Elso carved, is essentially a figure of Elso himself. Nonetheless, Elso's Martí is on the small side, standing some inches less than Martí's five foot five and the artist's lanky six foot: in other words, Elso miniaturized the Apostle, and himself. It is auratic: as has often been noted, it is made in the manner of baroque Spanish American church saints, accomplished with the help of his mother-in-law, a "specialist in disguises." It is iconoclastic.

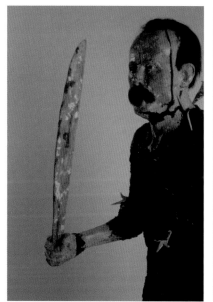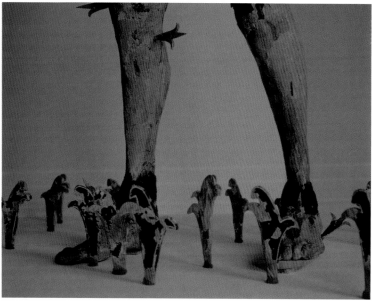

Martí carries a machete, polysemous symbol: independence warrior, cane cutter,
but in any case, "an opinion that many historians and biographers of José Martí
do not share at all."[143] It is humble, not clothed in the fine Dominican suit or even
the *guayabera*: Elso's Martí is dressed in a rough paste of dirt and wax, and he is
barefoot—either naked or buried, or both. It is failed: insofar as we read the figure
in terms of war, that was a terrain in which Martí did not excel: he entered battle
only once and died almost immediately. It is a martyred Martí, the man who will
soon be dead, sacrificed in mud rather than glory. It is agrarian: the Havana-born
poet, who lived in more than a dozen of the American hemisphere's great cities,
including fifteen years in New York, strides here in a field of green sprouts, sug-
gesting, along with the red "darts" that pierce his body, an earthy cycle of death
and regeneration.

 The final attribute we might add to this list would be what Medina has called
a "theological state of indecision":[144] Elso's Martí alights on three continents
through allusion and method (among other things, the figure is "charged" in the
manner of Afro-Cuban ritual dolls), and hundreds of years of history and culture
in the Americas, producing a thought-sphere that is far too complex and apostatic
to be encompassed ideologically, religiously, morally, aesthetically, emotion-
ally, or intellectually. It achieves, through formal means best recognizable in the
folk carvings of popular heroes, some amplifications to and reopenings of the

meaning of Martí whose essence, as that of all the heroes, had become fixed and frozen a long time before. There is an interesting analogy with how religious icons are understood to function: rather than depict the saints, they are the means by which holy beings actually become present: present *in their images*. Paramythological and parahistorical, icons are symbols intended to be clear in their meaning, and Elso took Cuba's central icon and made it so complex, contradictory, emotional, and ambiguous that it was impossible to nail down. No, it said, it can never be clear. Martí's death had set the standard for proportions of sacrifice in Cuba, and Elso's Martí died incomplete and unresolved, his entire project reopened as a wound in the work, an open wound at the heart of the contemporaneous Revolution.[145] Elso's Martí incited, as Aguilera said in distancing himself, a "terrible desire to believe." Elso's earlier works had suggested something similar, but with the Martí, the most recognized face in Cuba, he voiced the question at its point of densest articulation.

Elso's Martí, which was also himself, set up an ambiguity in self-image as a way to counter the mandate to a certain "identity." Elso's Martí doubled history by registering the human body—the form most suggestive for a viewer's self-identification (sentimentalization)—in its most literal, neutral, and physical dimension, but with a slight displacement from the real (remember that the figure is slightly miniaturized. Remember that it borrows from the artist's body for the shape of its hands and feet). Elso's Martí traced entropy inevitably to monumentality and chose a critical history as the only viable and emancipatory return. Elso's Martí escaped monumental history's discouragement (we can never measure up), antiquarianism's first principle of remove, and acknowledged that in fact it was living with a very tenacious, unrequited past. Elso's Martí made plain the doubled relation that he and others had to their own social space: with the ambivalence of both insider and outsider positions they were part of it, identified with it, plugged into its energy source, but unsatisfied by it and profoundly critical of it. Elso's Martí, in its act of historical memory, had rescued remembering from rote distraction in the name of reconstituting a sense of personal, everyday ethics. It had collapsed the vertical gap of deity and reclaimed the revolutionary promise of everyday heroism. Its doubling made the hero, and the "terrible desire to believe," uncanny, potent, unnerving, and poignantly awry.

Elso finished his Martí just in time to show it in 1986 in the second Havana Biennial, and as he was preparing to move to Mexico to remarry. (His departure was to presage the exodus, a few years later, of almost the entire generation of artists from the island.) His Martí, seen in the joy and pain of his return to the beloved landscape, the moment before his death, therefore crosses paths with

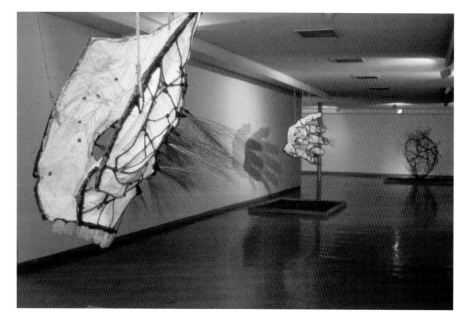

Juan Francisco Elso Padilla, *La transparencia de Dios* (The transparency of God), 1987–88 (unfinished), installation view. Branches, jute, amate paper, wax, straw, volcanic sand, mirrors, cloth, iron, glass eyes. Photograph by Gerardo Suter.

the artist, seen in the moment of his departure from that same beloved place. Predictably, it was immediately the center of a quiet scandal—quiet in that the jury, which wanted to award it with the prize that it obviously deserved, was "persuaded" not to.[146] A fact that startles us out of our reverie on Martí, liberation, humility, and sacrifice, but does not surprise us. Elso had been consistently belittled in official circles, his visions of myth, spirituality, and history apparently too ethereal or inchoate for the positivists who had to make decisions about culture for the masses. Until he left for Mexico he had pretty much kept to himself, absorbed in his work or in conversation with friends. In fact it was not until he was in the hospital dying of leukemia (and after his presentation in the Venice Biennale had been a runaway success, with the entire ensemble of works sold to an American collector and the image of his *El guerrero* being taken up by the Italian press as an unofficial symbol of the Biennale) that he began to seem "important."

The "open," or threshhold question of the work, though, does not reside in its unusual depictions per se, though they were unsettling enough in themselves. Elso's braid of representations started from the seeds of America, dared to Martí, and finally extended to *The transparency of God,* the latter constellated, as it were, with what were to have been "the tools of creation" and the face and hand of God, while Bolívar, the Great Liberator, "brandished" the sky itself.[147]

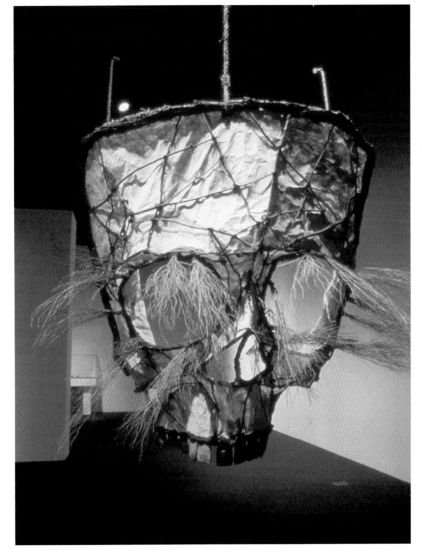

Juan Francisco Elso Padilla, *La transparencia de Dios,* 1987–88, detail showing *El rostro de Dios* (The face of God), 51 x 51 x 20 inches. Photograph by Gerardo Suter.

But I was wrong when I spoke of "representations," because that is not what these works are. Elso was not representing the great men, the great ideals, the great myths: he was going back and working on them. They were, he understood, not finished, they were open, they were wounds. He realized that the great men were all pointing to a destiny that had come no nearer. The radiant wake of the historical roster: why else list their names like a liturgy, if not to

invoke their dreams—invoke them as alive, urgent, not pacified by the stature conferred by history? To make Martí in *that* way, then, by the hands of a "son of the Revolution"? They stand as indictment. And finally he dared to propose that the continent was not yet created, that it needed both new "tools" and the anger of those who dared to imagine liberation to make that creation possible. If indeed America now waited for its moment of inception, what to make of all that had been "built" thus far, including all that had been put up during thirty years of socialist construction? Elso looked at all of it: the Indo-American heritage, the living Afro-Cuban spirituality, the panoply of martyrs, the wisdom and counsel of the national hero, the quiet rage of frustration, and also at how all of those had been deployed by the "Cuba" that administered their power. Elso above all revealed a political dimension in these "nonpolitical" artists: a political dimension, understood broadly enough to encompass the ethical discomforts, the moral anger, and the humanist dreams that were the points of origination and persistence for them. And moved, step-by-step, to an audacious thought: there is valor scattered in our legacy, but it is not adding up. Revolution had been the great creative act of the Cuban people, and now it was broken. The artist brought Martí back to life, a doleful return to be sure, a risk he "had to run," a "responsibility." Creation itself must be reimagined, because it was broken.

2. Laughing

The Revolution is running extremely, extraordinarily late.
—ANTONIO NEGRI (2004)

Glexis Novoa had staked his claim as "the worst painter in Cuba" with his 1988 debut exhibition *To Be or Not to Be (Etapa Romántica)* (Romantic stage).

THIS WORK WAS MADE BY A YOUNG ARTIST, BORN UNDER AND LIVING IN THE REVOLUTION. HAVANA, CUBA

one of the paintings bleated in an unappealing green, brushed across a background of matching finesse and taste.

THIS PICTURE IS MADE WITH EXCELLENT DUTCH ACRYLICS AND A MAGNIFICENT *GUARRO* PAPER. GOD WILLING, I WILL BE VERY FAMOUS SO YOU CAN BUY IT WITH FULL CONFIDENCE.

MORE OR LESS said another mess, aptly summing itself up.

Fake words from annoyingly apocryphal languages: NUEMS, GUAYUGUA, RIZUCELTANO, WESCTINKS, GUAMANY. Unbelievably bad color sense, stupendously horrible compositions, embarrassing, ruinous technique: truly rude, ugly, juvenile paintings making jokes about everything, including themselves.

Contemporary art in Havana was newly self-reflexive and self-aware, thanks in large measure to the importations and disruptions of the *Volumen Uno* generation. Conceptualism, minimalism, postmodernism, an "expanded idea of art"—all had become the subjects of discussion, and so there was, for the first time, a specialized public prepared to deconstruct art along the lines anticipated by Novoa.

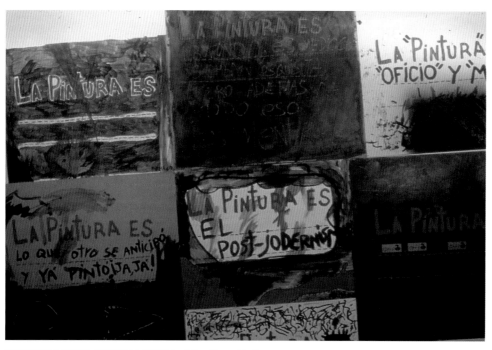

He wanted to push things one step further, though, and undermine that new expertise as well—to throw even the idea of renovating art into an identity crisis and unmask even the antipretentious as, in its own way, yet another set of art's pretensions. *Etapa Romántica* was a general mess of an exhibition that meant to, and did, confuse everybody, hung up between critique, repudiation, and acceptance of the ideas that seemed to be in the work.

Novoa was a bad painter, in a way you can be only if you're really trying. Which made the fact that he got the nod from the state cultural apparatus paradoxical: "bad" or, worse, "mediocre" artist was the stock alibi leveled against those who were considered politically problematic in the 1980s, much as "homosexual" and "bourgeois" had been deployed in earlier periods. Nonetheless, his gadfly antics, artlessness, and dubious sincerity had raised the bar on freshness in the new Cuban art, and his work was sent everywhere by the Ministry of Culture—Boston, Moscow, San Juan, Cuenca, Madrid. He was not just an enfant terrible but also an exportable one.

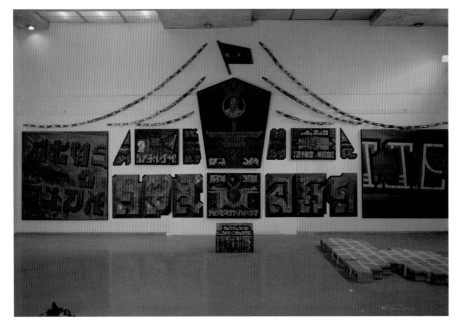

Glexis Novoa, *Patria o muerte: (Etapa Práctica)* (Fatherland or death: [practical stage]), 1989, installation view. Oil on cardboard, paper chains, other media; approximately 4 x 10 m. Courtesy of the artist.

It might have come as something of a surprise, then, when less than a year later he opened the exhibition *Patria o muerte (Etapa Práctica)* (Fatherland or death [practical stage]) in the Castillo de la Fuerza.[1] "I know of no greater cynicism in the history of art," Gerardo Mosquera wrote. "He's a double agent, an infiltrator."[2]

The *Etapa Práctica* consisted of gigantic installations that looked like the epitome of communist monumentalism, the walls covered with images of painted banners, brutalist architectural forms, and sharply snapped vanishing points. Sometimes, the shadow of a marching, cheering crowd would appear across the horizon, and sometimes there were medallions, hallowed recesses where portraits dwelled.[3] The bravura cardboards extolled something unknowable, since their Cyrillic was as faux as the rest of the work's fastidious facetiousness. (For a later version of the work at the *Kuba OK* show in Düsseldorf, Novoa added an empty podium and strung some paper chains in front of it, heightening the installation's frontality. During the opening the German curator had the Cuban ambassador deliver his welcoming remarks from that predella, thereby adding another layer— whether wittingly or not—to the work's cheek.) The shamelessly broad devices repeated the *Etapa Romántica*'s hammering subtlety, but "practicality" added a new theme: this stage had an ironic approach to both of the major auras, not only of artistic genius but also of the Revolution. Novoa's patriotic heraldry suggested a nation both exaggerated and unsubstantiated: the work overrefracted a corrupt

ornamentalism, turning the impulse and armature of socialism into mere pattern. It was hopelessly equivocal, even while unmistakable.

"*Etapa Romántica,*" says Novoa,

was completely linked to the censorship of Tomás Esson and Carlos Cárdenas, who were my good friends and classmates. . . . I was really shocked by all that. And so I designed a body of work that would not be censored but that would, at the same time, say everything they had not been able to say and still make me successful artistically, let me make money, and have a strong impact within the art scene. And that's the way it went: the curators would come and they'd take the work, it was really big work and it worked better because of that, it was supermacho, it had strong materials, and because it was painted directly onto the wall they had to invite me to the show to install it, so they had to bring me to Spain, to Germany. . . . It was all a huge joke on the system. Very direct, very intellectual—everybody knew what was going on, and those who didn't were just confused, they couldn't figure out if it was fascist or Russian or what, they didn't exactly know.

So I took advantage of all of that, shamelessly, everybody knew but it was well thought through, it functioned perfectly and there wasn't any problem at all, I just operated above all that. It was all perfectly clear, I made a fascist symbol, a swastika, out of two crossed hammers; really it was a strong symbol because of the convergence of those two totalitarian systems. It was premeditated and pragmatic and open, I didn't hide anything. Mosquera wrote about all these ideas, and the functionaries came to see the work to see if there was something out of control but no, they were the features of Mao, the features

of Che, of Ochoa whom they shot, of Castro, symbols of the Revolution, but they weren't, apparently they were that but not really, because there would be a little change, or a little mixture with something else. It would be Che's silhouette, but with my face, so it wasn't Che any more.[4]

A few months later *Etapa Práctica* was shown again, in the third Havana Biennial, to great acclaim. Amazingly, Novoa had ascended to the top of the elite contingent of young artists promoted both at home and abroad by the cultural administration, even as the political atmosphere tightened, artists got more confrontational, and it became routine for exhibitions to be closed by the authorities—not necessarily in that order. *Etapa Práctica* had raised the Jolly Roger over the new fleet.

Laughing

Something *inside comedy is not funny. The form refuses to define itself on its own terms. . . . it does more than acknowledge an ache. . . . To be funny is to have been where agony was.*
—WALTER KERR, *TRAGEDY AND COMEDY*

Laughter is a joint glued together with paradox and contradiction in the new Cuban art. Some of its forms delight in play, while others are fierce, even frightful; it ranges from slapstick to grief and despair, passing through simulation, sarcasm, avoidance, confrontation, defiance, hope, diversion, camouflage, dissimulation, and projection—among other things—along the way. Laughter afforded fun, release, catharsis, and vengeance. It was a subtractive medium and also infinitely additive and expandable, an indirect, strategic move and also an outright affront. It was physical, psychological, and social; affection, relief, and warfare.

Laughing was an implement of and against power, invoking the *choteo,* one of the most important cultural traditions on the island. Laughter in the new Cuban art was inspired by—and it improved on—piety, totality, and eternity. It was both a way to cut to the chase and to conceal, a way to void the pretentiousness of public address with an apparently affable scuff. Laughter's transgression "involves the limit," lives in mutual dependency and definition with it in an almost inexhaustible relationship. It is, says Michel Foucault of transgression, "like a flash of lightning in the night . . . which lights up the night from the inside . . . and yet owes to the dark the stark clarity of its manifestation, its harrowing and poised singularity."[5]

In the new Cuban art, humor has been related less to tragedy than to the grotesque. This makes for a more agitated realm, more asymptotic and unrequited: more protean, corporeal, and criminal. Laughter's transgression in the new

Cuban art succeeded, or superseded, the "confused sleep of dialectics" and loosed the "play of contradiction" in its full, fearsome range.[6]

The grotesque—which is said to arise from profound incommensurability—was like the *choteo*'s fraternal twin in the new Cuban art. It shared the joke's sociability and pedestrian realm, but added an oneiric tone, gave rise to horror and laughter in the same breath, related both to spiritual and to scatological impulses. This grotesque was the inevitable trajectory of a lone fact: revolutions are destined to eat their young. Charles Baudelaire named terror as part of laughter's substrate: the tacitly illogical form of horror, the other, waking brain that recognizes having had its own nightmares.

Oftentimes, laughter has little to do with happiness, which is the province of kitsch. The artists' grotesque outdid the Revolution's own self-kitschization (the Museum of the Revolution's incessant "second tear"); funniness and agony dialecticize and goad each other on. All this composed an image of the nation: a version of itself that had been subjected to too many pressures, limits, difficulties, fatigues, and denials, and haloed by a floating layer of the eternal, the vision, the dream doubled onto itself. A laugh insisted, rode the growl of the grotesque and the ascending lyric of kitsch. Caricatures were vivisections, parodies, miscegenations, mimicry, body snatching, soul stealing, necrophilia, resurrection.[7] Somewhere in this trefoil of humor/grotesque/kitsch, laughter spoke: gigantism, absurdity, exaggerated sexuality, rude nakedness, distortion, abjectness, tautology, cartoonery, amputation, ruination, damnation, queasiness, exuberance. Humor was the great tuning mechanism, operating at every scale and in every key. Chago, the great artist and cartoonist silenced in the 1970s, had named it variously: "humor otro" (humor, the other), "humor ninguno" (humor none), "humor gnosis."[8]

In the midst of the armed struggle, the guerrillas had managed to publish the broadside *El Cubano Libre,* and in 1958 Chago, who had climbed the Sierra Maestra to join the rebel army, talked them into adding a humor supplement. Chago's comic strip featuring "Julito 26," the rakish mascot of the *milicianos,* offered a vibrant image of the rebels that made them seem real and victory possible, contrary to the propaganda being spread by the national media under Fulgencio Batista. Despite his unquestionable revolutionary commitment, Chago was independent and irreverent to his core, and Julito's commentary on the reality of daily life and revolution went straight to the heart of the matter: in one wry frame he excitedly pumps a big balloon full of air, the words "Standard of Living" emblazoned across it.

When the fighting was over and revolution morphed into regime, Julito gradually gave way to the dark skepticism and heavy spaces of a new character—aptly

named Salomón—the new face of Cuba's struggle. "Salomón is the privileged owner of the most profound silence," wrote Tonel,

> an eminently visual character, he throws aside the superfluous and clings to the essences, covering them with onomatopoeias, cryptic sounds, baths of light and the absurd. Absurd, like all, rooted in the quotidian, nourished by black humor, eschatology, anguished interpellations (existential, as was said at the time) before the unfathomable ins and outs of life: death, sex, word, laughter. In him, as in all of Chago's work, there is a difficult beauty, truly precious: that which gleams only when the doubt is sincere. Others (Acosta León, Antonia Eiriz, Umberto Peña) visited horror as an aesthetic territory: Chago fixed his residence there.[9]

Even Luis Camnitzer, whose readings of Cuba have been generally sympathetic, finds in Salomón a fearful intonation:

> Dialogue and communication (or their opposites, monologue and the failure to communicate) are his main concerns in this darkened world. Interlocutors cannibalize each other, a severed hand metamorphoses into a resentful dog, a man emerges from a pile of dirt adopting some of its formal qualities, and Socialism appears in danger of becoming the topic of idle chatter (or a background music to be ignored).[10]

Chago's agonic pessimism, his sex, scatology, and grotesque, constituted some of the decade's most radical work. He was already "having problems" by 1963, when his book *El humor otro* was "not allowed to circulate" (until the end of the 1980s), and his exhibition *La Kaka: El Humor Ninguno* was canceled in 1965. By 1967 he had already entered a withdrawal "as fruitful as bitter," as Tonel put it, making art in private and working for the next twenty-eight years as the art editor and designer of *Granma*. "And a suicide, what is he?" asks one of Chago's characters. "An impatient man," replies the shadow.

Uproar

So what happens is that it was too late, the movement of visual arts was too strong, too important. And so we did a kind of swan song, a performance called "The Baseball Game."... State security organized its own game next to ours, you know the way people like that think is always very limited.... So anyhow I was the umpire. I put on a cap, and I had these glasses that were a lot like the ones that Castro wore in the early days of the Revolution, and my role consisted in—this

LEFT Santiago Armada (Chago), *Puertas al infinito* (Doors to infinity), 1983. Ink on paper; 28 x 21 cm. Courtesy Armada family.

RIGHT Santiago Armada (Chago), *Salomon: ¡Cuánto tiempo perdido!* (Salomon: How much time wasted!), 1963. Ink on paper; 11 ⅜ x 14 ¾ inches. Courtesy Armada family.

was a secret, I didn't tell anyone—to ump the game in the most arbitrary way possible. So I'd call somebody "out" who was actually safe, and vice versa—so it was the same as how he runs the country, right? Me, with a beard, cap, and glasses. From a distance it looked just like the archetype of el señor. Since there was nothing manifest going on they let it happen, I think they let it happen mostly because it was a show of force, because all of the artists were there. Everyone went up to bat, it was an amazing camaraderie, people came just to say, "I am here."... And I think it was too much to be able to punish.... so they said OK, let's leave these crazy guys, we're still in control, they're fucked, there's no vanguard any more.... But we, without talking about it—it was like a kind of collective consciousness, we pushed as far as we could, and always with intelligence, which is what art makes it possible to do.
—RUBÉN TORRES LLORCA, INTERVIEW WITH JUAN MARTÍNEZ

By 1986 the pressures of both external change and internal corrosion had become intense enough that Fidel Castro launched the highly rhetorical "Process of Rectification of Errors and Negative Tendencies." Rectification was initially undertaken to put the Revolution back onto the "correct path," tightening quality controls and work norms, weeding out corruption and renewing the work ethic and spirit of voluntarism. It quickly took on the much more ideological meaning of "purifying" the Cuban Revolution.[11] A year into it, Castro referred to Rectification in the following terms:

What are we rectifying? We're rectifying all those things—and there are many—that strayed from the revolutionary spirit; from revolutionary work, revolutionary virtue, revolutionary effort, revolutionary responsibility; all those things that strayed from the spirit of solidarity among people. We're rectifying all the shoddiness and mediocrity that is precisely the negation of Che's ideas, his revolutionary thought, his style, his spirit, and his example.[12]

Rectification was a rejection of the principles of perestroika and glasnost, an effort to ward off any Cuban version of the changes taking place under the Soviet reform movement.[13] The nationalist pretext of Rectification insisted on a "Cuban solution to Cuban problems." Rectification turned out to be an empty promise ("Rectification, but not too much," as Mosquera put it at the time),[14] but initially it had seemed to signal an opportunity for liberalization. Artists repeatedly cited it as the rubric for their increasingly heated work. In a 1988 interview with *El Caimán Barbudo*, Lázaro Saavedra put it like this: "It's no coincidence, the growing call to a new consciousness and an art focused on problems of social consciousness, morality, history, politics. The process of rectification and the growth of new focuses in art, both began around 1986." Eduardo Ponjuán and René Francisco echoed Saavedra's sentiments, and his sense of responsibility and agency: "Faced with the evidence of a loss of values, which brought a process of rectification in political, economic and social sectors, the artists assume responsibility, counterattacking with a very special faith in the generative values of art on the life of the society."[15] Against the thrombosis diagnosed but bypassed by Rectification, artists deployed a humor corrosive enough to restore the arterial flow.

One primary target was the art system itself, since that was the arena in which artists' complicity was most intricate. Novoa's success had shown that it was indeed possible to play games with the system, but it had centered on the parts dealing with promotion and had structured the game such that those mechanisms would be redirected (to support his work) rather than particularly destabilized. In that sense it was a cynical project, astute in assessing the possibilities offered by the situation but not especially ambitious in the criteria it established for its own value. The quartet of ABTV (Tanya Angulo, Juan Pablo Ballester, José Ángel Toirac, and Ileana Villazón) was also concerned with the complicated ways in which artists were incorporated into the intertwining sets of ideological and financial functions that the official cultural engines performed, no matter how intent they might be on escaping that belonging. From about 1988 they developed a loosely collective artistic and curatorial practice that addressed the apparatuses and enclosures through which culture was defined, administered,

produced, and promoted in Cuba, and through which the work of the new Cuban art was being both enabled and hobbled.

ABTV often worked as a sort of copy machine that produced critical replicas and countersystems of distribution. In their exhibition *Él que imita fracasa* (He who imitates fails) they faithfully reproduced—in triplicate, with astonishing technical bravura—the heavily gestural, abstract canvases of one of their teachers. In their 1989 curatorial project *Nosotros* they repeated the retrospective exhibition of work by Raúl Martínez staged earlier at the National Museum of Fine Arts, in such a way that their selections and narrative emphasized what Toirac called the "loose ends" of the museum's exhibition[16] and shed an "indiscreet light on the links that most tautly connect art and politics . . . in Cuba."[17] In each case the act of repeating exposed the various mythologies surrounding the original—the unrepeatability of abstraction and the untroubled heroism of the revolutionary artist.

Martínez, although a pillar of revolutionary voluntarism in the 1960s, had eventually run afoul of the political directorate. His work during the 1960s was heterodox, an effusive and energetic contribution to the "new culture" that included painting, posters, photography, magazine and book design, and teaching. In the early 1960s he had continued painting in an abstract expressionist vein (then popular across Latin America), but with subject matter inspired by the historic and heroic struggle (e.g., his *Sierra Maestra* of 1960). Despite the growing disapproval of abstraction he defended it on principle as valid expression, although by 1964 he had come to feel differently: "I realized there was a problem of social context. There was no reason to support the showing of this painting. Then I felt very bad because if the social medium didn't need it, that implied that it was necessary to search for a new language."[18]

Martínez's 1964 exhibition *Homenajes* included works such as *26 de julio, Playa Girón,* and *Patria o muerte*: gestural, collaged compositions owing much to Robert Rauschenberg, whom Martínez pointed to as an important influence. Although these works retained an expressionist feel, they were clearly in the process of dropping the abstract prefix. Critics likened the works to the impromptu murals of the CDRs (Committees in Defense of the Revolution, a kind of neighborhood watch that serves as a link between the residents in the area and the structures of the Communist Party) and the placards that people painted for rallies and demonstrations. Virgilio Piñera called the exhibition a cyclone.

In 1966 Martínez completed the transition with an extended series based on the portrait of José Martí, with increasingly vivid colors replacing the previous work's moody tones. By 1968 he had replaced the historical Martí with more

recent heroes: Castro, Che Guevara, Camilo Cienfuegos, the people. In these canvases, echoed stylistically in Martínez's cinema posters of about the same time, a genetic strain even more foreign than expressionism was introduced: pop art.[19] The style's deadpan optimism, its cheerful streamlining and multiplied, gridded subjects, was understood in official circles as the problem child of capitalism. Martínez's pop art, though, was a felt work, mixing sincerity with irony: it was a different kind of doubleness, not a Warholian duplicity or knowing wink but an inside job. The heroic visage was serialized onto pop art's antipersonality grid: *Oye América* (1967) boxes in twenty identical, orating Castros, thus resolving a fundamental problem in the imaging of saints: as Martínez himself noted, when he made just one image it was "too static," and so he decided to use more.[20] And so the questions that Martínez's canvases framed reverberated: about greatness, singularity, and the massified imagery that filled Cuban public space. His images carnivalized the Revolution's heroes, in the process transforming them into a much more troubled iconography.

Between 1966 and 1970 Martínez's work had an increasingly dense involvement with revolutionary iconography, and it is therefore curious to note, as ABTV did, that the work was infrequently exhibited in Cuba during those years and scarcely mentioned by Cuban critics.[21] "I tackled political figures," said the artist, "and the difficulties came, because that was not the desired image. I began to have problems, I imagine, because I was not deemed suitable to paint those things."[22] Despite having been *malvisto,* though, Martínez had been almost fully canonized by the time of his retrospective,[23] and it was the terms of that rehabilitation on which the younger artists focused. To the museum's "illustration of History" they counterposed a curatorial thesis that probed the works "in relation to a specific context," mounting a retrospective that consisted of photocopies and forgotten works in place of masterpieces, "dispens[ing] with the 'pictures' and present[ing] documentary information instead."

For their catalog, they prepared a chronology of Martínez's career that differed somewhat from the museum's version. In 1968, they note, he contributed a work to the *Velada Solemne en Homenaje al Che*—a work that could never be shown again (a work absent from the museum's chronology), because "it was not considered opportune to exhibit the image of the dead Che." (The work was not included in the National Museum's exhibition, because of "restoration problems.") By 1978 Martínez had gone "fourteen years without a solo show," as the artists (but not the museum) note. In 1982 he "began to live from his work," he "professionalizes," and in 1985 he "begins to work with assistants," another item elided in the museum's perspective.[24] The second exhibition, then, emphasized

those aspects of Martínez's life and work that the first exhibition had hidden under accolades, finding in the older artist a direct precedent for the conflictive stance being developed by artists in the 1980s rather than a paragon of revolutionary purity.

ABTV's most important project was probably *"Homage to Hans Haacke,"* an analysis of the art market's historical precedents in Cuba and patterns of institutional collusion with it. The Revolution was at the heart of both investigations. ABTV dug up, for example, the case of Orlando Yanes, the artist who had made both the behemoth portrait of Che facing the Plaza de la Revolución and a 1952 portrait of Batista: displaying the images side by side, they "demonstrate[d] how Orlando Yanes used the same 'formula' to express two different political realities."[25] They attacked the official promotion of the quasi-naive painter Manuel Mendive, "condemn[ing]—metaphorizing—the hyperbolization of the values of exchange, and the mercantilization of our patrimony, taking on Mendive's work as victim, and as paragon of this policy." Returning to the image of Che—without doubt the most densely marketed of the Revolution's logos—they analyzed the portrait of him that had become ubiquitous, looking into the history of the photograph's distribution for clues about how images are fetishized and cultural artifacts merchandized, in a symbiosis of culture and power. "Alberto Korda took the photo of Che in Havana," the artists report,

> on March 5, 1960. In that moment, the photograph was not known publicly. When Che had already disappeared from the national scene, the Italian editor Giangiacomo Feltrinelli visited Havana, interested in finding a photo of Che to publish as a poster in Milan. Casa de las Américas put him in touch with Korda, who gave him two copies of the photograph as a gift. The poster, released in 1967 in an edition of tens of thousands, made the image of Che known worldwide. Feltrinelli took the author's rights, without crediting Korda (*Revista Fototécnica,* No. 3, 1982, pp. 27 and 28). One of those copies is held at Casa de las Américas: we reproduce it here, along with this history, in order to sell it for a price of three pesos. (The three-peso bill issued by the National Bank of Cuba bears the same image of Che.)

The image that came to "best incarnate Che's values," in other words, was stolen property. Restealing it in 1989, however, proved more difficult—according to Toirac's wife, the sales were not permitted.[26] To top things off, the group invited Novoa to contribute to the project, deepening the intertextuality of the Castillo project overall and complicating the critique of the "Haacke" project. As they explained in the (never-released) catalog:

When we invited to take part in our exhibition, an artist who had already participated in the project (Glexis Novoa), we were making a parody of the selection process that determined our participation. Glexis appropriates the methodology of *"Tribute to Hans Haacke"* for parodying our attitude to the institutional frame that promotes us. This work reveals that Glexis's critical attitude was premeditated by us in the same way that the institution that promotes the Project (National Council for the Plastic Arts) foresaw and took in our own criticism. These procedures of appropriation and parody together with the previous information witness that the Ministry of Culture offered its support to the Project as a means of making its policy and institutional management updated; it also shows that we took advantage of this situation to carry out this exhibition; that Glexis used us to exhibit in the Project once more. And that we used Glexis to express all that has been aforementioned.

The invisible line of the permissible had been migrating with the increasingly tense situation around the young artists, and with this project it was again crossed: amid extensive and heated conversation between the artists and the vice minister of culture (first, Marcia Leiseca, who had been sympathetic to the project, and then the more hard-line Omar González), the deletions ("changes") stipulated for the show were unacceptable to the artists. Consequently, it never opened.

Art was in the middle of things in an extremely tense Cuba. A new hard-line had emerged in the political class, the economy had begun to implode, and the "special" relationship with the USSR—Cuba's economic lifeline—was clearly coming to an end. Artists formed small, informal collectives with shifting memberships and went to work: it was a kind of hooligan hotwire job, bypassing official ignition (institutional) circuits and magnetizing a large following in Havana. The audaciousness of the young artists had risen up into a sustained, raucous crescendo, leading the way in raising for public discussion the taboo subjects of corruption, dogmatism, cult of personality, lack of democracy, and so on, as had the velocity of their public presence in Havana, as had the battery of retaliations against them. The new Cuban art had become an uproar. "It was a phenomenon," claims Novoa,

> it was like powder that starts to explode, like "pow pow pow," it started all of a sudden . . . it started to happen and so within art there was more and more space. . . . it happened like something completely natural for the artists, something intuitive, everyone incorporating a stronger and stronger political content.[27]

Alberto Casado, *La escultura de Toirac* (Toirac's sculpture), 1996. Aluminum foil, paint, and serigraphic inks on glass; 16 x 19 inches. Courtesy of the artist.

"Choteo"

They're also like jokes. In the Center for the Development of Visual Arts some artists were gathered to present their work to Peter Ludwig. Toirac had a series of little sculptures of Fidel, and he had them on top of a table. So the son of another artist in the competition banged into the table accidentally, and knocked one of the Fidel sculptures onto the floor. And the story goes that at that moment Mosquera exclaimed, "Holy shit, he fell at last!"

—ALBERTO CASADO, INTERVIEW WITH AUTHOR

Socialism or Death! (same difference . . .) went the joke at the end of the 1980s. Sometimes, as Slavoj Žižek has said, the only truly subversive thing to do when confronted with a power discourse is simply to take it at its word.[28]

Carlos Rodríguez Cárdenas's refried slogans had picked up on the reverberations that angled back at governmental rhetoric from the Cuban street. That rhetoric had enjoyed a rebirth of sorts at the hands of Roberto Robaína, head of the Union of Communist Youth (UJC). "Robertico" eschewed the stuffy protocols typical of high-level offices for a jeans and sneakers ambience: concerned that

the Party's propaganda had become tired and irrelevant, he launched a major initiative to renovate it, interjecting popular slang into political slogans.[29] The stentorian sloganeering that had come down intact from the Sierras now had its own youth culture, soon ubiquitous on the city's walls and billboards.

In revolutionary Cuba, oration has been the principal way to galvanize mass sentiment.[30] And so, much of the critical art that began to appear in the second half of the 1980s worked through one or another means of doubling and shifting that omnipresent rhetoric and newspeak. In a social space saturated with empty words, artists flung a cascade of tropes: parody, paradox, irony, sarcasm, hyperbole, impersonation, and burlesque, among them. The young artists took that sonority and made it contradict and oppose itself, strain against its own apparent truths, exaggerate and attenuate itself and play dumb. Humor was a key tool and tactic. It was promiscuous and profuse, slipping between genres and media from low to high in a manner entirely consistent with the popular and creole humor at the center of the Cuban psyche. Satirical, parodic humor, in the hands of the artists, emanated inevitably from their triadic base: Romanticism. Revolution. Youth.

Cárdenas's *refranes* had impersonated the Voice and ventriloquized it into the mouths of innocents. His figures lined up like a Babylonian procession, and his caustic italics wrapped around what Henri Bergson once called "something mechanical encrusted upon the living," revealing the mind-blindness of their rote repetition. The reprised slogans split the difference between the original message and its opposite, bringing tremendous pressure to bear on the political language. The work did not so much distort what it copied as reduce it to semiotic essence, sounding a percussive echo steeped in irony.

That irony was not always universally perceptible and on occasion fell victim to the "delirium of interpretation" that less sympathetic viewers brought to the new Cuban art: for example, on the occasion of an exhibition in Las Villas, a secret counterrevolutionary message was detected in the phrase "úsalos contra la desinformación" ("use them against disinformation")—"úsalos" as in "USA." Cárdenas's *adoquines* (cobblestones: "namely, a small object but heavy and strong") were to have been shown in the exhibition *Artista de calidad* in October 1988, but the show never opened. "¡YA!" Novoa had written for his friend's catalog,

> In the middle of all this, and after having seen this show, I can identify myself subtlely: YAAAA … ARGHSSSSAAA … ARGRRR … YAA … GRRRRR … BUAGGGGRRR … YAAAAYAAAAA … Luckily, Carlos is not alone, in fact he has quite a lot of company.[31]

"First, relax," begins Orlando Hernández in the same publication. "Don't make that face."

> To rectify is to create, to seek the new says Carlos, and he kept wiping the bus window with his fist to see things better. Every morning the sun discovers the marvel of all the days. The reality. Nothing more and nothing less. Dialectic. Like the classics insisted. Also ugly. Uncomfortable. Unforeseen. So give me an A. Give me an R. Give me a T. What's that spell? I can't hear you. Louder! Meditate—Carlos replies. Meditate, and I don't mean Buddhism or yoga. Change.

Impositional speech was effectively foregrounded by artistic speech, othered and denaturalized. The cardboard-and-tempera aesthetic, likewise, faithfully reproduced the Party's glaucomic graphic style on billboards and the hand-painted slogans on crumbling cement walls. The two were distinct but abutting, overlapping and interpenetrating texts, between which the constant operation of similarity and contrast shed light in both directions. This situation was itself doubled in much of the criticism, which was often full of clever word plays that bit, mimicked, and parodied, alongside the artworks.

During the second half of the 1980s young Cuban artists took the complex idea of autonomy put forward by *Volumen Uno* and tied it to a more explicit idea of political responsibility. If that earlier cohort's force could be called seminal, their successors' impact might best be described as germinal, suggesting contagion rather than progeny. Laughter became their toxic antibody, part of the organism and poison to it. It was an art still in the making, full of possibility—one moment an aggressive undertow, then a jester's provocation, pressuring the tensions, voicing them, seeing just how far they would go. The battle was not—as Mosquera pointed out—simply against "concrete politics" but rather for and from a revolutionary ethic.[32] "*Reviva la revolu…*" read the placard in Aldito Menéndez's 1988 installation, literally an invocation to "revive the mess," "revive the confusion," but playing on the political slogan *Viva la Revolución*. An empty dish sat on the floor, alongside a note with the following request: "As you can see, this work is almost blank. I could only start it due to a lack of materials. Please help me."

The propellant of this work was an anarchist energy, a built-in skepticism and lack of automatic hierarchy between artist and power. All of these are core attributes of perhaps the most quintessentially Cuban expression, the *choteo*. As Jorge Mañach elucidates in his classic 1928 essay, *La crisis de la alta cultura en Cuba: Indagación del choteo* (The crisis of high culture in Cuba: Inquiry into the *choteo*), sarcasm has enormous cultural authority in Cuba, and so the witty aggressions of the new Cuban art stood hard by national tradition.[33]

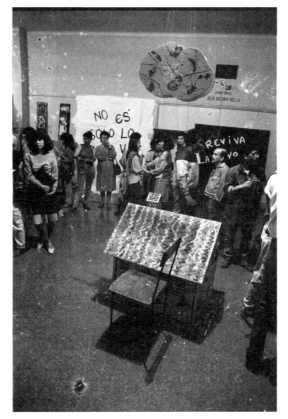

View of the exhibition *No es solo lo que ves* (It's not just what you see), with Aldito Menéndez's *Reviva la revolu…* (Revive the revolu…/revive the mess), 1988, in rear. Courtesy Aldito Menéndez. Photograph courtesy Glexis Novoa.

Mañach sets out to answer a single question: why do Cubans always make fun of things? He argues that Cuban humor, characterized by the ubiquitous *choteo* ("that perversion of a joke") is a key feature of the national psychology and sociology, a specific, situational response that cannot be understood apart from Cuba's long history of struggling under and against illegitimate authority: "More than an innate tendency in our character, it's the result of a certain collective experience … it's the spectacle of a false authority, which exacerbates the naturally critical spirit of the creole wit." Importantly, though, Mañach links this to anti-intellectualism, a "silent antipathy" toward, an ironic distrust of, an "attitude of indifference toward and even contempt for intellectual concerns."[34]

Mañach was not the only one to wonder about this subject. Cinto Vitier traced the roots of the *choteo* as follows: "After Independence was achieved through the political and especially the economic mediation of the United States; when the routine of coups and uprisings had started; when government

corruption and civil disenchantment had begun, the incredulous and mocking inner nature of the Cuban rose to the surface."[35] Even in 1912 the great Cuban anthropologist Fernando Ortiz had wondered: "Wouldn't it be an effect of social depression, that which the *choteo* has to produce?"[36]

The *choteo* is allergic to authority and prestige, the "enemy of order, in all its manifestations . . . which always carries within it the effects of disorder."[37] Like the art of Charlie Chaplin, the *choteo* is "a symphony in the key of frustrated dignity": it is revenge, confusion, and subversion, it "itches" to devalorize, it is a "discharge" that eliminates the "psychic dynamite" of resentment (66, 68, 69).

The *choteo* is a vernacular humor, completely up-to-date. It indulges in, even adores, a "natural hyperbolism, a tendency to always designate things in the most extreme terms, to dispense with exactitude" (74). Its roots in anti authoritarianism are tangent to another refusal that Mañach identifies as particularly *criollo,* an impatience "against every form of excessively imperative exemplarity," in which informality structures interactions, even those with power: "the not giving of much importance to anything, putting everything on the same level of the most intimate" (77), as he notes. This "creole familiarity," an "annulment of social distances," constitutes a crucial ingredient of the *choteo,* lubricating or ameliorating or cloaking its aggression: if, in English, familiarity breeds contempt, Mañach says, in Cuba it "just gives rise to a joke" (79). While there are light, breezy tones to the *choteo,* it is a profound skepticism that it vents most importantly, and which insulates against adversity and bitterness: "a tiny arrow that always hits the bull's-eye—the center of gravity—waving a foolish little flag" (85).

Fundamentally, the *choteo* is a "subterfuge against the strong" (62–63). It is an instinctive defense of one's "absolute liberty of caprice and improvisation. For that reason it abominates, humorously, every principle of conduct and disciplinary requirement: of absolute truth, punctuality, conscience, ritual and ceremoniousness, the methodical" (70–71). Crucially, this is a rebellion of the individual against the "mechanism of collective force." We might then trace the contour of the *choteo*'s constant ribbing under the Cuban adaptation of socialism.

The *choteo,* reborn in the new Cuban art, performed a double-bonding operation, creating identification between the artists and their audience and shooting that circuit through with renewed solidarity. Kitsch formed part of this dynamic. Kitschization was already a proven tactic in the new Cuban art, and as the decade progressed it gained depth as a strategy. The compulsion to kitsch was in large measure retaliatory, a riposte to the moral conventionalism of the government's stiffening resolve. Flavio Garciandía's girl in the grass was not photorealism, it was kitsch-as-counterkitsch, the third tear after Milan Kundera's second.

Garciandía's cliché-fest of swans, palms, hammers, and sickles had swooned between two worlds of kitsch, its affection for the material one accentuating the ridicule of the other—the spurious dogmatism he had matured under. Even if the political language had begun to "soften" in the 1980s, to move to the cadence of the ordinary and routine, it retained the fundamentally anesthetic quality of rhetorical kitsch. The parodic works by Novoa and Cárdenas had emptied that kitsch of its politics and turned it into pure sentiment, emptied it of its communicative and socializing roles and filled it with self-ironizing and indeterminate nostalgia, emptied it of its mawkish illusionism and filled its pretensions of unity with a hash of snickers. No longer lost in the rapture of the multitude, those laughers escaped its hypnotic sway. Among other things this immediately uncovered the question of the future that, on the one hand, had never seemed so pressing but, on the other, had never been so thoroughly blanketed under mythical and martyrological cloud cover.

ABTV had organized *"Homage to Hans Haacke"* as part of a cycle of exhibitions at the Castillo de la Fuerza in 1989.[38] This cycle of shows, organized by Alejandro Aguilera, Alexis Somoza, and Félix Suazo, although initially proposed as a series focusing on sculpture, evolved into an effort to deal with the mounting crisis between the young artists and the Cuban state. By creating a forum for debate about the controversial work, the Castillo de la Fuerza project took a gamble with the institution of art, making an effort to engage with it productively on artistic terms. The Castillo was a relatively safe venue—that is, it was expected to draw a narrow, specialized audience: in fact, the gallery hours proposed were 9 a.m. to 5 p.m., ruling out attendance by Cuban workers but perfect for tourists, and the shows there were intended to provide an outlet for the critical work and a setting in which it could be discussed in serious terms. (Interestingly, as Aguilera points out, the Castillo de la Fuerza was a site full of ironic resonance for the project. "Its name is full of historical insinuations and subtleties: Castle of the Royal [Real] Force. Someone at the time pointed out that our project had converted into 'The Real Force of the Castle.' The castle was never actually used for the defensive purposes for which it was built: that is, it was basically born as a historical relic of power in Cuba.")[39] Initially, a cycle of twelve shows was planned, with work by almost every one of the new generation's iconoclasts. It was an extraordinary project under any circumstances, but most pointedly given the extreme political tensions that roiled around the artists. Nonetheless, the Castillo de la Fuerza became famous mostly as the site where the rhythm of censorship shifted into high gear: of the dozen planned projects, six were prepared and five actually opened. Of those five only four remained open for the duration of their scheduled run.[40]

A little less than a year after Cárdenas's unrequited exhibition, the duo Ponjuán and René Francisco ran into trouble with their show at the Castillo, this time with irreversible consequences for the situation-at-large. They installed *Artista Melodramático*: it opened and remained open for a few days, was closed for "discussion" and then reopened, absent several works. New questions were raised, and, for her refusal to go any further in curtailing the show, Vice Minister of Culture Leiseca was fired. Omar González replaced her and her support for the young artists with a much more orthodox position, maintained within a logic largely external to art.

It was not so much that Ponjuán and René Francisco's humor had become too combustible as that the offending works had pushed far into the forbidden territory of images of Castro. The *commandante* stared back from a bathroom mirror at a guy in pajama bottoms flexing his biceps. He was the searchlight at the top of the castle's turret, shining divine guidance into the night's distance ("Ideas reach farther than light"); he was the face on a buxom, dumpy middle-aged woman marching in a rally; he was seen through one of the Castillo's windows ("the real force of the castle"). He appeared in a profile traced with bits of broken mirror under the word "Suicide." The work was a significant departure from Ponjuán and René Francisco's previous efforts that, though also acidic, had manipulated a much more coded imagery in a dense thicket of postmodernist reference and appropriation. That work was meticulous, literary, associative, and inventive, interested in the classic Soviet avant-garde of the early twentieth century and borrowing much from it in a way that was both ironic and attentive to its visual solutions. The "melodramatic" works were not. A few people within the community of artists suggested that Ponjuán and René Francisco had opportunistically jumped on the bandwagon in search of a succès de scandale; many more observed that they, along with most of the young artists, were working in a way that was demanded by the circumstances that they, and the country, were living.

It had become clear that not only the work's daring but also the limits imposed on it were extremely variable. Although talk of "limits" implies a correlation with consistent, objective conditions, censorship often does not—although it purports to—operate in such a systematic and orderly manner. In the case of the new Cuban art, it seemed to be as sensitive to personality and behavior as to content and the relative delicacy of any particular moment. On the other hand, momentum built on the artists' side not only as a function of swelling nerve but also in relation to other accumulating factors, including that of an external market that motivated further escalation in a couple of ways: first of all, that market's appetite was whetted by the frisson of conflict between art and state. Meanwhile,

the market created opportunity for the artists outside Cuba, such that jail was no longer the only option for those who "went too far."

Setting aside the question of the artists' intentions, a simple observation is in order: the works in *Artista Melodramático* were a sledgehammer. In his study of tragedy and comedy the theater critic Walter Kerr astutely observed that, "rather than pit himself directly against what he knows will defy him, the wise fool sneaks around it, dances an untiring ballet of delay around it. . . . he dances his sly search forever. The structure of comedy may participate in this 'forever,' uncoiling itself like so many laps around a track instead of penetrating the center."[41] Satire can be a terrifically versatile form, its savagery proportional to its dexterity. In *Artista Melodramático,* all of that potential scope and subtlety was reduced to the most obvious means and dispatched at point-blank range—long on message and short on texture. It was no longer associative and indirect; it no longer mixed an ambiguous affection with its arrows. Perhaps the time had come when artists could no longer afford the patience and distance of "wise fools." In any case, it had become clear that, if they wanted to play a role beyond that of tragic victims, they would have to be better tacticians.

The ironic repetition of the regime's language and image had pried open a space between the individual and power, engendered a separation of identities, and reestablished ideology as exterior. It was humor through defetishizing tautology: the words were only words, the man was only a man, and their life force as concept and symbol was annihilated. Meanwhile, the status of the artwork and of the concept Art, again in crisis, slipped into another disguise on the margins of both galleries and mass rallies. "The periphery theatricalizes," says the Chilean critic Nelly Richard, "to ridicule the dominant European belief in the integrity of the model."[42]

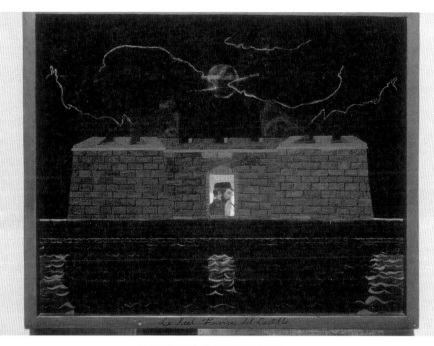

"Jodedera"

While Glexis sang he kept time with his feet and tried to dance a guaguancó. *And then a few moments after he started, an unexpected intervention from the public: Merceditas, one of the funniest* locas *of Old Havana, threw herself at him, who was dying of laughter and dancing: they started dancing together, improvising choruses. This provoked laughter and great tumult among everyone. When nobody expected anything more a hysterical shout was heard and someone emerged from the crowd, moving in the strangest manner, dressed in a red shirt of a style somewhere between medieval and a space suit, entering to the accompaniment of the singers, doing his psychedelic dance: it was Arturo Cuenca.*
—UNSIGNED TYPESCRIPT, EXPOSICIÓN "AIRE FRESCO" (APRIL 1987)

The *choteo,* although a shared cultural characteristic, was still an individual behavior. But what was happening in the visual arts increasingly took on a collective character, reflecting the sense of a shared purpose and the artists' determination to stretch the limits of art and its agency in order to stretch the permissible in political terms. The *jodedera* came to characterize a performative extension of the new Cuban art, concerned with public space in the form of a collective being or will.[43] It was an acceleration of force.

Great bursts of performative energy invaded conferences and spilled onto streets. They attached themselves like barnacles to the art world's creaky events and ceremonies, pestering those spaces just like the exhibitions were doing in the galleries. Performances erupted from individuals and from the bad-boy collectives like Arte Calle and Grupo Provisional, some announced, some not, and some the subject of tremendous rumors. Minimally scripted, minimally documented, minimally consecrated, they shifted the mixed resignation and aggression of the *choteo* into the high voltage of the *jodedera.*

In 1986 a group of students at the vocational art school "20 de Octubre" launched Arte Calle as a sort of "sos to revolutionary art," with Aldito Menéndez as ringleader.[44] The group's members, adolescents between fifteen and eighteen years old, thought of themselves as "art terrorists," an "aesthetic and Cuban parody of the Red Brigades,"[45] a clandestine gang that wanted to function

> as a bomb. . . . we had some proposals, that the government would never accept. And so we functioned more than anything else as a sort of catalyst within the field of art so that other people might feel themselves somehow within this space or in the context, in order to be able to do things. . . . [We] wanted to discuss things and change things . . . somehow, by aggression.[46]

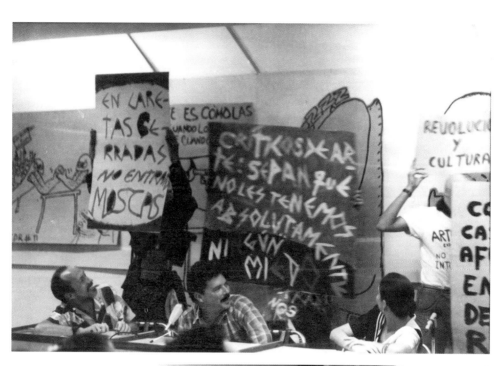

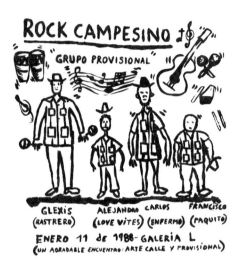

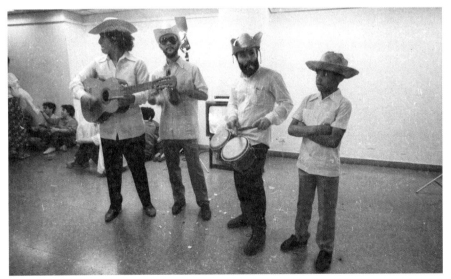

The group soon made a name for itself with works such as *No queremos intoxicarnos,* an intervention at a roundtable discussion, "The Concept of Art," to which they arrived wearing gas masks and carrying placards mocking political slogans: "Art critics: know that we have absolutely no fear of you" (mimicking the billboard that has stood for years in front of the U.S. Interests Section, declaiming, "*Señores imperialistas,* know that we have absolutely no fear of you!"). Absurdity flourished in their work: the sentries at the entrance to their *Ojo Pinto* exhibition were

a tethered goose and a couple of caged birds,[47] and at the opening the "invited guests" Grupo Provisional, disguised as the trio "Rock Campesino," wandered the gallery incessantly playing a tuneless, drunken version of "Guantanamera."[48] Somewhat more restrained, Abdel Hernández lay on a pallet with his ankles tied together, silently reading a magazine article about Joseph Beuys in front of a framed picture of Christ with a photo of Che stuck onto it.

But it was not all a joke. The group staged *Easy Shopping* in 1988 as a response to the government's establishment of *casas de oro,* establishments that bought gold and silver heirlooms from citizens in an attempt to generate hard currency revenues. In Arte Calle's view this amounted to the return of Hernán Cortés: "The Spaniards come with their little mirrors, the Indians hand over the gold." As a gesture of antineocolonialism they painted their bodies gold and silver and paraded through Old Havana's streets until, having attracted a substantial crowd that followed them to the edge of the harbor, they threw themselves into the filthy, oil-slicked waters. It was, according to Novoa, "like an act of suicide. For ethics."[49] Significantly, with this beautiful, tragic image and with their later, guerrilla murals (one, painted in the same spot where an earlier mural of theirs had been painted out by state security, said, simply, "Revenge"), Arte Calle fulfilled its promise of taking up positions in the city, whether in obscure corners or right in the middle of things, using the city not as backdrop but as battleground.

Arte Calle's nocturnal guerrilla actions fed avid rumor circuits throughout Havana. "When, for example, we made the mural that said, 'Art is just a few steps from the cemetery' in front of the Colón Cemetery in Havana," wrote Menéndez, "the rumor that spread was that a group of youngsters had painted a poster on a tomb in the graveyard that said 'Freedom has been buried by the Revolution.' Or, when we abbreviated our group name in signing a mural as 'AC,' people would interpret it as 'Abajo Castro' ('Down with Castro')."[50]

By 1987, having become known as an artistic entity, the group members felt they were betraying the original idea of "taking art to the street and that the artist merge somehow with the people and that it be an art for the people."[51] Their solution to this dilemma of "success" was to dissolve into Arte Calle Tachado ("crossed out"). Nonetheless as a group they organized one more project, the exhibition *Nueve alquimistas y un ciego* (Nine alchemists and a blind man),[52] which sought to put the concept of art legitimated by institutions into crisis. The show did, indeed, prompt a crisis, but it was one that enveloped the artists themselves.

Ariel Serrano's work for the show, *¿Dónde estás caballero gallardo, hecho historia o hecho tierra? (Che Guevara)* (Where are you gallant knight, made history or made earth?),[53] was a large portrait of the guerrilla martyr that covered

most of the gallery floor. During the opening, someone dressed in a policeman's uniform—a stranger to the artists—walked across the work, and then some others improvised a kind of dance on it.[54] The artists were promptly accused of sacrilege, and a scathing review of the show was published in *Juventud Rebelde,* authored not by an individual writer but by the entire "Cultural Editorial Group." The show was attacked for "vulgarity, superficialism, the absolute absence of convincing artistic value, and an excess of snobbery," and for "coarse dogmatism and schematic pronouncements supposedly critical of socio-ethical problems." The show was, the editors concluded, "contrary to the interests of our socialist culture."[55] Despite the review's denunciation of the exhibition on aesthetic grounds, there was no mention, much less discussion, of any of the exhibited works (a fact pointed out in the artists' response—which the newspaper refused to publish), a flimsy strategy that was used regularly to deflect attention away from the content of problematic artworks. The artists protested that the article was a political manipulation: whatever the weaknesses of the artworks, they were the sincere expressions of young people "who are part of this Revolution and who are integrated and committed to the destiny and political reality of this country in the process of building socialism."[56] In the wake of the scandal, Arte Calle was placed under continual surveillance by state security, and not long afterward, in January 1988, it dissolved for real and for good.

Grupo Provisional started at more or less the same time as Arte Calle and shared that group's anarchic ethic, its roughhouse aesthetic tied to the punk and *rockero* subcultures, and, most importantly, its para-artistic conception of art's relation to politics. True to its name, Grupo Provisional took an occasional and tactical form, existing only when there was a project.[57]

Grupo Provisional made an appearance at the same conference that Arte Calle had disrupted with gas masks, putting on a cacophonic awards ceremony honoring the very same critics that Arte Calle had just catcalled. *Japón* (Japan) took its name from Alejandro Acosta, a nine-year-old neighbor of Novoa's. The boy was

> schizophrenic, half crazy, and he had an expression for whatever he found that was good; instead of saying "Yuma" [a popular colloquialism for the United States] he said it was JAPÓN, "this is JAPÓN!" We made a presentation of prizes to certain personalities like Mosquera, Tonel . . . and every time I mentioned one of those people I asked the boy "What is Aldo Menéndez like?" and the boy would shout to me through the microphone "JAPOOOÓN!!" But it was a hysterical shout, it was crazy, and I'd say to him, "But why can't I hear you?" "JAPÓN!!" The boy was in his element there.[58]

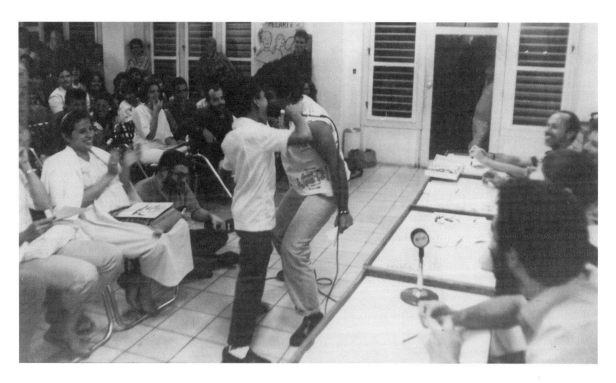

Grupo Provisional, *¡Japón!* 1988.
Courtesy Glexis Novoa.

Grupo Provisional's 1988 performance *Very Good Rauschenberg* took place on the occasion of Rauschenberg's gargantuan ROCI–Cuba (Rauschenberg Overseas Cultural Exchange–Cuba) exhibition that was stuffed into Havana's museums and galleries at the time.[59] Grupo Provisional stormed the National Museum's auditorium bearing signs reading "Very Good Rauschenberg" which they insisted (in Spanish, which he did not understand) that the befuddled artist autograph. Meanwhile, Menéndez, dressed only in a loincloth and sitting on the floor directly before the artist, listened intently and inscrutably. Grupo Provisional's faux-groupie play was masterfully impish, skewering the "very good" artist, and the museum's self-colonizing decision to turn itself over to Rauschenberg's self-aggrandizement. Their simple, silly gesture farted on myth at several levels: the art student's adulation of fame, the anti-imperialist position of the Cuban national institution, the "Indian's" warm embrace of the conqueror, the "universality" of the language of art.

At times, their sensibility goosed melodrama into the totally ridiculous. Novoa, in a hilarious version of Viennese actionism, ripped out the obviously fake guts he had stuffed into his Led Zeppelin T-shirt to reveal the bloodied copy of

Revolución y Cultura protecting him from an accident. It was "a kind of ridiculous persona," he confessed,

> who appears and spills his guts, but you could see that it was a lie. A stupid thing, stupid gestures, that had to do with the attitude of heavy metal—we didn't understand English, we didn't understand any of that but yeah, what we absorbed was the violence, the satanic thing, and it was a completely ingenuous thing, it was a communication between mutes.[60]

(Later on Toirac did a second version of Novoa's piece, but substituting candies for the guts.) A general inclination to false leads, a preference for quandaries and buried allusions, began to infect the literal concerns and immediate utility of satire. In *A buen entendedor, pocas palabras* (For one in the know, few words are necessary), Francisco and Francisco Lastra ran through the streets as though in an obstacle course, leaping and veering until they reached the entrance of a building under construction. "GUATARI MASA, GUATARI MASA" they yammered, the phonetic equivalent (more or less) of "What's going on here?" in Japanese.

Performances, exhibitions, interventions, debates, disturbances, aggressions, retaliations, and counterretaliations all piled up like tightly packed isobars throughout 1987, 1988, and 1989. Performance lived between humor and surprise, opening "an infinity of strategies" for getting away with works of "conflictive contents."[61] The work ranged from nihilism to aching sincerity: tonalities agreed and disagreed, a multitude of tempos syncopating each other. The wave carried a feeling of danger, an affirmative aggression as enormously popular as it was

LEFT Grupo Provisional, *Very Good Rauschenberg,* 1988. Photograph courtesy Glexis Novoa.

RIGHT Glexis Novoa, *No es solo lo que ves,* performance and video in the exhibition *No es solo lo que ves,* 1988, University of Havana. Courtesy of the artist.

Grupo Art-De (Arte-Derecho), *Artista como hombre público* (Artist as public man), 1988. Performance in park at Twenty-third and G, Vedado, Havana. Courtesy of Juan-Sí González.

energetic. The anti-aesthetic of the performances was a way to pull the rug out from under the hero worship and aggressive piety of officially mandated selfhood, replacing it with an embedded pest.

Art-De (Arte-Derechos) staged a series of weekly events in a popular Havana park, taking the decisive step of abandoning "art" and the shelter of its various institutional mechanisms.[62] The Brigada Hermanos Saiz (the youth wing of UNEAC, the Cuban artists' and writers' union and therefore an organ of the Communist Party) had actually provided support and cover for even the most provocative works—so long as they were legitimated on the grounds of being art. In that case, the Brigada's role was to manage the situation and to work with the dynamics of the "adolescent rebellion" to produce a more positive dynamic. Art-De's cardinal sin was to position itself completely outside this official safety net, seeking neither recognition as art nor the support of any arm of the cultural apparatus for creating or presenting its members' work. By taking over public space and inviting participation—totally unmediated—from anyone, there was, as one spectator put it, "no divorce between their role as citizens and as artists."[63] These events were mostly of an audience-participatory sort: Juan-Sí González notes that "we faced all kinds of publics, we faced their questions and their thoughts and on occasion they offended us. Everything that happened there was part of the work."[64] *Me han jodido el ánimo* (They've fucked up my spirit) was emblematic of their anguished, abreactive performances, in which González wrapped himself

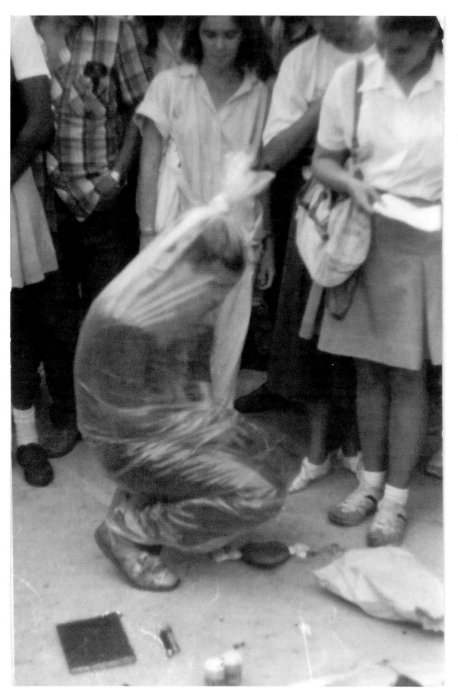

Juan-Sí González, *Me han jodido el ánimo* (They've fucked up my spirit), 1988. Performance in park at Twenty-third and G, Vedado, Havana. Courtesy of the artist.

in a large plastic bag and slowly suffocated in a display of existential agony until a panicked spectator finally stepped in and tore the plastic away from his face. The extremely high quotient of angst in their works allowed art-world observers to carefully dismiss them as bad artists, but they magnetized crowds in the park nonetheless.[65] Their events became the site of extraordinary public debates about art, about Cuban society and its problems, and about the places where those could or should intersect: "To my way of thinking," one spectator commented, "it is more a generational movement, a sociological phenomenon, which shows the desire of the youth to participate in a process of change that the entire country is immersed in. . . . As a phenomenon, a movement, it seems to me important: you have to follow it, look at it closely and support it, and hopefully it will not be just here in the park."[66]

With their direct invocation of the issue of human rights (taboo in Cuba, since all activism vis-à-vis human rights is seen as external [meaning, U.S.] subterfuge), Art-De brought into play one of the dilemmas that artistic collectives faced under socialism: in Cuba, where priority is placed on a collective conception of human rights, Art-De located those rights within the individual, as is typical in Western liberal tradition.[67] By forming a collective based explicitly in political dissent, it declared the socialist collective promulgated and prophesized by the state to be a fraud. Of all the contestatory groups, it was Art-De that received the fullest measure of the state's displeasure: the group was censored and had its works confiscated by the police, and on several occasions members were arrested; finally, two of its members were imprisoned, and the exile that González entered in 1991 was not the "low intensity" one of his compatriots who had left for Mexico.

While there may have been general agreement among artists about goals, there were real differences on strategy and tactics. These were perhaps most clearly manifested in the piece done by an assembly of artists in the Plaza de la Revolución on the occasion of Che's sixtieth birthday in 1988, twenty years after the martyr's death.[68] Robaína, as part of his policy of constructive engagement with Cuban youth who were agitating for change, solicited the artists: in general, maintaining contact with the artists advanced the state's need to find new mechanisms of control. Ernesto Leal even says that, ironically, Arte Calle wound up teaching the state how to manage what was, then, a new level of aggressiveness, an art that no longer stayed within the precincts of art and that therefore achieved a new level of "concreteness":

> It's regrettable, but all that experience of Arte Calle actually was of service to the state, the government, as to how to treat that kind of activity. Up until

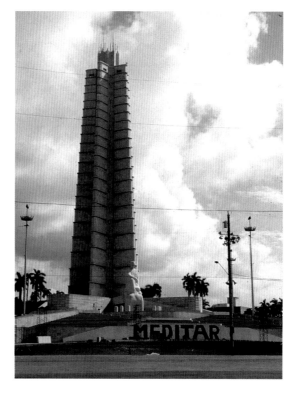

Various artists, *MEDITAR* (Meditate). Photograph by Hubert Octavio Moreno Rodríguez (taken one day after *MEDITAR*).

that moment, nothing had occurred in Cuban culture with that degree of aggressiveness—that we didn't care about losing anything. They could put us in prison and there would be no problem because we were students—that is, we had our parents who would see to us somehow. And up to that moment they had not known how to tackle that, not even with what happened with the writers in the sixties or seventies—there had been nothing like what we did because these were concrete actions, that went even beyond art. That reached the social sphere, to give things to people in the streets, to make performances, to create problems. And I believe that that helped them to develop a strategy.[69]

After much debate, the group decided to make a large sign reading *MEDITAR*, a plaintive demand for reflection.[70] The other option that had been considered was a sign reprising Menéndez's *Reviva la revolu . . .*, moving its suggestive message from a gallery to the most important political platform on the island. The disagreement was not only over the conciliatory tone of the former proposal that, like perestroika (of which the artists were very aware), was a basically reformist

proposition, but also with regard to the nature of the pact with power that would, or would not, be conserved. According to Leal, the goal for some was not the overthrow of socialism but the emergence of a "real," or "radical" form of it.[71] In these terms, *MEDITAR* represented a fundamentally unacceptable compromise in agreeing to coexist with power, and on terms acceptable to it. *MEDITAR*'s neutral, philosophical, and inoffensive tone masked the fact that others in the group were far too disenchanted to believe that simply thinking about things was any kind of response. According to Novoa, he and Cárdenas ultimately decided to withdraw from the group,

> because the mind-set was very positivist. One had to be there, one has to say something that causes one to reflect. . . . the thing was not to lose the space of Power. That's what Abdel Hernández said, that was the thing that was inducing, managing all the artists. Originally we wanted to make it "Reviva la Revolu . . ." without ending the word. And that turned out to be too strong for the Central Committee (in this particular case we were "handled" directly by Dr. Más Zábala), because it was as though the Revolution were dead, and we were going to recuperate it, revive it. But it was very strong at that moment, and we had to "edit" it, and say nothing really. And well, that's the way those things went.[72]

If the performance work was carnivalesque it was also polemical, in the sense of pushing message to grotesque proportions and a surfeit of meanings. Polemic as a rhetorical form was well suited to the moment, able to fix images sharply and quickly, giving an indelibility that compensated for the difficulty of marshaling more thoughtful formulations. The work's hastiness constituted a unique intervention into a situation that was, on the one hand, excessively rigid and, on the other, extremely unstable and rapidly changing: not a counter- or corrective discourse but something more along the lines of a triggering device. The *jodedera* had the form of a game more than an artwork per se, creating territory and action, and centered on relations and scenarios instead of narratives. The games were gestures, not products: gestures invoking social relations, pertaining to the domain of politics and ethics, and not "merely" to that of aesthetics. Games, gestures that broke the false antinomy of ends and means, shifting artistic practice from the object to the (social) body. Among other things, this had a kind of libertine ring as a refusal of the continual exhortations for self-discipline, self-control, and self-abnegation into the massified body of the nation.

On September 24, 1989, practically every artist and critic left in Havana met up in the Círculo Social José Antonio Echevarría (the old Vedado Tennis Club)

in Havana. The event had been announced on a few posters around the city under the banner of "Cuban art dedicates itself to baseball," and, forewarned, state security had arranged a game of its own on the next field over. "If we can't make art, we'll play ball," the artists said, and that's exactly what they did, on the day that many consider to have been the swan song for the new Cuban art.[73]

The performance work was charismatic not only for its humor but also for what it did to public space. Daily life in a socialist metropolis transpires in an accentuated metaphor to theater: social space is continually occupied with performances, mostly of the command variety, and in that setting the *jodedera*'s stream of countertheatricality was exciting. The rising pulse of activity was important to the success of the new Cuban art in creating a sense of public dialogue, letting it accumulate into enough of a presence to become something more substantial than an occasional sally. Gossip and rumor—historically among the most important means of communication on the island—spread the word about the constant onslaught of events, attracting a public that was not only effervescent but also heterogenous. Never before had stories about visual art "been on the lips of workers like one incendiary more," as Menéndez put it.[74]

The direct encounter with the audience was pivotal to the twinned goals of effecting meaningful social change and voiding the elite status traditional to art and its publics. The artist's agency was no longer completely internal (in a closed circuit with the form and content of the work) but acquired a social aspect that encompassed an ascending order of scales: the audience, the institution of art, and society as a whole. It has often been said that what the young artists accomplished was to "say out loud what everyone was thinking," but it was probably more than that: the dynamic exchanges they set in motion may well have changed the location and nature of public discussion about the country's problems. With the artists' actions, that discussion was no longer sequestered into private and secret space: thus aerated, the debate intensified. The avalanche of events and performances in Havana was almost entirely organized by the artists themselves, and so it was a kind of public address that left behind the designated physical spaces of art and its institutional horizon, framing the artistic context rather than being framed by it. A tense balance was negotiated between guerrilla actions and institutional compliance: for the most part it was better to go ahead without asking permission (since the answer would probably be no anyhow), and do things "in the name of the Revolution."[75] From the perspective of political power this was especially problematic: if artists simply jumped over the mediating strata of cultural institutions, this would force a direct confrontation between artists and the state.

Shit

Lázaro and Ciro's opening at the Galería Servando Cabrera Moreno: very few people there, and Ciro is sitting around looking uncomfortable. The gallery room is locked behind a metal gate and dark. Nobody seems to know what we're waiting for. Finally a microphone is set up and some guy starts making the usual speech. Suddenly Lázaro comes flying through the front door shouting "It's SHIT!!" and punching at the functionary. Rosa [from the Ministry of Culture], standing next to me, immediately starts telling me that it's a performance. Lázaro is now going for the other guy and a bunch of others are trying to figure out how to get at him without getting clobbered. Everything goes into slow motion. A woman who works there opens the gallery gate and the fluorescent lights flicker on and she's shoving people in and saying, Everyone go now into the exhibition. The pack of guys is hauling Lázaro off into a closet and trying to pull the door shut behind them. Ciro is ashen, impassive. Rosa keeps saying, It's a performance. The young artist standing next to me whispers in my other ear, The fist of Lázaro is the fist of his generation.
—AUTHOR'S TRAVEL NOTES (NOVEMBER 1991)

Novoa, Cárdenas, and Ponjuán and René Francisco's use of a political lexicon to attack political targets revealed a perhaps reified view of political struggle. Shit, however, was a little more subtle.

Shit abounded in the third Biennial in 1989, but curatorial sleight of hand meant that it didn't stink. The Biennial had become too important a gathering, not only for artists and specialists but also for the international press, and the young artists had become too thoroughly accepted by their audience as the face of contemporary Cuban art—and so the raucousness of the new Cuban art was present, but tucked away into an exhibition, *La tradición de humor* (The tradition of humor).[76] Cárdenas built a big stage set, festooned its walls with turds, and called it *Filosofía popular* (Popular philosophy). Inside, with the same lovely brushwork as before, an orgy of Freudian dimensions took place. Sex and defecation commingled, and his brick-men turned into an effluvium of shit-figures. Messages written in shit pigment hung among the paintings: "La palabra que captura la verdad no tiene que ser bella" (The word that encloses truth doesn't have to be beautiful), said one. "*Arte*" noted another, the word spelled out in turds and being shot at with shit bullets. A ruler lying on a painting of turds was a "Medida de los cosas" (Measure of things). Elsewhere in the gallery Tomás Esson's Talisman sprinkled bowel movements like lucky charms, all under the radar of comedy.

Shit moved the energy to the offbeat. It was centrifugal and scattering: it let life beyond "politics," outside the grammar of asseverations, be its arena too.

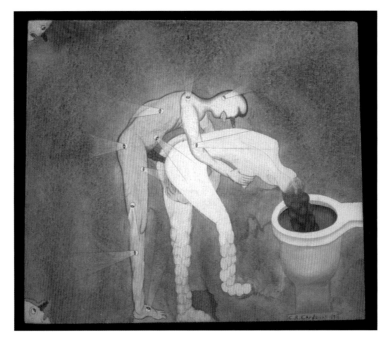

Shit has psychic connotations of play, property, and hostility, and it formed an essential element of the polyglot array of artistic practices. Shit countered the ponderous cadence of the Revolution in crisis and traversed it with the energies of popular protest. Politics, sex, and shit were drawn close together, not in the name of analogy but close enough to feel each other's heat.

But shit is not only shit, that indelicate but punctual expression. Shit is also condensation, compression, and ellipsis. Shit conveyed revulsion, it faded into the grotesque and elegiac. This was yet another chamber of laughter, filled with licentiousness, malice, and hurt. It did not find the same consolations in play that the *choteo* and *jodedera* did.

Shit constituted a form of realism as things collapsed: its abjection held itself in dialectical tension with the spectacle of late, crumbling socialism, with its silenced public sphere and gloomy prospects. On the evening of May 4, 1990, the exhibition *El objeto esculturado* opened in Havana. The U.S. military was conducting maneuvers off Guantánamo, and Cuba was on a formal state of alert. In front of the enormous crowd Ángel Delgado, still a student at ISA, dropped a copy of *Granma* on the floor, dropped his pants, and shat onto it. Within a matter of days Beatriz Aulet was fired for having allowed the performance to happen, and Delgado was sentenced to six months in prison.[77] If the scandal

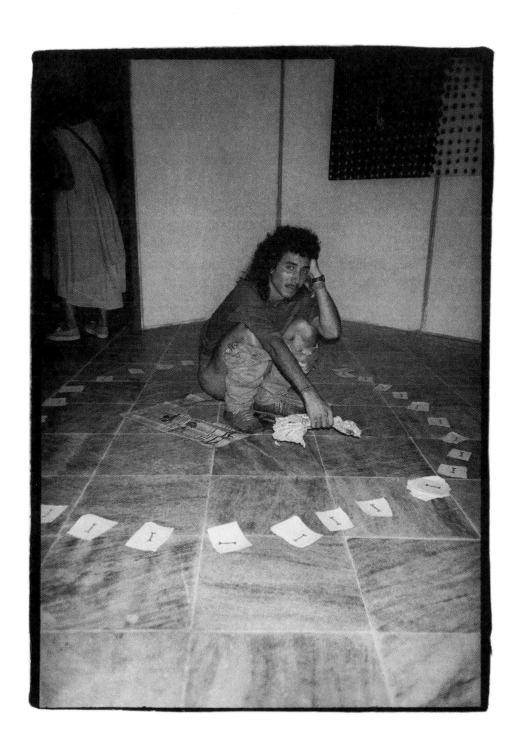

around Esson's show had left a "bad taste and sense of impotence" among the young artists,[78] Delgado's sentence was a visceral blow. Castro made another clarion announcement in August, and the country officially entered the "Special Period." The giant Sandino neon sign in Miramar was quietly taken away. Police became a ubiquitous presence on the city's streets, as did their petty harassments. Handwritten signs papered the walls: MORE UNITED THAN EVER AGAINST THE AGGRESSION! DEATH TO THE INVADER! (Two years before, Tonel had shown *El bloqueo*, a map of Cuba in the form of a pile of cinderblocks: a supreme tautology, it suggested that not only was the island blocked from the outside, it constituted its own worst enemy as well. The island becomes a plaza, an empty ceremonial platform. From around the same time, Cárdenas's *El turismo es cultura* pictured the island surrounded by a cartoon brick wall, airplanes heading in from all directions. All on a sunny day.)

By the end of the year the hysteria of the first Special Period days was mostly gone, and people were "accustomed." Most foods were rationed and difficult to get, water supplies were erratic, and the transport system was practically shut down because of oil shortages. From the air it looked like a ghost country of empty roads. Nighttime brought pitch darkness to most streets, and a new campaign proclaimed "FIDEL[ITY] FOREVER!" Solve the riddle of the synchronous empty store shelves and media reports of a bumper potato crop by plugging the refrigerator into the television, suggested the "other" language.

The Ministry of Culture, like most of the government, was broke, and the new directive was clear: the new Cuban art was to be "commercialized." Faced with terrible economic prospects, political impasse, and opportunity abroad, artists began leaving in droves, compounding the city's awful silence. Initially, most maintained a "low-intensity exile" in Mexico, though political pressures eventually conspired to leave asylum in the United States as a more viable option.

"The important thing is not to laugh. That's where all the confusion starts," advises Orlando Hernández with regard to Tonel, the figure in the new Cuban art most commonly referred to as a humorist. Tonel's immediately recognizable line traces a cartoon universe, a one-two punch that appends a wry, slightly pained exploration of impediment, difficulties on the individual level, to the quick reflex of an easy laugh—the cloud format, as it were, of the former, put into relief by the visually evident and cheery intonations of the latter. Satire was, as Tonel cites Martí's phrase, a whip with bells.[79]

In Tonel, humor is not the root: it is neither tragedy's salving double nor the Freudian release; it is not the Bahktinian underclass growl nor the Grouchoesque nor Chaplinesque nor any other categorical arabesque; it is a strange, elusive,

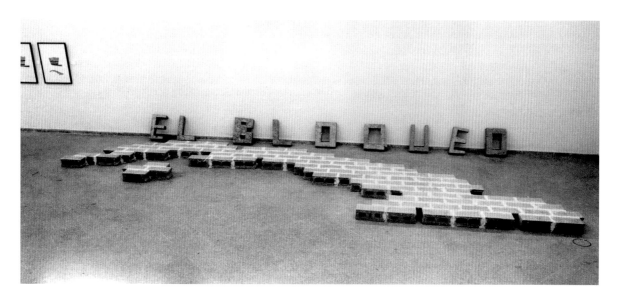

Antonio Eligio Fernández
(Tonel), *El bloqueo* (The
Blockade), 1989. Installation
at Third Havana Biennial;
approximately 3 x 9 x ½ m.
Collection Museo Nacional
de Bellas Artes, Havana,
Cuba. Courtesy of the artist.
Photograph by Eduardo Rubén.

graceful, kindhearted onslaught of—failure. Complicated failure, personal and deep and irremediable, but livable. In fact, precisely failure that is lived: slight, fleeting, resonant, soulful, and, somehow, dignified. A Kama Sutra of quiet foibles, much of it happens in the course of intimacy that is, of course, where our failure is both most likely and most complicated. The humorous register intensifies and focuses doubt: as Nell says in Samuel Beckett's *Endgame,* "Nothing is funnier than unhappiness." Tonel is in this sense not so far from Chago, and he was the first to bring that other work back from its decades-long obscurity—an act completely consistent with Tonel's own tonalities in its wistful graciousness.[80]

Of Chago it has been said: "With regard to the sexual themes (phalluses, vaginas, asses, condoms, fuckings), as well as the scatological ones (diarrhea, spit, ejaculations, and the rest), Chago is a pioneer incredibly out in front of all those pre-postpornographic winks."[81] Sex in Tonel's pages, in all its mythologies and typologies, is likewise dispatched over and over: a woman asks for the time while her lover lies on top of her (a knife embeds itself in his back); another takes note, during sex, of a toucan in the room. The deadpan captions are pushed to the extreme margins of the page. The work inspires smiles, but their aftertaste brings a quietly sinking feeling. (Tonel himself appears often enough in the drawings to sound a slightly confessional tone.) But the intimate erotic of Tonel's images is not only that: the sexual failure in his drawings (the "patriotic phallus," Eugenio Valdés called it) should be read on more than one level. Tonel's existential loopiness, his extremely light touch, registers the apparently normal, the

small failures almost passing unnoticed, as Hernández points out, but they are the bull's-eye of the image.

Romantic and sentimental: *Happiness,* he called his show at the end of the ghastly year of 1991, a year among several when Cuba slid into darkness, slid toward the possible "zero option" of total self-(in)sufficiency. The show for which the catalog cover bears the image of a man who has, with the machete clenched between his teeth, cut off his own arm.[82] Whose back cover bears the simple outline of the Cuban island. *Happiness,* which figured in his 1989 show in which he summarized: *Me, What I Want Is To Be Happy.* Not everyone was amused. Toni Piñera, writing in *Granma,* dismissed the work as false and vulgar. "Antonio Eligio Fernández," he snipped,

—¡UN TUCÁN!

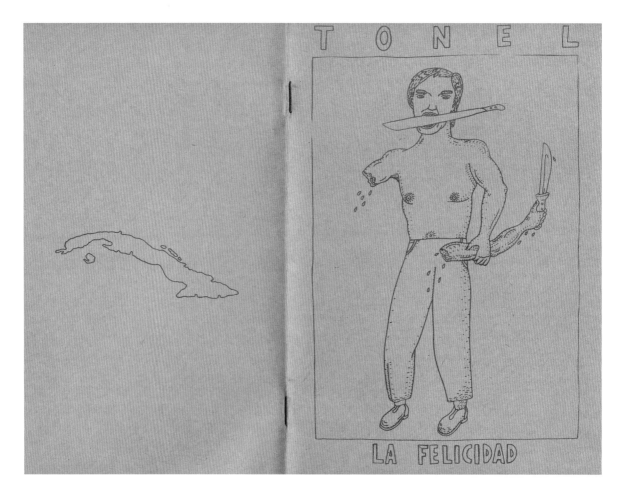

Antonio Eligio Fernández (Tonel), cover and back cover for *La felicidad* (Happiness), a self-published catalog for a solo exhibition at Tonel's home in 1991. Catalog design by Tonel. Mimeograph print on paper; cover size 9 x 6 ⅛ inches. Courtesy of the artist. Photograph by Tonel.

has succeeded in provoking the viewer. The issue in question is the extent to which signs and expressions alien to artistic language can become, constitute, a new visual currency. And if it is fair to sell the public—the people—the (to me) frank vulgarity of his artistic proposals.... Certainly it isn't easy to amuse by delighting in images unfairly identified with popular erotic expression. And this aestheticization of the sexual brings us back to our point of departure: an implicit and explicit "porno" vision in the occult pictographs of deformed sensibilities, whose definitive expression doesn't even reach the level of pornography, precisely because of its ambiguity and immaturity.[83]

Beyond the matter of Piñera's torturous logic, what could be more unambiguous than the fact that neither the political nor the quotidian—the daily philosophy,

the popular erotic—were anything but full of ambiguity? And so in Tonel's lines there are not the heavy paradoxes, the stinging ironies, but rather an emotional impact barely registering above the silent din of their rooms. Tonel's line is a straightforward one, with no volumetric aspirations, no rapid pulse of expression or excitement: it is a slow line, an especially ingenuous one, a bolero—or so it would seem. The work bears "a certain element of self-protection," as Tonel explains, "a desire to confuse, a way of fortifying one's self-defenses, one's spiritual and discursive defenses. There is also the sense of the work as a shield, as a boundary between you and others."[84] It is, nonetheless—or perhaps therefore—"complicit" with its audience. God is not cruel but I do think he is subtle, Albert Einstein is reputed to have said, and it is a thought that might be put as an afterword to Tonel's work.

Well outside those rooms the fourth Biennial opened in 1991, and visitors found everything a mess. The economy was a basket case, and "tourist apartheid" was a new, humiliating twist. A generalized negative feeling about intellectuals trailed a suggestion by Castro that they were somehow to blame for the country's problems, and even Armando Hart had declared that no criticism would be tolerated. The fight in the cultural sector had become a fundamental dispute over the values of Cuban society. Administrators seemed to be backing off, saying that the situation was "delicate" and extending that newspeak into an exceedingly avoidant way of doing business. Comparisons to the bad old days of the 1970s were frequent: in some versions that meant that things would eventually be resolved for the better (the *Volumen Uno* model), while for others the parallel was dire (Mariel). It is not coincidental that various darknesses began to pervade artworks—sexual aggression, the harrowing ravines of the grotesque: even kitsch, that ultimate denier of shit, registered in anxiety. Artworks now countered not only the sanitizing idea of art promulgated by the new cultural regime but also the romantic notions of the artists about themselves. The heroic—both versions—was the fountain of this newly uneasy, distressed social imaginary, its generative spring. Another vortex whorled, this one swirling together humor–fear–shit, bitter for its introduction of helplessness and subordination into the mix.

The successes of the *Volumen Uno* generation in securing an open space for art had, as one of its consequences, created a freer subjecthood for those who followed: this led inevitably to a sharpened confrontation with power. Together with the country's spiralling ideological crisis, this also had the effect of putting the whole idea of the proper balance between political and artistic considerations into new question. As the political speech of the artworks became both stronger and more self-evident, it was increasingly the grounds on which artists were censored.

The work of the young artist-pranksters during the second half of the 1980s was the logical outcome of a particular educational experience. While the first cohort of professors at the Instituto Superior de Arte, the national art college, at the end of the 1970s had been rigid Soviet academics ("Imagine," recalled Soto, "that you were marching like a soldier to the door of the art classroom. . . . you close the door and the professor inside says: now relax, be creative, free your mind"),[85] they were replaced in the early 1980s by Garciandía, Consuelo Castañeda, and Osvaldo Sánchez, among others, who developed a much more conceptual structure and curriculum. It was a more cynical approach that referred directly to institutional politics, rhetorical excesses, and other aspects of the environment and turned them into the concrete objects of deconstruction.[86] The new professors catalyzed a more critical and analytic artistic process among their students.[87]

Meanwhile, the artists had been developing momentum. Exhibitions drew crowds, and it was not only other artists who were attending: among the many who had noticed that something was happening was the staff of the U.S. Interests Section (generally assumed to be CIA), who saw the young artists as a potentially exploitable dissident force.[88] Not coincidentally, the new Cuban art was also being followed closely at very high levels of the Cuban political leadership. By 1989, according to reliable accounts, Carlos Aldana was personally inspecting and editing each exhibition before it was allowed to open. "Imagine," noted one observer, "the ideologue, the guy who was third in power—Fidel, Raúl and him. And there he was, going to every exhibition."

Nonetheless, within the Ministry of Culture there was a relatively liberal contingent that was the group responsible for and—at least to a large extent—able to make the relevant decisions on a day-to-day basis about art. The extraordinary attention focused on visual art raised the stakes, and it seems possible that the force of the response against the young artists inspired an equal will to defend them, with the artists themselves functioning both as synecdoche and as exemplar on both sides of the apparat. In any case there is no doubt that these dynamics were catalytic for the artists, who suddenly saw themselves acting in and on history. The fissure, the tensions, and the ensuing instability may have also introduced a certain illogic and unpredictability into the situation: here it is important to remember that Cuban socialism had germinated from deeply spontaneous and antidogmatic roots, intrinsically more susceptible (open) to accidental and extrasystemic elements than the rigidities and certainties of the Soviet model. Pressure came from many sides, none of them monolithic. Everything was a dynamic part of an unpredictable system: a triangular relation between art (provocation), official reaction, and humorous shift created an odd

stutter, disrupting the reliability of the chain reaction and preventing the consolidation of a superior, Archimedean point of control.

Support from critics was also key. Mosquera, who issued an apparently limitless stream of reviews and essays throughout the decade, unflaggingly reinforced two basic themes: first, the artists and their critique were fully situated within the revolutionary context, and second, what they were doing was fully recognizable as art—moreover, as art of exceptional quality. Both of these were crucial strategic arguments against the powerful individuals and forces that would have preferred for the new Cuban art to quietly go away.

Other factors were also in play. Flexibility, so key to the social explosion of the new Cuban art, was a factor of youth, surprise, and spontaneous enthusiasm. Through the first half of the 1980s a broadly held and impressive sense of imminence was a key condition of possibility for the new Cuban art. It provided momentum, fueling an incredibly dense and rapidly accelerating activity. The critical work also provided, to some extent, a safety valve that released some of the enormous pressure that had been building in the society. And it provided, on a limited scale, a laboratory in which the security machinery could gain experience in dealing with unrest, something it had not really had to contend with previously. Within certain (though constantly shifting) limits, then, the challenge of the new Cuban art served a useful function from the perspective of Power. As any dialectician or psychologist could have predicted, however, such a dynamic political situation did not resolve into equilibrium but continued in its spiral path. "It gave a push," says Novoa,

> and people came closer and closer. Artists were more astute all the time, more ingenious in making work that wouldn't go past the limits but at the same time the discourse was strong and it tried to get over. Still so romantic, so romantic.[89]

The principle of limited scope was also crucial. The works were (for the most part) not only exquisitely attuned to the political limits of the moment, they were also art. Their satire, therefore, operated as a stylistic accoutrement rather than as "politics," and did so within and from the institutional space of art rather than "in public." Satire may have been an aggression against power, but as a form of artistic expression it was acceptable—within certain limits—since in that context it was a form of removal and distancing, a displacement of expression founded in a certain element of uncertainty. The humor in the works was key: if people are laughing—in the land of the *choteo,* no less—they are harder to vilify than if they are throwing bricks. All of this put the ironizing artists into an ironic position,

needing to keel to a clear, bordered current of "art" while demolishing that art in the name of one that had complex, not "just" aesthetic, agency.

That continued to be the case through the 1980s, though under ever-worsening circumstances. Purges came in the Ministry of Agriculture, the Ministry of Construction, the Tourism Institute, and the Movie Industry Institute.[90] The Ministry of Culture underwent its own parallel crisis, and Vice Minister Leiseca was gone by the time the Biennial opened at the end of 1989, replaced, as in the other arms of Cuban government, with a political hard-liner. Aulet, director of the Centro de Desarollo de las Artes Visuales, followed Leiseca's fate a few months later, and permission and ambiguity slammed to a halt with the imprisonment of Delgado, the first-ever incarceration of an artist as punishment for his work. Even for those who were there every step of the way, it was shocking.

All of this mattered a lot more than we might normally expect in the case of art. The silencing, marginalization, and censorship of artists mattered because they were popular. They were children of the Revolution, products of it, and what they were saying was not some vanguard position of critique but what many, "ordinary" Cubans were thinking and feeling. Second, the works were themselves very Cuban, brimming with the humor and intonations of Havana's streets. Infanticide, and suicide. Third, it was so visible. Cuban art had become hot in the international art world, and the scandals were an embarrassment. Just as the Padilla affair had done in 1971, the official hostility to the new Cuban art occasioned expressions of concern and outrage from precisely the leftist cultural figures who had always been the spine of revolutionary Cuba's international stature. In the space of just a few years and in a vortex somewhere between laughter and shit, visual art became the primary interlocutor of Cuban society, surely one of the most vertiginous intervals in the history of art anywhere.

Emptying

There follows a wild sequence of transformations. The cat opens its jaws in order to kill the mouse, but the mouse turns into a fish and jumps into water. Instantly the master turns into a net, and swims after the fish. He has almost caught it when it turns into a pheasant. This the master chases as a falcon. His claws are already on its body when the pheasant turns into a red-cheeked apple which drops straight into the king's lap. The master turns into a knife in the king's hand. The king is about to cut the apple into pieces but it is gone and in its place is a small heap of millet. A hen and her chicks stand before it—the master again. They peck up the grains until there is only one left. This, in the very last moment, becomes a needle. The hen and

its chicks turn into a thread in the needle's eye. The needle bursts into flame and the thread is burnt up. The master is dead. The needle changes back into the boy, who goes home to his father.

—ELIAS CANETTI, *CROWDS AND POWER*

In late 1991 the guidelines for representations of Fidel were revised: it was forbidden to show him standing next to anybody taller or to show him eating, and it was forbidden to divulge any information on his personal life.[91] The year before, Fernando Rodríguez had embarked on a long-term project with his fictional collaborator Francisco de la Cal, an old charcoal worker blinded in the early days of the Revolution.[92] In Francisco's mind the revolution is an apparition, glimpsed in the images remembered or imagined that he narrates to Rodríguez so that he can make them visible: this mix of memory and dream produces a revolution of perplexity, comprising moments tangent to the prismatic Cuban hagiography. Francisco, a surrogate for what Rodríguez might want to say, throws the curveball for him.

Like any proper epic the story unfolds with a wealth of peripheral detail. There are jokes inside jokes, all inside a primitivist idiom that is and is not ironic, tinged with a Rousseauian regret of the lost paradise. Francisco dreams that Fidel marries the Virgen de la Caridad del Cobre (Cuba's patron saint)— who is Francisco's daughter in the dream—and Francisco thereby becomes the father who heals the nation's Catholic–atheist/revolutionary wound. In another frame a blindfolded Fidel plays a game of Pin the Tail on the Donkey while blind Francisco stands by, pointing the way. Lunching at the popular tourist spot la Bodeguita del Medio, the image of Fidel and his bride is repeated in a miniature version of itself hanging on the wall of the first image in an infinite recursion, a *mise en abyme* of the heretical–sacral, intimate moment. The images transpire in a deep, textured space, cavelike windows inside rough, foliated frames. It is an illusory space, its three-dimensionalism carved as private: the inverse of the flat spaces of Novoa, Esson, Cárdenas, or even Garciandía, which had pushed their subjects forward into social (shared) space.

The Rodríguez–Francisco works swim in ironies, one of them being that Francisco is precisely the everyman creator envisioned in the late-1960s and early-1970s cultural policy as the one best qualified to create revolutionary culture. It is the task of the "elite" creator (ISA-schooled Rodríguez) to record his pastorale. The structure of the dialogue between Francisco and Rodríguez parodies that earlier, autocratic populism, finding it alive and well in the form of the 1990s resurgence of state-driven street markets filled with kitsch figurines of Che, *mulatas,* and *orishas*: "their" figures are carved with exactly the same trivial

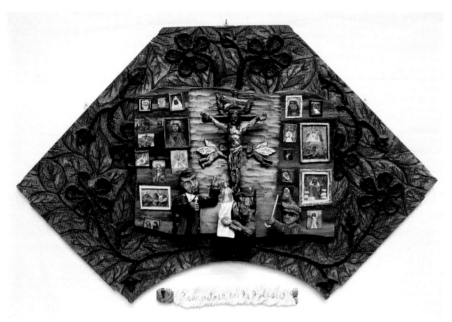

visual language as those souvenir counterparts. Rodríguez–Francisco's characters are not personalities so much as personae, identified by iconic accessories: Fidel's beard, the virgin's white trapezoidal cloak, Francisco's dark glasses. In this general atmosphere of hack emblematizing, Rodríguez's deshabille technical tour de force both conforms to and reproves this indignity to the revolutionary heritage.

Rodríguez's "identity" is multiplied fractionally, maybe one and a half times, and the effect is a broken mirror: Rodríguez and Francisco are collaborators, codependents, and opposites. They hold hands in a Möbius striptease. Francisco liberates Rodríguez: he is not only a doubled self but a substitute one who is dovetailed and interlaced, who simulates and expresses what the artist's equivocation can't. Although he is supposedly an innocent informant, Francisco's veracity is continually in doubt: even his occupation (charcoal) negates his name (lime, used in whitewash), and the images that he narrates to Rodríguez in the name of memory are actually fantasy of the most corrosive sort. But the work's affectionate feel boomerangs it, doubles it back on itself, and what seems to be acid turns out to also be homage. Who is the cynic? Rodríguez invents an idealist and hides his own cynicism under Francisco's credulity. But it becomes clear that Rodríguez is also being had by Francisco: at one point the blind man is offered an operation to restore his sight, but declines. "Why? Because if he suddenly saw, everything

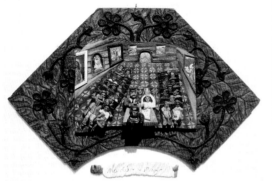

could seem a fraud to him."[93] The elaborate ruse, the endless dissembling guarantees above all that, finally, nobody will be to blame.

Rodríguez's political transvestitism was a sign of the new times, in which humor converted from fist to charm. There was no longer an "essential" political subject who operated from conviction, but only drag's overproduction of political iconicity, the adornment of the belief. Identity becomes a bewildering game played with assumed, borrowed, and masqueraded selves. Rodríguez, as author, was as post- as Francisco was blind. He was not the only one. Osvaldo Yero, one of his contemporaries, had taken to smartly reproducing the kitsch plaster figurines so popular in Cuban living rooms, replacing the Indians and saints with miniaturized national symbols in a kinder and gentler take on parody. Interiority was expressed unreliably, cagily. Comedy is cruel, says Kundera, because it "brutally reveals the meaninglessness of everything."[94] At its surreal acme, it "takes us inside . . . into the *horror* of the comic." The comic is not there "to make the tragic more bearable by lightening the tone; it doesn't *accompany* the tragic, not at all, it *nips it in the bud* and thus deprives the victims of the only consolation they could hope for: the consolation to be found in the (real or supposed) grandeur of tragedy. The engineer loses his homeland, and everybody laughs."[95] But in 1990s Cuba the temptation grew to leave horror aside and backfill the comic vacuum with manners, just in time to accommodate the curators and collectors who began to fill the planes heading in from all directions.

Comedy, detached from its originary tragedy, approached metaphor in an evasive maneuver and a departure from certainty. This coincided with the opening of the market. Prostitution had never really been eradicated in Cuba, and in the 1990s it resurfaced in a whole spectrum of forms. With the new reliance on tourist dollars, the process of dealing with foreigners was inevitably placed somewhere on a continuum between dependency and hustling. Both humor and the mystique of protest had become internationally recognized trademarks of the new Cuban art, and so, even though politics no longer seemed so viable and things no longer seemed so funny, it was important to hew close enough to the brand to retain the market. A new crop of painter–historians soon perfected this apatetic strategy (their works are closely enough related to seem like some kind of mini-school: yet another case of the "return to painting" that seems to happen when market conditions encourage the production of portable and attractive objects), and the humorist tendency segued into mannerist agnosticism.

History, mostly left aside as a subject during the cyclone years, reemerged like Rip van Winkle in the works of the painters Pedro Álvarez, Douglas Pérez, and Armando Mariño. History, out of sorts and no longer tolling against failed

dreams, now gained a humorous vocation: as critique, such work revealed not only its negative but also its positive interest in its subject. Although these artists knew how to think historically, they had perhaps come to doubt that they were living in a meaningful history, and their painterliness functioned partly as a moat around the "content" of their works.

Álvarez made historical and contemporary Havana coexist in a flurried potpourri of nineteenth-century-style costumbrist idylls and Coca-Cola and Benetton logos. Chiaroscuro pools of light captured the tourist-paradise trilogy of '53 Skylark Buicks, spooky Afro-Cuban rituals, and Creole ladies, all painted with the exaggerated light and emotion of postwar magazine ads. Havana's colonial cathedral looms in a warbly gray mist like something out of the Addams Family, a fish-eye perspective bloats the car's fenders outward, and a big red socialist banner flutters in the muttering gloom. This was Special Period reporting, with a preference for nocturnal scenes (the light level of an urban power blackout); it was Special Period expression, with its penchant for pituitous textures and tempestuous, wind-battered skies; it was Special Period art, unfailingly soignée and technically polite. It was Special Period history painting, which collapsed the different epochs of the island's past into a narration of permanent subjection, denying the version that maintained that Cuba moved from colony to republic to revolution, as though there was an important distinction to be made between the first two and the third.

Pérez also violated time in the historical (heroic) sense. His narratives unfolded in an abridged, not-real time, allowing his colliding, asynchronous references to disguise contemporary commentary as either historical reportage or science fiction. The ruse provided some cover for his frequent references to racism—something almost never discussed in Cuba—that was nonetheless one of the salient social features of the Special Period. In a 1999 series based on the classic Ortiz study *Contrapunto cubano del tabaco y del azúcar*, the nineteenth-century wealthy are arrayed across the middleground while the foreground is filled with half-naked black women in traditional African dress: a bunch of Special Period policemen (also all black) mingle with the *negritas*, all set against a grand, baroque theater lobby.[96] Another canvas arrays the range from black through *mora, mulata, trigueña*, and white: below the figures is a color chart, a minimalist set of lines that emphasize the plane of the image and thereby the plane of the historical fiction. Working in a similar vein, Mariño filled his paintings around the end of the 1990s with corrosive historical fictions in which Cuban and European–Western art history crash into each other: one characteristic image has an Indian and a black slave standing guard in front of a Picasso self-portrait. In another, a

little slave boy in shredded pants contemplates a wall hung with noble portraits and self-portraits, the muscles rippling in his back (*¿Dónde pongo mi retrato?* [Where do I put my picture?]). Another Sambo dashes through a gallery past one of Umberto Boccioni's paintings of speed, echoing its spirit of escape and destruction (*Carrera con obstáculos* [Obstacle race]), and another pisses into a urinal while a taciturn Marcel Duchamp sits by the sink (*Marcel Duchamp en el reflejo de la postmodernidad* [Marcel Duchamp in the reflection of postmodernity]).

At the time, these works had a feel of basic continuity with the barbed and aggressive currents of the second half of the 1980s, and it is perhaps only in retrospect that their sheer politeness begins to take charge. There is the odd sensation first of all of political molt: while there is ample allegorical texture, it is missing a sense of quest. The conflicts linger, immobile and frozen in the telling. There is the sense of someone having asked permission to tell a joke, which he then does with taste and aplomb.

Pedro Álvarez, *Cinderella's '53 Skylark Buick*, 1999. Oil on canvas; 45 x 57 ¼ inches. Courtesy of Carmen Cabrera Álvarez. Photograph courtesy of Track 16 Gallery, Santa Monica. Collection of Howard Farber, New York.

TOP, LEFT Armando Mariño, *¿Dónde pongo mi retrato?* (Where do I put my portrait?), 1997. Oil on canvas; 178 x 150 cm. Courtesy of the artist. Private collection.

TOP, RIGHT Armando Mariño, *Carrera de obstáculos* (Obstacle race), 1997. Oil on canvas. Courtesy of the artist. Private collection.

BOTTOM Armando Mariño, *Marcel Duchamp en el reflejo de la postmodernidad* (Marcel Duchamp in the reflection of postmodernity), 1997. Oil on canvas; 125 x 150 cm. Courtesy of the artist. Private collection.

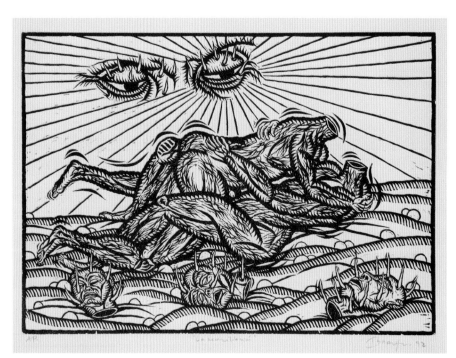

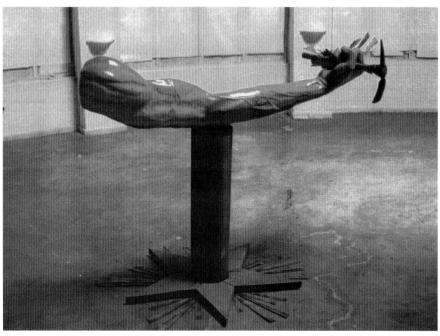

TOP Ibrahim Miranda
Ramos, *La reconciliación* (The
reconciliation), 1991. Woodcut;
42.8 x 58.7 cm. Courtesy of
the artist.

BOTTOM Esterio Segura
Mora, *La diestra* (The right
hand), 1991. 84 x 240 x 50
cm. Courtesy of the artist.
Collection Museo Nacional de
Bellas Artes, Havana.

But not everyone shared their pertness. As the Special Period wore on, humor, along with other enthusiasms, was a casualty of many exhaustions. Mañach had noted that the *choteo* changed form and intensity in different historical moments: thus, while his essay was originally written during the politically dynamic period of the 1920s, by 1955 he was moved to add the following note:

> Today it is possible to affirm, if not the disappearance of the *choteo* in Cuba since those critical years that came a little after I wrote the essay, at least its attenuation. The revolutionary process of the thirties and forties, so tense, so anguished, so bloody at times, came to dramatize the Cuban, to the extreme of bringing him (it) on occasion to tragic excesses. The *choteo* is no longer the nearly ubiquitous phenomenon that it was in days gone by; now the little trumpet scarcely sounds or, at least, it has no circulatory presence. History, little by little, keeps modifying our character.[97]

In effect, the same thing happened again forty years later. Not only the political humor of the visual artists, but also the other circuits through which popular humor had circulated practically disappeared. This diminuendo also brought profound changes in the content of popular humor. The political humor of the 1980s, nourished by a broad and energetic critical spirit, yielded to a cynical, disaffected roster—racist, regionalist, and homophobic in orientation—nourished and motivated by a sense of futility and defeat. The loss of the utopian horizon.

Gloaming tones enveloped the city. The new darkness was the exodus, it was the unlit city despairing at night, it was the fear of things getting even worse; and in it grew a new grotesque. Here is some of what was produced in 1991, the year after Rodríguez's Francisco was born: Alejandro Aguilera strung iron flowers across a big rebar screen, a harsh, angry remembrance of Camilo Cienfuegos that was violently at odds with the annual tradition of tossing blossoms into the sea (*33 Flores para Camilo*).[98] Lázaro García's varnished classicism produced yet more excellent canvases, portraits of bodies violated by too many eyes, in the wrong places, too many heads, necks growing out of crowns; Napoleonic, denuded and alone in a fearful sea; a dolorous madonna bleeding from the forehead. Ibrahim Miranda produced impeccable woodcuts that maximized the violent strokes of their medium: decapitated, copulating figures, their heads pierced with spikes while god observes through heavy-lidded eyes. Esterio Segura, perhaps the most visually brilliant of all, made a massive, amputated arm with the plaster and gesso technique of church saints, and filled its mighty fist with gilt thunderbolts. More muscles, huge and rippling.[99] Refusing such good visual manners, Luis Gómez hacked giant legs from tree trunks and propped them up in a corner,

clubbed and immobile. Kcho fashioned the shape of the island as birdcage, jail cell, the legendary ladder—emblem of resistance—standing on wobbly branches with broken and rusted machetes (weapon of choice in the late-nineteenth-century war of independence) serving as rungs with the blades facing upward.[100] A gentle crest of palm—the Cuban national tree—crowned the ramshackle ascent. Sitting in his prison cell, Delgado filled one after another encrypted page with stories of prison's barbarities—though of course nobody would know about this work for some time yet. Pierced, broken, deformed, tortured, amputated, horrible bodies. This grotesque was a registration of the body against the impossibility of daily life. This grotesque could never quite balance, never quite gel, never quite escape its wounded condition.

In August 1994 the trickle of Cubans setting out to sea in rafts became a surge: an even more desperate Mariel, completely disorganized, clandestine, and deadly. The Biennial that year shook with the trauma: Tania Bruguera stuffed her belongings into a mass of bundles jumbled into the shape of the island and lay, as if dead, in a wreck of a dinghy. Manuel Piña's photographic series *Aguas baldías* (Water wastelands) looked out from the city's crumbling sea wall into an empty horizon. Sandra Ramos filled old suitcases with paintings and trinkets suggestive of the losses of departure. It was the *balsero* Biennial, but no representation of the other side was permitted (Mexican Lourdes Grobet's photographs of recent exiles

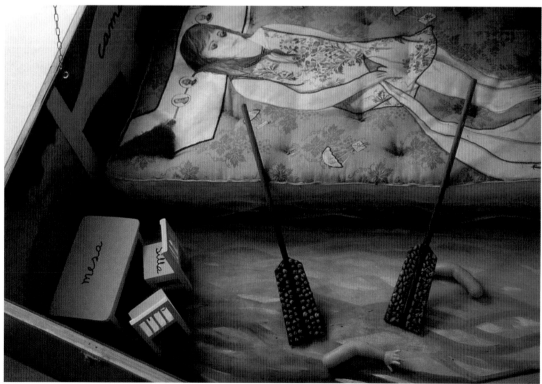

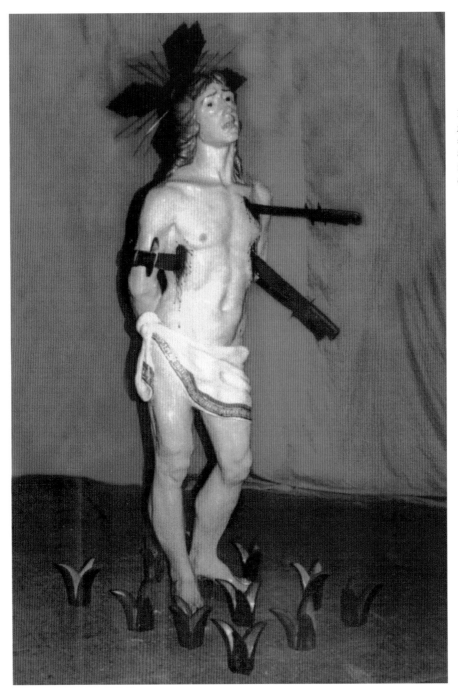

Esterio Segura Mora, *Santo de paseo por el trópico* (Saint on a stroll in the tropics), 1991. 180 x 80 x 90 cm. Courtesy of the artist. Collection Museo Nacional de Bellas Artes, Havana.

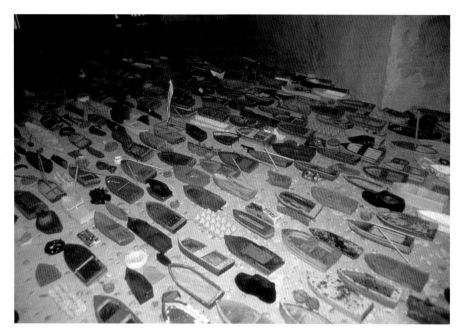

in Mexico were de-installed almost immediately), leaving only the suffocating, pervading sense of disaster. Havana was literally collapsing, as Carlos Garaicoa's works attested in their gorgeous lament. Segura's giant, anonymous forearm morphed into St. Sebastian—*Santo de paseo por el trópico* (Saint on a stroll in the tropics)—with an anguished look and *contrapposto* grace, pierced with machetes. Kcho laid out hundreds of cast-off and pitiful items in *Regata*—old flotsam, flip-flops, and toy boats, a maquette of the wave of departures in the shape of a miniature but gigantic flotilla pointed to the north. Elsewhere he fitted a gleaming grand piano with a pair of battered oars, in what was probably the most powerful work of that particular emigration. Martyrdom and ruination, everywhere.

The market was the way out, at least for artists. Lacking inside (wo)men to form a bridge between artist and state, the new level of polarization spawned a new dynamic that was itself resolved, temporarily, in the dynamic of the market, the new bridge of mutual interest. Novoa's *Etapa Práctica* had been a turning point, away from the uncomplicated idealism of making things better, and taking advantage of what was becoming available to artists outside the country. Open secrets were traded for semiprivate games: rather than being interested in the viewer, the artist could now assume that the viewer would take an interest in him. Peter Sloterdijk has suggested the idea of foam as a metaphor for contemporary social systems: "Multichamber systems consisting of spaces formed by gas pressure

and surface tensions, which restrict and deform one another according to fairly strict geometric laws."[101] Foam's disjointed, "interautistic," and "mimetic" relations replace the paradigm of "communication" inherent to a world of "weight and solid substances"—revolution, modernity.[102] Likewise, much of the politics and aggression of the artworks was increasingly part of a never-ending web of relations (entanglements), no longer other to and disarticulated from what they poked at, and therefore no longer particularly objectionable or threatening.[103]

It was a raw time, amoral in some respects, in which the impulse to deface echoed mostly as one to efface, to pass. And the language and sense of the multitude, so mobile, incommensurable, rebellious (at least potentially), and creative, quietly morphed into the language of the new entrepreneurialism. As befits any market situation, marketing became important. So it was not inappropriate that the work became advertisements for conviction, rather than conviction itself. For artists living well on the island, perhaps, Cuba was no longer an identity: it was a home base.

For some. The new Cuban art was an increasingly fragmented and prismatic expression, if less committed to its native social scape, still no less emblematic of it. Rodríguez had gotten mileage out of twinning Fidel with the church, and Toirac pegged him to corporate marketing—the logo for Yves Saint Laurent's Opium perfume captioning a handshake between the pope and the *commandante* (in a suit)—to evidence the other substrate of the new socialism.

The German chocolatier Peter Ludwig had jump-started a market for Cuban art in 1990 with his wholesale purchase of most of the exhibition *Kuba ok*. The show was the perfect starter kit, full of robustly "Cuban" and big, visually striking installations. There were Garciandía's potted plants and red and black sickles; Cárdenas's gigantic wall hanging proclaiming *Patria o Muerte*; Novoa's *Etapa Práctica*; Ciro Quintana's intricate *Made in Cuba* with its hip, postmodern "intertextuality to the third degree,"[104] Bedia's wall-sized graphics, potently spiritist and symbolist; Magdalena Campos's secular mythologizing wall rebuses dotted with hearts, spears, and swans (*Opciones para el mito: Leda piensa* [Options for the myth: Leda thinking], *La ofrenda de la propia sangre* [The offering of one's own blood]); Rubén Torres Llorca's elaborate skyscraper altars with their beautifully familiar quotidianity; a big scatter installation by Segundo Planes full of lush primary colors and quizzical references; and Saavedra's *Altar to Saint Joseph Beuys,* with its kitsch wallpaper and sprawl of diplomas, *ofrendas,* and plane tickets. García's paintings, though modest in scale, sparkled in their bejeweled technique, and finally, there was the collective ABTV broken in two: Angulo with Toirac, and Villazón with Ballester, both teams doing facsimiles of the other works in the show.

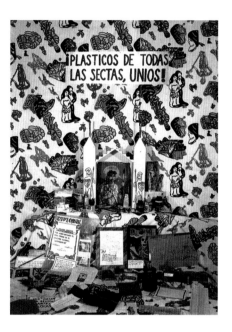

Lázaro A. Saavedra González,
Altar to St. Joseph Beuys, 1989.
Courtesy of the artist.

From then on the focus of the new Cuban art would seem increasingly centrifugal, giving rise to suspicions, as Rubén de la Nuez so delicately put it, "that the responses offered by the new Cuban art might be directed to satisfy basically questions formulated in other contexts."[105] That year, "many young artists began to envision their possible entry into the international art market."[106] Less and less room was available for a renovatory push, and so the lure of reward from "other contexts" and the difficulty and fatigue associated with "directing its responses" to Cuba spiraled around each other toward an aesthetically exportable and politically neutered condition.[107]

Ludwig's intervention in the economics of Cuban art had been a checkered matter. He had haggled over prices with the Fondo de Bienes Culturales until it agreed to ridiculous discounts;[108] magnanimously offered to support the Biennial, only to cut a check barely enough to cover the cost of nails; magnanimously established the Ludwig Foundation in Havana to "teach Cubans about contemporary art,"[109] with a meager budget entirely inadequate to the organization's imperial goals; and received an honorary doctorate for his troubles. Ludwig himself made an appearance in the 1994 Biennial in Ponjuán and René Francisco's *Sueño, arte, mercado* (Dream, art, and market), a sprawling tour de force that took lethal aim at the commercialization of the Cuban art scene. Formal portraits of Ludwig and his curator, faked copies of *Art in America* featuring Cuban art, quasi-constructivist

TOP Eduardo Ponjuán González and René Francisco Rodríguez, *Sueño, arte, mercado* (Dream, art, market), 1994, detail. Fake *Art in America* magazine cover, issue on "Migrations and Art/Utopias and Art," featuring work by Carlos Rodríguez Cárdenas on cover. Courtesy of the artists.

BOTTOM Eduardo Ponjuán González and René Francisco Rodríguez, *Sueño, arte, mercado,* 1994, detail. Peter Ludwig seated in front of Havana harbor. Courtesy of the artists.

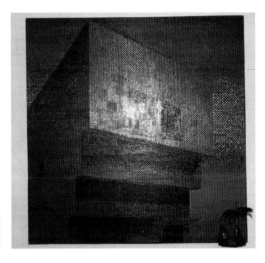

paintings of the Guggenheim and Whitney museums (the Whitney a gorgeous, smoldering red, with a little palm tree in front), plane tickets, festooned islands and dollar signs, crucifixion-shadows, homemade lanterns with Coke can bases, toy ships, toy planes, the national flags of Cuba, Germany, and the United States fitted together into a geometric, abstract plane: all this and more populated the installation, layering it with surly ironies, conceptual punchlines, and satirical exuberance. Ponjuán and René Francisco's work exuded—again—an optimism in its troubling with complexity.

The fifth Biennial was also the scene of the spectacular exhibition/performance *A falta de pan: camellos. Un oasis en el camino de la necesidad al mercado* (In a pinch: camels. An oasis on the path of necessity to the market).[110] Staged by the rogue corporation Eighties SA,[111] this "alternative to the Biennial" lampooned the new commercialism in Cuban art and put the Biennial at the center of that process. The artists drove up to the widely publicized opening in a taxi, dressed in Arab-looking robes and making a commotion: after a chaotic interval, one of them delivered a welcoming speech imitating the speaking style of Armando Hart. The show included a series of counterfeit money that assigned higher-denomination bills to artists according to the robustness of their clienteles (Saavedra was worth only one dollar, while Tonel garnered five hundred): both those who had left the island and those who had stayed were included. The weeklong activities were promised to close (after a day off "to wash the camels") with "auctions, raffles, rebates and end-of-week discounts; the best place, the best music, and the best sales."

A falta de pan..., like the somewhat earlier projects by ABTV, worked to pull aside the final curtain: if the new Cuban art had received its first impetus from the struggle for autonomy from ideological pressure, it was the illusion of art's refuge from economic coercion that was swept away a decade or so later. As in that earlier moment, Cuban art occupied a position that was at once oppositional and inherently part and parcel of that which it opposed. As the economic situation had become absolutely dire, the market came to mean not only prestige but also survival. Younger artists were swept up with fewer reservations: among other things, the idea of fighting for change had also been pretty much discredited, since those who had fought had mostly wound up leaving, and nothing much had changed.

Félix Ernesto Pérez, one of those behind *A falta de pan...*, also produced the *Super Eighties Game* in 1994, which was

> inspired by the realities and effects of the art market on the work and its product (the artist).... The objective of the game is to invest in all the institutions, overcome the pitfalls until you achieve economic prosperity— the mercantile perpetuation of the values of art, the patrimonialization of cultural capital.[112]

Super Eighties Game, "dedicated to the generation of the eighties," made fun of everything—even (especially) of those who had made fun of things in the golden-era past. The section of the game named after the famous *Juego de pelota,* for instance, provides the following rolls of the dice:

> 2—HOME RUN: Advance to the Ministry of Culture to ventilate the problems and concerns of the young Cuban ART. Pick an ASSISTANCE card and earn $500,000 USD.

> 3—OUT: The excessive tension between artist–institution reaches the extreme limits of its elasticity. Your punishment is four turns in the CENSORSHIP square.[113]

But all of that pertained to only one of the commercializations of Cuban art. The other, which targeted a less-sophisticated rank of tourist, flourished in the street markets packed with pictures of the usual subjects—palm trees, *mulatas,* Old Havana landmarks, and scenic vistas painted in any and all cheesy stylizations. It was into this system that Joel Rojas, who had started out as a member of the "new" art, eventually made his way. As a first-year student at ISA in 1989, Rojas had painted a couple of large and strapping caricatures of Fidel in the style of Michelangelo's *David*—sort of. While only three black-and-white photos remain

of the work, it is clear from them that the central icon was rendered with a festive air and surrounded by playfully iconoclastic references to Cuban and socialist folklore. Explaining the genesis of the work more than a decade later, Rojas linked it to various popular image banks from his childhood in the island's interior, references that expanded considerably on the narrowly ideological reading that the painting was accorded at the time it was made:

> They had popular festivals in my town, that had a lot of kitsch, big dolls . . . a carnivalesque thing, the *parrandas* of Remedios, which are pretty important in the national culture . . . , there were big posters . . . and in the terminals, in those places I traveled through constantly, . . . where there was represented, kind of . . . like a socialist realism Cuban-style . . . big slogans. . . . it was all a grandiloquent aesthetic and so in a certain manner I incorporated that, not mimetically into the work, but in a certain manner, that grandiloquent spirit.[114]

Rojas's paintings were confiscated from his studio in ISA, and he was expelled for his attack against the highest symbol of the country's dignity. Upon his further appeal to the minister of culture, he was effectively blackballed from any future participation in exhibitions or competitions. "With the cause of a work considered a conscious outrage to the Revolution," read Hart's Resolution,

> and to the revolutionary determination of our people, something which qualifies as Very Grave. . . . said work being undisputably disrespectful to the Revolution, which makes it incompatible with the aesthetic principles of our society.

Rojas now exhibits his work every week in the burgeoning street market near the Cathedral, along with dozens of other painters, crocheters, and Che figurine-makers. Ironically, unlike many of his former classmates, he is making a living with his work. The situation is another of the paradoxes that logic trips on in Cuba: a mandated identity turned back on itself, in the form of a blacklisted artist mounting a faux-nationalist formula to sell cynical works to tourists.[115]

The dynamic of censorship had two main phases: at first it was shocking and catalytic, energizing resistance. After a while, and once it had become a constant feature that showed no signs of abating, it became inuring and deadening, productive of cynicism instead of defiance, metaphor instead of satire. Panels, conferences, and other types of public discussions about art, so numerous in the 1980s, were a thing of the past, no longer permitted by the cultural institutions. Magazines, journals, and newspapers no longer printed critical texts.[116] It was clear in all sectors, not only in culture, that new policies were in place. On

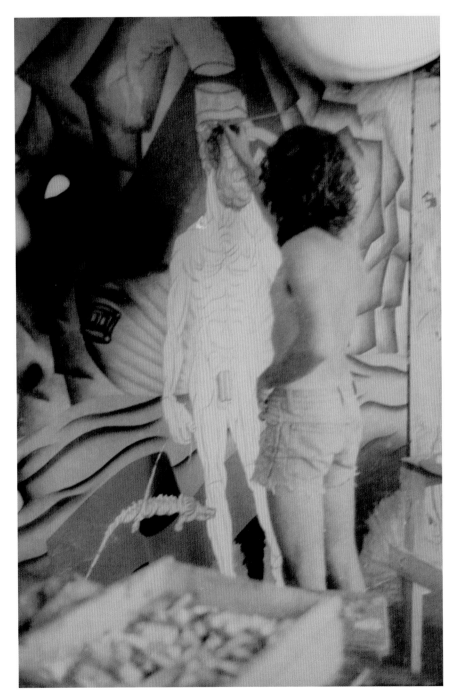

Joel Humberto Rojas Pérez, *El David* (The David), 1989. Oil on canvas. Courtesy of the artist. Photograph by Ibrahim Miranda.

August 5, 1994, the first street riots since 1959 erupted on the Malecón.[117] In the weeks that followed, an estimated thirty-four thousand people put out to sea.

Excursus

D-FLAT MAJOR: A leering key, degenerating into grief and rapture. It cannot laugh, but it can smile; it cannot howl, but at least it can grimace through its weeping.
B-FLAT MINOR: An oddity, for the most part dressed in the garment of night. It is somewhat disgruntled and embraces most rarely a pleasant mien. Mockery against God and the world; displeasure with itself and with everything; preparations for suicide resound in this key.
E MAJOR: loud shouts for joy, laughing pleasure, and still not altogether full gratification . . .
F-SHARP MINOR: a gloomy key. It pulls at passion as a dog biting at one's pant leg. It always languishes for the repose of A major or for the conquering bliss of D major.
—CHRISTIAN FRIEDRICH DAVID SCHUBART, *CHARACTERISTICS OF THE MUSICAL KEYS*

A longitudinal cut through the period might be the case of Lázaro Saavedra. Saavedra was born in 1964 and was a member of the seventh graduating class at ISA in 1988: he was therefore a part of the second "promotion" of artists, *Los novísimos* (the very newest), who came just a few years after *La plástica joven* (The young art). (The term *jóvenes más joven* [the younger young ones] began to appear around 1989, completing the hyperbole.) Unlike almost all of his cohort, however, Saavedra did not leave Cuba in the years around 1990, and his career has tracked an acute parallel to the dynamics of the new Cuban art. This is most clearly exemplified through his participation in the Havana Biennial.

Biennials have often served as vehicles for civic and political aspirations that extend far beyond the art world: potent showcases for local, regional, or national ambitions, they have been inaugurated in city after city where political and economic accelerations demand such splashy public cotillions. But Havana, at least in the beginning, was different. The Biennial, inaugurated in 1984 as the result of one of Castro's brainstorms, was initially organized to mount a counterdiscourse to the capitalist and commodified foundations of the hegemonic art world. It occupied the role of antidote to the homogenizing forces of the marketplace, and of potential model for an alternative practice. It was a stalwart advocate of the need for a forum outside the mainstream, in which new and local discourses and aesthetics could grow: it told a story different from the stories told by internationals elsewhere in the world. As the only biennial operated by a socialist country, it stood for anticommercialism and solidarity among artists. The Biennial's

staunchly anti-imperialist mission had presaged much of the subsequent post-modern discourse regarding the decentering of the art world and of cultural legitimacy generally, and Havana had therefore acquired a certain cachet for its clarity of vision and for having been there first.[118]

In its original, idealist construction, the Biennial was meant as a gathering place to bring artists together from throughout the Third World and bring art to the Cuban public. Populist exhibitions of things like African wire toys and folkloric representations of Simón Bolívar (both in 1989) were staged alongside the main exhibitions of contemporary art, and open-air salsa concerts and fashion shows brought the Biennial into the city's public spaces. These projects began to disappear beginning around the fourth installment (not coincidentally, the time of Mosquera's departure from the curatorial staff), replaced with a more uniform, high-culture approach. No longer simply a Third World curiosity, Havana became a magnet for influential curators, dealers, and collectors, a site at which significant business was done. While the Biennial's primary audience was initially composed of people who shared many key referents (Latin American or Third World identification, problematized relation to the artistic mainstream, conditions of underdevelopment, a vaunted sense of the artist's social purpose, etc.), it was to become increasingly a typical international art crowd, shopping for trends and new discoveries. This parabolic trajectory culminated in the 2,000 visitors (1,500 from the United States) reputed to have flown in to Havana in 2000 for the seventh Biennial.

Saavedra began participating in the Biennial in 1989 and had a presence subsequently in the fourth and sixth installments: he thus spans the crucial dialectic in Cuban art between vanguard and postutopia.[119] His contributions tracked to the larger political and economic currents of their moments: in 1989 Saavedra used his invitation to the Biennial to make fun of the opportunism that was growing among Cuban artists in equal proportion to the interest of the international art world. His censored exhibition in 1991,[120] *El desafío de mi arte* (The challenge of my art), would have consisted of photocopies of some earlier works and of Saavedra's CV, along with a letter offering himself for sale. The work's title mimicked the Biennial theme—*The Challenge to Colonization*—and so, ironically, the incident exposed the extent to which defiance was actually permissible, at least on the part of artists. In the wake of his fisticuffs Saavedra was not invited to participate in the 1994 Biennial, but returned in 1997, contributing a graveyard.

Like Novoa, Saavedra had started out doing work that was humorous and self-satirical (in the sense of making fun of art and artists), but which soon opened to questions of another order. Like Chago, he explored a morass of

LEFT Lázaro A. Saavedra González, *El arte un arma de lucha* (Art, a weapon of struggle), 1988. Oil on canvas. Courtesy of the artist. Collection Museo Nacional de Bellas Artes, Havana.

CENTER Lázaro A. Saavedra González, *Detector ideológico* (Ideological detector), 1989. Courtesy of the artist. Collection Museo Nacional de Bellas Artes, Havana.

RIGHT Lázaro A. Saavedra González, *Problemas formales* (Formal problems), from the series *Mesa sueca* (Smorgasbord), 1988. Courtesy of the artist.

entangled and resistant existential questions in ways that were preeminently popular—in its language, in its perspective, in its humor, and in its games of ego and alter ego.

Saavedra's early works used a quick graphic language to "demonstrate" problems belonging to Fine Art. Paintings became ventriloquists, mimics, and liars: "I am the brilliant color," proclaimed one image with a rosy blob in its center; "Cave painting showing the prodigal son" said another, which didn't; "Look at me. Interrogate me. Re-create your vision in me. I am Texture," tautologized a third. But already—and he was only then graduating from ISA—there were signs of another kind of fermentation. Careless letters spelled out the nugget of the bad old days—"ART A WEAPON OF STRUGGLE"—above an equally dismissive still life in a diptych that proved that it was not. A year later, as part of his *Altar to St. Joseph Beuys* and as the wave of censorship spread through Havana galleries, Saavedra made his *Ideological Detector* (which the museum also owns, but kept in storage).[121] "No problem" it reads on one end of the scale, progressing through "Problematic," "Counterrevolutionary" ("Unconscious" and then "Conscious"), before climaxing in "*Diversión.*"[122] "Made in Cuba," notes the trademark.

From the beginning, Saavedra's drawings had been populated with his "*hombrecitos,*" wisecracking homunculi who surveilled his pictures much as the shadows split from their bodies in the *Mad Magazine* comic strip *The Shadow Knows,* to do and say what the person really had in mind. The little men were nothing more elaborate than loopy outlines with big eyes, but they were amazingly querulous. They were little Brechtian critics (self-critics), functionaries, angels, and alter egos, who issued a constant stream of quips, gripes, and whoppers,

mercilessly popping the balloon of the artwork's diegetic space. Their subnarratives undermined the ostensible work, dismembered it, and set up a quarrel with art itself. The *hombrecitos* were snipers aiming expletives at any and all assertions. The whole lot of Saavedra's characters lied, dissimulated, and suffered gladly in an ongoing identity crisis. A tree pines to be an artwork, Egyptian tomb figures dribble basketballs, one of the little men pulls away the flesh from Karl Marx's cheek and says: "Hey, don't you see? He was flesh and blood." "Love doesn't exist," says a guy with a gun to his head. "Do it! Do it!" says one of the *hombrecitos*. "Life is shit," says another. A rocket ship takes off in the corner; "Come back!" demands yet another. "Shut up!" says a last to all the rest. "Wounds? Wounds don't matter," says one at the center of another page. "True!" affirms a second. "It's great to be alive," another. "Feel it, pal," says the last one, draped around a bottle. The little men were wicked children, causing mayhem in the classroom and Young Pioneer meetings, by turns excessively rational and bored, excessively didactic, smart-assed, enamored, misleading, and overliteral. They were the impudence, the lightness of the almost-joke, the painful joke, and the cruel joke, which cut a path to the deeper questions that were the work's real subject. They were only the start.

The *hombrecitos* had marked Saavedra's fundamental conviction—increasingly archaic, as it seemed—of art as ethic. As the difficulties facing the new Cuban art became more and more severe, Saavedra became preoccupied not so much with the emerging market but with the conditions inside Cuba that had precipitated it, and with artists' avidity for it. Above all, it was the artists' complicity with those systems that earned his sarcasm: instead of focusing on how the state wielded power, he looked at the many ways that artists formed an integral part of that control.

Dr. Jekyll and Mr. Hyde, Saavedra's piece for the 1989 Biennial, consisted of a couple of pieces of paper on a pedestal. The remainder of the six meters of space allotted to him—in this, his first Biennial—was left blank. An identical letter was printed on each page, the first in Spanish, typed onto a crumpled piece of paper with an old typewriter and the other in English: crisp, clean, computer generated. "The artwork that is being exhibited here, before you, is a magical work," it read.

> The work will be invisible to all those individuals who have been formed with an aesthetic conscience:
>
> — underdeveloped or neocolonized
> — subordinated to the "great" biennials (visited or through catalogs)
> — subordinated to mercantile art, etc.
>
> This work can only be seen and understood by those who have in their minds the germs of the new aesthetic conscience that is required by the art of the third world.
>
> Thanks for coming.

The fourth Havana Biennial, *The Challenge to Colonization,* opened in November 1991, themed to contest the upcoming raft of Columbian quincentenary celebrations in museums to the north. Bizarrely, the opening ceremony at the La Cabaña fortress complex included a parading company of soldiers dressed up as a colonial-era honor guard. The incident with Saavedra's nonopening, which had preceded the Biennial opening by a day, had created a sense of exhilaration among some, seeming to promise that the ugly side of what was happening in Cuba would no longer be erased from view. Nonetheless, it was the elephant in the press room, and anyone who bothered to inquire privately about what had happened was told that the problem was only that Saavedra had not delivered the work to the gallery in time to be properly installed. (Saavedra vehemently disputed this claim. The other version of what had happened, which circulated as a rumor during the Biennial's opening week, was that the gallery director

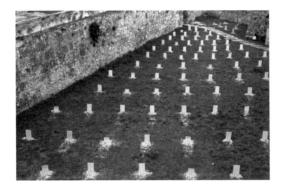

Lázaro A. Saavedra González, *Sepultados por el olvido* (Buried by oblivion), 1997. Courtesy of the artist. Photograph by the author.

had not recognized photocopies as art.) The schedule of exhibitions and events distributed at that press conference did not include any of the Cuban exhibitions—that information was not "ready" yet. Politics was noticeably absent in the Cuban participation, and meanwhile many of the artists who had caused such a ruckus were re-creating and hybridizing their late-1980s works for a new clientele at Nina Menocal's gallery in Mexico City.

Six years later, Saavedra's installation of blank gravestones, *Sepultados por el olvido* (Buried by oblivion), fronted a bullet-pocked wall that was well known locally as the unmarked site of the executions that had culminated Che's revolutionary tribunals. The Biennial's amnesiac theme that year was *The Individual and His Memory,* and Saavedra's piece, more than commemorating the rememberers, invoked the architects of the forgetting.

The simmering damnation of *Sepultados . . .* was a marked, even shocking departure from the humorous bite of Saavedra's other work, but it was not the first time that he had replaced satire and catharsis with a more melancholic vengeance. In January 1990 Saavedra had withdrawn from art and joined the Microbrigada 35. Two years later, finally somewhat distanced from the desolation of that experience, he produced *Metamórfosis,* a series of small paintings reflecting on his lonesome conversation there with himself.

Metamórfosis is one of the most painful works of the new Cuban art and, in its way, one of the most honest. It is not, however, a tragic one. In the beginning, Saavedra's attitude in the *micro* was full of brio. "I'm going to make a work that will document the Olympic career of *microbrigadistas* with wheelbarrows full of rubble," he enthuses, "I'm going to make a work showing my certificate. . . . I'm proud to be a *microbrigadista*! I love my hardhat. To be covered in cement. . . . To be a workingman. . . . To see things from up here . . . I'm proud. . . . Proud," he chants, larger than life atop the rickety scaffolding. Saavedra's rhapsodies are, on both occasions, the first half of a split screen in which the balloon quickly deflates

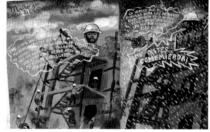

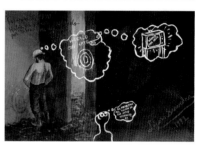

in a serio-comic kind of way, witnessed by his dog ("Divina") in one image and biblical thunderbolts in the other. He can't think. He has no ideas, just "a headful of cement." The *hombrecitos* arrive just in time: "Do it with art" they dictate, and so Saavedra starts getting ideas again, while pissing in a spiral shaped much like Smithson's jetty against "everybody's favorite spot." He begins to look better: he is bronzed and strong, and if his expression is slightly shell-shocked, still he finds himself outdoors, breathing deeply. In the next frames he has waded out into an azure sea with a tiny palm tree nestled in his arms; he meditates at the water's edge at sunset; he becomes fascinated with the "incredible will" of the crabs; he kneels at the edge of a puddle on a beautiful afternoon, fascinated this time by wasps collecting mud for their nest: "Holy shit, they're sculptors!" Squatting in the woods with his pants around his ankles is a bucolic revelation: "How fresh! . . . what silence . . . this place is five stars" (five big stars dangle around him). "That's it! I'm never going back to the latrines." No *hombrecitos* inspire him this time, but the trees are hung with framed paintings, and the night is beautiful. Saavedra is constantly veering from one extreme to the other: halcyon proclamations yield to morbid gloom, he combats his asthma with robust evening strolls under lovely, darkening skies, each image vivid with luminous color. The series battles endlessly with and against hope, its saddened humor keeping it around as an echo.

It may be helpful to think of *Metamórfosis* in relation to the form of a maze. In Novoa and Cárdenas, the slogans were first sung and then sung backward as

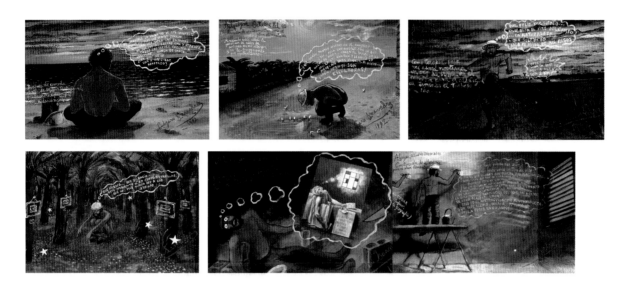

nonsense: the exit, as it were, was a repetition of the entry. In Saavedra's maze, the way in is through voluntarism rather than cynicism, and so the confrontation is with himself: the retrograde motion, like the little men, occasions an inversion—a metamorphosis. Saavedra, as political subject, embodies the collision of opposites—determination and despair—both one thing and its reverse, neither canceling nor destroying the other, but rather transforming each other in the course of their conflict. This is the labyrinth that refuses the symmetry and requital of catharsis or the inertia of false closure. Its game is not a hunt for Humanity or Destiny; rather, it points toward a receding horizon, its humor deepened by careworn hope. In *Metamórfosis* Saavedra keeps nearing and then fleeing his own hints of artistic and metaphysical significance, ruthlessly exposing both his own pretenses and their collapse to the transcendent. More than anything, and striking a new chord in the new Cuban art, the work conveyed a growing capacity for empathy, its precariety always on the verge, but always falling short of, rescue.

The Last Laugh

Every artist (whether or not he wants to) shows a part of his inner being, a feeling, exposes an idea. Not I. I am not an artist. I simply won't allow myself to be! I don't want anyone putting their dirty hands in my mud. What's within is mine.
—EZEKIEL SUÁREZ, "ADENTRO ES MÍO"

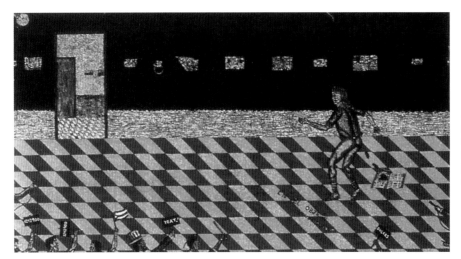

Alberto Casado, *En el objeto esculturado* (In the Sculptured Object), 1998. Aluminum foil, paint, serigraphic inks on glass; 18 x 32 inches. Courtesy of the artist.

But humor did not disappear from the Cuban street, and neither anger nor disappointment sounded the final note of the 1990s. Something else got the last laugh, like a satyr play in classical tragedy: an aftermath, a mockery of the stuff of the tragedy itself.

SATELLITE DISH OR DEATH! WE SHALL OVERCOME! [*"¡Parabólico o Muerte! ¡Venceremos!"*] read a Havana street graffiti in the middle of the decade, as homemade dishes sprouted by the thousands to capture the signals provocatively donated by Ted Turner. Cárdenas was not the only one to notice how easily the bromides of virtue could be collapsed into nonsense by transposing it into an everyday of another sort.

A joke at the end of the decade—one of many—ripped into the new windbags of the Special Period:

> White guy with sandals: tourist
> Black guy with sandals: hustler [*buscavida*]
>
> White guy with backpack: student
> Black guy with backpack: black market beef trafficker [*traficante*] (beef being
> one of the most heavily policed commodities).[123]

Monte Rouge, a DVD circulating underground in 2005, tells the story of two state security agents who are going around placing microphones in peoples' homes to listen in on their complaints against the government. The thing is, however, that they're asking permission from the residents. It's a new politics, "in which they ask people to keep talking trash about the government, but from now on

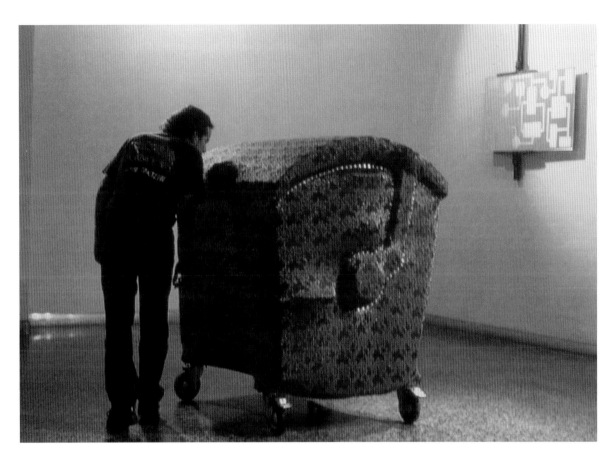

Yoan Capote, *Análisis de la belleza* (Analysis of beauty), 1999. Dumpster, fabric. Courtesy of the artist.

from within the house where they installed the microphones. . . . The agents told Nicanor that he was selected for the microphone installation because his criticisms were 'really sagacious' and moreover because his house was nearby and they didn't have a car available. . . . When they ask him to do a sound check, the official named Segura suggests that he say 'something subversive, to heat things up' and the citizen O'Donell shouts: 'I'd love to have a satellite dish!' At the end of the DVD, one of the agents offers to sell him a dish— forbidden in Cuba—but asks him to keep it 'between you and me, because this other guy is pretty square.'"[124]

Gone, perhaps, was the preoccupation with disenchantment, its basically restless impulse ripened into a humor exulting in its freedom from illusion: a humor far from solace. On the other hand, the younger artist Alberto Casado (b. 1970) began his career with a brilliant bit of recidivist innocence. Casado, who comes from the popular neighborhood of Guanabacoa, began re-creating key

moments in the history of the 1980s movement, in 1993. With the exodus, much of that history was, if not lost, at least drifted far into oblivion, and its legacy had passed from "history" to rumor by the time Casado started resurrecting it. His works, made of recycled pieces of glass and tinfoil, were materially appropriate to that realm of underground gossip, and his project consolidated that history as barrio legendry with its kitsch, cheesy rendition. Delgado shits, and people cheer on the margins.

In 2003 the artists Luis Gárciga Romay and Miguel Moya Sánchez staged a work, in the form of a telephone opinion poll, called *La Lucha*. "Are you in the Struggle?" they asked the dozens of unsuspecting participants, using the same tone they might have used to ask about toothpaste: 31.48 percent replied yes, 24.07 percent no, 7.41 percent abstained, and 37.04 percent were classified as other. That same year, Yoan Capote brocaded a dumpster, and left it at that. "The critical sense arises in Cuba from wherever with the advent of a youth confronted with a heavy collective experience," Mañach had written in closing. "The *choteo* like mental liberation is on the defensive. The time has come to be critically happy, disciplined yet audacious, conscientiously disrespectful."[125] Following in the footsteps of those like Chago, the humor of the new Cuban art was popular, vernacular, somatic, and fertile. It had various logics, some exogenous and some glandular: psychological, teleological, tautological, e(n)tymological, ideological, scatological, paralogical . . . Equidistant from anger and hope, hovering there in the space of a laugh.

Interlude: **Withdrawal**

La plástica cubana se dedica al béisbol (Cuban art dedicates itself to baseball), Havana, September 29, 1989. Photograph by José A. Figueroa. Courtesy of the photographer and Cristina Vives, Havana.

The act of disappearance is often an intense one.
—JEAN BAUDRILLARD, INTERVIEW WITH CATHERINE FRANCHLIN (1991)

The new Cuban art developed shape and force during the 1980s, accumulating from a profound and charismatic to a cyclonic presence in the life of the society. In the extremely varied production of the decade, an overriding feature remained consistent, namely, of art as a "social organism," a spontaneous insistence not only on an ethical valence intrinsic to art but on the belonging of art to the public arena.

Around 1989 things began to change dramatically. The gravity of the change can be inferred from the description of Cuban social life provided by the editor Ambrosio Fornet—hardly an ideological opponent of Cuban state power. Fornet takes note of a "bicephalous" condition,

a profound change on the level of social life that impacts emotional structures—the world of feelings, values, norms of conduct, the attitude toward the future—and which can therefore generate profound changes on the level of the society's symbolic expressions. . . . What it produced, I believe, was a crisis of legitimacy of ideology, a profound discrepancy between the theoretical and the quotidian consciousness, between public and private discourse.[1]

The new reality of that public and private space was the "Special Period in Time of Peace," declared late in 1990 by Fidel Castro in recognition of the economic and psychological liquification of the country. Cuba would survive by operating under wartime provisions and would undertake a strategy for economic recovery (including opening to foreign investments, the unbridled development of the tourist industry, and allowing the creation of small businesses in the service sector) that departed from, if not outright contradicted, the socialist ideology maintained at the core of political power and control. This fundamental schism predicated an economic recovery that was wobbly at best and bred a malignant labyrinth of petty corruption that eventually undercut even the most resolute belief in the revolutionary project of emancipation and dignity. The quotidian, now experienced mostly as a web of problems, difficulties, and impedances, bled into the spaces previously occupied by future-directed hopes and the grand scale of revolutionary ambition. The psychosocial privatization, the incessant mercantilization of daily life and of survival, "the overwhelming experience of misery, always reductive and spiritually impoverishing," to put it in Margarita Mateo's terms,[2] did not merely supplant but largely exhausted reserves of spiritual or revolutionary energy.

Against this broad psychohistorical backdrop, the Cuban disenchantment lurched ahead under each new blow:

On April 2, 1989, Mikhail Gorbachev arrives in Havana on a visit that clearly signaled the imminent end to the special relationship between the USSR and Cuba.

Three months later, in July, Major General Arnaldo Ochoa, the most popular military commander in Cuba, is arrested along with three other officers on charges of drug trafficking, and executed by firing squad a few days later after a brief trial. The Ochoa scandal sharply raises the sense of disillusionment with the government among many Cubans, reflecting deep fatigue and cynicism at the heights of power.[3]

Four months later, the Berlin Wall "sparkles" to the ground in November.[4]

One month later, on December 20, 1989, the United States invades Panama, Cuba's main conduit for Western goods. Cuba essentially loses access to Panama's banking system and free trade zone.

Two months later, on Feb. 25, 1990, the revolutionary Sandinista regime is voted out of power in Nicaragua, effectively ending the era of leftist revolution in Central America.[5]

That summer, Castro's declaration of the Special Period reversed the promise made by the Revolution: it was no longer of the horizon, but of the worst.

On May 24, 1991, Cuba completes the withdrawal of its troops from Angola. Around the same time, the Angolan ruling party renounces its commitment to Marxism.[6]

In the first half of 1991 the first thousand *balseros* arrive in Florida. By the end of that summer, and on the last day of the Havana Pan American Games (August 18, 1991)—Cuba won with 140 gold medals—the USSR itself begins to unravel.

Gorbachev announces (September 11, 1991) that he will withdraw all Soviet troops from Cuba, and Russia ends all economic assistance to Cuba, including petroleum subsidies (December 1991).[7]

By 1992 Soviet/Russian trade with its former communist partners falls to 7 percent of its former value.

The Cuban Democracy Act introduced by U.S. Representative Robert Torricelli (D-NJ) passes U.S. Congress (October 5, 1992), curtailing shipments to Cuba of food and medical supplies by subsidiaries of U.S. companies.

In the rewritten 1992 Cuban Constitution, while references to Marxism-Leninism remain, the line "Guided by the victorious doctrine of Marxism-Leninism," along with references to the Soviet Union, has been deleted.

Economically, ideologically, logistically, psychologically, Cuba imploded. Dire shortages cascaded from the national to the personal scale: food, electricity, gasoline, transportation, basic household goods, clothing, medicines, even soap—even water—all became either unavailable or unaffordable.[8] The ration system provided only a fraction of the goods previously guaranteed, and only a fraction of the previous quantity. A teeming, ruthless black market compensated for what had disappeared on the shelves of state stores. A relative few became relatively

rich, while virtually the entire population was incorporated into a daily cycle of illegality and clandestinity, cocooned by the isolation and paranoia that secrecy generates. Those without dollars fell further and further behind as prices soared and fewer and fewer goods were available for purchase with (worthless) pesos.[9] A million Chinese bicycles replaced cars and buses around 1991.[10] *Granma* called it a "transportation revolution," the Cuban government organized an international conference on the theme "Bikes: Vehicle for the Twenty-first Century," European journals and conferences lauded the "greening" and "sustainability" of Cuban public transportation, and on the streets of Havana the resultant slew of traffic accidents filled hospitals that could provide neither medicines nor basic care.[11] The accumulated impact of severe food shortages became a public health crisis as malnutrition spread, and by the winter of 1992 a serious epidemic of polyneuritis had blinded thousands.

In 1992 the Cuban Constitution was amended to recognize and protect foreign property, and in 1993, for the first time since 1959, the dollar was permitted to circulate legally.[12] With dollarization, goods returned to state stores but at greatly inflated prices; meanwhile, small businesses cropped up and went under in sporadic bursts, as waves of new legislation and taxation continually destabilized the emergent system of private entrepreneurship and forced it further and further into criminality. In state-run enterprises absenteeism, theft, lack of discipline, low-level sabotage, and a general lack of authority on management's part further dismantled what was already an unproductive sector.

In 1990 the government had initiated a major push to (re)develop Cuba's tourism industry as the fulcrum of economic recovery, and in 1994 gave this activity full cabinet-level status with the creation of the Ministry of Tourism: hundreds of thousands of new visitors enjoyed hotels, restaurants, taxis, clubs, and beaches that were off-limits for Cubans in the new system that came to be known as "tourist apartheid." Havana's already precarious infrastructure groaned under increased migration from the provinces, and as colonial-era buildings were being restored to delight tourists in the Old City, others literally collapsed onto their inhabitants in neighborhoods outside that picturesque, well-lighted zone. Cuba went backward, from cars to bicycles, from electricity to candles. In 1993 the national leadership set the goal of harvesting 70 percent of the sugar crop by hand, literally inverting the extent to which the nation had managed to mechanize that industry during the preceding two decades.[13]

The military's purview increased dramatically, even before the collapse of the USSR, and by the early 1990s it was involved in sugar, the merchant marine, civil aviation, banking, cigars, electronics, and foreign trade. Gaviota SA (the

major tourism company) is a military venture, and since 1993 it has developed subsidiaries dealing in information technology, electronic equipment, cargo and mail delivery, and the dollar stores ("Stores for the Recovery of Hard Currency"), all of which led to the development of a military–entrepreneurial class immune from the crisis.[14] (The Museum of the Revolution explains this in somewhat different terms: the armed forces "not only have been strengthened in this critical period, but also have contributed to economic activity that benefits the entire population.")[15] Meanwhile a new masquerade, by which some existing mass organizations (including the Federation of Cuban Women, the National Assembly of Small Peasants, and the Union of Cuban Writers and Artists) were declared to be NGOs, made them eligible for foreign aid but further decreased their legitimacy inside the country. New NGOs, including the Ludwig Foundation (for several years a key funding mechanism in the visual arts), were started following the same logic and, generally, the same outcome.[16]

The exigencies of the Special Period were not conducive to collectivism. People survived the worst of it by devising individual solutions, and paranoia and mistrust became the structural replacements for solidarity.[17] Or maybe it is more accurate to say that collectivism was forced underground, in the form of countless new networks and informal systems. Getting most foods, arranging transportation, Internet access, entertainment, and many other basic components of daily life came to involve these baroque, improvisational, secret systems. Everything was for sale: people hawked their furniture, family heirlooms, books, even statues from cemetery crypts, even themselves: "If even basic necessities of life were elevated, given the impossibility of satisfying them, to the level of extravagances," says Antonio José Ponte, "likewise it would also be difficult to draw the line between a love affair and prostitution."[18] Prostitution, like the black market, was the new open secret, alternately ignored, criminalized, and tacitly fomented by the state: in March 1991 *Playboy Magazine* ran a photo spread on Cuban women posed at tourist resorts—apparently with the cooperation of Cuban authorities.[19] (*Jinetero/as,* as was sometimes remarked, were the only workers in Cuba who owned the means of their own production.) A resurgence of racism—another social ill supposedly eradicated by the Revolution—elicited a concomitant silencing of any discussion of the subject, "in the interests of national unity."

The increasing economic disparities made the precipitous decline of living standards an even bitterer pill for the majority to swallow.[20] The economic–social pyramid inverted, along with the value system that drove it, placing jobs involving dollars (sex and hotel work, taxi driving) above those involving the social

good (doctors, teachers). In either case, it was precarious, and individual survival came to hinge on normalizing previously taboo behaviors such as the acceptance of money from exiled family members—for those lucky enough to have them. Foreign capital and desires, once again, dominated Cuban life.

The space for airing the country's problems underwent expansions and contractions during the length of the crisis.[21] The widely touted *Llamamiento* in preparation for the Fourth Communist Party Congress in October 1991 yielded demands for decentralization, economic efficiency, greater popular participation in decision making, democratization of political institutions (including the Communist Party and the National Assembly), greater tolerance of religion and other marginalized groups, the reopening of farmers' markets, calls for a freer press, the condemnation of tourist apartheid, and an end to restrictions on foreign travel: but precious little actual change.[22] The penal code was toughened with two new laws for the defense of national sovereignty that further limited criticism of the regime (known outside Cuba as the *leyes mordazas,* or gag laws),[23] and the police and security presence on the street was pumped up, partly to ensure the well-being of tourists.

The Special Period soon became shorthand not only for omnipresent corruption but also for the acceptance of it.[24] A pattern of internal corrosion in values and conviction intensified into a *doble moral*,[25] the inevitable result of the sudden impossibilizing of a decent and honest life, combined with decades of state paternalism. The sense of belonging to and participating in anything more than a lonely and desperate struggle for survival steadily evanesced in an oceanic sense of defeat and loss, the intensity of which mirrored the emotional investment that people had made in the utopian project of the Revolution. This was perhaps the Special Period's heaviest blow. In light of all this "it is understandable," as Eugenio Valdés put it, "that many have made evasion a mechanism for self-defense in a place where the apocalyptical is part of the habitual."[26]

"The most generalized social response to the crisis," according to the sociologist Haroldo Dilla Alfonso, was not "opposition to the system or the regime, but anomie and simulation." By the summer of 1994 thousands of Cubans were taking their chances, fleeing the island in ramshackle, often deadly, rafts. In a fifteen-day period in August 1994, thirty thousand people set out to sea. Thousands died on the way, and thousands more who arrived found only the limbo of detention in Guantánamo, as the U.S. and Cuban governments bickered about their fate. Between 1990 and 1995, again according to Dilla, the number of suicides in Cuba "remained at the very high level of twenty persons per one hundred thousand, a proportion that doubled for persons over forty years of age."[27] Setting the outer

limit, as it were, to the range of the possible withdrawals. ("To die for the father-land is to live," sings the Cuban national anthem.)[28]

As the millennium shuddered to an end, the whole system had become well enough articulated to yield its own, new symbolic regimen, and the kitschization of the Revolution became an intentional, strategic cannibalization. For instance? In Varadero's beachfront hotels, tourism operators organized fashion show extravaganzas featuring semi-clad models in spike heels and T-shirts embla-zoned with the familiar iconic image of Che Guevara.[29] *contrast in realities*

Withdrawing

The yarns of seamen have a direct simplicity, the whole meaning of which lies within the shell of a cracked nut. But Marlow was not typical (if his propensity to spin yarns be excepted), and to him the meaning of an episode was not inside like a kernel but outside, enveloping the tale which brought it out only as a glow brings out a haze, in the likeness of one of those misty halos that sometimes are made visible by the spectral illumination of moonshine.

—JOSEPH CONRAD, *THE HEART OF DARKNESS*

Optimism is perhaps the most important commitment that a revolution requires of its minions, and in the Special Period optimism was shrouded under a new social fabric of mutual disappointment and shared solipsism. Vast territories opened up in the tiny cracks between disillusionment and pessimism, between observa-tion, wisdom, and honesty, between depression and self-protection. If the *choteo*'s levity was a national trait, then so was a penchant for protracted, aggrandizing melancholy, as the Museum of the Revolution had so clearly evidenced. And if the *choteo*'s social force had oscillated in historical periods, it alternated closely with disenchantment. In the Special Period, melancholy was, or became, the flip side of laughing: not its opposite, successor, or consequence, but its other side—its own aspect. Both fit perfectly into a frame of heroics, anti-establishment aggression and hostility, passivity and alienation, erudition and piety; both were necessary to the Cuban process and to its art. Melancholy was intrinsic, but it was not recon-ciled: sadly, we see that in Rodríguez's fable, congress between the revolutionary and the skeptic turns on the figure of the chimera Francisco, whose crossed spe-cies render him impotent. Francisco, doppelgänger for the new Cuban art.

In the 1990s a primary mode in the new Cuban art was that of withdrawal. Cuban art's disenchantments in the 1990s hinged on a complex of adjacent and interconnected factors, encompassing not only economic but also broad ideologi-cal, social, geopolitical, historical, pedagogical, and psychological realities. The

withdrawals were a complicated and often ambiguous response to a complicated and often confusing situation. Among the major strains, we could list an abandonment of the public—as site, audience, and aspiration; a retreat from an ethic of collectivism; a defensive restoration of the visual in visual art; shifting fortunes for the literal and the metaphoric, shifting of artists' self-positioning relative to official institutions, and shifting of those institutions' own evolutionary logics. A baseline of existential reduction, along with the vanishing, or vanquishing, of the integral citizenship manifest in the 1980s art, created a simultaneously centrifugal and centripetal physics, pushing the orbit of artistic concern toward universalism, on the one hand, and privatism, on the other. With regard to the middle orbit, namely, Cuba as an entity in itself, artists became, often, voyeurs of the decline. The map of the island appeared again and again like a nervous tic, a tattered remnant of the archaic history of mapping mythic (utopian) isles. Utopia had been an idea with real psychic valence in Cuba, and its subsequent absence lay at the heart of these withdrawals.

The figure of withdrawal is itself highly ambiguous, or at least polyvalent; withdrawal as disengagement, forfeiture of hope, renunciation of utopia (which is itself a special kind of withdrawal). Withdrawal as transference and sublimation, indifference or scorn; as removal, retirement, retraction, recursion, reclusion, or restriction; withdrawal as failure of nerve, as neurotic symptom, as refuge. Withdrawal of participation. Withdrawals from actuality and from possibility, withdrawals as aggression and as defensive feints, withdrawals that create absences and those that create, in absences, even more forceful or threatening presences. "Activate voids, announce absences," José Toirac demanded. Some withdrawals were heartfelt, others ironic, and so on, especially keeping in mind that the "withdrawal of visuality"—according to Benjamin Buchloh—has itself been a key strategy in visual art since the early twentieth century.

The question of withdrawal is a question of thresholds, and the complexity of the new Cuban art's withdrawal showed that thresholds were no longer clear—if they ever were. The equivocation of withdrawal, moreover, which makes it as much an irresolute as decisive maneuver, suggests a provisional response, a hesitation or holding pattern: an ambiguity that is coextensive and consubstantial with a social landscape in which skeins of intertwining rumors carry at least as much authority as any allegedly authoritative account. Withdrawal's silent rebellion, its distaste for overt moralism, was as much reminiscent of as in opposition to the former art and spirit. Withdrawal, as it seems, was equally a measure of disenchantment and an adaptation to that which is terrifying within it. What I

mean to indicate with this preliminary taxonomy is the complexity of this relatively soft maneuver.

1. Withdrawal from, withdrawal to, the promised land: Withdrawal faced both inward and outward. Around 1990 nearly an entire generation of artists withdraws (emigrates) from the country.[30] The orphaned generation of artists decides to stay, but then also stages an elaborate withdrawal of its own, from the utopia of the social into the compensatory terrain of the personal, a move away from the idea of acting within the public realm for purposes of concerted social transformation. This withdrawal, ostensibly a signal of alienation, was, however, often described in affirmative, rather than detractive terms, one critic even going so far as to claim that it represented a move "toward a utopian extraterritoriality found in the precarious security of rumor and metaphor."[31] Their withdrawal from the addiction to utopia required the methadone of simulations of it, micro-scale re-creations of it, metaphors of it.

The emigration, or "exodus," as it is known in more biblical terms, was actively facilitated by official policy: the customary barriers to leaving were, we might say, withdrawn.[32] The exodus, of course, was not only a desire to leave but also to arrive, and for many of the artists that arrival occasioned yet another level of withdrawal, in which the ostensible content of their work was preserved (the "look") while the fact of deterritorialization brought a new emptiness to this most territorialized of creative productions.

The exodus had cleansed the landscape and erased the vexations of the past, but it had also left the Ministry of Culture with a vacuum, and so a new class of students was promptly declared to be the Next Generation of the new Cuban art. Recent history's absence, along with everything else, was withdrawn, backfilled with the promotion of the next bunch of artists.[33]

2. Withdrawal from a utopics of the horizon: What had changed, says Mateo, was

> the nature of our gaze: the cracks, before imperceptible in the face of the
> vastness of the landscape, were always there, it was just that the eye,
> accustomed to looking at things in too grand a scale—so much so that it
> lost itself in the horizon—did not notice them. . . . This dream, then, helped
> us to keep swimming in the midst of the shipwreck, and not only with the
> goal of reaching the shore simply to die there.[34]

they started to see the cracks

Somewhere around 1990 that epic horizon was wiped away—dissolved as limit, for the artists, and buried as aspiration in the struggle to survive, for everyone who remained. The artistic credo of "helping to make history" suddenly came to seem not only vain but absurd, and an "aesthetic of the zoom" provided a replacement spatialization.

Etymologically, horizon as "bounding circle" refers equally to future and to past, both to potential and to preserved knowledge. The vacuum created by the loss of both past and future imaginary filled with the minutiae and wreckage of the quotidian present, for better and for worse. Better, for the end of confusing the imaginary with the empirical, the ideal and the real. And worse, because it was that same confusion, that habituated conflation, that had justified and legitimated sacrifice in the name of redemption.

3. Withdrawal from the public into the private . . . While the doublespeak of state rhetoric had been such a target for the contestatory works of the 1980s, in the 1990s the permeating corruption of daily life confounded the public–private divide. This introjected taint sideswiped the ethicist position that art had previously assumed, while the privatization of reality socialized a new generation of artists into a world with neither shared values nor credible moral imperatives. In a public space riddled with heroics this was withdrawal as antidote, the verso of the recto that was the closure of public space, a sow's ear remedy to refunctionalize the private.

. . . from the epic to the mundane: A problematic reification pressured the situation of Cuban artists in the early 1990s on many levels: reification of the revolutionary project and of its leaders and New Consciousness; reification of the artists as bearers of an authentic popular expression; reification of the idea of critique and of art's special role in that process, and so forth. All that metaphysical backlighting eventually added up to an unsustainable moral expectation, and, meanwhile, the sense of collapse had become constitutive and intimate. Perhaps, then, a wholesale rejection of the exalted is not surprising, and a whole range of work lay somewhere in this territory between expressive aphasia and therapeutic transference.

4. Withdrawal from the collective to the individual: With the exodus, and even slightly before, the collectives that had been so catalytic in the late 1980s mostly disbanded, and along with other aspects of the overall retreat artists mostly worked individually, in a return to studio-based practice. The breakdown of the solidarity that had existed in the 1980s was the result of many things,

including psychological isolation, increased travel, and increased competition. Paradoxically, critics baptized these artists as a generation within the first moments of the decade, an agglutinating that followed a mostly promotional, commercial logic.

By the second half of the 1990s, as the shock of the new pauperization had eased into routine status and as yet another generation of young artists had been defined, a new current of collectivization began to take shape, catalyzed in part by a pedagogical project initiated by René Francisco at the Instituto Superior de Arte in 1990. In this return to a self-consciously collectivist artistic practice, the crisscrossing lines of public–private and collective–individual were infused with the suggestion that not only the public is a potential site for revolution. This new personal subjectivity departed from a selfhood defined in classically socialist and collectivist terms, even to the point of dismantling it. Community was postulated as neither cohered nor ongoing, but was emphasized—even in the language that artists used to describe their own association into collective groups—as provisional, and as aggregate rather than synthetic.

5. Withdrawal from political controversy: and, meanwhile, dismissing the earlier politics as messianic, or utopian, or otherwise misguided.

Art and politics, though still extremely close, became extricable and both, as Jacques Rancière has said of another disenchantment, "wandered from littoral to littoral."[35] The skeptical generation that came of age in these years—not old enough to be implicated fully in the former period but present at its demise, not young enough to be formed free of its shadow—straddled the gap between a past that had been definitively ended and a looming future that promised a measure of celebrity and prosperity for those willing to play the new game. Lower-case matters of timing and contingency explained more than Destiny or History did, and secularization—one of the disenchantments—shifted politics from ideologies to business and administration.

A complex market psychology may also be at play in this withdrawal. A central contradiction of the entire 1980s phenomenon was that the non- or anticommercial art and the persona of the revolutionary artist were both so easily convertible into a marketable entity. In the 1990s artists, curators, and critics faced a new contradiction between continuity with the established branding and the rupture that would have signaled innovation and its value. All of the players in Havana had a vested interest in maintaining the continuity of "the new Cuban art," even though some sort of rupture seemed required to make room for the new players. Hence the curious ambivalence that enveloped the contestatory spirit of

the 1980s in nostalgia, meanwhile denouncing it as vanguardist arrogance that was never really effective as "politics" to begin with. This conundrum led to an apostrophizing art, an art rife with symbols—again, the map of the island—that functioned as a kind of palimpsest of the former deconstructivist and iconoclastic tendencies. The impasse of transgression yielded to a new commodity logic.

6. Withdrawal from confrontation with the Institution of Art: It became clear that absorption represented a much more efficient and up-to-date means of control than bare-knuckled censorship. Institutional identity became newly evasive: a wave of dissembling, the "no answer" in place of the answer of "no," the retrospective washing of biographies, all amplified the normal effects of forgetting and generational succession and conviction fatigue, to refashion the institutional profile into a more benign presence. New promotional policies developed by the Ministry of Culture depended on a tactic of seduction and co-optation, obscuring the power dynamics with a facade of mutual interest and respect.

A new class of curators gestated and took over the job—until then done by artists—of organizing exhibitions. Institutional critique persisted, but became more tautological: curatorial projects about curating, and so forth. The institutions got bigger and more pervasive, the boundaries of officialdom blurred, and as the decade wore on, artists exercised substantially less independence from the institution of art. The "offensive/creative maneuver of refusing to collaborate" was almost completely metabolized. If, previously, the relationship artist–institution was characterized by the constant negotiation over and even struggle for power, the new situation made that relationship one of highly ambiguous intimacy and symbiosis.

7. The partly satirical withdrawal from satire to metaphor or, in the words of one very postmodern critic, from the "romantic" to the "transvestite."[36] The turn to metaphor, which is closely related to the abandonment of an explicitly "political" language, is one of the most frequently cited shifts in the trajectory of Cuban art of the period. Consecrated in the 1993 exhibition *Metáforas del templo,* it has been accorded the status of a generational characteristic—or alibi—consisting of working under the radar by camouflaging problematic content with the ambiguity and misdirection of metaphor. Despite its resistance to the declarative or verdictive, this melancholic tack is not uncommunicative, just characteristically indirect and circuitous. The primary note sounded moved from felt to ironic to cynical, and opened a huge new gap between double meaning and ambiguity.

replaced metaphor and allegory w/ ambiguity

Metaphor, allegory, metonymy, and synecdoche were symbolic languages into which Cuban art strategically backed off as it learned to coexist with the diminished force of hope in the country and to face a jittery state machinery at the same time, all against an unfamiliar new backdrop of the rules of the marketplace. "Ambiguity," said Tonel, "always a recourse, is now central."[37]

8. Withdrawal from the conceptual to the visual: The work that was most vigorously promoted during the 1990s showed a marked interest in what Cuban critics took to calling a "restoration of the visual paradigm," replacing a more conceptualist approach with a production embedded in formal questions of technique and visual pleasure. Form and content, visual art's own persistent and spurious mind–body problem, were given a new life of confusion. If in the 1980s Cuban art came to be characterized by an extraordinary public visibility, at the same time the artists were experimenting with forms of practice that were in terse relation to visuality. Conversely, in the 1990s there was a return to visuality, and meanwhile a general withdrawal from visibility in the Cuban context was compensated by a meteoric rise in visibility abroad.

One must imagine Sisyphus happy.
—ALBERT CAMUS, "THE MYTH OF SISYPHUS"

The whole dramaturgy of the Revolution, so readily complicit with individual despair, reached new heights of theatricality, underscoring the abyss between its eternal heroics and the devitalized existence of its citizens. If the 1980s artwork had pointed to social and political deficiencies, the 1990s expressed a scorched interiority: a self voided of belief, hollowed out by adamantine struggle and riven by the *doble moral*. Scarcity, together with the perversities of the new economy, conspired to a vast fetishization incorporating virtually everything, including art. It is tempting to summarize these processes of withdrawal as a progression from revolt, through disenchantment, to a crypto-real. This at least indicates dimensions of intensity, loss, and dissembling, and of a phenomenon that occurs at both an individual–psychological and a social–historical level.

One great achievement of the new Cuban art had been its integration into the larger project of building society. This is probably the terrain that most clearly manifests the rupture that sheared one moment from the next at the beginning of the 1990s; even as art was more fully incorporated into the (now commodity) logic of the Cuban state, it was also definitively cast as other to the state's fundamental project, existing as one of its means rather than one of its elements. Following in the wake of contestation and questioning, disenchantment's silence

bred a profound lassitude, in which ideas of pragmatism and cynicism became coextensive. Although artistic practice apparently lost none of its intensity, it suddenly lost its center.

But this is too simple. For one thing, the withdrawals were never monolithic, and the act of withdrawing did not pave the way to any conclusions. If the first form of these withdrawals was contrapuntal, within a binary argument and consciousness, they eventually resided within the open question of an ethical art. An abject underside of decay was always part of modernism's idealism, and withdrawal's bruised reflection was no less necessary, no less constitutive, than the prior exhilaration.

The 1980s conflict was not, or not only, one between art and power. The conflict was an internal one as well, that invoked peoples' own ideals in painful ways. It was perhaps that quality of internal quarrel that gave the conflict its force, complexity, and importance: no straw man could ever pose as ferocious a challenge to oneself and one's beliefs as one's own riven convictions can. There is something terrifying within disenchantment, with its brittle, wary prohibitions against desire. These withdrawals seemed to function as a kind of scar tissue guarding a deeper condition of longing—the painful a priori of withdrawal.

Deprived of its accelerant, the new Cuban art looked elsewhere for momentum and found it in withdrawal. In 1989, at the height of the censorship crisis, pretty much all of the artists got together to withdraw. "If we can't make art," they declared, "we'll play ball." That act of collective withdrawal is still regarded as a high point of the poetics, and the politics, of the new Cuban art. Sometime around 1990, the writer Virgilio Piñera came back from the dead. Piñera's voice was one of absolute alienation, of circular traps, of the irreal and the ridiculous. Gay and flagrant, Piñera's darkness and his invisibility dated from both sides of the great curtain of 1959. Around 1990 Piñera's work appeared in Cuba for the first time in a couple of decades, and his 1942 poem *La isla en peso* (The weight of the island), beginning with the line "The damned circumstance of water on all sides forces me to sit at the coffee table," was the starting point for work after work in the new Cuban art. In 1994, after so many had left and things had supposedly settled down into a new détente, Ezequiel Suárez withdrew to his home after his exhibition *The Bauhaus Front* at the Galería 23 y 12 was censored for, among other things, its declarations that "the institutions are shit." Suárez and Sandra Ceballos promptly declared their home a gallery named *Espacio Aglutinador* and rehung the works there. It was perhaps the most felicitous of all, in the tatterdemalion array of withdrawals. "AGLUTINADOR (art space)," they declared,

intends to exhibit and distribute the work of Cuban artists of all "sects"—alive or dead, residing within or without Cuba, young or old, known or unknown, promoted or nearly forgotten, modest or pedantic—as long as they are of indisputable quality and, above all, have that necessary dose of honesty and anxiety concerning the creation of venerable art. AGLUTINADOR is a cultural space, not a boutique. It does not intend to be elitist or avant-garde or populist or backward looking: it wants to be (or become) just. Its only commitment is to art. It is not a "project." It is not a lovely idea put to paper by a highly organized mind. AGLUTINADOR is an event; it is happening quickly, naturally. . . . The possibilities for error are infinite.

If there is anything that AGLUTINADOR avoids like the plague it is coherence, that boring and nauseating "goodness" of the conscience.

Charles Baudelaire said: "Art is long."

AGLUTINADOR (art space) says: "What a lucid man!"

Beuys used to say: "Every man is an artist . . ."

To this we would add: "And every house is a gallery."

3. Museum

And the soldiers wore green and camouflage uniforms because they did not want the enemy to see them, which was modern at the time because in previous wars soldiers had worn brightly colored uniforms in order to be visible from afar.

And in 1989, an American political scientist invented a theory about the end of history, according to which history had actually come to an end, because modern science and new means of communication allowed people to live in prosperity, and universal prosperity was the guarantee of democracy and not the contrary as the Enlightenment philosophers and Humanists had once believed. And citizens were actually consumers and consumers were also citizens and all forms of society evolved toward liberal democracy and liberal democracy would in turn lead to the demise of all authoritarian forms of government and to political and economic freedom and equality and a new age in human history, but it would no longer be historical. But lots of people did not know the theory and continued to make history as if nothing had happened.

—PATRIK OUREDNÍK, *EUROPEANA: A BRIEF HISTORY OF THE TWENTIETH CENTURY*

The National Form

In a political process notable for its forceful symbolic language, the withdrawal, or removal, of history, was one of the earliest gestures. After the triumph of the Revolution, the monuments lining Havana's Avenida de los Presidentes were literally taken off their pedestals, a symbolic declaration of the new historical era then being opened. (In a delightful serendipity, the patinated bronze shoes of one

of them, firmly embedded in their cement, were left behind as an absurdist relic.) But the withdrawal of history has not always been such a redemptive subtraction.

The narration and consolidation of history is the core function of a national museum, and Cuba's was closed for restoration during the crucial years of 1996–2001. By the time it reopened, much of the recent past had lapsed into a status somewhere between oblivion and myth. The rumpus of the new Cuban art was sloughed off like scapegoats used to be in the Bible, the ones who not only took the blame but were banished so that the community could forget.[1]

The installation of works from *Volumen Uno* forward at the National Museum of Fine Arts was the first ever permanent display of the new Cuban art in Cuba, and it stands as an amnesiac masterpiece, cynically dovetailing with the exodus in a further cancellation of evidence and memory. The version of the 1980s that it presents suffers a kind of curatorial blackout in which forms are remembered, but dismembered from their context and meaning. The most controversial artists are represented with misleadingly benign works, or with excerpts from larger works that, decapitated, become little more than formal exercises. To wit: Tomás Esson, best known for his censored painting in which a mulatto Che Guevara presided over an energetic, bestial copulation, is represented by *La gallina del tutú rosado,* in which his signature grotesque figuration takes the form of a gigantic, whacked-out chicken straddling a big shit-brown egg. José Ángel Toirac and Tanya Angulo, half of the collective that had taken such pitiless aim at the intersections of art and power in Cuba, are represented with *Cuba campeón*, framing a Cuban boxer standing victorious over the hunched form of a fighter in a USA jersey: a far cry from the quartet's more pointed unravelings of the Revolution's iconography. Lázaro Saavedra is represented by a faux-naïve still life of flowers in a pitcher, roughly captioned "Art, a weapon of the struggle." The piece is hung alongside a folk painting, Noel Guzmán Bofill's *Las profecías de Ezekiel,* as though to suggest that its rustic technique was the gist of the work. "Look," says Corina Matamoros, the curator who designed the installation, "they have something in common. Lázaro painted his picture as though he were a popular artist, and so I put them together, because he did that, he copied those works that are sold in the streets, in the plazas for tourists. I did that intentionally."[2] Saavedra, of course, was making fun of the ideas about art and culture that had been sanctioned and prohibited in the name of Cuban socialism, but the museum's juxtaposition inverts all that into an anti-art punchline. In any case, Bofill (according to Matamoros) was very happy to have his work hanging in the gallery with the *jóvenes* rather than segregated in the room farther back where the rest of the folk painters are on display.

Some individuals are missing altogether, like Carlos Cárdenas (which Matamoros blamed on a lack of space).[3] And, maybe worst of all, the museum's confected narrative contains no shred of evidence of the artistic collectives that produced some of the decade's key works and also fed individual production in fundamental ways. The narrative makes no sense without them: the individual works float untethered to any underlying and propelling ethic, and the museum's reverse alchemy reduces the works to artistic facticity.

On top of all this, the museum's version of history suffers from an anemic commitment to any of the streams of popular cultural production in the country—especially disturbing in the context of a socialist country committed to cultural populism. Moreover, where that production does appear, other problems arise. There is indeed a gallery devoted to Arte Popular from the 1970s, "a moment," said Matamoros, "when popular art flourished . . . all that popular painting that blossomed. Why? Because the Revolution favored it, it supported the idea that people should have access to culture, and that the talented ones would not be lost. This was the fruit of the Revolution, and there was a big explosion in the 1970s."[4] The 1970s, those same years known as the "Gray" ones, with their attempt to chart the narrow straits of revolutionary culture, brighten up in the museum's celebratory whitewash.

Other, non-"problematic" works are installed incorrectly: for example, Juan Francisco Elso's *La mano creadora* (The creating hand) is mounted flat on the wall rather than floating in space, voiding the interactive intent at the core of the piece. The curator chalks this up to architectural limitations: although the museum had undergone a rehab in which all of the interior spaces were reconfigured, the kind of open gallery spaces that would have suited the contemporary collection were not built because they would have disrupted the "consistency" of the institution's display. Matamoros's goal was to emplace her collection within that consistency, to normalize the new Cuban art within the history of Cuban art:

> The logic of this art is different, but nonetheless when you arrange the whole museum you have to find a unitary logic and so, always, there are parts that are more compromised than others. And I think that my part is the most compromised, in the sense of museography. But the important thing—and although we know that the gallery suffers defects—the most important thing for me was that this art join with all this tradition. That was my great objective, that this art would not be seen as something that was not art, or as something that is radically different.[5]

This is a classic museological dilemma: the imperative to establish, on the one hand, a uniform rubric that orders the past so that it points to the present while

also establishing the distinct nature of different works, periods, or tendencies. But at the National Museum of Fine Arts consistency trumps difference and suggests that nothing much changes when the new Cuban art begins. The National Museum of Fine Arts returned to the new Cuban art and, in doing that, turned it inside out. As in the Museum of the Revolution, history and memory are encouraged to converge, the latter scripted and seduced by the concatenation and persuasion of the display. It was, the museum's ablutions suggest, an archipelago of art and not a hornet's nest, at times impish and iconoclastic, but its creative afflatus amounting, in the end, to a transgressor-without-portfolio.

Museums broker and administrate memory with keen authority; they are machines par excellence for the naturalization of the invented. What they display is perhaps the most highly orchestrated of vistas developed yet in Western society, a doubling of the world to concur with an editorial platform delivered vertically. The Cuban National Museum of Fine Arts is no exception. It writes the nation through its genius, the perfect counterbalance to that other museum written in blood, the one of the Revolution. Like that other museum, the National Museum of Fine Arts brought the national essence into a separate and protected space, the better to tell its story as incantation. The "new Cuban art" available at the museum was its own simulacrum, its rebirth as museum display—as history—ascendant over the work done by the original.

Reaction within the artistic and intellectual community to the museum's sundered installation was predictably critical, but never visible, since no public commentary or debate was allowed to surface. Meanwhile, an anthology of art criticism from the 1980s was published in Havana in 2002: if the book's breezy title, *Déjame que te cuente* (Let me tell you . . .) was not clear enough as an editorial statement, then its high school yearbook–style selection of snapshots is. The anecdotalization of the 1980s proceeds apace.[6]

But Matamoros, or those who counseled her in the exertion to historicize the new Cuban art, missed a step right at the start: Flavio Garciandía's girl in the grass was big. Too big, bigger than Amilcar Cabral next to her, the leader of postcolonial Guinea-Bissau who was among those radical leaders personally favored by Fidel Castro. And she was sideways, off the heroic vertical.

Museum, Not Horizon

What to say? In the face of the tragic account of the road to Calvary, that of the resurrection did not measure up.

—MARC AUGÉ, *OBLIVION*

The reopening of the National Museum of Fine Arts coincided with a blizzard of new museums in Havana. Museums opened or reopened across the city in those same 1990s when so many other things fell apart. The Museum of Silver Work (1996). The Farmacia Museo Taquechel (1996). The Firemen's Museum (1995). The empty chairs on which Fidel and Pope John Paul II had perched during the latter's historic 1998 visit, installed, on a red carpet in a convent-turned-museum. Seventy new museums between 1996 and 2004 alone.[7] The museum was a primary structure erected by a new partnership between historians, ideologicians, and tourism promoters. The city of Havana itself, or part of it anyhow, became a museum as colonial plazas sprang to new life within a cordoned zone of light, not far from where the cruise ships were now (again) coming in to port.[8] Havana, Cuba itself, immobilized, reified, museumified, equally beguiling for its redevelopment as for its dilapidation. "Small museums are cropping up all over Old Havana," the London Sunday Times gushed in 2003:

> They are cheap entertainment, but the best thing to do is concentrate on the big ones, mainly the Museum of the Revolution, in the old Presidential Palace. . . . Outside, there is a collection of tanks, military airplanes and even an armored tractor. Inside there is a fascinating retelling of the Revolution of 1959 to be found. Part of the rhetoric is, comically, a cliché, but the blood and the passion is there everywhere.[9]

Yes, by the time of all this activity the worst of the Special Period was over, at least in terms of national statistics. Economic collapse slowed and then reversed, slightly; blackouts eased, transportation resumed (though never regaining its previous level of service), and desperate flights from the island began to let up. What those statistics did not capture, however, was the fact that, for every one whose situation had improved, there were many falling ever deeper into indigence, with no hope on the horizon.

The monuments on Avenida de los Presidentes had been erected during the second decade of the twentieth century by the government of José Miguel Gómez. The parade included each of the country's presidents, climaxing in an extravagant marble peristyle dedicated to Gómez himself at the avenue's summit. Around 2000 the statue of Gómez reappeared on its perch, as silently and mysteriously as it had disappeared decades before. Small, awkward bronzes of Salvador Allende and Simón Bolívar also cropped up, and in a park not far away a bronze of John Lennon materialized as well.[10] The Beatle is now guarded like national patrimony because people kept stealing his bronze spectacles, so if you go to see it a kindly guard will appear and put them on the statue long enough for you to take a picture.

Statue of John Lennon, with guard, Vedado, Havana, 2001. Photograph by the author.

As the history of the 1980s had been so well ordered at the National Museum of Fine Arts, as the history of the nation had been so excruciatingly well enacted in the Museum of the Revolution, Cuba was invented anew for a new beholder, both foreign and domestic. What all those new museums were doing, besides drawing tourist dollars, was reversing what had been, since 1959, a utopian discourse pointing forward, with a prophylactic rebuilding of the past.

Cuba had never been translated, repeated, so often. Translation, repetition: phenomena constellated around the need to hold something fast, to recuperate something that has been lost. The repetition machine of the museum remade Cuba as coherent, comprehensible, and valorous: museums are, in their way, little utopias, ideal versions unassailable in their logic and completeness, and now the Museum Cuba had replaced the Utopia Cuba.

"I belong to a defeated generation," wrote Carlos Garaicoa, probably the Cuban artist most closely identified with the weight of dead hope.[11] That failure led him inward, telescoping the site of inquiry down to the minuscule: he opened his career with a simple work, a random numeral painted onto a wall. "Mysteries, oftentimes obvious," Orlando Hernández wrote about it; "public, out in the open, scarcely distinguishable from what we call the real, the immediate, and for that much more obscure, less decipherable, as happens with the mystery of all the small, the quotidian, the trivial. A simple 6. . . . A childish drawing made with chalk on a wall. Transient signs, ephemeral, whose scant loquacity often buries some transcendent message."[12]

Garaicoa's subject at the time was the literal and ongoing collapse of Havana, and through an individualizing and privatizing of the mythic he relocated the site of salvation, "as if to cure the city,"[13] as Gerardo Mosquera saw it, compensating, ironizing, and musealizing it.

Carlos Garaicoa Manso, *Homenaje al seis* (Homage to six), 1992. Installation: poly-chromed plaster object, two cibachrome photographs (50 x 60 cm), three sepia photographs on color paper (18 x 24 cm); 120 x 300 cm. Courtesy of Carlos Garaicoa Studio. Collection of Luiz Augusto Teixeira de Freitas, Portugal.

Carlos Garaicoa Manso, *Acerca de la construcción de la verdadera Torre de Babel* (About the construction of the real Tower of Babel), 1994–95. Photograph; 18 x 24 cm. Ink and watercolor on card; 50 x 70 cm. Courtesy Carlos Garaicoa Studio. Collection of Saul Dennison.

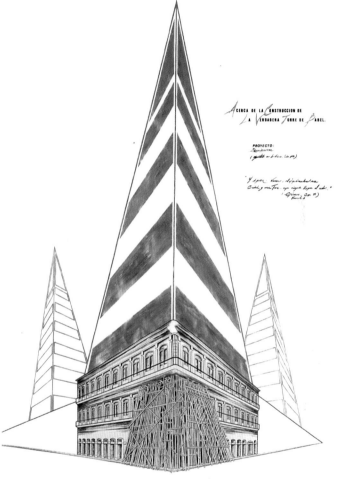

The series of diptychs that Garaicoa produced between 1993 and 1995 was universally legible according to an equation familiar to any tourist—of ruins, beauty, melancholy, and nostalgia—and became a kind of logo for Cuban art of the time. In stereo images of Havana ruins paired with fanciful proposals for their restoration, he lovingly traced the filigree of rickety scaffolds, offered as metaphor for the fragile state of the local architecture, psyche, and social structure. A sparkling, cruel pyramid towers over the process of decay in *Acerca de la construcción de la verdadera Torre de Babel* (About the construction of the real Tower of Babel), shifting the local catastrophe into a biblical register. At a later stage of

TOP, LEFT Carlos Garaicoa
Manso, *Jardín japonés*
(Japanese garden), from the
installation *Jardín japonés,
jardín cubano* (Japanese
garden, Cuban garden), 1997.
Installation: stones, wood,
Japanese doors, text, and color
photographs (80 x 100 cm);
variable dimensions, detail.
Courtesy Carlos Garaicoa Studio.

TOP, RIGHT Carlos Garaicoa
Manso, *Jardín japonés*, from
the installation *Jardín japonés,
jardín cubano*, 1997, detail.
Courtesy Carlos Garaicoa Studio.

BOTTOM Carlos Garaicoa
Manso, *Jardín cubano* (Cuban
garden), from the installation
Jardín japonés, jardín cubano,
1997. Courtesy Carlos
Garaicoa Studio.

the city's collapse he made twin gardens, one "Japanese" and the other "Cuban":
the former consisted of an immaculate raked expanse, dotted with gargoyles and
capitals that had fallen off of the crumbling colonial facades, while the latter was
a garbage-strewn lot where a building used to be. In their exquisite precision,
Japanese gardens plant a question around the idea of perfectability: Garaicoa's
rendition situated that question against the harsh evidence of breakdown.

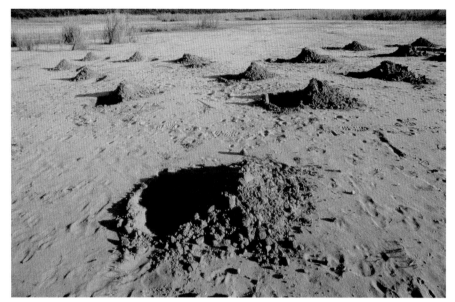

Carlos Garaicoa Manso, *En las hierbas del verano* (In the summer grass), 1997. Installation: Hi 8 video transferred to VHS, seven monitors. Courtesy Carlos Garaicoa Studio.

In 1997 Garaicoa was invited to Angola. Arriving in Cuito Cuanavale (site of the decisive battle of that brutal war—decisive, especially in terms of Cuba's participation), he spent days digging holes in what had been a principal battlefield and leaving little piles of the excavated dirt by the holes.[14] The dead landscape was refigured as city of the dead, all of its graves violated. Angola had already been displaced from official Cuban memory, but in Garaicoa's piece it reappeared as a kind of dark mirror. The violence of the image and its fearful reverberations were an index of the trauma that the war in Angola was for Cubans of Garaicoa's generation, both in itself and as pentimento of the years in which Cuba's own slow deterioration groaned on and on. Later, to exhibit the work Garaicoa showed photos of the action alongside a couplet by the seventeenth-century Japanese poet Basho: "It is boring now in the summer grass. The glorious dreams of ancient warriors."

Garaicoa was fundamentally suspicious of grand ideas ("somehow, at some point, we were fooled"),[15] allergic to declarations and partial to "mundane spaces" that he aspired to "reinstate . . . as spaces of discourse."[16] (Elsewhere, he refers to the work's function as "a kind of street rumor.")[17] He restored bits of the broken-down to fictive splendor,[18] in an excavating rehistoricization of the city that adroitly sidestepped the causes of that History: "a refusal," as he put it, "to venture answers for the causes of an absurd event."[19]

TOP Manuel Piña, *Camina* (Walk), from the series *Aguas baldías,* 1992–94. Photograph; 120 x 240 cm. Courtesy of the artist.

CENTER Manuel Piña, *Panteón* (Mausoleum), from the series *Aguas baldías,* 1992–94. Photograph; 120 x 240 cm. Courtesy of the artist.

BOTTOM Manuel Piña, *Salto* (Leap), from the series *Aguas baldías,* 1992–94. Photograph; 120 x 240 cm. Courtesy of the artist.

LEFT Iván Capote, *Historia* (History), 2000. Glass, metal, marker, and eraser. Courtesy of the artist.

RIGHT Ernesto Leal Basilio, *Aquí tampoco* (Not here either), 2001. Ten Ilfordchrome pictures; each 100 x 120 cm; edition of three. Courtesy of the artist.

differentiation between politics + history

It was, perhaps most of all, a ductile and sectile work, resplendent in its woundedness. The great force of Garaicoa's imagery derived in no small measure from what seemed to be precisely an inability to give up on the utopian, but he could no longer get a firm enough hold on it. His contact with "utopia" is already in quotation marks, already too far removed from the experience of struggle toward it. And so the works map utopia from a distance that is inevitably sweetened, retaining the beautiful form of its hope but grounded in the profound bitterness of its frustrations and betrayals. Such works came mostly from the tradition of lamentations, but thanks to the generalized expectations of the new Cuban art a denunciatory subtext has often been aggregated to it. "My art is not political," said the artist, hedging his bets, "but it is playing a game with politics. It is a little judgment of history."[20] The insistently plangent tone held on to ideas of the gracious, the noble and heroic, even if only through irony. In spaces of quiet ecstasy and despair in a city falling to pieces, utopia, even in ruins, still exported well.

Manuel Piña also rendered history and its documents, utopia and loss. Piña's photographic series *Aguas baldías* (Water wastelands, 1992–94) also achieved an almost iconic status, both for the simple elegance of its imagery and for its resonance with the *balsero* tragedy. As though the political and economic discourse of emigration had been exhausted, still without satisfying the need to understand it, Piña proposed *Aguas baldías* as an alternative, "existentialist" perspective.[21] The images are all frames enclosing the horizon, mostly empty but sometimes punctuated by solitary figures walking along the sea wall (literal edge between here and there) or—centered in the span of an unmodulated frame—leaping. Not Yves Klein's mystical, fantastic leap (*The Painter of Space Hurls Himself into the Void!*) but a leap toward something that is neither really there nor within reach. The horizon is sometimes distant and sometimes a close-up Malecón wall, and it is the vacillation between those two scales of enclosure that gives the work its

tense, rather than wistful, charge, suggesting profound isolation and the unlikeli-ness of release: the incommensurability of the disappearances into the sea.[22]

Garaicoa and Piña's work marked a trend to a narrowed range of emotions, inexorably tied to decay and abandonment. Utopia is still raised as a project, but put down in the same place where it was found, advanced not as a problematic but as a kind of virtuous worry. The trend pressed on and, as if to literalize the emptied circle of the utopian horizon, Iván Capote made a machine that drew and then erased the same mark in an endless revolving gesture.[23] Withdrawal, the contraption signaled, into an already detonated absurdity.

The extreme museumification was something that artists worked variously within, with regard to, and against. As a teenager, Ernesto Leal had been part of the radical collective Arte Calle, but by the 1990s he seemed haunted by the enclosure, even suffocation, of the private. He photographed dust under furni-ture (*Aquí tampoco* [Not here either]), blowing up the murky prints big enough to suggest an unrequited search. The forensic enlargements yielded only grain: not here either. In *Guided Tour* (2000) Leal collaged together images of his family's apartment and of the space suit worn by a Cuban astronaut who was trained to go into space on a Soviet launch in the 1980s but didn't. The mannequin, which has a strangely dewy expression, hovers ridiculously in the family home, col-lapsing the heroic display of thwarted history into a boring domestic comedy (the astronaut presides over a grimy kitchen scene, stands next to an old plastic bucket brimming with crusty suds, and hangs upside down in front of a doorway, through which we see Leal's mother sitting at the kitchen table). The work unifies the space of the artist's home and that of the Museum of Air in Havana (where the suit is on display), the two interpenetrating and "contaminating" each other. It is yet another of his frail, absurdist spaces of retreat from the bombast, the museumification, the false ecstasy of official culture.[24] As it happens, there are two space suits in Havana museums. Arnaldo Tamayo Méndez's suit stands origi-nary and triumphant in the halls of the Museum of the Revolution, "the first Latin American cosmonaut, during the Cuba–USSR flight in 1980." But in the Museum of Air, the museum of the sky and of human flight, stands the relic of J. A. López Falcón, who never got off the ground.

The museum is a space not only of legitimation but also of collection and consecration, and around 1996 the team working under the name of Gabinete Ordo Amoris undertook the task of identifying the creativity and small genius in the emergency-inspired improvisations of the city's inhabitants.[25] In 1991 Mosquera had written about Adriano Buergo that he worked "with the world of odds and ends from the 1940s and 50s that have had to continue putting in a day's

work in Cuba, the world of objects adapted to new functions in a crude and utili-
tarian homemade bricolage of everyday things that have held up to the blockade,
the auto-blockade, and scarcity."[26] That scarcity had snowballed with the new
privations, but the Special Period was not a simple matter of dejection. It was alive
with informal economies and underground networks, self-regulating systems,
and above all with spontaneous inventions, scavenging, and ingenuity. Those
improvisations filled in the gaps where the formal, centralized systems had failed,
and usurped their authority. In recognition of the centrality that homemade, collo-
quial manufacture had acquired, Gabinete Ordo Amoris granted it museum status.

Trained in design rather than art, Gabinete Ordo Amoris's idea of the object
suffered none of the stigma attached to functionality and found no existential
split between form and content. And so the artists set out to collect and display,
to gather evidence of the thousands of small inventions that Cubans devised out
of the detritus of the everyday in order to get through it. *Agua con azúcar* (Water
with sugar) presented those objects according to the logic of a cabinet of curiosi-
ties, cataloging and ordering the breadth of its universe: a catalog of remedies in
place of a catalog of certainties.[27] The humblest bits of anonymous origin were
vested with the museum's formal, ideological, existential, and even moral author-
ity. Buergo's work was itself heir to the recycling and cannibalizing tradition that
began even before the triumph of the Revolution, of the Parts Committees, the
Convention of Innovators and Inventers, and the Association of Innovators and
Rationalizers: "Worker, Build Your Own Machinery!" a slogan rang in 1961.[28] Four
decades later Cuba was still jury-rigging, more reliant than ever on the spontane-
ous popular solutions that lubricated the decomposing everyday.

A couple of years later Gabinete Ordo Amoris shifted from an archaeological
to a mimetic strategy and began to duplicate those surrogate, quasi-replicas with
precision and on a much grander scale. For the seventh Biennial they installed *Un
día como otro cualquiera,* a cluster of homemade antennae that crowded the ceil-
ing of a cavernous stone room in El Morro. Connected to nothing, the antennae
were homemade receptors for an off-limits signal, mute in the colonial fortress-
turned-museum.

The Mandarin Array

> YOAN CAPOTE: Now, art is important for the profile of the country. And so
> it responds to very macro-level political structures. That we have not been able
> to comprehend.

Ordo Amoris Cabinet (Francis Acea and Diango Hernández), *Un día como otro cualquiera* (A day like any other day), 2000. Havana Biennial, 2001. Courtesy of the artists. Photograph by Francis Acea.

IVÁN CAPOTE: The artist is no longer the ingenuous one of the 1980s, in the sense of Don Quixote, who wanted to die: now, the artist is more, I don't know, not intelligent so much as . . .

YC: . . . logical

IC: Yes, more logical, because history exists, you look back . . .

YC: In the '80s yeah, there was a tremendous brouhaha [*bateo*] with the institution, it was pure Cuban . . .

IC: There's a tradition of heroism here in Cuba . . .

YC: This doesn't seem to be hero's times. That's why not only has the institution opened, but also the artists don't challenge as much, there is not so much provocation anymore.

IC: There isn't that guts [*valentía*] any more, I don't know what to call it . . .

YC: . . . that rebelliousness . . .

IC: . . . that rebellion without a cause . . .

YC: Those times are over.

A debilitated, silent interregnum had followed the exodus. For a few years, the combination of trepidation and lack conspired to leave Havana galleries either empty or filled with banalities, all on the safe side of an insecure truce. But another group of young artists got fed up, and in 1993 they organized an exhibition of their own. Unlike the open promise of *Volumen Uno* (promising, that is, further editions), this one was equivocal and elliptical: *Las metáforas del templo* (The metaphors of the temple). One way to deal with impasse and frustration is to mythify it, universalize it, metaphorize it.

Las metáforas del templo was a way to test the new footing and see what was possible. In this sense it was also the coming-out party for the next generation, organized—not coincidentally—at the same time that the curators of the next Havana Biennial were looking for artists. The gambit was a success on both counts: the show attracted significant attention, encountered minimal resistance (none of the works were pulled, though the catalog was, apparently because of its essay by Mosquera), and seven of the eleven artists in the show made it into the Biennial. The exhibition's bloodless coup was a serendipitous precursor to the legalization of the dollar, about three months later.

A broad range of metaphor filled the show, from Fernando Rodríguez/ Francisco de la Cal's dissimulations to Alberto Casado's not-quite-folkloric pictures of things that happened in the 1980s, Jorge Luis Marrero's not-quite scrupulous remakes of his own drawings from before he became an artist, and Osvaldo Yero's versions of national symbols that were just like the plaster tchotchkes in everyone's living rooms. Irony abounded, as in the new history painting by Douglas Pérez, the new academic painting that suggested something opposite to its own august form, and Esterio Segura's own polychromed plasters—consummately crafted and impressive objects drawing a parabola (to use his term) along which disparate beliefs were linked.

The new Cuban art of the 1990s, packed with its adjacent leitmotifs of doubt and knowing, oozed metaphor throughout. Innately amphibian and conceivably neutral, metaphor worked in much the same way as the new political and institutional climate for culture. At one end of its range metaphor condenses and extracts the gist, and at the other it maximizes the range of suggestiveness. The work was parallel to that of the 1980s, but ranged along a metaphoric continuum from the moralizing allegory to its lackluster sibling Euphemism, that comparative scheme emptied of hope—and here it's worth remembering the term that apostrophized those years from the highest level: the Special Period, more a condition of asymbolia than of allusive relation. At the same time, figurative language is always asymmetrical, which accounts for its force. An animating capacity laid on that continuum of metaphor, and for every act of evasion that it sheltered, metaphor also spawned important symbolic spaces. Metaphor loosened the meaning of the "original" through its juxtapositions and comparisons, clarifying and/or muddying, linking and/or distancing, condensing and/or deconventionalizing. It was this multiple, oscillating nature that gave metaphor range and richness in Cuban art of the 1990s, and that made it both a reaction to and consequence of the contentious times that had preceded it.

The works in *Las metáforas del templo* shared a preoccupation with the skilled hand of the artist. Just as academic painting had been experiencing resurgence, and just as Segura had brought back religious (not spiritual) sculpture, so too other forms of expert production arose to license another generation. Besides the "high" cultural forms of painting and sculpture, adroit production of "minor" craft and kitsch also proliferated (woodworking, plaster figurines, folk paintings), and Abel Barroso's woodcuts, Garaicoa's excellent draftsmanship, and Ibrahim Miranda's impeccable printmaking rounded out the set with the medium ground of a more mechanical register. Industrious, refined, irreproachable, this new visual poise came with a certain dose of irony, living a double life as commodity

that did, and did not, accept its own status. But whatever its discomforts, it also brought its own consolation. If, in the 1980s, artists had used creative forms that reflected the contingency of their moment, in the 1990s a renewed emphasis on mastery of execution produced works that would endure.[29]

More than "visual," the new work was crafted, formulated, pored over, and almost painfully self-conscious. It used a more specialized calculus, having to do with the eye of the connoisseur: the one who inspects closely, not the one who passes by on the street. Not unconnected to this, the new art of the 1990s was a gallery and museum art, its physicality deliberated in terms of contexts designed especially for art. The danger of art continuing to function and grow as popular phenomenon was trumped: art was again art, safely contained in institutional space. With the falling away of the "extra-artistic," a reabsorption into, and reacquiescence to, the forms of art itself displaced to one degree or another what had been, in the 1980s, a primarily conceptual footing. Much of the interest in the 1980s work came from its testing of limits: this process advanced later on, then, to become one of intuiting those limits and internalizing them. Special Period Cuba was a place with many shadows and hiding places, and the art that it occasioned was often filled with the sense of those internal and exterior labyrinths. This contributed dimensions of thoughtfulness while acceding a loss of spontaneity: it yielded a more calculated art, more strategic, more "mature," perhaps, and certainly more vocational.

The paradigm of the testimonial genre inverted, and the position of the creator switched from public eye, transcriber or reproducer, to alien (artistic) authorship. An inversion of the aesthetic premise also took place: while the testimonial was morally theorized on the basis of "making literature with life itself," the 1990s works often took form in a high-gloss materiality. New materials were suddenly available on the island—"steel, glass, everything," for those with dollars.[30] A latter-day minimalist adoration of spotless, industrial surfaces grew thanks to the black market's panoply of goods that had been shipped in for the new hotels and shops and restaurants and museums. In this case, though, rather than reflect the condition of "everyone's" cars and refrigerators and work cubicles, the new shine in Havana reflected the artists' successful entry into the dollarized, tourism-driven commodity plane—both a million miles, and just a few blocks, from the blacked-out streets strewn with the rubble of homes where their neighbors used to live. In place of the grinding difficulties lived by most Cubans, artists began to contend with the problems of artists anywhere: increased anxiety about position, envy and competition, fear of obsolescence at an early age, dependency on the whims of a capricious buyer, and a fundamental need to be charming

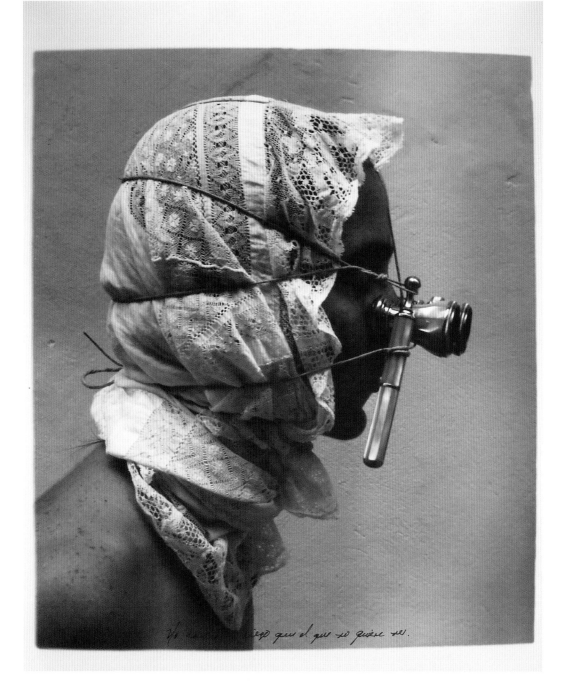

and attractive—equally to foreign customers and to local administrators—to lure the former and reassure the latter that nothing untoward would be forthcoming.[31]

Las metáforas del templo had been the leading, public edge of a new promotion of the new Cuban art. There was a lot of work, including a new line of photography proposing a piecemeal, intensified identity. René Peña's super-contrast black-and-white images of his own body theatricalized race as a lush visual spectacle. Cirenaica Moreira's images of herself entrapped in strange instruments took up where Marta María Pérez had left off, transposing the earlier artist's cultural resonance into an arresting oddity. It was, much of it, photography produced within the enclosure of the studio, a musing sort of work referring back to fantasy in retreat from "immediatism," self-portraiture that felt frozen in a place defined by an unmoving, cyclopean point of observation. Writing in the catalog for the *Arenas Movedizas* (Quicksand) exhibition, Mosquera read that photography as continuous with the "Elso zone," with its "inclinations . . . to interiorization, stage craft, to rites and symbolization." The works were "characterized by a certain reprogramming of art toward the religious–philosophical, united with an existential experience of the works."[32] That show argued for continuity between generations of artists, in the form of philosophical affinities more than in programmatic, thematic, or formal alliances: arguing, in its elegiac tones, that the new Cuban art was intact.

Some carved out more isolated spaces. Miranda, working quietly in his studio as he had since the early 1990s, issued streams of prints, woodcuts, and quilts persistently returning to questions of Cuba, of multiples and of darkness, in an incredibly self-sufficient practice far from the races and competitions. Juan Carlos Alom excavated the space under his mother's kitchen and turned it into an "independent cinema." Ezequiel Suárez and Sandra Ceballos turned their living room into a gallery. They filled Aglutinador with an extraordinary exhibition during the seventh Havana Biennial in 2000, inserting memorabilia from the 1980s into the deracinated, tiptoeing project of the Biennial. Artists and writers lent their souvenirs, sketches, little gifts received years before, exhibition announcements, amulets, "mysterious boxes," fragments: loose ends. *Permanecer nuestra colectiva* was a project of collecting and restoring history, of countermemory against the official and institutional amnesia. The humble, quirky, incidental objects were pinned to the walls in place of the defenses of museography, surfacing from personal troves in lieu of the vetted, bought, cataloged, and conserved. The exhibition comprised bits and pieces organized according to personal logics and social circuits, defying the separating, chronologizing, patterning, occulting impulse of the museum; its jumble of memory silenced the judgments (and all

the masters they served) that had been the fate of the "art of the 80s." The show was a mnemonic depth charge, all the more potent for its dismissal of the bronzed national gesticulation. "It is not because they are also works of art," Orlando Hernández wrote,

> nor because they have a certain sentimental, emotional quality. Nor because they remind me of moments or friends who are far away or dead. It is something else. I have a special interest in this type of objects and documents—in general made without grand pretentions—because they show me with greater clarity that the artificial nature of art almost always ends by hiding, confusing, destroying: the real contents, true, stripped of the sensibility of the artist. The superiority (aesthetic, moral, human) that I see in many of these objects consists precisely in that quality, in that they do not manifest—or manifest very little—the damaging pressure that the expectations of others have on artistic creation. If only all art were made the same way, as if it didn't matter.[33]

The Projected Self

There is no such thing as society, only individuals and their families.
—MARGARET THATCHER

The museum's oldest story is the one about the nation, about whom it claims, what it represents, and what it has or has occasioned to be achieved. Since the beginning the new Cuban art had been a kind of independent identity laboratory, working counter to the broadcasts of *cubanía*. But as the work had come to circulate more widely abroad and less importantly at home, its "identity" ran up against new dilemmas. At a certain point, "being Cuban" clashed with aspirations of universality: it was probably not coincidental that what "Cuban" meant had never before been so unclear.

De la Cal's stories had been more or less a chronicle of what was happening in Cuba—economic problems, touristification, moral fraud, ideological disintegration, emigration, and so on—until around 1998, by which time Rodríguez had amassed a solid list of international exhibitions. But then the conceit of the work changed: the work was now less "about Cuba" than "universal," not "about politics" but about "human relations." "I think that, for me, the image doesn't matter," Rodríguez said in a 2002 interview. "The most important thing in my work was not the image of Fidel, but rather everything that surrounded him in that work, all the fiction. I think that the image of Fidel was . . . to play with the spectator, it

Fernando Rodríguez, *Economía de espacio vertical* (Economy of vertical space), 2000. Installation at Liebman Magnan Gallery, New York. Carved wood, fabric, metal. Private collection, New York. Courtesy of the artist and Cristina Vives, Havana.

TOP Fernando Rodríguez, Untitled *(Spiral),* from the series *Puramente formal* (Purely formal), 2002. Carved wood, polyester resin, and sawdust; 41 x 41 x 39 cm. Private collection. Courtesy of the artist and Cristina Vives, Havana.

BOTTOM Fernando Rodríguez, *Unidos* (United), from the series *De una experiencia colectiva* (From a collective experience), 2001. Carved wood, sash cramp (metal). Collection of Nancy and Roderic Daley. Courtesy of the artist and Cristina Vives, Havana.

wasn't to be directly critical, not at all, it was to play a little joke, to make people laugh, to fool around. . . . Before, you didn't have to sell one work in order to make another; people made art out of love for it. . . . before, you lived with yourself, with groups of people, but today you have to live with the world."[34]

Francisco was no longer drawn as a historical character and became the signifier of anonymity, density, and privation. Rodríguez carved thousands of him and placed them in settings in which their mass and collectivity became a minimalist, nonpartisan gesture. *Puramente formal* (Purely formal), as the title of Rodríguez's 2002 exhibition said: "Francisco is mass. Mass is form. The form may be devoid of content."[35] The jester flaunts his melancholy and breaks the spell.

Francisco no longer narrates, no longer has something to tell; he simply appears, over and over and over. If the specificity of the early scenes gave the works a tragicomic aura—the details of moment and material surroundings always slightly akimbo to the utopian text—the social–historical surrounding drops out in the blankness and semantic susurrus of the later work. If placeness and situatedness was formerly paramount, now place was glanced at and abandoned, and the playlet was staged in the ex-territorial space of the White Cube and in hazy, not historical, time.

The market made a set of contradictory demands: to retain the hallmarks of the new Cuban art, to come up with something fresh, and also to be transparent enough that the viewer didn't feel left out of the joke. This conundrum was closely linked to the one that opposed political and visual art, since for instance that which read most sharply as Cuban had been a politics only schematically understood by most outside viewers in terms of some vague conflict between freedom and tyranny. And so Rodríguez ends his own, ambivalent return to revolutionary sentiment, replacing it with a turn away from the Cuban to the world. Rodríguez, living in a world of givens, had discovered Stylistic Political Art.

Indeed, nothing had signaled "the Cuban" more succinctly than "politics," and that was an identification that Luis Gómez had always hated on a visceral level. Gómez, who had studied with Elso, despised the "oppositions, contractions, repulsions . . . the seduction, mutual taking-advantage, preconceived winks, exaggerated exports" in the relationship between art and power—that same relationship that had often been understood as the nerve center of the new Cuban art.[36] He vehemently disassociated himself from what he considered to be its mistaken principles, especially its social and political agency and renovating aspirations, its ethical mandate and "extra-artistic" reach. Gómez put the swindle of politics alongside that of salvation, and art, as he saw it, was neither.[37] It is somehow strange, then, if not contradictory, that there has always

been an intense spiritual intuition ("both 'elevated' and existential") at the core of Gómez's work.[38] But it is an amazingly skeptical kind of spiritualism, resoundingly secular and with equal doses of romanticism and ulcerating utopian desires layered on top of it.

More than communicating *something*, Gómez made museal atmospheres, manipulating space as a way to manipulate consciousness within it. In 1990 he built a voluminous wooden form—a whale—to almost completely fill the volume of a gallery, leaving only crawlspace for the viewer. The *Quiet Room* asphyxiated the space. It was not a representation of the Cuban situation so much as an excrescence of it, evocative of its feelings of claustrophobia and biblical sense of destiny, grandeur, and sad beauty. Like that of others, Gómez's sense of the symbolic had been formed within the excesses of the image regimes of Cuban public space, with their formulas, icons, and simplified equations. In his work, a heavy symbolic charge is conjured again and again, but the meanings are kept extremely indistinct, as though it is the act of symbolization itself that counts rather than that which is specifically signaled. No beautiful exaltation embroiders Gómez's work; symbols are almost always frustrated, thwarted in their social vocation and intensely hermetic.

Gómez's 1999 series *Mil días de lluvia* (A thousand days of rain) consisted of as many photographs of basically nothing, shot as a kind of diary or "souvenir" of places he traveled to. The deep cynicism at the core of the piece worked ruthlessly to deflate any overreaching rhetorical claims about art's transformational writ. The images intentionally "lose the documentary function," writing in tones rather than colors about a labyrinthine interiority. It was an iterative, rather than immediatist, visuality built of resemblances rather than representations, offering a mysterious world that did not track to the historical. The languid feel reflects the *mal du siècle* of its subject, a sort of exhaustion not lacking for lyricism but energized by disbelief.[39]

Gómez's work created a certain kind of spatial, sensorial, even emotional experience, at once dense and removed. It was a space whose generally smooth pace and ritual slowness compensated the unevenness and inconclusiveness that engulfed what lay outside its doors: it was a space a lot like that of the museum. In the museum, the lessened speed of sanctuary makes things proceed and progress with dignity and solidity. The museum's scale pertains to condensation and compaction, distillation and focus: it muses endlessly, spherically. Gómez turned the museum into a hallucination and in the process suggested that its (his) identifications were closer to loss than to creation, its (his) very being an act directed against it.

wtf ?!

Luis Edgardo Gómez
Armenteros, *Quiet Room*, 1998.
Wood; 15 x 6 x 3 m. Collection of
the artist.

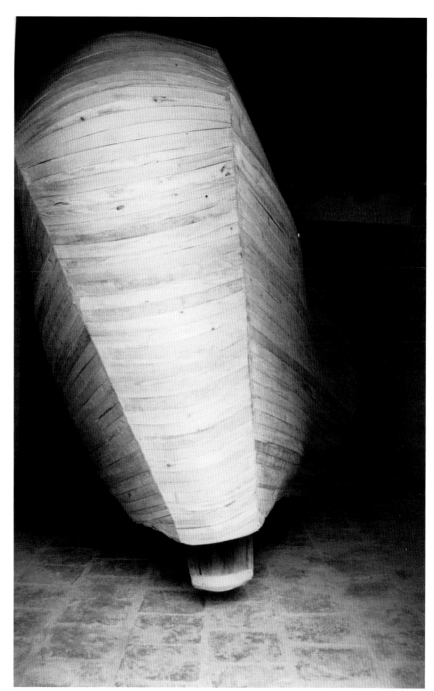

When grand programs have failed, improvisation gains enhanced authenticity. The rhetoric of community supplanted that of the collective, a more intimate and unrehearsed formulation laden with declensions of simplicity and naturalness. It was a romantic turn. The romantic spirit introduces a profound uncompletability: it injects doubt into the heart of ideas about history and destiny, with both liberatory and victimizing results. Its program of personal questioning occasioned by a legacy of aspiration and regret produces, finally, an infinite longing. In Cuba, romanticism's ethos of the personal repudiated social consensus. If, as Theodor Adorno had it, the loss of utopia is the loss of the capacity to "imagine the totality" as something radically different, then this occasioned, in the new Cuban art, a rethinking of the most basic question of socialism, namely, of the individual's identity vis-à-vis the collective. And so it was not just the limits of tolerance and the nature of the social semantic space that changed, but the very persona of the individual as agent in society.

Much art is motivated by conflict, and the question of private–public had been also a question about where the conflict was seen to arise. For many artists, the deep internal corrosions of life in the Special Period had located the most urgent conflicts within themselves. While the public space that was imagined before was a valiant one where important things were possible, once faith in that possibility died, the revolutionary Public repaired to the domestic, distaff space, or to a public space that was now relatively minor. A tone of reluctant elegy full of ambivalent emotions had filled works such as Leal's, as much bleached as aerated by their social location.

The new Cuban art was compulsively looking over its shoulder: Was the past safely laid to rest, was the past lost? Was the new Cuban art over, was it co-opted (by whom?), was it new again? Was art politics, was it safe, was it replaced by the market? Was the new Cuban art still Cuban? What was its place in the world, what did "Cuban" mean any more? These dilemmas tested everyone, not only those youngest and newest, but also the ones who had been there before and were contending not only with the changed situation but also with their own evolution as artists, their own complex needs to both maintain continuity and demarcate distance from the past. As we know, returns are never the same as the original, and that is a good thing particularly when that original has Talmudic[1] status: the expulsion from the Eden of unconflicted ethical protest, the wandering in the desert of savage capitalism, the interpretation of every single move in relation to a pristine original, the casting of every single change as a darkening of an original brightness.

[1] jewish legal text

A new bunch of collectives formed in these shadows. It was not only nostalgia, though it was certainly that in part: among other things, the new groups gestated in the classrooms of René Francisco and Saavedra, and from their dreams, memories, and charisma. But the young students were not simply pawns or surrogates; they were youngsters—again—unrequited in their idealism and yearning to be artists in a way that mattered: mattered deeply, mattered broadly, mattered as Cuban. An almost schizophrenic sense of vocation took hold, at once a suspicion verging on conviction that art's radical calling had become anachronistic and a powerful desire for exactly that kind of restorative, self-determining agency. Francisco's DUPP (Desde una pragmática pedagogía [From a pragmatic pedagogy]) was the first of these new collectives to solidify, and the new era was marked by Francisco's own rebirth in Beuysian vest and fedora.

Art-into-life returned, or remained, as a dream, but now as a means of escape from the orbit of not power, or politics, exactly, but more like the official, the administered, the deadened falseness of consensus and collectivity. It was the shining paradox of a collective based in self-reliance as an almost aesthetic virtue, a new transcendentalism of romantic, spiritualizing overtones. The new collectivity entrusted the responsibilities for proper conduct of the society to the private sector and to the even smaller subset of the individual: a kind of Dickensian belief that it was in the cultivation of empathy for the sufferings of others that social change could be effected. It was a politics of empathy and description, definitively not mass, definitively not confrontational. "There is one thing that must be made very clear," a DUPP member explained,

> and that is that we never proposed ourselves as being avant-garde artists. . . .
> We never said, we are going to make a new language, we are going to propose
> a new dynamic of art, nothing at all like that. What preoccupied us was to
> use what was happening with us, that level of dialogue of the group and yes, to
> revive some things that had happened in Cuban art. . . . We were not interested
> in making fashionable art, but rather an art that was in relationship with
> the quotidian.[40]

La casa nacional (January 1990) was DUPP's first realization of its pragmatic pedagogy, and it consisted of making home improvements in a *solar*.[41] The artists solicited the inhabitants of the slum and fulfilled their requests, thus spending a month occupied with "repairing personal objects, remodeling the house, paint for doors, numbers to identify its rooms, dining tables, pictures of martyrs for the communal living room, pictures with religious themes and with descriptions of historical characters, a mural to give information about the community, a plaque

[handwritten margin note:] pragmatism and art as empathy + solution

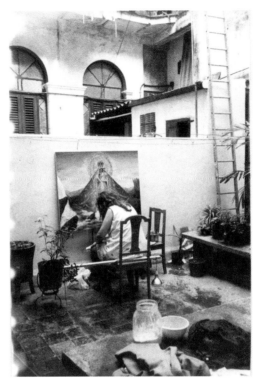

TOP DUPP [Desde una pragmática pedagógica (From a pragmatic pedagogy)], *La casa nacional* (The national house), 1990. Courtesy of René Francisco Rodríguez.

BOTTOM DUPP, *La casa nacional*, 1990. Courtesy of René Francisco Rodríguez.

to identify the building historically, cleaning the house and update chats with the neighbors."[42]

La casa nacional borrowed a somewhat generic aesthetic solution to address a problem both universal and specifically Cuban, and Special Period Cuban at that: the "uselessness" of an art ruptured from life. DUPP, said Francisco, "resolves itself directly in 'banal' and quotidian contexts, in the street and not in the lecture halls, such that all of the conceptual implications of the institutional status of art would be incarnated without hypocrisy or intellectual distance, converting itself, and converting us into instruments, tools-bridges."[43] DUPP proposed that art's "other" was no more, and instead of artworks its members produced "experiential objects." The project was an odd hybrid, part retreat from the institutional apparatus of art and partly entwined with the institutional nature of Cuban society (it was organized with the help of the local CDR).

"Projects of social–cultural insertion" had been a mainstay of the early 1980s in Cuba, a different point at which artists and institutions had found reason to cooperate. *Arte en la fábrica,* in 1983, had brought forty-two artists into eight factories for nine days. The project had all the veneer of an official effort (it was announced as a celebration of the twenty-fifth anniversary of the Revolution), but its participants included many of the least conventional of the young artists.[44] They did whatever the workers requested, which in one case meant touching up a portrait of Che Guevara and, in another, painting a mural according to their tastes—which Garciandía did with relish, painting "straight," virtually the same kitsch imagery that he was queering in his studio. The voluntarism of the artists was therefore, probably, complex.[45] Between 1983 and 1991 the massive *Telarte* project produced two million meters of fabric designed by 150 artists—enough to cover the length of the island 1.6 times over.[46] In 1985 the hugely expensive *Arte en la carretera* placed nineteen billboards on the island's central highway: among the images that puzzled nearby residents were Tomás Sánchez's hyperrealist painting of grass that looked just like the grasses all around, only much bigger, and Rafael Zarza's two cows painted something like Warhol's Marilyn Monroe.

But it was not only the institutions that generated projects intent on merging into the daily life of the island: DUPP was also echoing an important strain of work by artists such as Abdel Hernández's (mostly unrealized) *Proyecto Hacer,*[47] and, more importantly, the subsequent *Proyecto Pilón* in 1989. In these projects, the goal was to interact on an equal footing with local communities, partly by developing projects in a more long-lasting way and on a deeper cultural level.

Proyecto Hacer proposed to "link art with socially useful work, offering the individual new perspectives for confronting and coming to understand his own

activity; to design a pedagogical method applicable to the art schools while look-ing forward to professional activities; and to create a cultural treasure for people that will arise from within their communities, their own lives and spiritual char-acters."[48] The group's ambitious program and eclectic reach (members included artists, musicians, graphic designers, and journalists) reflected the breadth of Hernández's vision. He proposed "Transart" in place of art, encompassing "exhi-bitions installed in the homes of impoverished people . . . and anthropological actions and experiences in distant rural communities. [Hernández] gath-ered psychologists, sociologists, and artists to execute extensive works linked directly with street life, involving young people suffering from social ailments. These works gravitated between therapy, art, and anthropology. . . . His [project] included a pedagogy for the actor, a theory of the creative, and a methodology for social work."[49] Despite Hernández's considerable energy, *Proyecto Hacer* seems to have existed mostly in theoretical terms, but another project with similar goals and definitions, and some of the same participants, did materialize in 1989.

At the height of the tensions, censorship, and confrontations, this extraor-dinary project was launched in the impoverished eastern town of Pilón—a fact that, among other things, also brought into much clearer focus the assumptions about the inherent affinity between artist collectives and the "public" that had been implicit in much of the work during the latter half of the decade. Departing not only from the architectural and bureaucratic institutions of art but also from the urban center within which the "new art" had been mostly confined, the Pilón project envisioned an entirely new situation in which the definition and practice of art itself would emerge from the public, and its circumstances, rather than be overlaid onto it.[50]

The project arose from the artists' dissatisfaction with the narrowness of the audience and the social discourse that was engaged by their work. Despite the significant public presence that the new art had achieved, the audience for this work was still, with few exceptions, limited to the orbit of the specialist and aficionado. "The public that went to the galleries was practically the same," recalled Pilón participant Saavedra; "they were art students, the artists them-selves, or people who in one way or another were connected with art, worked in it or were part of the institution of art. Everything was closed. Obviously, the artists had friends and maybe occasionally a lot of those friends visited the galler-ies. There were also students at the university who had nothing at all to do with art, physics students, mathematics students or other subjects. And then there was a moment when there was a desire to open up a lot."[51] Frustration with this situation had already found repeated expression, whether in Arte Calle's street

commotions or Art-De's actions and debates in the parks. Each move out of the gallery and museum drew a parallel between the idea of the public body and public space, and implied a change in the identity of the spectator that was being sought. Leaving the gallery and museum facilitated this work in the direction of a new audience, and the move out of Havana signaled an even more radical effort to engage those who had largely been left behind by the Revolution and its cultural projects. The Pilón project went further than Arte Calle, Grupo Provisional, or even Art-De had in implicating the bystander in critical acts, through its immersiveness (the artists lived in the small town for several months) and in its total recasting of the source of art itself. Moreover, the project was staged in a location in which the general level of dissatisfaction with the Revolution was sharpened by poverty and remoteness ("for instance," as Saavedra explained, "people there said that the Revolution had passed through Pilón and never returned. Or that if a cow was slaughtered in Havana what arrived in Pilón was the tail. One man said to me, Why should he keep watch at night if the thief operated during the day?"):[52] its threat of stirring up local sentiment was probably among the reasons why it was eventually blocked.

The significant gap between what the Revolution extolled and what it administered as cultural policy was catalytic: many artists and intellectuals felt passionately about the possibility of being part of building a truly integrated, revolutionary culture, "demystified and desanctified" not in order to be recruited into rhetoric but to realize culture's potential as what the Paidea group called a "practical–transformational praxis."[53] By the end of the 1980s many artists in Havana had come to see their work, and their responsibility, as effecting political and social transformation. This was understood to mean both challenging policies and bureaucracies, and also reasserting questions of a just society and dignified citizenry. Theirs was an idea of art that worked fundamentally not in visual changes but as a form of mental transformation. The Pilón project took this ambition, which until then had mostly been directed toward transforming the spectator's thinking, and turned it inward toward the artists themselves as well. The project was structured such that, in removing all of the assumptions and tacit agreements about art, it fundamentally challenged the artists' view of themselves and of what they were doing. In this, it was perhaps the most honest collective project of all, if we understand collectivity as essentially a manner of relinquishing the defended self-identification in search of a truly social one.

The project in Pilón was utopian, and some read it as utopian-revolutionary: Mosquera declared it the most revolutionary artistic proposal generated until that moment.[54] The artists' idea was to live in Pilón and learn to understand the

people and life there, and to make art with them in a fully collaborative process. The work, and the idea of "art," would arise from those people and that place, not from any prior expertise or professionalism that the artists brought with them. In fact this was the crux of the matter, if the project was to avoid becoming just another example, however well intended, of cultural colonialism.

Unlike Arte Calle's works, which sought to destabilize official structures, the Pilón project made a "pact with power." They made a formal proposal to officials at the Ministry of Culture who oversaw visual art. Not only was the project officially approved, but also it generated such strong support that Armando Hart, the minister of culture himself, met publically with the artists during a visit to the region.[55] Despite—or perhaps because of—this ideological and financial backing, the Pilón project was caught in the middle of the power struggle between the relatively liberal Hart and the ideology chief Carlos Aldana.

Arriving in Pilón, the artists immediately encountered strong resistance from local Party officials and, although they remained for an extended period, they were prevented from accomplishing much. Ultimately, Ministry officials counseled them that it was "advisable" that they withdraw.[56] While not everyone was in agreement, several of the artists decided to leave, and the project folded, "frustrated," as Saavedra later explained, "precisely because of the level of contradiction that existed in the political structures there."[57]

Pilón was, probably not coincidentally, also the project that brought the internal strains in the collective into sharper relief: this is not surprising given the extremely tense conditions under which the group was working. But it also seems likely that these internal tensions resulted from the fact that the artists were working in even more unknown territory, and thus there was less background consensus about what they were trying to accomplish.[58] Perhaps for this reason, the group's interactions with the local public were relatively limited, despite the original plan: they did work together on some things, most notably an exhibition (censored) of more or less documentary nature about the realities of life in Pilón, but it seems to have been primarily the interactions among the artists that were the project's axis. Ironically, once art's other was allowed to be truly other, rather than just a revised version of art, the collective collapsed into a conversation with itself.

In the end, it was the day-to-day experience of life in Pilón, more than the aesthetic experience, which had the most impact on the artists. They were shocked by the poverty they saw and by the level of anger against the Revolution, in a zone that was supposedly the beneficiary of a special plan for rural development and that had special significance in revolutionary history. (Pilón was actually suggested as the location for the project by Marcia Leiseca, then the vice

minister of culture, who had a certain emotional attachment to the town because it had once been the home of Celia Sánchez, companion to Fidel Castro until her death. The cultural reanimation of Pilón, one of the poorest and most underdeveloped areas of the island, therefore may have connoted a reanimation in other terms, harking back to the most hopeful period of the Revolution.) The utopian plan of making art in Pilón had disintegrated in the midst of this situation and the fierce political infighting that the artists had been caught in, and their idea of art, inevitably, changed: "Many of my utopias crumbled," Saavedra recalled; "it diminished me somewhat.... or I was a little more realistic about the transformative capacity of art."[59] As long as art had remained within the sphere of Art, it was possible to hold utopian expectations for its transformative power. However, there was a double exit from the precinct of Art: one was into a practice no longer divorced from political activity, and the other was to Pilón, outside the realm of a definable, historically continuous, and recognizable idea of art. One exit led to exile, the other to despair: Saavedra, after living in Pilón for eight months, finally went back to Havana, stopped making art, and joined a construction brigade.

Against that historical backdrop, DUPP's revival of "projects of social insertion" in the 1990s took on an ambiguous status. *La casa nacional* stood within this troubled history: coming not long after Pilón, but undertaken by a much younger group of artists, its return was far from straightforward. The old avant-garde dream of art-into-life again raised its head and mostly settled for a conflation, or confusion of the two, an aestheticizing remediation of the everyday rather than the art demanded by a more radical position, "adjacent, parallel to . . .—but also convergent, divergent, tangent, diagonal" to life.[60] It was an intransigent problem, and nine years after *La casa nacional,* DUPP's project in the La Época department store, found it again. La Época was one of Havana's most popular and trafficked stores at the time, "a place of eagerness, of repressed desires, of satisfaction and also, due to some of the new changes in our society, grantor of prestige."[61] The artists inserted their works amid the consumer goods, in some cases confusing the two and provoking an "estrangement" on the part of the public. According to Yuneikis Villalonga and Elvis Fuentes, the artists identified their works in the store as substitutes for the National Museum of Fine Arts, which was closed at the time for restoration: "Stores are shaping people's taste. Many go there as they go to a museum, to watch and not touch."[62] The project planted questions around the emporium's consumerism-beyond-reach, but it was, finally, only resident within that commodity environment, a duplication of the estrangement already established by the unaffordability of the goods. The work, in other words, was positioned before its audience, more than between them.

DUPP recurred sporadically through the 1990s, eminently a creature of its moments.[63] It recommenced with a new group of students in January 1992, in the full misery of the Special Period, in the form of the "Department of Debates and Exhibitions," that "dreamt of being a mini-Ministry of Culture," as René Francisco wrote, to "stand guard over the treasury of that spirit of the eighties that had been disarticulated with the vacuum and the emigration. All this, from within the teaching context, which I think was the only space that had not been definitively closed."[64] By 1997 the situation in Havana was quite different, and the third DUPP to take shape was far more conventional than its predecessors: this time it was "Galería DUPP," more concerned, as the name suggested, with art and its spaces than with defying those. That third manifestation of DUPP arose from a complicated mixture of idealistic, pragmatic, and opportunistic motivations. As DUPP members explained:

> Perhaps we were wanting to change the structure of thinking prevalent at ISA. . . . Because ISA was concentrated on another dynamic of work, a lot of individualism, a lot of individual art; people were not working as we did. And perhaps, we saw that one could exploit the space of ISA: everything was destroyed, the studios didn't work, they closed at three in the afternoon, and we arrived with a dynamic of work that required the studios to be open all the time, that there be conditions in which one could work, and we made a bit of a scandal and noise, and pushed here and pushed there until we got a space and began to work. . . . And then something important that happened that year was that, this coincided with the sixth Havana Biennial, and within the exhibit of ISA, five or six of us first-year students managed to be included, something that had never happened until that moment. Then as a result of that, René became interested in returning to the idea of the pragmatic, because perhaps earlier he had not felt something like a certain motivation by the students themselves, and then we began to work together starting at the beginning of the second year.[65]

With the ideational core of collectivity hollowed out, the impulse to come together came mostly from a need to "belong to something."[66] *La casa nacional* was perhaps one of the most romantic works of the new Cuban art, with that spirit infusing both its utopian rhetoric and the lyrical dystopianism of its intervention. It was, in many ways, a moment of willed innocence, a wistful gesture made in the face of the enormous new fear of the future that gaped across the country. And although it is easy—too easy, probably—to dismiss the project as opportunistic, or light, that would keep us from noticing something important:

the assumed substrate of promise. But it was a different kind of promise, neither of the horizon nor the abyss, but one of lateness.

Lateness was not simply a function of age, maturity, failure, or some combination thereof: its relation to loss was not simple or direct. It was lateness in the sense that the dying Edward Said used the term, as a "catastrophic commentator on the present."[67] It had to do with creativity after the engines and inspirations of youthful hope had to be left behind by young people. *La casa nacional*'s lateness had nothing to do with snatching victory from defeat; in fact, it had nothing to do with victory (although it would have been impossible without defeat at some point). Its lateness sang no dirges and in fact had little interest in the past as reliquary or melancholic repository.

This lateness might indeed have been a transitional time and state but, if it was, that could never be evident because it did not look to the future in a prognosticatory mode. *La casa nacional*'s lateness did not place its bets on what it paved the way toward and therefore had to be content with, and fill itself with, what it was, along with what little it could rescue from the past without undue keening. Lateness in *La casa nacional* was full bloom and full bore, with no apologies, but it was also a bourgeois kind of lateness that had renounced "the aim of reconciling 'the universally human' with a concrete way of being human."[68] This is the prerogative of late style: "It has the power to render disenchantment and pleasure without resolving the contradiction between them."[69] Nevertheless, it had to contend, even if privately, with the fact that it was indeed late: too late, in a time other than the one that had been imagined for greatness. Ultimately, according to Said, lateness comes when the limits of art have been encountered, but it does not satisfy itself with accepting them. Late works are the catastrophes, "able neither to draw back from nor fully to consummate [the] desire for the beloved, yet elusive object."[70]

Cultural production had become its own industry, in the process falsely eliminating the distance between art and dollarized life, and thereby revealing the contradictions of the avant-gardist project.[71] *La casa nacional* had ministrated generously, but in effect it had also rarefied the misery of habitation in a *solar* by situating it as an artwork—the life itself, the life of other people, was commandeered as a work of art. In fact, the work seemed less adequate to the blurring of art and life than to the staging of a *tableau vivant* representing the dilemma of being privileged artists in a socialist system; the artists' genuine desire to "do something" with their work inadvertently contributed to the spectacularization of poverty, and while the project empaneled them as samaritans in the local context, it also aligned them with benevolent imperialism as they intervened into the local from the vantage point of the international. Indeed, how could there not be a

measure of ironic detachment for artists who were heirs to a movement that had spent the past decade renouncing precisely that psychological realism, that mandate to an "excessive extra-artistic compromise"?

As an artwork, it is hard to say where the work itself lay: was it in the acts of home decoration or in the documents and photographs through which *La casa nacional* has lived, subsequently, as art? ("Dianelis Pérez lived with this family during the entire event, from the 9th until the 31st of January," reads one photo caption. "She took on all the chores of the mother, and painted a religious picture that the father requested. She kept the diary of *La casa nacional.*") The project had an imminent voyeuristic aspect, not unrelated to the commercial structure that had made the Cuban everyday the subject of curiosity: as with all the new museums, the projection into art space tempted it toward gimmickry, blurring the line between reality, simulation, and representation.

The reiterated desire to fuse art and life in DUPP's works, among other things, was strangely also a way to depoliticize, or apoliticize, it. The life that received attention was daily rather than ideological, as though those realms could be so surgically detached from each other. A minimization of the maximalist proposition of the earlier, more utopian proposition regarding art, DUPP's iteration of the old dualism often sequestered life in the smaller zone of privacy, an ideology that renounced ideology and mustered its own, sad, tautological demise. DUPP had discovered a terrible quandary.

Haunted by these contradictions, "art of social insertion" flowered in Havana through the 1990s, following a trend well established in more-developed metropolitan centers elsewhere. Tangent to the seventh Biennial in 2000, an exhibition titled *Esta es su casa Vicenta* provided an old woman living in a wreck of a house with badly needed home repairs, in exchange for the use of her house as a gallery. Works were installed in situ; Ángel Delgado's prison table settings were arranged on Vicenta's table, and Casado's tin foil and glass paintings hung on the bedroom walls. The act was, by turns, lavish and palliative, decadent and tragic, humane and exploitative, its bold strokes tracing the melodrama of the lived situation and animating it by its contradictions.

Public space was by then in a sharp binary relation with the private, with no cultural space buffering between them. The public had become the unrelenting space of the performance of commitment, while the private was the incessant realm of *resolver*. The starkness of the situation provoked discomfort among many Biennial guests, and sometimes condemnation. Santiago Sierra, in Havana as part of Taiyana Pimentel's independent project *Extramuros,* organized a cocktail party on the artist Sandra Ramos's patio one evening. Guests, aware

only that they had been "invited for a drink," sat around on benches that were actually boxes hiding Cubans who had been paid to lie there silently.

While the exhibition in Vicenta's house was an unofficial one organized to promote artists left out by the Biennial, "art of social insertion" was sanctified by the Biennial itself the next time around, as one of its two "creative orientations."[72] The theme that year was art and life, and it played out, once more, as a polemical armature more than exhibitionary or artistic fact, its promise to turn the entire city into a "gigantic and plural gallery for every taste and appetite" belied by, among other things, the fact that it was only those spaces sanctioned by the Biennial that were permitted to exhibit anything. "Art" proceeded largely undisturbed in installations, maquettes, photographs and proposals, while "life" was pictured, pointed at and to, manicured and aestheticized in a diverse panoply of appearances. The Biennial had slid from an actual to a largely fictionalized social space, from the imminence of desire to the formality of outcomes. In what appeared to be a gesture of disgust, the Cuban collective Enema drew some blood from their arms and made a sausage, which then putrefied in a vitrine over the ensuing days while the Biennial office presided over the "urban interventions" of *Isaroko* (staged in the *solar* de la California), and *Mover las cosas* in the relentless housing blocks of Alamar—both quintessential Havana slums. Elsewhere in the Biennial that year, DIP—the Departamento de Intervenciones Públicas—completed the cycle of trivialization.

The Biennial's resurgent social-interventionist vocation stood in interesting relation to the emergent "Battle of Ideas" that was replacing the Special Period as ideological armature for the country: culture, as had been proven in the "decisive moment" of the battle for Elián González's return, had a "strategic role" to play "in the resistance of [the] people."[73] The Battle of Ideas, a concerted effort to culturalize the social and political space of the nation in the name of the Revolution, comprised a massive campaign of media programming, arts instruction, and other "cultural" projects undertaken by the national leadership and its cultural vehicles. As such, it advanced a direct assault against the "unforeseen transformations in the national socio-class [*socioclasista*] structure," namely, a new individualism that amounted to a profound incursion against the sacred ideas of collectivism.[74] This was not the cultural turn of the "creative industries" school of thought that has been argued in continuity with the instrumentalization of culture in the United States and Europe, in which culture is lauded as an advanced engine for capital development. It seemed, rather, to be an increasingly conscious tool of a pointedly local strategy of deploying culture in a crusade no longer waged

with exported revolution but with the thorough and careful management of what goes on inside peoples' heads.

The genealogy of this new cultural infusionism, though, is difficult to trace simply, since it also seems to arise from the anguishing decline of art and artists' relevance in Cuba. The interventionist and relational trends in mainstream artistic practice, which had become well known in Cuba, seemed to offer new promise for local artists, and for the Biennial, in the context of the crisis at the beginning of the 1990s. It suggested, perhaps, a potential way to deal with the new economic and social estrangement of art and artists from the daily life of the city, and with the profound collapse of the ethical idea of art that had animated the 1980s movement. This aim of being consequential to the life of the city and its inhabitants, though, stood in chlorotic relation to the early accomplishments of the Biennial in precisely that arena: the relationship to the immediate environment was now phrased in the language of intervention rather than participation, and meanwhile the main site of the exhibition remained inaccessible to local residents.

Saavedra's students banded together as the collective Enema in mid-2000.[75] The group's name (it means the same in Spanish and English) was a succinct declaration of their opinion of Cuban art, what it had become, and what it needed. Living in and working out of ISA's derelict facilities, they developed an artistic practice that required little more than their own bodies, consisting in using classic performances as readymades and reenacting them. The group was especially drawn to the kind of harrowing, somatic works that artists like Marina Abramović and Chris Burden produced in the 1960s and 1970s, based in physical ordeals, tests of endurance, and quietistic displays of pain.[76]

Their transposition of those works occasioned a radical alteration in the meaning of the original, taking what were, in some cases, emphatically isolationist artistic gestures and recasting them as collectivist existentialism. Reperforming one of Abramović's originally solo works, Enema's *Rompiendo el hielo* (Breaking the ice) involved handing off a large block of ice from one to another until it melted away: performed by a group, the emphasis displaced the experience of pain into an uneasy truce in which the collective did, and did not, become a sheltering body.[77]

The collective body itself was Enema's principal concern, and their performances often manifested it as the site of difficulty, conflict, or impossibility, with a recurrent motif of individual bodies forced into a kind of transindividuality that never quite fuses into a collective self. The struggle, awkwardness, and lack of privacy—basically, the indignities—that were intrinsic to that attempt became the fundamental persona of their work. The group lived for several days tied together

by a length of rope (*Amarre*), just as Linda Montano and TehChing Hsieh had done, but for an entire year in 1983–84,[78] and showed the work later on as a serio-comic, strangely touching video documentary full of indiscreet and bumbling moments. (For the 2001 Salon Nacional, Enema presented a video version of this work, retitled "Therapy #4: One Much Closer to the Other," making fun of the theme of the recent seventh Havana Biennial, *One Closer to the Other,* which had forested an endless parade of artistic banalities about "communication" between individuals.) They consumed a giant banquet meal (*Paladar, el arte cubano*) at which each individual fed the person sitting next to him or her in a constitution-ally inelegant rendering of generosity.

Enema's work hovered around and inquired into the everyday, and especially its more abject passages. However, the group was adept at creating arresting images, and much of its work, paradoxically, seemed to aspire to an almost iconic status. The overall effect was of an ambivalent, estranging zone in which the continual passage back and forth between individual and collective manifested an enormous tension between public and private selves, between confession and display. This was never more forceful than in *Ustedes ven lo que sienten/Nosotros vemos,* the group's reprise of Abramović's 1984 *You See What You Feel/We See,* which the group knew about from a single black-and-white photograph. Enema group members took the original work's odd, occult feel into public space, hanging by their ankles for twenty-five minutes, hands behind their backs, from scaffolding erected in the middle of a gallery patio during the opening of the National Salon. The artists dangled silently, high above the crowd, their presence and perception inverted from it, and meanwhile a live video feed doubled the inversion: the crowd saw them upright in the monitors, but bizarre, hair pulled vertically, expressions strained by an invisible reverse gravity. A shocking, incomprehensible, mesmerizing private space, thick around these spectral cocoons, overflowed the gaiety of the event and silenced it.

Although Enema was often seen as a revival of the "spirit of the '80s," they had a relationship to the cultural apparatus that complicated that continuity. Their projects, whether the magazine in which they reprinted forgotten documents from that other time,[79] or the performances, were facilitated and funded by the state. Thus, although, for example, in April 2001 they restaged the infamous *Juego de pelota,* Enema's game was done with the cooperation of, rather than in defiance of, official agencies. "It was like Ah Ha!" Hanoi Pérez explained, "like an action of the eighties but in the spirit of the nineties. It was like, The artist has acted—the artist of the nineties—and has survived and has gotten involved and has understood how it works."[80] The collective had become a

supple enough vessel to contain various contradictions: both outlaw and client, refuge and launchpad.

Havana in the 1990s was a space of pumped-up displays, their mass and frequency inversely proportional to the sense of de-animation, fragmentation, and torpor of the Special Period. The public body was constantly exhorted to take to the streets in displays of militancy and commitment. The frenzy peaked at the decade's close with the Elián González saga, on which occasion the Anti-Imperialist Tribunal (also known as the Plaza de la Dignidad) was erected, a monstrous cement arena in front of the U.S Interests Section. The plaza was flanked by pillars inscribed with the names of martyrs, and punctuated at its end with an astonishing bronze of José Martí perched high on a pedestal, cradling a small boy in his arms (presumably, Elián) and wagging his finger at the Yankees.[81] In due course, the plaza became the brunt of popular ridicule—the "protestorum," it was nicknamed, in recognition of the staged nature of its gatherings,[82] and a joke went around that Martí's pointing finger meant "las visas están allí"—the visas are over there!

Public space was spectacularized and annealed, public identity scripted and massified, even the effusions of protest were stage directed, all in the name of the *patria in extremis.* In November 2000 Enema put on a very different kind of spectacle. The group invited some transvestite cabaret performers to stage their show at ISA, but with a twist: at the end of the show, the performers changed back into their straight clothes, onstage.[83] Video recordings of the event convey the stunning emotional response, the sense of empathy and acknowledgment, from the audience and then back to the audience from the performers at the moment of their defrocking. The pushing of the forbidden, marginal, private self into public visibility, the convulsive and humorized transgression, the play of identity, doubles, and social mirages, all so complex in Cuban society, were enacted to the wild applause of an audience that recognized, in the burlesque of cross-dressers, essentially their own plight.

The Beneficent Endowment

I had a girlfriend in the '80s, and her father didn't want her to see me because I was just an artist. These days, he wants us to get back together, precisely because *I'm an artist.*
—JOSÉ ÁNGEL VINCENCH

Regarding the official embrace of popular art, ABTV had made the following observation: "[Ángel Iñigo is] . . . a peasant who spent his free time carving, in a very spontaneous manner, big blocks of stone. Now, the Sectorial de Cultura de

la Provincia de Guantánamo pays him a salary to do his work. Since his works cannot be moved to a gallery, the farm where they're located has been converted into a museum, with a guard, visiting hours, and tourist transportation."[84] The museum not only historicizes and commemorates, it authenticates and invests.

The trio of Los Carpinteros turned professional around the middle of the 1990s, and it is impossible to understand their work apart from the context of the "avalanche" of Havana's restoration.[85] Garaicoa's Havana may have been crumbling, but Los Carpinteros' city was a brand-new theme park. Their production of luxuriously crafted furniture pointed to a bourgeois, neobaroque space, part of the heritage then actively being resuscitated in the restoration program in the capital.

In October 1993, in the depths of the crisis, Decreto Ley 143 was passed, under which the city historian's office was permitted to reinvest any tourism-derived income into further restoration projects. In December 1994 (only a few months after the *balsero* crisis) the Plan Maestro para la Revitalización Integral de la Habana Vieja was released, revealing the restoration operation as what the historian Antoni Kapcia has called "a vast commercial, artistic and archaeological–historical project, which is, simultaneously, and self-evidently a declaration of national cultural identity on a scale which few could have predicted in the 1980s."[86] The program generated a network of training establishments that produced young specialists to perform the restoration work, reestablishing the status of these various artisanal skills. "Now, however, artisan skills have been developed more broadly for social use, in construction-related trades on a larger stage and with greater opportunity for prestige, purpose and a sense of belonging."[87] Los Carpinteros' lauding of the artisan must, then, be seen in the context of (if not in tandem with) the Cuban government's own reestimation of artisanal value.

At the same time, their work retained some of the vocabulary of the old new Cuban art's critical attitude: *Estuche* (Jewelry case), for example, was a huge cabinet of drawers in the shape of a hand grenade, made with the best woodworker's skill. The motif of misplaced, pointless drawers repeats: there is a hand, modeled and named after Elso's (*La mano creadora*) and a model of the Focsa Building in Havana,[88] and other series also repeated the inutility of apparently functional objects: a sofa with gas burners across its seat, a staircase with electric burners on each step, a "plantation" composed of rows of coffee pots on cement blocks. The trio's drawings never depicted the objects in use, lending them a strangely frozen sense—they could work, but they won't.

Los Carpinteros were truly Special Period artists: formed in a moment when both the physical reality and the political and psychological solidity of Cuba fell

Los Carpinteros, *Estuche* (Jewelry case), 1999. Wood; 88 ⅝ x 51 x 51 inches; unique. Copyright Los Carpinteros. Courtesy Sean Kelly Gallery, New York. Collection The Montreal Museum of Fine Arts.

apart, they wrapped cynicism around the entire proposition of creativity. As early as their 1994 graduation thesis they had written that

> we have made a game out of creation, and for this classic temptation—characteristic of the medium—we have only one response: our style of work, which transforms the problem of artistic production into mere fun, and which we use as intuitive energy in the construction of our ideas. That is why we at first believed the game was lost, and we have no idea when it could finish. . . . Who could know this? What really interests us is the game itself, without caring how much one loses in it and how risky and unstable this kind of game is. At all events, if it does finish, another game begins. The death of our game is not a problem. IT WOULD BE WORSE TO LOSE THE DESIRE![89]

Los Carpinteros, *Sofa caliente* (Hot sofa), 2001. Powder coated steel; 33 x 78 x 32 inches. Copyright Los Carpinteros. Courtesy Sean Kelly Gallery, New York. Collection Los Angeles County Museum of Art.

The collapse of the dream was no longer a bitter or painful sensation; it appears as simply the masterful combinatorial of overstatement and beauty, in which the unsatisfied longing becomes a field of play. Los Carpinteros' precious visuality and technique ironized the high–low problem, making artisanry, fused with nostalgia for colonial grandeur, the basis of a distinctly high art practice. (Their name, according to Marco Castillo Valdés, was chosen because it suggested the ambiguous territory "between a profession that is the carrier of ideology, and another that is apparently lacking in social responsibility.")[90] On the one hand, they repudiated the antiestablishment enthusiasms of the work of the late 1980s—"they did politics," as Castillo Valdés explained, "so we had to do something different. So we make furniture."[91] At the same time, they also extended its ironies to encompass the contradictions of the Special Period developments:

Cubans were materially poorer than before, but the wealth of bygone times was newly displayed in new precincts of observation. Artists were materially richer than before, but the popular status accorded to them in the 1980s had been lost, as their works became primarily export commodities. Visual art was of value to Cuba in promotional and hard currency terms, rather than as endogenous product and agent of struggle. The spaciousness of Los Carpinteros' high grandiloquent style, the gracefulness of their refunctionalized minimalism, camouflaged the close and narrow space that the new Cuban art occupied as it transitioned from its location within Cuban culture to its new mobility and viability elsewhere. In other words, art's space had been privatized.

Los Carpinteros demonstrated how successfully the new Cuban art could be museumified, and they were not alone. The conditions had been set to move into a more internationalized, "professionalized" arena, in the development of an external market and in the awareness among the artists of what was expected from them in that setting. Seminars were even held at ISA, that bastion of insubordination, on how to sell work, get a gallery, and deal with collectors. The rough-hewn aesthetic of the late 1980s, made of perishable materials and full of inside jokes, had indeed attracted attention and acclaim, but it was not ideally collectible. There was also something to be considered with regard to scale, since once the works left the scale of the island they had to compete with the routinely spectacular productions of globalized contemporary art. And in these terms we could find no better exemplar than Kcho, who became, briefly, the most famous Cuban artist since Wifredo Lam.

Kcho had debuted in 1991 with the show *Paisaje Popular Cubano,* in which he rendered the shape of the island in works of twigs and string.[92] It was a Cuba denoted with the most precarious of materials, in the most reduced of forms, with the most ambiguous, and ample, range of associations. Cuba became a space of enclosure, barely held together: a tenuous and fragile national space. It was a reduced Cuba, wrought with affection and pathos, with the poignancy of the miniaturist's touch. They were achingly beautiful works. Kcho's 1994 *La regata* was an amulet, improvising and multiplying the prayer of the horizon. All of its tiny, accidental boats were pointed toward the north wall of El Morro, toward the sea.

As notice of Kcho's work grew so did its size and, by the time of the sixth Biennial in 1997, he had settled into the twin vocabularies of gigantism and a recurrent imagery of boats and Tatlin's spiral: easy analogies, well suited to the architectural spaces and limited attention spans of the international art circuit. As notice of Kcho's work grew so did its verticality: the boats piled up to the ceiling like Brancusi's column, and the no-tech twig lattices sprouted coffee filters,

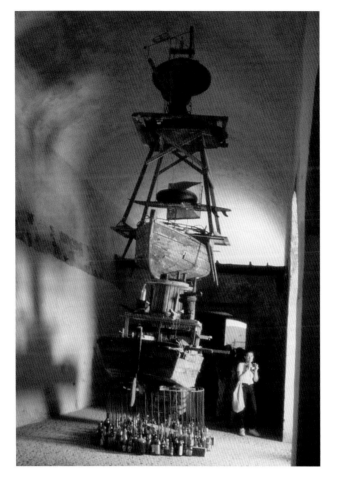

Kcho (Alexis Leyva Machado), *Archipiélago de mi pensamiento* (Archipelago of my thought), 1997. Copyright Kcho. Courtesy of Marlborough Gallery, New York. Photograph by the author.

à la Duchamp, in a metaphor of something. Totem poles, maybe, monumentalizing grief. As notice of Kcho's work grew so did its ambiguity: working in Brazil not long after his Havana *Regatta,* he pointed all of the boats at the center of the room, pointing inward, pointing nowhere—the work's gesture nothing more than a cipher, its destination nothing more than staying afloat.[93]

The Cuban National Museum of Fine Arts reopened in 2001 after five years of restoration with a show by Kcho: it was a jungle of little Tatlins, defunct, bipolar spirals accompanied by enough, nearly same large-scale drawings to keep collectors satisfied for some time. *La Jungla,* the name of the exhibition and of Lam's best-known painting, reminded locals that Kcho had been the first of the *jóvenes* to sell a work to the Museum of Modern Art, where Lam's great painting

had hung for years near the cloakroom. Rafael Acosta de Arriba, president of the Consejo Nacional de Artes Plásticas, a poet with a background in state security and the person overseeing the commercialization of the new Cuban art, provided the catalog essay.[94]

He begins with a breathless account of the artist's fame: "In the 36 months between November 1998 and today, in Cuba and six other countries, Kcho has had sixteen solo shows and has participated in fourteen group shows." "Outstanding within this itinerary," Acosta elaborates in the footnote, "are solo shows on the occasion of the 2000 ARCO Fair in Madrid, in the Crystal Palace (Parque del Retiro), the one in the Havana Biennial at the end of this year, and the one he shared with the master of minimalism Bruce Nauman in the Chicago Museum of Contemporary Art in 1999. All of them, exhibitions of great importance in the world of contemporary art, inclusions in 'the most exclusive circuits.' Additionally, we could cite the cover of *Art News*."[95] The sky is the limit: "Now, Kcho launches into a singular project: to reunite, in one gigantic installation, the three masters: Tatlin, Lam and himself." "Authentic revolutionary creators," Acosta certifies: "A great work of art has just been born."[96]

The attempt at a sincere engagement with Power had been definitively rebuffed at more or less the same time that an alternate audience came to appreciate the work based on a deflected apprehension of its meanings. The new Cuban art became a triangular conversation that took those external viewers into account. This was no simple matter, since there was not a single, monolithic market but a diffuse system with multiple layers. Clienteles, tastes, and prices ranged from the souvenir hunter to the investment-savvy art collector. In the street fairs filled with the wafting tunes of the Buena Vista Social Club where Joel Rojas was making his way, paintings were at the high end of a range of wares heavily stocked with revolutionary trinkets (one year there were two Che watches on offer: an expensive Swatch version, and a Cuban-made one selling for less). There were buyers for abstract paintings, for Zaida del Río's girlish bird-people, for Arturo Montoto's glowing still lifes, for Manuel Mendive's Afro-Cuban folklorica, for student works with the full or faint promise of being the next big thing, for everything up to and including Kcho, Los Carpinteros, Garaicoa, Tania Bruguera: players at the highest level of the international art scene. While the new Cuban art maintained and confirmed its place within those lofty ranks, it also lived in continuity with the spectrum of mawkish kitsch from which its utopian calling had once made it so distinct.

The crucial change was dollarization. The financial crisis provided both artists and administrators with a strong incentive to think of art as a solution in

economic and strategic, rather than intellectual and ideological, terms, and the decriminalization of the dollar in the summer of 1993 made the market a lifeline. In the new economy, artists could live well in Cuba with the dollars they earned: much better, in fact, than they could live abroad. Meanwhile, as the years passed, more and more of those who had left began to suffer the plight of artists under capitalism, and news of that filtered back to Havana, providing another disincentive to further emigration.

The dynamic of confrontation between artist and power had crested. The rote constancy of alternating beats became inuring, enervating: conflict, reprised too many times, converted into a deadening force, and a different kind of dynamic came into play based in co-optation instead of the *mano dura:* cycles of resistance met by cycles of (mutually beneficial) absorption. Peter Ludwig arrived in Havana in 1990, liked what he saw, and was soon the largest collector of new Cuban art in the world. Ludwig did his business entirely through government channels, with full cooperation: when he returned to Havana in 1992, officials made sure that all of the city's galleries were full of work for him to see and buy.

The new arrangement of mutual accommodation and co-optation was a trifecta, awarding cash, acclaim, and pacification to both artists and institutions. No longer focused on the subtracting of culture, state policy became one of managing its affirmative presence, a laissez-faire realpolitik that allowed for rebelliousness, within reason.[97] Early on the revolutionary state had learned, as the Catholic Church had some eras before, how to monopolize the production of images and incorporate their use into a broader iconic project. After a while, we might say, the Cuban state evolved a more sophisticated relationship to imagery, no longer under the Second Commandment's sway: the image of something could be detached from the thing itself and allowed to operate, free of veneration, as a commodity.

An "expanded dialogue between art and power," which was more than anything an encroaching financialization, came to sustain the relationship between artists and institutions and to stabilize it in a relation based in mutual dependency. This policy— orchestrated, many say, at very high levels—was one among various flanks of a unified strategy designed to renovate the government's international image.[98] The complicity of this softer and more tactical alliance largely replaced the need for a continuing censorship of the harsher variety. Toirac, among others, signaled this as a problem: "Our ethics should be less scandalized by censorship," he wrote, "than by manipulation."[99]

The old game of cat and mouse with the state had expanded to include new players, accommodating economics alongside politics at its home base. Artists,

administrators, and the political leadership finally had a ground of mutual inter-
est, and it lay outside the island. Things were much the same in the bigger picture.
The new economy had settled onto the relatively stable platform of political
power, business interests, and banditry—with extensive adaptation of each to
the others. A relation of reciprocal appeasement pertained all the way around:
the state needed the investors and businesses to develop tourism; the businesses
needed the state to retain control and keep the country relatively pacific and safe;
the state needed the black marketeers and their well-developed distribution net-
works to keep food and other goods circulating among the population; the black
marketeers needed the businesses (both private and state-run) as the source
from which to pilfer, and they needed state restrictions and dysfunction to create
the widespread need that fueled the black market.

Artists were avid for the new market, but it was understood that every-
thing depended on a precarious subalternity that could not be counted on to
last. Neither Ludwig nor the others, Iván de la Nuez and Juan Pablo Ballester
observed bitterly, "care about particular discourses or talents; it is, rather, to feed
a showcase collectionism that responds to a pre-established code. In that, Cuban
postmodernism will integrate the exotic side streets together with the new art of
the east, Chinese pop, Mexican Frida-ism and other 'othernesses' according to
custom. Perhaps very soon substituted by North Korean surrealism or Haitian
neoconceptualism."[100]

By the mid-1990s, the new Cuban art functioned more as a cluster of careers
than as a movement cohered in cognitive, political, or aesthetic terms. Individual
careers took off in individual directions, no longer dependent on omnibus exhibi-
tions of "Cuban Art" for an airing. Conversation among artists had shifted from
the excited debates of the 1980s to a routine of comparison—sales, invitations,
contacts, and so forth. The industrial streamlining of the processes of inspiration,
conceptualization, fabrication, positioning, and promotion became as close and
intricate as it is anywhere else in the world where artists compete against each
other to sell work.

Dollarization's new socioeconomic reality stretched, even broke, the continu-
ities between the new Cuban art and its familiar universe.[101] Things had changed,
and that change was experienced in the most direct and intimate terms: people
formed under the old ways, in the old times, found themselves out of step with
the new rules. The new Cuban art lived in two times at once, the old one and the
new. "There is no life outside the Revolution," Guevara had said in 1965.[102] But
dollarization had opened an "outside," created a space outside the Revolution's
insatiable appetite for commitment and sacrifice.

The Biennial, despite its idealistic roots, had always had an important commercial function, and in the 1990s it recalibrated into a site based in commodity trading. The sixth Biennial in 1997 was the first to have a gift shop (right across from Kcho's installation), but the seventh was the real watershed: 2,000 international visitors, 1,500 of them from the United States, descended on the city in search of art. Artists reported a virtual frenzy of buyers, with tour buses pulling up in front of one studio after another and people clamoring for works, even bidding on scraps of notes and drawings if there were no paintings left.[103] Meanwhile the Ludwig Foundation, impervious in its Vedado penthouse, had become one of the poshest party spots in town. Busloads of art tourists rolled up there, too, for lovely evening receptions amid the best of Havana's soft breezes and beautiful views. All of this was both noted and promoted by the international media: the next time around, the *New York Times* ran a review of the Biennial under the headline "Visions of Dollars Dance before Cuban Artists' Eyes." "Art has become big business in Cuba," the reporter advised. "While real estate developers and tourist agencies in the United States cannot do business with Cuba, art collectors can, and works of art here are generally considered good investments." "Younger generations of Cuban artists have become savvy about their careers," she notes. "They know the rewards of being noticed during the biennial are fellowships in the US, exhibitions in American galleries, gallery representation and cash from collectors."[104]

Ideology yielded to "humanism" amid art's rotund complicity with the institution of Art, and outsider status—not dissident, so much as disinterested— became an important goal and legend. A proportional protesting, by artists and curators, that they were completely "unofficial," or "independent," underscored the uneasiness prompted by that association. Nonetheless, underground galleries operated with tacit official permission, and even private sales eventually were channeled through official agencies in the process of obtaining the requisite export permits. And so, while the two realms did maintain some separation, a more discrete tension now animated the relationship between artists and power: the principle of simple contradiction no longer had much traction, since interests were now too conjoined to allow for frontal oppositions. In a sense, the extreme interest that the state had taken in art while regulation had focused on content was actually furthered and intensified, if redirected, in the new situation.

The upshot of these tight corners was a new new Cuban art, both continuous with and broken from the original one. There were, it became clear, many new Cuban arts. Cuban art, which had been so closely allied to the everyday of the city—its vernacular, informal routines, customs, and spaces of action and

interaction—became a more typical Art, answerable to criteria of value and meaning only episodically tangent to the everyday and articulating difference from, as much as commonality with, it. Critics and curators faced the same new economy, and opportunities abroad, coupled with enforced invisibility and disenchantment at home, propelled careers and discourse centrifugally and into translation.

A different set of moral expectations attached to this "postpolitical" condition, intertwined with the more transactional nature of an everyday focused on basic survival; a chastening of desire, reined in by the encounter with a reality severed from the abstracted, deferred, utopian dream. Even before 1989, a conviction had already been growing for decades within the web of postmodern discourses that future-oriented rationalities—inherently modernist in their teleological faith—and belief in the possibility of dramatic rupture (revolt, utopia) were both anachronistic and deluded. The end of the horizon is the loss of self-position, conjuring up another boundary, "not the horizon of a voyage" as Jacques Rancière puts it, "but the brink of an abyss . . . the opposite of a promise."[105] With the collapse of European socialism, the primary oppositional discourse vis-à-vis globalizing capitalism, these postmodern acquiescences led to a poetics of the in-between, a politics of the micro, an activism of evasion and deflection. It was a positionless condition sometimes remedied or recuperated as "globalism," and the new ambiguity in the new Cuban art of the 1990s signaled a withdrawal from a specifically Cuban content, turning references to Cuban experience and circumstances into a class of legible signs that signified a distressed but universal situation, more easily digested by the enzymes that break down images of suffering anywhere in the world.

The mercantilization of Cuba, and its footprints on art and life, had been taken up as subject since the late years of the 1980s. On a couple of occasions, Saavedra had offered himself for sale, once as an artist and once as a laborer. In the 1990s the new Cuban art's relation to the expanding web of market forces was visualized again and again: in Ponjuán and Francisco's 1994 magnum opus *Sueño, arte, mercado*; Abel Barroso's *Investment Time* (1998), a metonymic version of Cuban history as succession of commodities—sugar, tobacco, sex, foreign capital—all on a carousel topped with national flags and his *Third World Internet Café* (2000) filled with computers made of cardboard and wood that materialized the dream of First World connectivity into Cuban terms; Los Carpinteros' "ironic hedonism" making fun of the mania for luxury goods (Cuban art);[106] Abigaíl González's murky photographs suggesting sex for sale; Manuel Piña's fake billboards foregrounding tourism against national symbols (*Manipulations, Truths, and Other Illusions*, 1994–95); Beverly Mojena's fashions

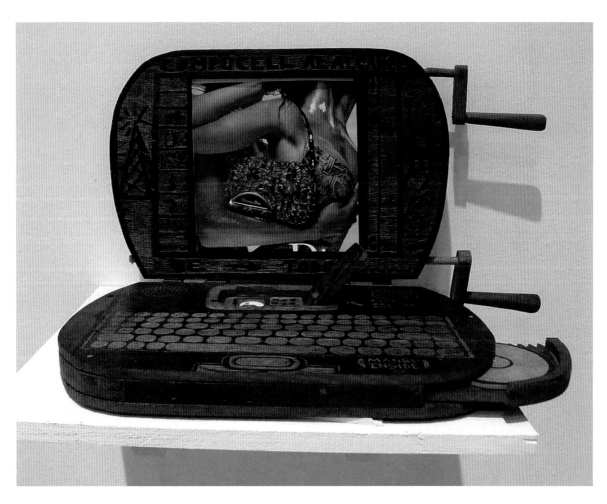

Abel Barroso, *Mango Inside*, from the installation *Third World Internet Café*, 2000. Courtesy of the artist.

and accessories made out of plastic shopping bags; Toirac's copies of Yves Saint Laurent and Marlboro ads inserting Fidel Castro into the familiar logoscapes.

Just as the late-1980s work had reflected the paradigmatic forms of speech of its time as the other, penumbral side of the hypergrammar, so works in the 1990s answered back in the intertwined languages of commerce and glossolalia. When reality has itself become so woozy and fugitive, declarations and descriptions can only skid off its surface, and metaphor located a profusion of ambiguities on either side of its comparative structure. Commerce was the new politics in the new Cuban art, and, as before, artists found themselves both critical and complicit. What was perhaps different than before, though, was that they no longer seemed angry.

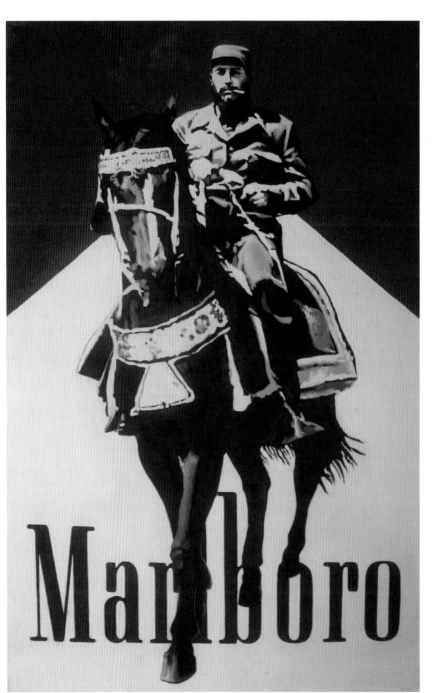

José Ángel Toirac Batista, *Marlboro*, from the series *New Times*, 1995. Oil on canvas; 90 x 60 cm. Copyright Toirac.

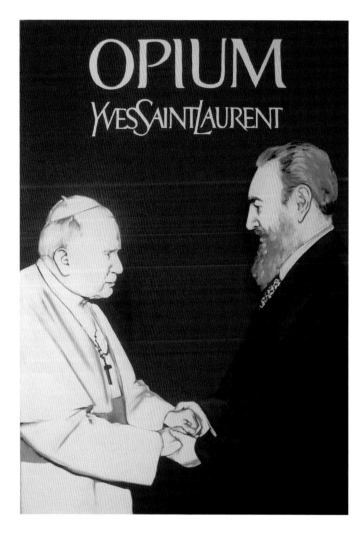

José Ángel Toirac Batista, *Opium*, from the series *New Times*, 1996. Oil on canvas; 90 x 60 cm. Copyright Toirac.

The Organizing Past

*ART OF THE EIGHTIES: Adj. Derogatory nickname used to suggest a feeble person [*hombre ruin*]// Ascep. Socio-political current whose representatives managed to eliminate the defects of the existing society, change its customs, politics and daily life, popularizing ideas of the good and of justice and of scientific knowledge// The art of the eighties was based in idealistic representation related to the determining role of conscience in the development of society// The guys of the eighties did not take into account the decisive importance of the economic*

conditions of development, and so they were not able to discover the objective laws of society, directing their paintbrushes at all the classes and strata of the society, and preferably at the powerful// Their activity contributed in large measure to torpedo the influence of opportunistic ideology// The art of the eighties struggled effectively not only against the myopia of the country's cultural institutions, but also against dogmatism and academic ways of thinking// The eighties, in its beautiful utopia, exerted considerable influence on the formation of the concepts and motivations of the designated representatives of the cynical school of the '90s// Some critics of renown, along with the utopian dreamers, held the ideas of the eighties in the highest esteem. (For more information, see Mexico City)

—DOUGLAS PÉREZ, "ARTISTIC VOCABULARY: MANUAL OF TERMS" (1994)

The question of rupture or continuity between the decades persisted in Cuban art of the 1990s. The problem was postulated in both directions, reflective of the different stakes for arguing the issue. Mosquera had taken to calling the new artists "weeds," suggesting that the soil of Cuban culture had inexorably continued to produce despite the apparently poor conditions for growth offered by the Special Period. (*Succisa virescit*—"Pruned, it grows again," say the Benedictines.) Others, however, perhaps sensing an opening in a time when the more-established critics had largely disappeared from the scene, developed a line of interpretation of the newest art based in assertions of rupture in the form of return—the "return to visuality" and the "retreat into metaphor."[107]

Each argument cuts both ways. While a history written in terms of continuity naturalizes the new Cuban art as a phenomenon with deep and organic rather than faddish roots, it also establishes the conditions for its continuing commercial success according to the dynamics of the familiarity, reliability, and durability of goods. On the other hand, a history emphasizing rupture is more protective of the radicalism and singularity of the new Cuban art in its first decade, while it also frees the 1990s work from the damnation of the copy. Art came under pressure to reinvent itself, both according to and surpassing the terms of the past. All of this left the new Cuban art in a conundrum: in the infidelity to the original that repetition necessarily implies, was there an advance—dialectical or otherwise—or a failure to measure up? In repeating, did the new work set up productive difference or dull sameness?

The turn to metaphor was generally understood in the context of political pressures ("censorship is the mother of metaphor," Borges said), and the return to visuality pertained, it was suggested, to the logic of the marketplace. Both were generally understood as rejections of the artistic approach that preceded the exodus and as a less-conflicted relation to the precepts of Art.[108]

They are both questionable claims, since neither metaphor nor visuality had been expelled in the work of the 1980s, and their presence did not exclude a political core, which is the real subject here. There were two major genealogies in the art of the 1980s, those of Garciandía and of Elso, each promulgated through both example and teaching. The former was what became so explosively visible at the end of the decade, but the other had also persisted and thrived more quietly. And even if we synopsize them as political and critical, in the former, and metaphoric and expressive in the latter, still it was not as though "the Elso zone" had no transgressive force or difficulties cohabiting with power. In fact it was Elso who, among all of the *Volumen Uno* artists, had received the worst treatment, and his students—Luis Gómez, Abdel Hernández, Tania Bruguera, Tanya Angulo—were among the most irascible of their generation. A critical thread ran through the core of the new Cuban art from the very beginning, taking many forms: this was as true of the very gesture of the *Volumen Uno* show as it was for the brickbats of the baseball game. And as for visuality, as the 1990 exhibition *Kuba ok* had made so evident—the new Cuban art was eminently, magisterially visual. Metaphor did not only pertain to evasion, disguise, and dissembling, and visuality did not only appear once a foreign buyer was imagined.

Nonetheless, there were basic changes in the conditions of possibility for art in the 1990s. Not only was politics a deflated and risky arena, not only had the mediating and facilitating layer of bureaucracy been removed: in addition, the entire sense of the visual arts as a community had atrophied. Gone was the tremendous symbiosis among artists, and between them and sympathetic critics: critics, like artists, had either left or been silenced.[109] The Cuban press no longer found space to run the vivid critical debates that had rankled in the 1980s, and in place of a robust dialogue, the norm became description, promotion, and second-hand arguments.[110] (Interestingly, in the United States at around the same time, the criticism program at the National Endowment for the Arts was one of the first victims of the culture wars.) Criticism lost its force, and its generative relation with the process of art making.

The difference between the decades is probably more a matter of emphasis than type, but it is no less fundamental for that clarification. Art in the 1990s was directed not only toward a non-Cuban reader but also toward circumstances that had become more complicated and conflicted, and that were less available to direct perception and analysis. The clear-cut geometries of a critical art engaging a unitary state—if they ever really existed—now lay on the far side of a period in which moral certainties had lost much of their explanatory power and political persuasiveness. Identities, ideals, and ideologies had become impossibly

contradictory and interpenetrated. The situation had become isostatic in institutional terms, stabilized by an equal pressure exerted from various sides. The play, or gaps, that had existed in the 1980s landscape had mostly been either filled by the ever-expanding cultural machinery (itself more and more isomorphic) or erased by security measures. The exodus had somehow stolen the ethical triumph of the 1980s, and what remained were its contradictions. Rereading the new Cuban art from the vantage point of the 1990s, many of its enthusiasms converted into liabilities: political optimism seemed misplaced ("Somehow, we were fooled"); ditto, making work just for the sake of making it, expecting to have real agency as an artist, and expecting things to change. The new politics performed a controversectomy, and both critics and artists delegitimized the earlier, contestatory work as hubristic, as parochial, and as an impoverished artistic language.[111] Its echo, in the form of stylistic device, worked as a kind of anadiplosis, a rhetorical figure that repeated the ending of one phase as the beginning of the next. Anadiplosis is tricky, and can go either way—its repetitions either a source of emphasis or the roots of a syllogism.

For its part, the state had also been gradually replacing politics as the primary icon for Cuba with a more neutral tropicality. New billboards along the highway from Havana to the Playas del Este, for example, beckoned tourists with pictures of smiling *mulatas* alongside the older ones that proclaimed the ongoing struggle and the campaigns to save water and electricity. Another anadiplosis, reaching further back in time.

The decade had begun, metaphorically, on May 10, 1990, when Ángel Delgado went to prison. Delgado's fate was probably the most direct and proximate cause of the various withdrawals and retreats, and from his cell he produced a body of extremely hidden work, recording and encoding the fear and despair that filled his six-month incarceration. He learned a new technique from the other prisoners and began painting used handkerchiefs with beautiful translucent pigments made by mixing colored pencils with cold cream. He painted the religious images that he could barter for cigarettes, but he also painted the darkness of the place, chronicling latrines, rapes, and rumors, and a fantasy of death and rebirth, redemption, release, and refuge. His simple pictographic vocabulary matched the material poverty of means, and the work had a kind of shimmering eloquence as it spoke of horror. Delgado also invented a private hieroglyphic alphabet, with which he filled pages and pages of secret journals diarizing the experience: "acts of liberty," in Mosquera's words,[112] "works of purification, of exorcism, in some way tools to forget, to erase, what had happened."[113]

Ángel Delgado, *Caridad del cobre*, 1990. Colored pencil, cold cream on handkerchief; 46 x 42 cm. Courtesy of the artist.

The exodus and Special Period had been blows against the body of collectivism and solidarity. Bruguera, who straddled the two moments of *Volumen Uno* and the baseball game, felt the loss with particular force, and her 1993–94 project *Memoria de la postguerra* had the utopian ambition of bringing the dispersed, broken body of the new Cuban art back into a totality—not only among those in Havana but rejoining them with those who had left, no matter how provisional and fragile that reunion might be. With *Memoria,* it became clear that the collective was as much a figure of mourning as of generation.

Tania Bruguera, *Memoria de la postguerra I* (Memory of the postwar I), 1993. Editing of a newspaper: collaboration with Cuban artists living in and outside Cuba. Black ink, newsprint; 13.4 x 8.4 inches. Copyright Tania Bruguera. Courtesy of the artist. Photograph by Tania Bruguera.

Strategically, and sarcastically, Bruguera produced *Memoria de la postguerra* as an underground newspaper that collected work from across the diaspora, and its unpublishable compendium concluded with a list of 106 Cuban artists who had left.[114] *Memoria* embodied the camaraderie—protective, jumpy, benighted, and blasphemous as ever—of the new, chastened present. But for all of Bruguera's mournful introductory tone ("'Postwar,' for its resemblance to the physical condition of the city, the interior state of the people, the social nature of art," read the front-page editorial), the paper was marked by a strange mixture of torment and silliness. With its ambiguous logo (the lettering either the work of a rushed street graffitist or else a victim's last words, dripping in blood), mock promotional campaigns (matching plastic ashtrays), articles with a dubiously journalistic gloss and news from the front, *Memoria* was a difficult work to parse, roving among

Tania Bruguera, *Memoria de la postguerra I*, 1993. Black ink, newsprint; 13.4 x 8.4 inches. Copyright Tania Bruguera. Courtesy of the artist. Photograph by Tania Bruguera.

mourning and malice, anguish, and disdain. Ceballos caught the mood with her *Psychiatric Exam of a Post-War Artist,* diagnosing "a noteworthy collapse of the upper cranial area" because of "an excess of cognitive information. Long period exhibited at work on theoretical works and forced concepts," and prescribing "five or six months of rest in the Swiss Alps, or in Cayo Largo" as the cure.

The war was over, and *Memoria* was at the press conference, held at "the Center for the Salvation of Plastic Arts, in the capital." A painter confirmed the rumors, Rafael López Ramos reported, "although an armistice has not been signed."

> Among these photostatic documents was not lacking an image of the members of the distinguished Ditch Diggers and the Laboratory of Anthropological Armaments working in the eastern village of Pilón, nor of the members of the Section of Projects of Social-Military Insertion, who today have bases in some city in Venezuela or travel ubiquitously around various countries in Latin America.
>
> Asked by this reporter about the possibility of a rejoining of forces by the army known in bygone days as *Young Art,* he responded with a laconic "No comment. . . ."
>
> The question that the artist could not answer precisely was the one regarding the exchange of prisoners and the repatriation of war refugees who remain for the most part in camps supervised by the UN in Mexico and the US. Nonetheless, he announced that the matter would be discussed in a meeting attended by both parties at the Prado Museum, neutral territory offered by the Spanish Ministry of Culture.[115]

Memoria de la postguerra was proof: solid, concrete proof of everything that was in danger of evanescing. And, with that squarely on the table, it kept returning to the question, What next? Rejoining forces? "I do not know to what extent or with what views the ranks will again restructure themselves," Bruguera wrote. "A new army advances, along with the survivors, with the given lessons of history, exhausted and alert in other areas, all youth grown violently old. And the latent need, awaiting, again dressed as a bride at the gates of legitimacy still with transcendental hardships. . . . Will we again wait another decade for the forge? Will we again stay by the side of the road, maimed and resigned? Will we again hope to believe ourselves the center of the world at the wrong moment? Do we have enough time left? These are the fifteen minutes that again have been our lot."[116]

The first issue of *Memoria* came out in November 1993, in the depths of the Special Period. The second issue was published in June 1994, if anything an

even worse moment. It hit a nerve: its compendium of bitterness, nostalgia, and mockery revolving, more or less, around the theme of migration (including a snapshot of two jubilant *balseros*) was apparently too much. The paper was censored before it could be distributed, its editorial team was subjected to threats and intimidation (one of them was detained), and that was the end of it.[117] The work had succeeded in the eternal artistic goal of exceeding its own limits: it had "entered the larger society, not as an artwork but as an event," and that had been its downfall.[118]

Bruguera stopped working for some time after that, and when she resumed it was in a changed voice. "I felt I had compromised, and at the same time I worried about how one continues to make work under such circumstances. Do I bend to their demands, or do I do my own work?"[119] She shifted to solo performance, transforming her body into the suggestive site of suffering at which the political was lived and the generalities of society became concrete. Bruguera treated live performance as a possible escape from the typical representational status of a work of art and, therefore, a potential route back to the everyday, a reconnection with a Cuba beyond the new cultural cottage industries. Paradoxically, although performance offered "the immediacy of the need, the intensity of life, and the freedom of the ephemeral," her embodiment of the form led to a brooding, bruised, and cloistered work.[120] The new Cuban art of the 1980s was a forceful referent in the 1990s, present in—because of—its absence, present as both dirge and insistence. It was an impossible and contradictory legacy, something to reject and to recapture, an anguishing loss and a failure better left in the past.

Bruguera was another of Elso's students, and she bore his imprint deeply. Returning to the idea of human flight that her teacher had identified with pre-Columbian myths about shamans and transcontinental unity, Bruguera's version instead conjured an image of incipient catastrophe and radical isolation. In repeated performances of *Estudio de taller* (Studio study) she hoisted herself into metal straps "that act as the bars used by censors," and slumped from the highest part of gallery walls, naked and wordless.[121]

Bruguera's nudity in performance, like her intense concentration, stillness, and silence, created a problematic, difficult intimacy. In *El peso de la culpa* (The burden of guilt, 1997), she strapped the carcass of a lamb—a "shield"—to her body. With a glazed affect she knelt before small bowls containing saltwater and dirt, methodically mixing and eating them until she could not continue.[122] The work, performed in a room of her house in a marginal area of Old Havana, confronted her audience with the surrender and degradation of her act, and humiliated them with their voyeuristic status.

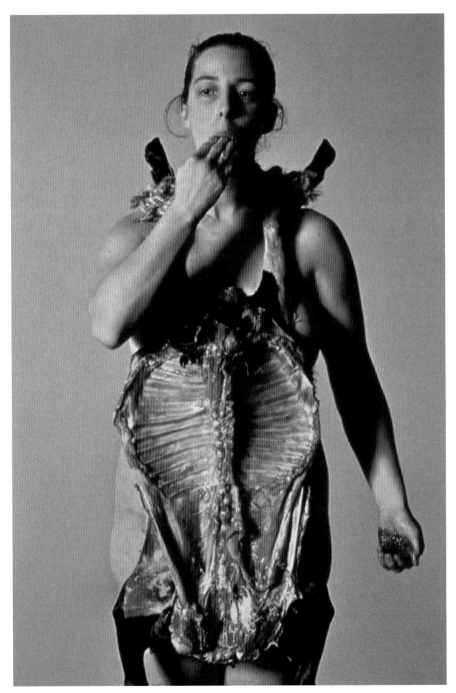

Tania Bruguera, *El peso de la culpa* (The burden of guilt), 1997–99. Reenactment of a historical event. Decapitated lamb, rope, water, salt, Cuban soil; variable dimensions. Copyright Tania Bruguera. Courtesy of the artist. Photograph by Museo de Bellas Artes.

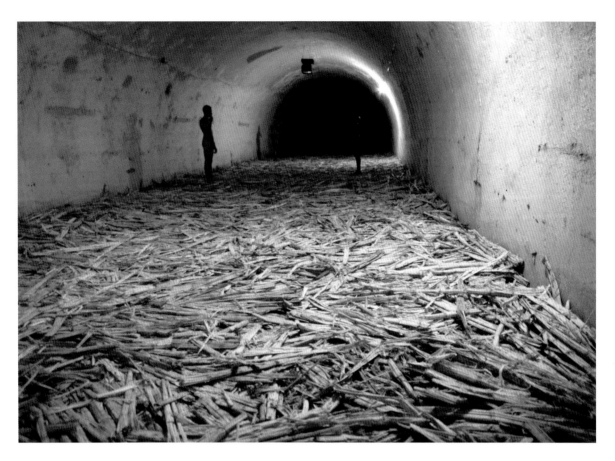

Tania Bruguera, *Sin título—*
Habana, 2000 (Untitled—Havana,
2000), 2000. Video performance
and installation: milled sugar-
cane, black and white monitor,
Cubans, DVD disc, DVD player;
13.12 x 39.37 x 164.04 feet.
Copyright Tania Bruguera.
Courtesy of the artist.
Photograph by Casey Stoll.

Bruguera's highly repetitive and ritualized actions, very ordinary in them-
selves, accumulated psychic force through their multiplication. Toying with the
inevitably theatrical pall of somatic performance is a risky way to work, in which
the solo presence, the atmosphere of dense gravity, the slowness and repetitious-
ness, can easily slide into self-importance and moralizing pretentiousness. These
dangers became even more acute as Bruguera's professional success slowly
moved her into the new upper class and therefore out of the conditions of daily
abjection on which her work often dwelt. She began to address the problem by no
longer performing in the work, instead hiring her neighbors.

They appeared, memorably, in Bruguera's work for the seventh Biennial in
2000. The piece was staged in nearly total darkness in one of the Cabaña for-
tress's stone vaults.[123] A small television hung from the ceiling played a loop of
historical footage of Fidel Castro, mostly seen in more "human" moments. The

video had the effect of deheroizing the figure represented with such enormity in the media; it was an affectionate effect, which somehow shredded the enforced affection of the official representations.[124] Those images hovered in the darkness, and only after some time viewers became aware of the presence of naked men in the room, performing various small, routine gestures—bowing rhythmically, rubbing themselves in motions something like washing. The performers, presumably, were there to communicate, but their "messages" were indistinct to the point of illegibility. ("A gesture," says the artist elsewhere, "is about repeating an action from everyday life and putting it into a conscious space. The gesture creates an atmosphere.")[125] The entire space was carpeted with rotting sugar cane that exuded an overwhelming, sweetly sickening stench, finalizing the work's air of claustrophobia, mystery, and dread. The work suggested private things, pain, an exculpating tangle of sensations and possible meanings. "You are alone here," her accompanying text read, "or not. You are implicated. . . . You've been standing there for some forty years, or maybe five minutes. . . . Your feet sink in the milled, useless and infertile sugarcane as you head back toward the greater light. (Have you always walked this way?)"

Throughout the 1990s, though, Bruguera became more and more unhappy with her work, even as the invitations to residencies and exhibitions abroad multiplied. Bruguera's had been a kind of mourning work, but it short-circuited that task by resolving too easily into Art. A whiff of falseness trailed the work's indelible images and its angst, and a plangently obligatory tone. The work's existentialist perseverations became their own subject. Bruguera, maybe more than anyone else, had been obsessed with longing for the earlier times—not so much for their politics as for the intensity and humanity of their bonds, and the sense of shared responsibility for each other that had underlain everything. That sense may indeed have been mostly a myth, but it was one that had accumulated a lot of traction over the fallow years. After a couple of stillborn efforts to revive her newspaper, Bruguera settled on an approach that returned to one of the earliest gambits of the new Cuban art: teaching. She opened the *Taller Arte de Conducta* in 2003 with the stated goal to "create space for creation and discourse," focused on "the limits of the social body."[126] The project is Bruguera's own quasi-utopian gesture that fosters an artistic practice uncowed by market considerations and based in intensive artistic interaction. *Arte de Conducta* advances a more sociological kind of art, not necessarily, or not exclusively, based in Bruguera's own work but heavily influenced by core commitments to social agency and honest exchange.

A characteristic sensibility and focus developed in the students' work, much of it playing on the edge of legality. The laws in question tended to be those per-

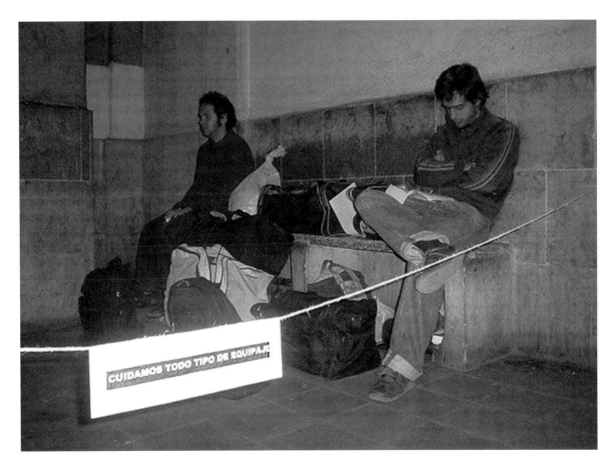

Luis o Miguel (Luis Gárciga and Miguel Moya), *Guarding a Wish*, 2004. Service offered in Cienfuegos city bus station. Courtesy of the artists.

taining to social conditions, the black market, and so forth, rarely touching on directly ideological concerns. Various works provided "services," often of dubious value: Luis o Miguel, authors of the *¿Está en la lucha?* telephone survey, mustered a one-night performance at the Cienfuegos train station consisting in the offer to mind peoples' bags, since there was no baggage checkroom there. The team of Celia y Yunior hung around in front of courthouses and offered themselves as witnesses for weddings (two are required by law) and, in a series of related actions, repeatedly married and divorced each other (there is no legal limit). The marriages had a number of resonances: for one thing, marriage (to a foreigner) is one of the few legal means for leaving the island; for another, marriage (between Cubans) is rewarded by the state with a free buffet for the wedding party—a bonanza that people often resell on the black market. In another piece the artists took on the government's campaign to save electricity by living without

Celia y Yunior (Celia González and Yunior Aguiar), *Marital Status*, 2004–8. Legal action (work in progress): six marriage certificates and six divorce certificates. Courtesy of the artists.

power for six months, then exhibiting the work in the form of the null electric bill. Such work engaged in a kind of game with the ubiquitous systems of control, highlighting the continual fluidity on both sides as people invented new ways to circumvent regulations, which were in turn modified to neutralize the innovations, and so forth in an endless corkscrew of impediments. The works proposed a "third way" to deal with institutions, neither obeying nor disobeying, but using the laws in ways that were not foreseen.

The habitual, mostly petty, criminality that had become standard was a source of humiliation for people at the beginning of the Special Period, but it was soon integrated and naturalized: these works seemed pointed at that cycle of personal absorption and degradation. The encompassing nature of the regulatory state was pushed into the foreground, as was its absence of persuasive operative logics: the state as ideology had been replaced by the state as police, watchdogs, inspectors, and petty bureaucrats, a penetrating disciplinary apparatus standing in for moral certainties.

Bruguera's workshop was the most concerted, programmatic, and systematic of the efforts to make things (as good) as they once were, to remove the neo- prefix from the Cuban avant-garde, to reclaim, as it were, its ability to "reclaim the pasts," rather than just endlessly recycle them. But even that effort, brilliantly

positioned between the institutional and its counter,[127] the international art world and the local situation, has yielded an intense sense of straining at limits that seem more than anything else to be internal. Even an art of withdrawal, as it turned out, an art framed in something like the opposite of asseverations, will eventually frame its own paradigms.

Withdrawal, perhaps, had a neutral moral valence in the fresh wake of the shocks and traumas of the censorships, exodus, and social implosion, but by the end of the 1990s it had decayed into conservatism on both sides. With the institution of art heavily invested in promotional activities and the threat of retaliation against artists for problematic content a more distant specter, many artists, and most officials, could turn their attention to work under the banner of "playing the game." Ponjuán, who, with René Francisco had produced some of the most blasphemous work of the late 1980s, traveled a path from mockery to muttering, disabused of the hope for a work of art to "mean" anything. By 2002 Ponjuán's work was an intentionally banal display, featuring an extended series of drawings based on 1950s girlie pictures. As he saw it, the fixed sense of message that he had tried to impart in his earlier work was a misguided impulse. In its place he suggested a model based on the uncertainty principles of quantum physics, which make it impossible to describe the world with any precision and lead, therefore, to a "diffuse rather than didactic" aesthetic, a withdrawn gaze no longer at risk of being mistaken.[128]

By the end of the 1990s some of the newest youngsters had recognized this warm bath as advantageous and advanced an infirmary aesthetic, an "aesthetic of the zoom" as Glenda León has politely called it. León's attempt to refunctionalize the private, or reinscribe possibility in the detail that is "suffered" in the course of everyday life, according to an admiring critic, "decenters" the spectator from his or her quotidian existence, and provides distance from which to contemplate.[129] "I try," said León, "to be the most *light* possible: the least quantity of weight possible."[130] Among other things, what this Prozac realism yielded in her work was a video composed of a single close-up shot of someone blinking. It was a depressingly chirpy anticlimax to *La Jetée,* Chris Marker's classic work of experimental cinema: León's work dilates on the tiny act, and the extreme close-up, even if it affords new detail, crops meaning so severely as to basically desemantize the work.[131] *Genealogía,* a subsequent piece, lined up three pictures "in chronological order" of TV "On" buttons (American, Russian, Chinese), "allud[ing] to a parallel succession of paradigms in a much wider sphere."[132] Yet another work (*Prolongación del deseo,* 2001–2) panned across the endless queue of people waiting at the famous Coppelia ice cream park, in snapshots taped end to end. The

frustrations and irritations of a daily life largely made up of waiting were trans-
formed into a pretty schadenfreude: the naive pleasure of the work read as an
index of the distance that had opened between the artist and the desperation that
surrounded her in the new Cuban economy. It was a grammar of twee, discon-
tinuous phrases unconnected to any larger unifying forms: although the work's
lightness wanted to argue for a fulcrum point joining the banal and the sublime,
it proffered only a reduced time, telescoped from the historical (meaning, con-
nected to other times) to the space of an instant. When her objects or gestures
snapped into focus (A TV knob! A blink!), they comprised a negative of the tradi-
tion of *verité* with its long, detail-laden takes of the messiness of everyday life,
the pain of duration. To the contrary its truth content lay in this: it was an art that
promised to promise nothing.

Along with this artistic coquetry came a parallel shift in the language of art
criticism. For example, the following linguistic wizardry from Javier Marimón on
the subject of León's work:

> Glenda brings to her messages a formulation of vagueness, of philosophical
> insinuation, for example: *every sound is a form of time;* a sense that does
> not appeal directly to a You [*un tú*], but rather to the totality.... [when you
> encounter one of her messages] you've come to a secret form, that form that
> on its own escapes from whatever separation between the phrase and you,
> and it's not necessary that it be directed to you in particular, but rather to the
> abstraction, that you are also in that moment, that you will believe you are....
> You are not indispensable; she says. Her maturity: she offers you a thought,
> where you can enter, a deep hole; or you can reject it; but nobody obliges
> you; her sinuosity, her indefinition takes shape in you, in your reactions and
> your acts. Another meaning has its origin in censorship.... Glenda adjusts
> meanings in the words, slow, lazy, that do not seep in harmoniously in slippery
> human nature. So she has diluted the gesture in the vacuum, her gesture has
> become the annulment of the gesture, such that it can penetrate every place
> or dimension without forcing itself in a physical labor that tries to accumulate
> more all the time, but rather that in the path of inaction *nothing is left to do.*

In every street there is an empty, tautological phrase left by her, that pinches you in the ass.[133]

Fed up with history, triumphant critics brought a heightened numbness to their expectations for art. Andrés Isaac Santana wrote of the painter Arturo Montoto that his purple, Sovietized academicism "as a whole brings back the often tainted resource of evocation to Cuban art, the somewhat lost possibility of astonishment, and the rescuing of an instant of beauty that the critical, protest-like spirit of many of his homologues had forced into passing away, by virtue of an unbridled abuse of the sociological well and its many contextual derivations."[134] Marimón, writing in 2000 about Jimmie Bonachea and Wilfredo Prieto, connected their work (*Urinario: No, yo no me engaño, yo lo vi*) to the idea of the "dumb" in which an idea is "transposed without proposing a substitute. . . . This piece (p)refers rites, exhausted concepts, *refritos*, lumps of ideology without precise direction."[135] The duo spent two years painting tiny ants—"almost five million," as an eponymous title affirms—to fill in the huge shape of an elephant. And so, as Marimón concludes, "James and Wilfredo, still amused, eviscerate the misery of that exclamation: *Y qué?*" Bugs provided a further platform in 2002 with Adrián Soca and Fabián Peña's collaborative wall drawings, *Biodibujos*, queasy and luscious traceries made entirely of dead insects. The duo kept it up for a couple of years and then appeared in an unfortunate full-page ad in *Art Nexus* magazine in 2005, pictured with their arms around each other and smiling. "Elsoca and Fabián are young Cuban artists represented by Nina Menocal in Mexico City," the copy read. "This photograph was taken earlier this year while they attended the exhibition of their work in Mexico as part of *Landings* [a show in Yucatán]. . . . After the exhibition, rather than returning to Cuba they fled for the USA, literally running across the dangerous US-Mexico border with no more than the clothes on their back."[136]

Prieto had his breakout moment in the 2001 Salón Nacional with *Apolítico*, a stand of thirty large-scale national flags reproduced with all of their colors transposed to a palette of black, white, and gray. As Prieto explained,

I chose the countries according to the flag design. I wanted flags with a minimal look, with general figures and no national shields or intermediary tones. . . . What I do in my work is a kind of poetic association. Symbolic associations too. I take objects and make only small changes to them. And so the point of the work is that you encounter it as though by chance: somehow it is a kind of joke, something very refreshing, as I see it. Because I think it is most important for art to underline, more than to say something—it's like leaving doors open, like opening a door, and not doing much else. That it gives us the chance to look, not so much to receive.[137]

Fabián y El Soca (Fabián
Peña Díaz and Adrián Soca),
Fresco, from the series
Biodibujos (Biodrawings), ca.
2001. Courtesy of the artists.
Photograph by the author.

Wilfredo Prieto, *Apolítico*
(Apolitical), 2003. Installation
at Havana Biennial. Courtesy of
Nogueras Blanchard, Barcelona.

Prieto's flags hailed visitors to the eighth Biennial in 2003, flying triumphantly on the parade grounds in front of the Cabaña citadel. The work's streamlined anti-politics was a hit: "Nothing was redder here," one reviewer dithered,

> than the deep (charcoal) field of the square Swiss banner.... The arbitrariness of national colors and, by extension, boundaries, borders, and identities, whose definitions through policy and negotiation define world politics, hit with the clarifying force of a shot of rum. Were these generic national insignia drained of politics? Were they all bleached by the tropical sun?[138]

Prieto's regalia read very differently on the two occasions on which it was presented in Cuba: the first time, installed on the roof of the Centro de Desarrollo de las Artes Visuales in Old Havana; it had sympathetic vibration with the laundry flapping on a clothesline on the next roof over. For the showing at the Biennial, the flags were hoisted onto portentously high poles and lined up in a march of greatness. *Apolítico* sold for $30,000 (or $65,000: rumors varied), and won the artist—at the age of twenty-five—notice in the *Chicago Tribune,* the *Washington*

Post, and *ArtForum* magazine. If the 1980s had denounced hypocrisy to save the world, the 1990s did it to hoist its career.

It was not simply a matter of reimpoverishment and disenchantment, of failed dreams and new worries, of a broken solidarity and a heightened isolation, although that was a terrible enough litany. But all those dreams had not been everyone's, and they were especially not so much to be found among those born too late to have breathed their fill of the sense of witness and excitement. The lost opportunity of political participation was not necessarily experienced, so much later, as a vacuum, and the new opportunity to compete on a world stage was not necessarily experienced as a substitute. And so forth. Like all messianic movements, the Cuban Revolution had been subject to routinization, to the destabilization of changing political circumstances and to the cycling of generations. The new artistic fundamentalism germinated in a cohort that had been only superficially acculturated to revolution. A link to politics was maintained, but at a lower degree of intensity—"subletting the leftovers of the strong ideas," as Jean Baudrillard once complained.[139] The recognition of the intrinsic politics of art was given over to a practice of art about politics. An antimonumentalist, anti-epic, anti-ethicist position, rejecting the twin missionary pretensions of the regime and of the "spirit of the '80s," along with the art of (bad) manners that the latter was seen to have become, launched a new promotion. It was the soft, second syllable of the trochaic foot of the everyday.

The Memory House

This is what I do. I do it because I like it, but, you, of course, want more explanation. And I can give it to you; I can give you many explanations. I can tell you that what I want is to penetrate your veins, make you laugh, stand behind your eyes and push out a tear. All that, and other things too (theoretical conjuring, rants, justifications…), because this work of art has many layers, many artists. But you want the truth, as always. And that, my dear, I cannot give you. . . . I am sorry; it is not in my best interest.
—EZEQUIEL SUÁREZ, *NEW SWISS ART*

Art in Cuba had ricocheted, within little more than a decade, from one extreme to another, from voices, stances, and—worst of all—dreams supercharged with directives for autonomy, political activism, and conscientization of the society, to a saturated, damaged and sometimes coy professionalism. It boomeranged from extrinsicality to involution, both of them extreme. Part of the problem was that the aesthetic paradigm (modernism) collapsed along with the political paradigm (also modernist, but a different one). It went from one end of the spectrum to the

other, very fast: too fast to be much more than reactive, too fast to understand much beyond the level of sensations and emotions. Too fast to escape the traps of its modernities: as *art*, it was still expected to do something important; as Cuban art, it was expected to maintain a certain exceptionalism; as the bearer of a certain legacy, it was still expected to maintain a certain type of dignity. There is something noxious in this mixture of speed, extremes, and expectations.

Rapid change inflates the value of the archive and encourages a renewed practice of returns and repetitions and other mnemonic devices that keep memory (history) from slipping away. In 2002 the French historian Pierre Nora argued that the "tidal wave of memorial concerns that ha[d] broken over the world," an "age of ardent, embattled, almost fetishistic 'memorialism' was evidence of a modernity preoccupied with the archaic instead of with progress.[140] That "memory" had supplanted "history" was a pointedly historical phenomenon that Nora framed, in the case of 1970s France, as a moment in which the confluence of several factors, including "the aftereffects of the economic crisis . . . and the exhaustion of the revolutionary idea most visibly encountered one another." A parallel kind of confluence coincided with Cuba's tidal wave of museums as well, and, along with all the new secular displays, the Revolution's monuments surged into the revolutionary vacuum. The 1997 return of Che's remains had swelled emotions toward the past and its valorization of sacrifice and struggle, and had reinscribed the Revolution in eternity. The timing could not have been more fortuitous.

Since 1959, time in Cuba had been organized with an almost numerological attention to anniversaries, and it was standard for even the most banal of administrative communiqués to be dated according to the revolutionary calendar. At a time when the identity of the collective had been effectively shattered and, along with it, the "prototypical collective memory," the revolutionary past could no longer serve as "the most potent vector directing historical times toward the future."[141] All this tended to emphasize the memory function of museums over their capitalizing one.

There has always been an odd tension around the question of rupture and continuity with regard to the new Cuban art, and Nora makes some interesting observations in this regard. "Historical time of the revolutionary type is informed by the desire for rupture," he writes, and indeed the entire shape of the Museum of the Revolution's narrative is hinged on the moment of the revolutionary breakthrough. But it is not that simple, since, it seems, the National Museum of Fine Arts was intent against the perception of rupture in its presentation of the new Cuban art. This is perhaps a problem of political (governmental) versus cultural time, in which the latter is not permitted the latitude of rupture independent of

the former: revolution is always in the sticky position of being constitutively in favor of acts of rupture, so long as its own is the last. This is, of course, a position that can be argued only in invisible ink, and so it raises problems in relation to propositions of continuity, "tradition," or "heritage": rupture's loss of a future becomes a de facto restoration of tradition's legitimacy. But it is tradition, in this case, of the sort that the word *heritage* proposes, namely, a distant object, "precious, mysterious, and imbued with an uncertain meaning."

Art's turn from the political to the social manifested the larger turn from history to memory that followed on the insidious, crippling doubts about revolution itself. History—as distinct from memory—typically aspires to scientific status, but Cuban socialism had never been particularly scientific, and when Cuba was cast out of the scientifically minded mother's nest it fell into memory. Remember the Biennial themed about individuals and memory—instead of the historicizing frame of the "challenge to colonialization," which had assumed that all the participants had a collective task at hand. The memory Biennial suggested that memory—as distinct from history—could be emancipatory and sacred, turning it inside out and emptying history of its mission at the same time. And then we could consider the status of testimony: within a collectivized mentality, the testimony of an individual had been understood as an essential reflection of the whole. But absent the collective frame, testimony inverts, and what ensues is a portraiture like Peña's and Moreira's: identity written as the single body represented in its particularities (surfaces) and turmoils, rather than signaled through iconic affiliation or the recitative of the saga. Moving the society's repository from history to memory was not only privatizing, it was also tantamount to saying that the individual's bond to the collective is not constitutive. The Museum of the Revolution had been part of an emancipatory reclamation of a heroic past, but the National Museum of Fine Arts came from a later stage in society and memory that was grounded in loss instead of victory. Cuba's lapse into memory almost seemed like a wounded recognition that it was not able to write history after all.

The country, and the artists, struggling against the impasses offered by both transgression and withdrawal, endured yet another conjugation. This time, it was a suffering undergone without the anticipated reimbursement of deliverance or redemption. Perhaps that was just as well, perhaps it signaled an end to the celibacy of a prolonged catharsis. An entire people, Virgilio Piñera said, can die from light as from the pest.

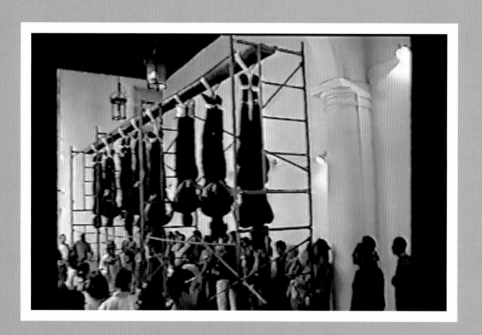

EPILOGUE ON THE HORIZON

Painting the Sky

When we got to the summit the first thing we saw was the sky (hung lifeless and colorless like a kitchen rag in my mother's hands!). It struck us as sad, it struck us as faded, it struck us as something less than a gift . . . so we decided to paint it (not paint it as itself, that is, "to paint the sky," but rather to paint on it, using it literally as a support and throwing paint on it until it looked better . . .)

Still panting from the exertion of the climb and with our blood practically mummified in our veins thanks to the cold, we took out our palettes and brushes, we wiggled our hips and nodded our heads in a show of agreement, and to get rid of the numbness, we started to paint . . .

Look, what took shape on that extraordinary celestial mural was something unique and astounding, simply indescribable:

We painted the experience of the climb and we prefigured that of the descent (that was the worst); we painted the magnificent Heights, the impassable abysses we had just come through, the full moon, the squalid pigs, the irreducible thicket; we painted a bus driving around; two who fainted, a monkey rushing by, and, in the Joaquín Reservoir, a hose (infinite, of course).

We hung around for a minute to look down, to the unfathomable valley (the usual hole of Piñera) and it suddenly struck us as something so foreign, so incommensurably far away and ordinary that we said to ourselves: "It's an ideal place for the human herd—that multitudinous and suffocating flesh—to relax completely and be happy; but not for us, who had just painted the sky, who had thus conquered an Ancient and longed for utopia: that of "high art." . . .

A little later—at dusk—we made a fire, and we fell around it heavily to eat our grub. We were tired, and our figures stood out sharply against the sky, which continued to be monstrously atavistic.

There are photos.

—EZEQUIEL SUÁREZ, "PINTANDO EL CIELO"

At the turn of the millennium the new Cuban art was: recuperative (modestly, conflictively, complicitously, and hopefully); privatistic (whether woundedly, defiantly, selfishly, pragmatically, or mystically); enthusiastically collectivist

(ditto); careerist (in a manner ranging from frank to cynical); innocently ahistorical, dispossessed of dangerous illusions, deprived of compelling dreams, beholden to and fed up with recent history, continuous with the traditions established by their teachers and born of, raised in, acculturated, politicized, and depoliticized by an unnervingly different historical moment. The catharsis of rising up, of speaking out, the catharsis of mass appeal, the catharsis of revolution, the catharsis of opposition, of critique, of illegality, of consequences, the catharsis of disenchantment, disillusionment, disappointment, bitterness, the catharsis of a reviling alienation, of moral contradiction and schizophrenic departure, the catharsis of pains sharply felt—the whole vertiginous, virtuoso, valedictory retinue, aimed at a horizon. "The finished time of tragedy," Marc Augé wrote, making a case for oblivion, and the "continuing time of the return."[1]

Crackdowns, clashes, convulsions, and withdrawals, all have their own rhythms, and in Cuba they have accelerated against each other in a dynamic complicated by the wild card of blowback, of unpredictable impacts and side effects and consequences and haloes. Paradigmatic dualities are one fiction built on the base of another, the cosmically reassuring one of Newtonian physics: for every action, there is an equal and opposite reaction. As though the vectors of force, even if sometimes occulted and occluded, eventually settle into a stable horizon.

Utopia resurfaces as a project, again and again, and there is history added each time. Utopia resurfaces, and to the charms and splendors of beginnings the new Cuban art adds a profound knowledge of disintegration. Utopia resurfaces, struggling against the iron link presumed between it and catharsis. Utopia resurfaces somewhere between or encompassing the filiations of oblivion and the suffering that remembering, inevitably, demands. What work can it do now? Amid the corroded debris of virtually every utopian premise that has been floated, the utopian imaginary—utopia uninscribed, undetonated—remained the itch somewhere deep inside, a palimpsest, an alluvial deposit, something like the stiff neck that comes from wrestling in a dream. Utopian imagining comes from awareness on some level of this persistence, at once determined to pursue, yet even more frightened of, the lingering impulse for utopia. Utopia resurfaces in the hothouse environment and the astounding, careening, terrifying speed of transformation.

What must be acknowledged is that the new Cuban art's period of luminescence reflected not only the percussion flakes of political conflict but also the cultural energies and commitments that have also characterized revolutionary Cuba. In retrospect now, and perhaps in disillusionment, it is worth remembering the historical fact that what was one of the most adventurous, audacious, and lively experiments in contemporary art arose precisely from the struggle to build

a more equitable society. These days, Cuba is a country depleted by experience and well instructed in the pitfalls of utopia, and culture is a means for increasingly distant purposes. How, without falling back on the strategy of hope, will the new Cuban art ensure—as it seems to still insist—that the question of culture remains one of exquisite importance? The answers may well be more entangled and anxious than the question seems to prefer.

Importantly, in the era of great conflict between artists and state, despite the vehemence of the disputes and the severity of their outcomes, those clashes were fueled above all by the force of conviction, on both (all) sides, and the cultural landscape was given deep sense by the importance of returning again and again to those sites of conflict. All that returning, all those inflections and relocations, like Ariadne's thread trying, somehow, to work back through the interminable labyrinth of losses, problems, distractions, and reactions, to work back to a clearer idea, a less-conflicted one: to fix a horizon. The quite possibly impossible task, of trying to—without illusions—avoid disillusionment.

Ever since the beginning the new Cuban art has been watched, in a deepening maze of watching and being watched and watching-being-watched. Probably more than any other country in the world, Cuba has been subject to intense and enduring scrutiny since the first moments of the Revolution's assumption of power. This scrutiny has been directed at the island from an almost unlimited array of perspectives, ranging from ultraconservative, anticommunist, and revanchist perspectives to Trotskyite, Bolivarian, and unrequitedly utopian positions that have demanded that Cuba realize and manifest the dreams so disappointingly foiled elsewhere in the continent and the world.

Each story asserts a shape, establishes a perspective, locates a horizon. The insistence on the horizon comes, I think, from all of this doubleness, this maze of reflections that has accumulated around, on, and inside of the new Cuban art. There, in place of a fixed (fixable) horizon, there were constantly changing ones. Those difficult, scarred horizons, that didn't resolve into a simple emotion, that didn't arrive at the end of their own pattern, that didn't languish in a full circle, that didn't put the epiphany at the end. Those regal, demanding, impossible horizons, placed in the past, hung by their heels, placed underfoot. Those puzzling lines, those inescapable contradictions haunted by the problem of ending, of keeping the anger from resolving into declarations or prognosis. The horizon is a puzzling line, half drawn by the new Cuban art and half filled in by its telling. The horizon is an obstinate notion, an implacable one even, and it is the last image I turn to here. The horizon of the page, a page among many pointed to the horizon.

That cursing and dreaming line, drawn in the dark. By mid-2002 the impact of 9/11 was everywhere in Havana, with empty hotels and beaches and larders, and Venezuela canceled the advantageous oil contract that had been in place, causing a new shortage and an impossible price increase. "Cuba for the Cubans," people quipped, except they can't afford it. Lifelong Havana residents recalled the city in its prime, the eclecticism of its architecture, the finery of the shops, the pace of life on the streets, with a mixture of pleasure and anger. One night at dinner a friend told me about the tunnels under Havana. They're all over the place, dug during the Special Period supposedly as air raid shelters (because the Yankee invasion was, they said, after all those years really coming this time), but really—or partly—to give all those out-of-work people a job to do. One day the project was mysteriously halted, as suddenly as it began, and then teenagers invaded the tunnels and turned them into subterranean discothèques. He told me all of this fantastically, accompanied by exclamations and gesticulations, and by the end it had become a full-scale epic with cave mouths and the horror of the underworld, a bijou nightmare weirder than Poe. And then burst out laughing.

NOTES

INTRODUCTION

1. Hermann Broch, *The Sleepwalkers*, 5th ed. (New York: Vintage Books, 1996), 482.

2. Guevara was captured on October 8, 1967, and killed the next day in La Higuera.

3. Apparently, Guevara's coffin is empty, since his remains were buried in a new mausoleum in Santa Clara, the site of his most important revolutionary battle. His hands, however, did remain in Havana, or at least according to visitors who claim to have been shown them in the Museum of the Revolution: the hands were amputated at the time of Guevara's death and sent to Castro.

4. Freddy Alborta, author of the famous photograph of Guevara's corpse, ascribes a profoundly religious sense to the image: "I had the impression that I was photographing a Christ, I had in fact entered that dimension. It was not a cadaver that I was photographing but something extraordinary. That was my impression, and that is perhaps why I took the photographs with such care: to demonstrate that it was not a simple cadaver" (quoted in Jeffrey Skoller, "The Future's Past: Re-Imaging the Cuban Revolution," *Afterimage,* March–April 1999, 14).

5. Fidel Castro, *Palabras a los intelectuales* (Havana: Ediciones del Consejo Nacional de Cultura, 1961), 11. Castro was not alone in formulations of this sort within the world socialist camp: in December 1961 the Hungarian leader János Kádár, who had earlier led attacks against "mavericks" (including liberals, reformists, and communists), announced a new policy under the slogan "He who is not against us is with us." This was a modification of Mátyás Rákosi's much less ambiguous earlier statement, "He who is not with us is against us." Kádár's puppet government launched a general relaxation of the worst excesses of the secret police in the post-1956 period, leading to the nicknaming of Hungary as "the jolliest barrack" in the socialist camp.

6. In a 2000 text the literary critic and editor Desiderio Navarro catalogs some of the questions that "never got a well-developed, clear and categorical answer" as follows: "Which events and processes of Cuban social and cultural reality form part of the Revolution and which do not? How can one distinguish which cultural texts or practices act against the Revolution? Which act for it? And which simply do not affect it? Which social criticism is revolutionary and which is counterrevolutionary? Who decides what is the correct answer to these questions? How and according to what criteria is this decision made? Does *not* going against the Revolution imply silence on the social ills of the pre-Revolutionary past that have survived or on the ills that have arisen due to erroneous political decisions and unresolved problems of the revolutionary period? Doesn't being for the Revolution imply

publicly revealing, criticizing and fighting these social ills and errors? And so on" ("In Medias Res Publicas: On Intellectuals and Social Criticism in the Cuban Public Sphere" [presented at the international conference "The Role of the Intellectual in the Public Sphere," organized by the Prince Claus Fund, Beirut, February 24–25, 2000]; reprinted in *Nepantla: Views from the South* 2 [2001]: 356).

7. The 1976 Cuban Constitution had stipulated a sharp division between form and content, decreeing, "Artistic creation is free, always when its content is not contrary to the Revolution. The forms of expression in the arts are free" (chapter 4, article 38 [2d]).

8. Throughout the 1960s a rapid process of revolutionary transformation brought not only social benefits (especially in housing, education, and racial equality) and a population "increasingly enrolled in, and empowered through, the various tasks of defense and socioeconomic revolution," as the historian Antoni Kapcia has described it, but also a mounting sense of economic and political crisis (*Havana: The Making of Cuban Culture* [Oxford: Berg, 2005], 119). Hostility from the United States began as early as Castro's April 1959 goodwill visit to New York and rapidly escalated into the embargo (autumn 1960) and the Bay of Pigs invasion (April 1961). The missile crisis of October 1962, attacks by counter-revolutionary "bandits" fighting the new regime from the Escambray mountains, and political divisions within the revolutionary directorate all radicalized the sense of isolation and siege on the island: the distance from Castro's 1961 proclamation to his words in 1971 reflect this process and its implications for culture.

Probably the most infamous episode was the "Padilla affair." In 1968 the poet Heberto Padilla won the UNEAC (Union of Cuban Writers and Artists) Prize, awarded by an international jury for his collection of poems *Fuera del juego* (Out of the game), but was not permitted to receive it: one poem, it was alleged, was "insufficiently committed." Padilla had already denounced the stifling atmosphere of the Cuban cultural scene in the Young Communist periodical, *El Caimán Barbudo,* for which he had been denounced, in turn, by Lisandro Otero, a prominent editor and novelist. The following year, Haydée Santamaría, the revolutionary veteran and president of the Casa de las Américas, explained to the competition jury that "nonpolitical" was an unacceptable political position for any artist. While Santamaría's requirements issued from the civilian side of Cuban society, the military was becoming increasingly involved in the oversight and direction of the country's cultural activity, and *Verde Olivo,* the organ of the armed forces, attacked Padilla and other writers "whose spinelessness," as they put it, "is matched only by their pornography and counter-revolutionism" (quoted in Hugh Thomas, *Cuba: or the Pursuit of Freedom* [New York: Da Capo, 1998], 1466).

The Padilla scandal crescendoed in his arrest on March 20, 1971, without charges and apparently by personal order of Castro. Many well-known European and Latin American writers, including Jean-Paul Sartre, Simone de Beauvoir, Octavio Paz, Carlos Fuentes, Gabriel García Márquez, Mario Vargas Llosa, and Julio Cortázar—an impressive list of supporters of the Revolution—sprang to his defense with a letter published in *Le Monde* expressing their "misgivings" and calling for Padilla's release. These criticisms, along with those that had arisen after Castro's approval of the 1968 invasion of Czechoslovakia, converted the ranks of foreign, leftist intellectuals who had been so supportive of the Cuban revolutionary process into a "mafia" of "false intellectuals," "petit-bourgeois pseudo-leftists of the capitalist world who used the Revolution as a springboard to win prestige

among the peoples of the underdeveloped countries" and who were denounced for their pretension "to act as judges of the Revolution" ("Declaración del Primer Congreso Nacional de Educación y Cultura," *Casa de las Américas,* nos. 65–66 [1971]: 4–19; quoted in Navarro, "In Medias Res Publicas," 358). A complicated web of discourses anathematizing critical interventions into "extra-artistic" matters such as social ills and political errors eventually produced a landscape in which criticism by artists and intellectuals was discouraged, suppressed, repressed, and punished, sometimes with severity.

On April 30, 1971, Castro closed the Congress on Education and Culture with his second dictum on culture, considerably more notorious than the first: "Art, a Weapon of the Revolution." If the ambiguity of Castro's earlier pronouncement was what had allowed for the cultural vibrancy of the 1960s, the militaristic metaphor of the second left little doubt about culture's new prospects. If the first demanded that all artists inscribe themselves and their production within the amorphous space of the revolutionary process, the second provided marching orders for a no-longer amorphous fact.

Padilla was released after a month and, in a forced public confession at UNEAC in late April, admitted to being "defeatist," "counterrevolutionary," "malignant," and "ingrate" (virtually the same vocabulary that had been used in the attacks on him), and called for his audience to redouble their optimism as "soldiers of the revolution." International reaction was fierce: protest letters comparing his confession with "the most sordid moments of the era of Stalinism" were signed by, among others, Pier Paolo Pasolini, Sartre, Susan Sontag, Paz, Italo Calvino, Marguerite Duras, Heinrich Böll, Hans Magnus Enzensberger, García Márquez, Fuentes, Vargas Llosa, and Cortázar (who later changed his mind), and appeared in newspapers in Mexico, Madrid, Buenos Aires, Paris, London, Rome, and elsewhere. The Revolution's identity as darling, both within and outside Cuba, was slipping away.

Even before the Padilla affair, there had been political and cultural confrontations between an orthodox and a more liberal cadre of the Revolution's leadership. These were at times quite intense, and spasms of censorship, marginalization of intellectuals, and ideological aspersions and denunciations had been sprinkled across the revolutionary period almost from the start. Sabá Cabrera Infante's film *P.M.* was not allowed to screen publicly in 1961, and in 1965 the UMAP reeducation camps (Unidades Militares de Ayuda a la Producción [Military units to aid production]) were established to rehabilitate dissidents and "social deviants" including Jehovah's Witnesses, Seventh-day Adventists, and homosexuals. Independent cultural venues were closed, most notably the newspaper supplement *Lunes de Revolución,* which had grouped together a dynamic and rebellious mix of young writers, artists, and musicians who considered themselves the Revolution's cultural arbiters, but whose vanguardist internationalism and tendency to see the writer as critical social conscience came into increasing conflict with the Revolution's evolving ideas of culture as a popular and collective activity.

9. Navarro, "In Medias Res Publicas," 357.

1. EVERYDAY

1. A similar point is made by the art historian Juan Martínez with regard to vanguard Cuban art of the 1920s and 1930s: "Along with the rejection of nineteenth century academicism and the embracing of an emotive and expressionist art, the belief in the realist

credo of art as an expression of everyday contemporary life, of the here and now" (*Cuban Art and National Identity: The Vanguardia Painters, 1927–1950* [Gainesville: University Press of Florida, 1994], 11).

2. Sylvère Lotringer, ed., *Foucault Live: Selected Interviews, 1961–1984* (New York: Semiotext(e), 1989), 434, 436.

3. Ibid., 305.

4. Benjamin Buchloh, "Interview with the Artists," in Luis Camnitzer, *New Art from Cuba* (Old Westbury: Amelie Wallace Gallery/State University of New York/College at Old Westbury, 1985), 7.

5. Iván de la Nuez, "Rubén Torres Llorca," in *Rubén Torres Llorca: Historias de amor y de muerte* (Mexico City: Ninart Centro de Cultura, 1992), 4.

6. For an extended exploration of Cuban cultural politics both prior to and immediately following the Revolution, see John Loomis, *A Revolution of Forms: Cuba's Forgotten Art Schools* (New York: Princeton Architectural Press, 1999).

7. Fernando Martínez Heredia, "In the Furnace of the Nineties: Identity and Society in Cuba Today," in "From Cuba," ed. John Beverley, special issue, *boundary 2* 29, no. 3 (2002): 142.

8. Quoted in Armando Hart Dávalos, *Changing the Rules of the Game* (Havana: Letras Cubanas, 1983), 59. Almost a century later, the displaced Ana Mendieta remarked: "If my branches are North American, my trunk is Cuban" (quoted in Laura Roulet, "Ana Mendieta and Carl Andre: Duet of Leaf and Stone," *Art Journal* 63, no. 3 [2004]: 84).

9. In the case of painters such as Carlos Enríquez, this depiction broke from rural idylls to include a strain of social protest alongside the mythical identifications, registering the miserable conditions in which *guajiros* actually lived.

10. Manual Vidal, writing in 1974 about Grupo Origen (quoted in José Veigas, Cristina Vives, Adolfo V. Nodal, Valia Garzón, and Dannys Montes de Oca, *Memoria: Cuban Art of the Twentieth Century* [Los Angeles: Cuban International Arts Foundation, 2002], 200).

11. Alberto Quevedo, writing in 1978 about Grupo Versiones del Paisaje (quoted in Veigas et al., *Memoria,* 203).

12. The point is made by Juan Martínez in "Cuban Vanguardia Painting in the 1930s," excerpted in Veigas et al., *Memoria,* 55. This strain of social protest and criticism was also registered in the novels of Luis Felipe Rodríguez and the poetry of Nicolás Guillén.

13. The review bore the prosaic title of *Arte y ganadería* ("Art and cattle-raising").

14. Hart, *Changing the Rules of the Game,* 25, 31.

15. Leandro Soto tells of a diplomat working in the Polish Embassy who used to funnel copies of a Warsaw art magazine to him and his friends: "The magazine *Polonia* was very important to us artists, since it had pictures of artworks from Poland, that were very up-to-date with what was happening internationally. So, through that magazine we found out about what was happening in the world" (Soto, interview with author, Phoenix, Arizona, March 22, 2003).

16. The painter Consuelo Castañeda put it this way in 1986: "Humberto [Castro] had a show entitled 'Black and White' with very sexually aggressive drawings. They went on exhibit and nothing happened. There was a time when this was a taboo, but that's no longer the case. Everything changed when the Ministry of Culture was formed in 1976. Armando Hart, who was put in charge, made it clear that we too are Western, thus freeing us from a very oppressive taboo. . . . The generation of artists that emerged after the triumph of the revolution developed a completely representational aesthetic. Besides, their work was totally political, pamphleteering, if you will. It got to the point that if somebody died for the revolution 100 prints or paintings were turned out. It was embarrassing. It was opportunistic, there can be no other explanation. We rejected artists. The day I need to make politically committed art I'll do it for my own reasons, not out of opportunism" (quoted in Coco Fusco and Robert Knafo, "Interviews with Cuban Artists," *Social Text,* no. 15 [1986]: 44).

17. The participants were Bedia, Juan Francisco Elso, José Manuel Fors, Garciandía, Israel León, Rogelio López Marín (Gory), Gustavo Pérez Monzón, Brey, Tomás Sánchez, Soto, and Rubén Torres Llorca. Osvaldo Sánchez has suggested that *Volumen Uno*'s preeminence as the moment of rupture has been overemphasized, and suggests the slightly later *Jóvenes Artistas: Retrospectiva* exhibition (October 1981, Salón Lalo Carrasco, Habana Libre Hotel) in its place ("Flavio Garciandía en el Museo de Arte Tropical," in *Flavio Garciandía* [Monterrey: Galería Ramis Barquet, 1995]). That exhibition, organized by Garciandía, Gerardo Mosquera, and José Veigas, did indeed include many more artists than *Volumen Uno,* including some who were notably absent from that earlier show, most especially Arturo Cuenca. *Jóvenes Artistas,* unlike *Volumen Uno,* however, included a wide spectrum of artists, from the young rebels to the most establishment, conservative painters, which made it less of a turning point than a general medley. On the other hand, its catholic scope (similar in this sense to *First Look: 19 Young Artists from Today's Cuba* shown in November of the same year at the Westbeth Gallery in New York City and organized by, among others, the Center for Cuban Studies) tended to collapse what had otherwise been understood as a radical difference between the two rosters of artists. Interestingly, the review of *Jóvenes Artistas* in *Juventud Rebelde* by Alejandro G. Alonso mentions works only by the upstart artists: Bedia, Pérez Monzón, Torres Llorca, Soto, and Brey (Alonso, "Exponen nuestros más recientes creadores," *Juventud Rebelde,* October 21, 1981, 4). In any case, it was *Volumen Uno* and not the other exhibition that provoked a strong public debate, and for that reason it seems justified to accept it as the watershed moment that it is often considered to have been.

18. Osvaldo Sánchez, "Sincretismo, postmodernismo y cultura de resistencia," in *Kuba OK: Arte actual de Cuba* (Düsseldorf: Städtische Kunsthalle Düsseldorf/Centro de Desarrollo de las Artes Visuales, Havana, 1990), 23.

19. Gerardo Mosquera, interview with author, Havana, March 26, 2002.

20. In fact, the word *curator* was hardly used in the Cuban context at the time: those who organized shows, throughout the 1980s, were generally referred to as "cultural promoters."

21. According to Soto, this was a deliberate strategy to defend the artists from political attack. As he explains, "The strategy we used was to invite the entire officialdom so that . . . they could see we were not against the establishment, that we wanted to make whatever

we pleased, or rather, look, this is not political . . . that we were not acting against the revolution. . . . Then, so they could see that we were not making, planting bombs, or taking shots, come to the opening so they can see. So that was the way we protected ourselves" (Soto, interview with author).

22. Flavio Garciandía, interview with author, Monterrey, Mexico, April 19, 2003. *Volumen Uno* was not the first exhibition to have been thwarted. Six of the *Volumen Uno* artists (Bedia, Elso, Fors, Pérez Monzón, Brey, and Torres Llorca) had planned to exhibit together in August 1978 in the Galería L exhibition *Seis Nuevos Pintores*: the exhibition was canceled by Teresa Crego, a gallery functionary, because of what she claimed was "a general lack of quality . . . because the general impression of the show was negative; and because the work was a reflection of ugliness and unpleasantness in our reality" (Crego, interviewed in 1968 by Julio Izaguirre Vichot, untitled PhD dissertation; quoted in Luis Camnitzer, *New Art of Cuba* [Austin: University of Texas Press, 1994], 1–2).

In 1979 many of the same artists (Bedia, Brey, Sánchez, Gory, Garciandía, Fors, Pérez Monzón, Emilio Rodríguez, Torres Llorca, Elso, Soto, and Carlos José Alfonso) organized *Pintura fresca* (Fresh paint), which was first presented at Fors's house. Staging the show in a private home was a way to put pressure on the system to make room for their work, and it worked: the show was subsequently booked into the Galería de Arte de Cienfuegos (November 1979). Soto, who had volunteered to be the gallery's curator, invited the rock group Liga Social (Social Bond) to play at the opening: according to Soto, "the local police intervened because of the ruckus and the next day rumors spread that we had all gotten naked in an act of rebellion. Once more the popular imagination exaggerated things" (Soto, "Ancestros" [Ancestors, 1979], reprinted in Coco Fusco, ed., *Corpus Delecti: Performance Art of the Americas* [London: Routledge, 2000], 274).

Several of the *Volumen Uno* artists had already participated in exhibitions with titles like *Sandino y Nicaragua en la plástica cubana* (Pérez Monzón) and *Exposición colectiva en homenaje a Martí* (Brey), and this did not automatically stop with *Volumen Uno*: in August 1981 Bedia, Cuenca, Fors, Elso, Garciandía, Gory, Pérez Monzón, Brey, Torres Llorca, Tonel (Antonio Eligio), and Soto made up eleven of the twenty-four artists participating in the exhibition *Después del Moncada* commemorating the "heroic gesture" at the Moncada barracks in 1953, the official beginning of the revolutionary struggle. The show was organized by the Brigada Hermanos Saíz (the cultural arm of the UJC [Union of Young Communists]) in the Galería 23 y 12 and was meant to provide tangible evidence of the "New Man" born in Cuba under socialism and revolution (all of the participating artists were born after the Moncada assault).

23. Tom Stoppard, *The Coast of Utopia II: Shipwreck* (London: Faber and Faber, 2002), 55.

24. Leandro Soto, e-mail to author, July 25, 2004.

25. Gerardo Mosquera, e-mail to author, July 27, 2004.

26. Angel Tomás González, "Desafío en San Rafael," in *El Caimán Barbudo*, the "Cultural Magazine of Cuban Youth," *La Habana*, no. 159 (March 1981): 7, 27, quoted in Veigas et al., *Memoria*, 456. "*Volumen Uno* is a statement in favor of 'change' in our art," González sniffed. "In general, the works exhibited—except for Tomás Sánchez's landscapes—promote a dedication to an artistic creativity essentially rooted in formalism and, therefore, in

the reduction of the communicational signs enclosing conceptual references to a given immediate reality. The exhibit falls into a fallacious homogeneity with a kind of cosmopolitan art that feigns ignorance of all geographical or ideological borders and thus leans toward the abandonment of any identification with the values that define our national identity. But this aesthetic attitude can imply the danger of taking a bearing from the route chartered by the 'vanguards' promoted and manipulated by the metropolitan powers. . . . With this exhibit of their works the group has proved that it has the technical skills to work with what is known as the newest tendencies. From this moment on, the challenge they face is to be more demanding with themselves so that they will turn out works with more comprehensive aesthetic results and, therefore, derived from an artistic conceptualization in harmony with the social and spiritual values of the reality in which they exist."

On the other hand, Alonso published a favorable review in *Juventud Rebelde,* providing crucial support in that official forum. A year later, when Bedia won the grand prize in the 1982 Salón Paisaje, Tomás again attacked and Alonso again defended.

27. Carol joined the Teatro Escambray in 1971 and founded the "Painting Debates," another experiment in socialized art making.

28. Various historical parallels ricochet between the vanguardist generation of Cuban painters and the *Volumen Uno* generation. On the most basic level, the 1920s vanguard was the first Republican-born and -formed generation (Cuba became a republic, at least in name, in 1902), while the initial cohort of the "new Cuban art" was the first one born and socialized under the Revolution. Both, it was murmured at times, had accomplished nothing more than a modernization of the artistic language, while in fact both groups were involved in efforts more far-ranging, and more political in essence, than that charge would seem to reflect. The former group was intent on modernizing Cuban society, a process that, as was typical in the Caribbean, had an important relationship to the anticolonial struggle. The 1920s vanguard, including Amelia Peláez, Carlos Enríquez, Eduardo Abela, and others was one aspect of a generalized critical movement among the Cuban population for reform, nationalist and intent on achieving sovereignty vis-à-vis the United States, ending the corrupt rule of Alfredo Zayas (1920–24) and then the Machado dictatorship (1928–33), and meanwhile, through art and literature, renewing Cuban culture and identity. Like their predecessors, the artists of the *Volumen Uno* generation treated the received, sacred cows of *cubanía* with utter disregard, instead asking the question about who they were in direct relation to the actual circumstances of the island and its being-in-the-world.

Furthermore, in the shift made by the second wave of vanguard painters in the 1930s (which emerged around Lezama Lima and the Grupo Orígenes—Mariano, René Portocarrero, Roberto Diago), there is a parallel to the transition from the 1980s to 1990s. In both moments, artists reacted against the "social" focus of their predecessors and moved toward a more "introspective sensibility, although without abandoning the nationalist preoccupation, now directed toward a 'Cubanness of essences'" (Gerardo Mosquera, "The New Cuban Art," in Aleš Erjavec, ed., *Postmodernism and the Postsocialist Condition* [Berkeley: University of California Press, 2003], 210). With Wifredo Lam, the project of refusing Europe, and particularly Paris, goes even further, becoming a project of constructing a national, even Caribbean, aesthetic and symbolic language by incorporating European modernism as an element or structure in a local discourse. In the 1950s Los Once opposed what had devolved into the "School of Havana," with its "redundancy

extended toward a 'Creolist' mannerism" and "tropical sweetness," and strove to achieve a "more international discourse." They were also important for their maintenance of a political stance against Batista: "Abstraction was for them a critical instrument, culturally nonconformist" (Mosquera, "New Cuban Art," 211). "A revolution of forms is a revolution of essentials," José Martí once said, and the new Cuban art thus inherited both the aspirations of the Revolution and also of those early avant-gardes, with their revolutions of forms.

29. Garciandía, interview with author.

30. Mosquera, "New Cuban Art," 217.

31. Soto, "Ancestros," 271.

32. Among others, the exodus included thousands of petty criminals who were released from the country's jails for export to the United States.

33. Quoted in *Granma,* April 13, 1980, and in Silvia Pedraza, "Democratization and Migration: Cuba's Exodus and the Development of Civil Society—Hindrance or Help?" (paper presented at the 2001 meeting of the Social Science History Association, Chicago, November 15–18, 2001; updated July 2002, http://www.pdc-cuba.org/DEMO_MIGRA.htm).

34. Quoted in *Granma,* April 22, 1980, and in Pedraza, "Democratization and Migration."

35. Osvaldo Sánchez, quoted in Kevin Power, "Cuba: One Story after Another," in *While Cuba Waits: Art in the Nineties* (Santa Monica, Calif.: Smart Art, 1999), 44.

36. Luis Camnitzer, "Access to the Mainstream," reprinted in Jane Farver, ed., *Luis Camnitzer: Retrospective Exhibition, 1966–1990* (New York: Lehman College Art Gallery, 1991), 41.

37. The young artists lived modestly, mostly from salaries earned at parallel jobs. In 1982, for example, Bedia was working in the Casa de Cultura del Municipio de Marianao as instructor of Plastic Arts (he later became a conservator/restorer at the National Museum of Fine Arts), and Pérez Monzón and Brey were instructors of Plastic Arts in the Casa de Cultura de Jaruco.

38. Ana Mendieta, quoted in Eva Cockcroft, "Culture and Survival," *Art and Artists,* February 1983, 16, and in Roulet, "Ana Mendieta and Carl Andre," 84.

39. Juan Francisco Elso, quoted in Gerardo Mosquera, "Last Conversation with Elso," *Revolución y cultura,* no. 5 (May 1989): 21–23. In 1977 President Carter lifted the ban on travel to Cuba (in place since 1973), and Mendieta began looking into how to make the trip. A series of back-channel conversations known as *el diálogo* through the late 1970s eventually led to agreements to grant exit visas to some political prisoners and allow expatriate visits to family on the island, among other things. Mendieta returned for the first time in January 1980 under the auspices of the Círculo de Cultura Cubana, and made seven trips between then and July 1983: she was the first exiled artist granted permission to work and exhibit on the island (Roulet, "Ana Mendieta and Carl Andre," 89).

In Bedia's view, Mendieta's initial revolutionary conviction in 1980 was sharply affected by her inevitable run-ins with the Cuban bureaucracy during her visits: "After a threatening altercation with Cuban customs officials in 1983, she did not return" (ibid., 91).

40. Cuban Constitution, chapter 4, article 38 (2d).

41. Garciandía, interview with author. The term *contenidismo programático* refers to the absolutization of the content of the work above and beyond the form.

42. The "massification" of culture became an important priority early in the 1960s, in order to transfer ownership of culture beyond the confines of specialists and professionals. Among the undertakings toward this end was an extensive project begun in 1961 to train art instructors: by 1963, graduates of the program were working in local schools and factories, and by 1969 the program had graduated around twenty-thousand instructors. Coming on the heels of the first explicit tensions between the revolutionary directorate and parts of the Cuban cultural avant-garde, the program had a clearly ideological and partisan profile and was, among other things, a means to lessen the credibility and clout of the "nostrums of a self-appointed vanguard." See Kapcia, *Havana,* 135–36.

43. Arturo Cuenca was probably the artist whose conceptualist intuition was strongest. Excluded from *Volumen Uno* because he was considered too much of a loose cannon to be trusted with handling the show's potentially volatile fallout, Cuenca was present but somewhat at the fringes of the scene in the early 1980s. Early on, Cuenca explicitly identified his practice as related to philosophy and critique, identifying those discourses as intrinsic to knowledge, progress, and revolution. His early work addressed questions of perception, incorporating science and ideology into its explorations along with aesthetics, psychology, and the history of the site. His explanations of his work tended to be full of references to philosophy, aesthetics, Marxism, perceptual psychology, science, ethics, semiotics, "para-consciousness," and "revolutionizing" the spectator. His texts were also almost uniformly difficult to penetrate or to square with the works themselves (which were mostly photographic, with another thread of work delving into fashion design as a semiotic system). Although, in this sense, the work did not live up to the ideas behind it, subsequent artists cited Cuenca as an important influence, maybe precisely because their encounters with him were mostly centered on his ideas rather than the actual works.

44. Juan-Sí González puts it like this: "It was very ingenuous in the beginning, we believed it was possible, a change from inside, we didn't believe in any change from outside, we didn't believe that this country [the United States] had to interfere, we were against the embargo, it was to create ... an internal dynamic of renovation, of thinking" (interview with author, Yellow Springs, Ohio, April 4, 2003).

45. Soto, interview with author.

46. Afro-Cuban religious practice has generally had a rough time under the revolutionary government, which has accepted it—more or less—at certain times as a folkloric expression, but which has been wary of the traditions when they were not shorn of their religious implications as living systems of belief. In the early 1960s there had been a lot of interest in the Afro-Cuban traditions, especially on the part of Cuban intellectuals; their emphasis on popular culture, and on linking culture to the vernacular, made these traditions very attractive. As the Revolution cemented its dogma of atheism, there was less and less public space for Santeria, and it was mostly relegated to official displays of "folklore." Rather than being seen as parallel to the revolutionary process in their populism, these practices were eventually seen as "obscurantist" and backward. Some years later the dynamic shifted somewhat in favor of the traditions: for one thing, the Cuban military

involvement in Africa would have made it politically awkward to decry the extension of African traditions in Cuba.

47. Ricardo Brey, quoted in Luis Camnitzer, "Ricardo Rodríguez Brey," in *Art Journal* 51, no. 4 (1992). At the house museum that bears his name in Havana, Humboldt is credited as "the second discoverer of the island." Humbolt—"cosmic theorist, climatologist, botanist, examiner of schist," as Aaron Sachs has described him—had brought an exquisite aesthetic sense to his project of measuring nature. Mentor to the young Simón Bolívar, he was an "ardent agnostic" who was filled with awe (Sachs, *The Humboldt Current: Nineteenth Century Exploration and the Roots of American Environmentalism* [London: Penguin, 2007], 8, 44).

48. Quoted in Camnitzer, "Ricardo Rodríguez Brey," 11.

49. Brey left Cuba in 1991, at Jan Hoet's invitation, to live in Ghent and prepare his work for *Documenta IX* in 1992: he moved to Europe because the United States was "too political a choice" (Brey, quoted in Walter Guadagnini, "Ricardo Brey in the Salzburg Kunstverein" in Hildegund Amanshauser, ed., *Jahresbericht 1997* [Salzburg: Salzburger Kunstverein, 1998], 34–39).

50. Orlando Hernández, "Tres visiones del héroe," in *Tres visiones del héroe: Pinturas de José Bedia* (Havana: Castillo de la Real Fuerza, 1987), unpaginated.

51. José Bedia, quoted in Buchloh, "Interview with the Artists," 7–11.

52. *Art of the Fantastic: Latin America, 1920–1987,* Indianapolis Museum of Art, Indianapolis, Indiana, 1987, and *Magiciens de la terre,* Centre Georges Pompidou and Grande Halle, Parc de la Villette, Paris, 1989.

53. Hernández, "Tres visiones del héroe."

54. Orlando Hernández, "Mapa (incompleto) de *Por América*," in Rachel Weiss, ed., *Por América: La obra de Juan Francisco Elso* (Mexico City: Universidad Nacional Autónoma de México/Instituto de Investigaciones Estéticas, 2002), 199–242.

55. Ibid., 217.

56. The show's ethnographic poetics were the occasion for one of the clearest instances of Mosquera's Trojan horse strategy of art criticism: in his contemporaneous writing he saw *Tierra, maíz, vida* as both Mayan and Marxist, with no contradiction implied. In the central image of a pyramid, portraying the different ways to cultivate and cut maize, Mosquera read a highly symbolic representation of the superstructural development of Mesoamerican societies as built on a maize economy, a superstructure of consciousness and intellectual development, all based on maize agriculture. There are allusions to Martí, likening Elso's reclamation of Indian traditions to the Cuban hero's calls for his countrymen to "tighten our identification with the rich cultural values of our América." A few sentences later Mosquera pursues the analogy, referring to Elso's "*nationalization* of valuable means," an act that, "according to [Sandinista minister of culture] Ernesto Cardenal, 'is as legitimate as the recuperation/takeover of banks'" (Gerardo Mosquera, "Tierra, maíz, vida," in *Tierra, maíz, vida* [Havana: Casa de la Cultura de Plaza, 1982], unpaginated).

For that matter, Elso may have done some camouflaging of his own. His text explaining *Noche, día,* a work acquired by the National Museum of Fine Arts, was written in two

versions. The one supplied to the museum includes a reference to July 26 as the "day of renewal," while the version of the text found in Elso's own archives does not include that patriotic reference.

57. The core legend is apparently of the Peruvian shaman "El tuno." In Ijka myth (Colombia), birds in human form carry the seeds necessary for human survival; the *colibrí* (hummingbird) carries *coca,* the eagle brings *yuca,* the *garrapatero* brings the seeds of flowers and trees, and the macaw brings the first grains of maize (see Rachel Weiss, "Notas para una cosmología Americana," in Weiss, *Por América,* 153).

 The shamanic conception of the world contains an idea of its stratification into superimposed realms. In the simplest form there are three layers—the terrestrial, the underground, and the celestial, and shamans move between all three. In some conceptions these layers are connected to each other with a ladder, a vine, a bridge, or a secret trail. According to some shamanic beliefs, the echeloned worlds beyond the terrestrial correspond to a microcosmos that consists of the individual's own interior world, which is to say that they are a representation of human consciousness.

58. Museo de la Revolución, *Guía del visitante,* 39.

59. José Ángel Toirac, *Valen Todos* (unpublished typescript, 1993–94).

60. Guy Pérez Cisneros, "Pintura y escultura en 1943," excerpted in Veigas et al., *Memoria,* 30. "Mariano" is the nickname of José Mariano Manuel Rodríguez Álvarez.

61. See de la Nuez, "Rubén Torres Llorca," 4.

62. Nelson Moya and Luis Quiros, "La naturaleza de la crítica de arte en la contemporaneidad: Entrevista con Gerardo Mosquera," in FANAL: *Revista Bimensual del Centro Regional de Documentación e Investigación en Arte (CRDIA) del Museo de Arte y Diseño Contemporáneo* 2, no. 13 (1996): 9, 10.

63. Gerardo Mosquera, "Volumen Uno: Cambio en la plástica cubana," *Arte en Colombia,* no. 40 (May 1989): 50.

64. Manuel Vidal, excerpt in "Crítica Internacional," in *Quince obras de Tomás Sánchez* (Mexico City: Galería Arvil, 1989), unpaginated.

65. Yoga, in addition to being "foreign," was also seen as problematic for its "occultism."

66. Antonio Eligio (Tonel), "70, 80, 90 . . . tal vez 100 impresiones sobre el arte en Cuba," in *Cuba siglo XX: Modernidad y sincretismo* (Las Palmas de Gran Canaria: Centro Atlántico de Arte Moderno, 1996), 418.

67. Gerardo Mosquera, "Seis nuevos pintores," in *Seis nuevos pintores* (Havana: Galería L, 1978), unpaginated.

68. Camnitzer recalls that a conversation he had with Pérez Monzón in 1983 was at least partly to blame: on seeing the Cuban's work, Camnitzer explained to him about the work of Sol LeWitt, which he saw as related. According to Camnitzer, the confrontation with the fact that his work was not "original" was extremely traumatic for Pérez Monzón (phone conversation with author, December 11, 2004).

69. Antonia Eiriz was one of Cuba's most celebrated painters until around 1968. She had been making harsh, expressionist paintings full of bitter and grotesque imagery since the early 1960s. Her visual vocabulary, as described by the curator Alejandro Anreus, "all subjects—particularly 'sacred' ones referring to motherhood, leadership and patriotism . . . —[we]re up for an autopsy-like inspection" ("The Road to Dystopia: The Paintings of Antonia Eiriz," *Art Journal* 63, no. 3 [2004]: 5). Nonetheless, her work found early support, perhaps in part because it was read to be commenting on global and historical, rather than Cuban and contemporary, anguish. Eiriz was included in the important 1962 exhibition *Pintores cubanos,* for which Edmundo Desnoes wrote, "Her pictures have a direct rela- tion with the grotesque elements of our time. After the ovens where the Nazis murdered millions of Jews and after the atomic bombs dropped by the United States on Hiroshima and Nagasaki, the idealization of reality has lost all its relevance. Eiriz's grotesque faces, her pictures in white, black and gray with light touches of intense colors, her tortured and violent forms, have their origin in the state of being in our time" ("1952–62 en la pintura cubana," in *Pintores cubanos* [Havana: Empresa Consolidada de Artes Gráficas del Minis- terio de Industrias, 1962], 47, quoted in Anreus, "Road to Dystopia," 7).

Desnoes notwithstanding, Eiriz's neofiguration, unlike much of the expressionism produced in the United States at the time, was not so much a product of self-absorption as a charged, eruptive political undercurrent. Things caught up with her in 1968. Her *Una tribuna para la paz democrática* of that year, with its elevated bank of microphones and blocky, faceless horde, was an unmistakable swipe at the Venezuelan Communist Party. The work was originally intended to have an installational component consisting of a wooden platform placed in front of it and two rows of folding chairs facing the painting, so that the museum visitor would have become the orator at the bank of microphones. With their acid, sinister smiles, the popular audience becomes a herd, a mob.

That year, the poet Heberto Padilla wrote of "those demagogues she paints, / who look like they are going to say so many things / and in the end do not dare to say anything at all" (*Fuera del juego* [Miami: Ediciones Universal, 1998], 31, quoted in Anreus, "Road to Dystopia," 11).

The painting was exhibited at the 1968 National Salon, where it was considered for, but not awarded, the painting prize. The literary critic José Antonio Portuondo, vice president of UNEAC, denounced it at a public meeting as grotesque, defeatist, and counterrevolu- tionary. (This account is provided by Eiriz's second husband, Manuel Gómez, quoted in Anreus, "Road to Dystopia," 13.) Eiriz quit painting that year and resigned from teaching in 1969. She returned to her hometown of Juanelo where she organized papier-mâché workshops with local CDRs. By the mid-1970s the sanctions that had been imposed on Eiriz were lightened, to the point that she was included in an official delegation to Moscow. She was further rehabilitated with exhibitions in and around Havana in 1986, 1987, and 1991. In 1993, severely depressed, she left to visit family in Miami and stayed there: shortly thereaf- ter, for the first time in twenty-five years, she started to paint again.

Her retreat from painting and into the apparent popularism of papier-mâché, however, was a complicated move, neither simply an act of revolutionary insistence in the face of the repression of her work as a painter (as Camnitzer has suggested) nor a paltry substitute and evidence of her incapacitation as an artist (as Toirac suggests). In fact, according to Navarro, "she was not in good shape economically at the time, and she welcomed the thaw. In her neighborhood of Juanelo, and in her CDR, she began to teach workshops in papier-

mâché, and then Nisia Agüero and María Rosa Almendros included her in the work of the Group for Community Development (Grupo de Desarrollo de Comunidades), bringing her to its workshops and seminars in various communities." Her work in these activities was "without the slightest tinge of irony," done both out of conviction and economic necessity (e-mail to author, May 4, 2004).

Interestingly, papier-mâché was a technique with no history or tradition in Cuba, so its reincarnation as a "popular" expression was pure invention: not yet meant for the tourist market (though it later became a mainstay), papier-mâché was supposed to be a cheap, accessible medium through which any and everyone could become an artist. The production was exhibited in galleries throughout the island, the realization of the cultural "massification" policies of the revolutionary government. Meanwhile, although the fad was not taken particularly seriously from the perspective of "high art," Eiriz's participation had lent some aura of high cultural legitimacy to it. Again according to Navarro, the papier-mâché fad "disappeared as quickly as it appeared. And one of the factors was precisely that a large part of the general public resisted the idea that anyone—even their most uneducated neighbor, could become an artist in a matter of a week or two." In addition, most of the production was exceptionally uniform, "ornamental, and with an extreme poverty of formal and chromatic patterns, etc." This may have been due, at least in part, to the manner of teaching: among other things, in the papier-mâché workshops the study of historical works of art was specifically excluded.

70. Magali Lara, interview with author, Mexico City, January 1993.

71. Luis Camnitzer, phone conversation with author, December 11, 2004.

72. José Ángel Toirac and Tanya Angulo, untitled statement, in *Gustavo Pérez Monzón: Diesiocho días* (Havana, 1989), unpaginated.

73. The "catalog" for the show followed suit, more a snapshot album than catalog per se, with informal photos of friends who had come to visit during the show and of people hanging around during the events.

74. Quoted in Eugenio Valdés Figueroa, "The Mirror of Desire," in José Ignacio Roca, *Carlos Garaicoa: La ruina; la utopía* (Bogotá: Biblioteca Luis Ángel Arango, 2000), 105.

75. Gerardo Mosquera, "Seis nuevos artistas cubanos," in *Contemporary Art from Havana* (London: Riverside Studios, 1989), unpaginated.

76. "The political domain has contaminated every statement," they declared. "But above all else, because national consciousness is 'often inactive in external life and always in the process of breakdown,' literature finds itself positively charged with the role and function of collective, and even revolutionary, enunciation" (Gilles Deleuze and Félix Guattari, *Kafka: Toward a Minor Literature* [Minneapolis: University of Minnesota Press, 1986], 17).

77. Ibid.

78. Soto, interview with author.

79. "Because for me it was impossible to work as an art teacher—that was the job that you got when you finished art school—I had to be the stage designer for the theater, and so I started to move around different theater groups in Cuba. Because the cleaning in the

theater had already happened one or two years before, theater was more open at this time. I was able to do through theater and through music groups a lot of performances that were impossible to do without that support" (Soto, interview with author).

Soto's theatrical work encompassed movement, scenography, training for actors, and creativity workshops, its interdisciplinarity largely inspired by the Polish director and theoretician Jerzy Grotowski. In fact, for his devotion to Grotowski's method Soto was offered a fellowship through the Polish embassy in Havana to study in Warsaw: unfortunately, the emergence of the Solidarity movement around the same time made Poland a political hot potato, and Soto was not permitted to accept.

80. Both Mosquera (writing in the *Retablo Familiar* catalog) and Soto himself (in "Ancestros," 273) pointed to that moment as crucial for the viability of Soto's career in Cuba.

81. Leandro Soto, statement in *Retablo Familiar* exhibition brochure (Havana: Casa de la Cultura de Plaza/Centro de Arte 23 y 12, 1984), unpaginated.

82. The performance was concurrent with the *Retablo Familiar* exhibition: the exhibition was at the 12 y 23 gallery, and the performance was at the Casa de la Cultura de Plaza.

83. Soto, e-mail to author.

84. Soto, interview with author.

85. Soto, statement in *Retablo Familiar* exhibition brochure.

86. Deleuze and Guattari, *Kafka,* 19, 25.

87. Deleuze and Guattari write of a "tetralinguistic model": "vernacular, maternal or territorial language, used in rural communities or rural in its origins; a vehicular, urban, governmental, even worldwide language, a language of businesses, commercial exchange, bureaucratic transmission, and so on, a language of the first sort of deterritorialization; referential language, language of sense and culture, entailing a cultural reterritorialization; mythic language, on the horizon of cultures, caught up in a spiritual or religious reterritorialization. The spatiotemporal categories of these languages differ sharply: vernacular language is *here*; vehicular language is *everywhere*; referential language is *over there*; mythic language is *beyond*" (*Kafka,* 23).

88. The exhibition title echoes a popular Cuban song of the 1950s in which a man waxes nostalgic about an evening kiss, walking with a woman on a tropical path toward the sea. The song is a syrupy, romantic evocation of the happy, carefree tropical life.

89. Sánchez, "Flavio Garciandía en el Museo de Arte Tropical," unpaginated.

90. Gerardo Mosquera, untitled essay, in *Flavio Garciandía: Obra reciente* (Villa Clara: Museo Provincial de Villa Clara, 1983), unpaginated.

91. Garciandía has suggested that this was indeed what he had in mind (interview with author).

92. By the time of his 1983 exhibition *Obra Reciente* (Sala Transitoria, Museo Provincial de Villa Clara, September 1983), at the age of twenty-nine, Garciandía had already participated in more than seventy group exhibitions in Cuba and abroad.

93. Cristina Vives, "Cuban Photography: A Personal History," in Tim B. Wride, ed., *Shifting Tides: Cuban Photography after the Revolution* (Los Angeles: Los Angeles County Museum of Art and Merrell, 2001), 96, 97.

94. Aldo Menéndez is often cited as the intellectual author of the hyperrealist movement and was an important defender of the work. He was joined by Garciandía, Gory, César Leal, Gilberto Frómeta, and Nélida López.

95. See Tonel, "70, 80, 90 . . . ," 415.

96. Garciandía, interview with author.

97. Tonel, "70, 80, 90 . . . ," 415.

98. Mosquera, "New Cuban Art," 219.

99. Osvaldo Sánchez, "Kitsch Is Immortal," in *The Transcultural Citation* (Sydney, Australia: Museum of Contemporary Art, 1993). Sánchez wrote his art history thesis in 1981 on "kitsch and popular culture in Cuba."

100. Sánchez, "Flavio Garciandía en el Museo de Arte Tropical," unpaginated.

101. Osvaldo Sánchez was the first to point out that Garciandía's drips confound Pollock's: of them, he remarked that "Pollock-type drippings lost their profundity and individual mystique, reduced to patterns, becoming a drop curtain of simulated spontaneity and of a serialized expressive freedom" ("Kitsch Is Immortal").

102. These paintings are curiously absent from the national museum's installation and its collection, which includes works from several of Garciandía's periods. In fact, Garciandía is the only artist in the Contemporary Cuban Art galleries to be included in several distinct periods of the installation's chronology.

103. Aguilera credits Octavio Paz with this observation ("La puerta y el patio" [unpublished manuscript, August 2004]).

104. Ibid.

105. Deleuze and Guattari, *Kafka,* 51.

106. Aguilera, "La puerta y el patio."

107. Ibid.

108. For a critique of the emergent testimonial genre, see Desiderio Navarro, "Lectura de un testimonio: Testimonio de una lectura," *La Gaceta de Cuba,* no. 1 (January–February 2003): 50–51. The text, although only published in 2003, was actually written in 1970.

109. Galería 23 y 12, August 1981.

110. Gerardo Mosquera, "Sano y sabroso," in *Sano y sabroso* (Havana: Galería 23 y 12, 1981). Villapol was a popular cooking author.

111. Mike Kelley, "Playing with Dead Things," in *The Uncanny* (Arnhem: Gemeentemuseum, Sonsbeek, 1993), 16.

112. Ibid., 17.

113. Fan-shaped windows traditional in Cuban colonial architecture.

114. The fan's travails are epic. As Mosquera recounts, it "suffers, dreams of its glorious past, sprouts wings and flies off to the 'consumer society.' But that's not his cup of tea, he freezes and returns home to be received by the love of the kerosene lamp. Difficult loves, García Márquez would say, because the lamp functions when there are blackouts and [the fan] needs electricity, and furthermore, its breeze extinguishes the weak feminine light of his lover. But there's a happy end, because a grand destiny awaits him: to become a sun—like in the Aztec myth—and to radiantly heat the kitsch paradise of a tourist beach" (Mosquera, "The 14 Sons of William Tell," in *No Man Is an Island* [Pori, Finland: Porin Taidemuseo, 1990], 46).

115. Members included Buergo, Delgado, Ciro Quintana, Lázaro Saavedra, and Ermy Taño.

116. Sánchez, "15 Artistas cubanos o del muro que nunca existió," in *15 Artistas Cubanos* (Mexico City: Ninart, Centro de Cultura, 1991).

117. Grupo Puré, *Puré Expone* (exhibition catalog), January 1986. The show was installed at the Galería L in Havana, and in the street outside the gallery.

118. "Really the group had a deep concern for ordinary life, and having such a concern for the events of daily life meant including them in your work, which made you realize that the reality had changed a lot. . . . the reality that *Volumen Uno* faced was very different from the reality which Puré faced" (Lázaro Saavedra, interview with author, Havana, December 12, 2002).

119. Tonel, "70, 80, 90 . . . ," 296.

120. This may seem like a very short interval to bother taking note of, but in the context of the period a year or two was a relatively long time. Remarkably, when Tonel wrote about Puré's inaugural exhibition he referred to it as "an assault on the relative homeostasis achieved in the five years following *Volumen Uno*": in other words, the situation was so dynamic that five years was considered a long time for there not to have been a major new shift (Tonel, "Acotaciones al relevo," *Temas*, no. 22 [1992]: 61, reprinted in Veigas et al., *Memoria*, 475).

121. This is Mosquera's term (Gerardo Mosquera, "Nuevos artistas," in *El Caimán Barbudo* 20, no. 228 [1986]: 2–4, reprinted in Veigas et al., *Memoria*, 475).

122. Saavedra, interview with author.

123. Gerardo Mosquera, "Haikus de Segundo Planes," in *Segundo Planes: Huellas Tóxicas o Sombra de Dios* (Monterrey: Galería Ramis Barquet, 1993), unpaginated.

124. Rimbaud's words are from 1871. Planes's 1990 show was titled *Yo no soy yo ni el otro. Yo no soy alguno ni ninguno* (I'm neither me nor the other. I'm neither anybody nor nobody).

125. Sánchez, "15 Artistas cubanos o del muro que nunca existió," 42.

126. Tomás Esson, undated interview with Luis Camnitzer. An explanation from Saavedra does less to let Hart off the hook: "The political structures of the Communist Party went over the head of the Ministry of Culture—that is, there was an exhibition that was censored

by the municipal government of the party, and the minister of culture wasn't able to prevent them from doing it. That is, he allowed it to be censored" (Saavedra, interview with author).

After the incident Esson was, by his own admission, more "cautious," and he was rewarded with continuing opportunities to participate in major shows abroad of Cuban art, including *Contemporary Art from Havana* (Riverside Studios, London), *Aktuelle Kunst aus Kuba* (Institut für Auslandsbezichungen, Stuttgart), *No Man Is an Island* (Porin Tademuseo, Finland), and *The Nearest Edge of the World: Art and Cuba Now* (Massachusetts College of Art, Boston).

According to Glexis Novoa, even before this particular incident there had been efforts to dissuade Esson from exposing his works in public. Novoa recalled that the Party functionary Carlos Mas Zábala, who had been assigned to "work with" the young artists, "drank a bottle of rum with Tomás and me, persuading Tomás to please not take the portraits of Castro with his head cut out of his house: Please, you can keep making them, but please don't take them out of the house. In very friendly terms, drinking rum, drunk, but telling him, Please, don't take them out, you'll have problems . . .

"Más Zábala was the guy who gave us the guidelines of what they wanted to have happen with the *jóvenes,* and he had to approve, finally, he had to edit. But we wanted to do things a little bit harder" (Glexis Novoa, interview with author, Miami, December 30, 2002).

127. Iván de la Nuez, "Al encuentro de los pasos perdidos," in *Cuba Siglo xx,* 69. In Alfredo Guevara's view, according to Ann Marie Bardach, the three more "liberal" institutions— his own ICAIC, Casa de las Américas, and the National Ballet—had been able to exempt themselves from the more hard-line, persecutory practices because of the strength of their leadership (consisting of himself, Santamaría, and Alicia Alonso) (Ann Louise Bardach, *Cuba Confidential: Love and Vengeance in Miami and Havana* [New York: Random House, 2002], 263).

128. Louis Marin, "Frontiers of Utopia: Past and Present," *Critical Inquiry* 19, no. 3 (Spring 1993): 416.

129. My travel notes from January 1989 include the following entry: "Visit to Esson's house. In order to photograph the paintings we have to carry them out into the street and lean them against the front of the house because there is no room inside. There is the flag/ organ painting and the goat-fucking with Che painting, and he is totally relaxed about putting them into the street. All the neighbors know these works and all the rest, and have no quarrel. In fact a couple comes by just to look again, and hang out for a while."

130. Osvaldo Sánchez, "Carlos Cárdenas," in *Carlos Cárdenas* (Monterrey: Ramis Barquet Gallery/Ninart Centro de Cultura, Mexico City, July 1991), unpaginated.

131. The cycle of shows at the Castillo was an extraordinary project. According to Osvaldo Sánchez, "The *Castillo de La Real Fuerza* turned into the expressive bastion of the young iconoclasts. In one year it is difficult to find another Latin American alternative space that exhibited a similar dynamic and quality. . . . Every exhibition bombarded the two common-places of Cuban social life: sex and politics. One piece served as trigger: in the naïf style, there was a Fidel in a square talking to thousands of people whose faces were replicas of Fidel's" (Sánchez, "15 Artistas cubanos o del muro que nunca existió," 43).

132. I confess that this curator is me, and that I therefore have no objectivity with regard to this particular anecdote.

133. Franklin Alvarez Fortún, "Mi casa soy yo." Regarding the continual promotion of new groups of artists to replace the ones in place, Tonel has remarked that it was a way to displace those with some experience and savvy with others who were less able to manipulate things. "In my opinion," he wrote, "what was of most importance in all of this was the breathless rhythm that such a phenomenon with its continual beheadings (unforeseeable, moreover, in the revivals) imposed on history and the evolution of the culture. A rhythm that explains the circumstantial ignorance shown by each new group of former, sometimes vital, passages. And whose basis is a sweet-sour mixture, the sum of a lack of a sense of history and a veiled or rampant opportunism, cooked and reheated over and over again, on the compliant hot coals of artists and institutions" (Tonel, "70, 80, 90 . . . ," 414).

134. Of the *microbrigadas,* the architect Eduardo Luis Rodríguez has written: "They were called Microbrigades and [that] was enough: everybody in the country knew what it was about. As with other important plans that demanded a massive popular participation, the concept had been initially stated in 1970 by Fidel Castro. The great housing shortage in the country would be faced from now on in a non-conventional way, not by means of the brigades of professional construction workers belonging to the Ministry of Construction, but by the same persons who needed housing, no matter their previous professions or trades, or that they didn't have the slightest idea of how to pour concrete onto a foundation, build a wall with a plumb-line, or even erect an almost-vertical column. The Cuban, always willing to improvise and with a marked epical predisposition, a tendency to feel as an indispensable protagonist before any assigned goal, would assume with hopeful joy the challenge to change the pen, the papers and the desk, for the shovel, the wheelbarrow and the white helmet indicative of the new heroes" ("The Microbrigadist," in *Carlos Garaicoa: Continuity of Somebody's Architecture* [Kassel: Documenta 11, 2002], 29).

135. González, interview with author.

136. Law 77, the Foreign Investment Act, was passed in the National Assembly in November 1996, opening the possibility of 100 percent foreign investment in businesses operated on Cuban soil. The law also offered tax breaks and incentives for venture capital. Under the law, however, foreign businesses could import only upper management and consultants, with the remainder of the labor force to be supplied by the Cuban government, and the land under the buildings would be leased, rather than sold to, the foreign investor.

137. Richard Foreman, *Unbalancing Acts: Foundations for a Theatre* (New York: Theatre Communications Group, 1992), 6.

138. "Unusual for being descriptive, historical, even sentimental, because a patriotism or nationalism inevitably shines through, something none of his generation went so far as to include in their works" (Hernández, "Mapa (incompleto) de *Por América*," 206).

139. Martí, born in 1853 in Havana, was exiled to Spain from 1871 to 1874, lived in France briefly during 1874, then in Mexico in 1875 until 1879 (with a little time in Guatemala). He went to New York on January 3, 1880, where he lived (except for some months in Venezu-

ela) until January 31, 1895, the date he left to return to Cuba. He died the following May 19, in his first battle.

140. Martínez Estrada, quoted in Hernández, "Mapa (incompleto) de *Por América*," 229.

141. José Martí, "War Diaries: Part ii, From Cap-Haïtien to Dos Ríos (May 9, 1895)," in *José Martí: Selected Writings* (New York: Penguin, 2002), 404–5.

142. In 1922, for example, the young republic passed laws requiring every municipality on the island to dedicate a statue, bust, plaque, or memorial to Martí. Congress encouraged each town to name a street after the Apostle and to place a bust of him in every public school. In the very different political moment of the 1950s, the U.S.-supported dictator Fulgencio Batista erected the monument to Martí that presides over the Plaza de la Revolución: the gigantic obelisk is a copy of a Schenley Whiskey advertisement that appeared at the 1939 New York World's Fair.

143. Hernández, "Mapa (incompleto) de *Por América*," 221.

144. Cuauhtémoc Medina, "La fragilidad como consistencia," in Weiss, *Por América*, 250.

145. Hernández suggests something similar. See "Mapa (incompleto) de *Por América*," 221.

146. To his credit, José Luis Rodríguez de Armas published an insightful and favorable review of the piece, "An Attempt to Resacralize the Image of Martí," *Huella* (suplemento cultural al periódico *Vanguardia*, date unknown). The review in *Bohemia*, on the other hand, made the following observations: "A poor sculpture of José Martí, machete held high, walks over a desolate terrain. For some of those present the assemblage was 'a lack of respect.' . . . This man that we see here is not fighting, he is ambling; he also is not brandishing a machete, he is dragging it. In addition he gives the impression of being a mute—Martí who was made of words!" (Leonel López-Nussa [Ele Nussa], *Bohemia*, December 13, 1986, 9).

Elso's Martí is now owned by the Hirschhorn Musem, part of the Smithsonian Institution, the national museum of the United States.

147. In this regard it is interesting to note that, in his 1893 speech on Bolívar, Martí had said: "His base is as broad as the mountains, his roots, like theirs, mingle with those of the earth itself, and like their peaks he stands, erect and sharp, the better to penetrate the rebellious heavens. He is to be seen knocking with his golden saber on Glory's gate" (quoted in José A. Balseiro, *The Americas Look at Each Other* [Miami: University of Miami Press, 1969], 23–24).

2. LAUGHING

1. This was a three-person show, March–April 1989, together with Tomás Esson and Carlos Rodríguez Cárdenas.

2. Mosquera, "14 Sons of William Tell," 47.

3. Francine Birbragher notes that "the famous photograph of Fidel entering Havana that the Communist Party of Cuba uses as its logo" inspired the silhouetted figures in the work's background (*Art Nexus*, no. 51 [2003]: 84).

4. Novoa, interview with author.

5. Michel Foucault, *Foucault Live: Selected Interviews, 1961–1984,* ed. Sylvère Lotringer (New York, Semiotext(e), 1989), 33–35.

6. Ibid., 38.

7. Eighteenth-century body snatchers in Britain were sometimes known as Resurrectionists.

8. Chago, quoted in Sandra Ceballos, "The Last Chago," in Luis Camnitzer, *From Sierra Maestra to La Habana: The Drawings of Chago* (New York: The Drawing Center, 2001), 10.

9. Tonel, "Brillo de Chago: 'Salomón' compartido," *ArteCubano,* no. 1 (1998): 18.

10. Luis Camnitzer, introduction to *From Sierra Maestra to La Habana: The Drawings of Chago* (New York: The Drawing Center, 2001), 8.

11. The period of Rectification was characterized by a couple of structural factors that had important implications for the nation's governability and for what was to become an increasingly ungovernable movement in the visual arts. Between 1986 and 1989 there was, according to the sociologist Haroldo Dilla Alfonso, a "climate of relative political tolerance, and the first signs since the consolidation of revolutionary power in the sixties of visible division among the political class" ("Cuba: The Changing Scenarios of Governability," in "From Cuba," ed. John Beverley, special issue, *boundary 2* 29, no. 3 [2002]: 61). Culture was caught in the split that opened in the Communist Party between orthodox and liberal (sometimes also described as Stalinist/Guevarist or Soviet/Cubanist) factions. This split was expressed with great succinctness in 1988 during the Tomás Esson scandal when Armando Hart, the minister of culture, came into direct conflict with Carlos Aldana, the Communist Party's ideology chief, over the allegedly counterrevolutionary content of Esson's work.

 Rectification coincided with a tendency toward economic stagnation, and so the malaise it sought to correct was economic as well as sociopolitical in nature. Cuba's economic problems actually began accumulating before the catastrophic withdrawal of Soviet support. Unlike much of Latin America, Cuba's economy grew from the mid-1970s to the mid-1980s. In addition to trade with the socialist bloc, Cuba was receiving—and paying back—loans from the West. But a series of factors combined to bring that growth to a halt. According to the economist Andrew Zimbalist, "Low sugar prices, plummeting petroleum prices (Cuba's re-export of Soviet petroleum provided roughly 40% of its hard currency earnings during 1983–1985), devastation from Hurricane Kate, several consecutive years of intensifying drought, drastic dollar devaluation, the tightening of the U.S. embargo and growing protectionism in Western markets, all combined to reduce Cuba's hard currency earnings by $337.1 million, or 27.1%" (quoted in Medea Benjamin, "Things Fall Apart," in "Cuba: Facing Challenge," special issue, *NACLA Report on the Americas* 24, no. 2 [1990]: 15).

12. From Castro's 1987 speech "Che's Ideas Are Absolutely Relevant Today," delivered at a ceremony marking the twentieth anniversary of Guevara's death and later published as a postscript to *Socialism and Man in Cuba* (Che Guevara, *Socialism and Man in Cuba* [New York: Pathfinder, 1989], 34).

13. Between 1985 and 1989 Mikhail Gorbachev succeeded in getting the CPSU to support far-reaching structural reforms (perestroika) in the economy, and a policy of openness, of freedom to speak the truth (glasnost). *Glasnost,* which comes from a Russian word roughly translated as "gossip," referred to openness, understood to mean openness about things that are wrong, the right not only to complain but also to be heard. In Castro's view, Gorbachev's mistake was to undertake glasnost in advance of perestroika.

14. Gerardo Mosquera, "Trece criterios sobre el nuevo arte cubano," *La Gaceta de Cuba,* June 24, 1989, 24.

15. Quoted in Abel Collazo, "Mis Inquietudes: Plástica Joven," *El Caimán Barbudo,* July 1988.

16. José Ángel Toirac, interview with author, Havana, December 22, 2002.

17. Tonel, "Acotaciones al relevo," 61, reprinted in Veigas et al., *Memoria,* 73.

18. Raúl Martínez, quoted in Roberto Cobas Amate, "Raúl Martínez: El desafío de los sesenta," in *Raúl Martínez: El desafío de los sesenta* (Havana: Palacio de Bellas Artes, 1995), 11.

19. Pop came to Cuba, along with op art, Magritte, Picasso, and other "Western" trends, through various U.S. art magazines that were still being subscribed to by the UNEAC and National Libraries. The "foreign" styles were, importantly, also featured in the Salon de Mayo in 1967.

20. Martínez, quoted in Cobas Amate, "Raúl Martínez," 15.

21. In fact, Martínez had only one solo show in Cuba between 1965 and 1978, in the provincial city of Santa Clara. Between 1966 and 1970 a total of seven reviews published in Cuba treated Martínez's work, and two of those were reprints of reviews published elsewhere (Veigas et al., *Memoria,* Artist Biographies CD Rom).

22. Raúl Martínez, quoted in José Ángel Toirac and Juan Pablo Ballester, *"Nosotros": Exposición antológica de la obra de Raúl Martínez* (Havana: Instituto Superior de Arte/ Centro Provincial de Artes Plásticas y Diseño, 1989), unpaginated (n. 6). Martínez's comment probably refers at least in part to his homosexuality.

23. In 1981 Martínez received the Medalla Distinción por la Cultura Cubana and in 1983 he received the Medalla Alejo Carpentier, which is granted by the Council of State.

24. Toirac and Ballester, *"Nosotros."*

25. ABTV, "Homenaje a Hans Haacke" (unpublished catalog, 1990).

26. Toirac, interview with author. Korda's image has reappeared thousands of times over the years. A new wave of Che-mania in 2004 was noted in the *New York Times* in an article titled "Give Me a Rebel, But Hold the Politics," by Ginia Bellafante. "Why the renewed interest in Che, when so many communist governments have failed? . . . There are many reasons for this, and one of them is Mike Tyson," who had had a picture of Che tattooed onto his ribcage. "Mao Zedong is another head we're thinking of using," says one of the vendors interviewed for the article, "I don't think people want these as a political statement, but I think they are drawn to the graphic intensity" (Ginia Bellafante, "Give Me a Rebel,

But Hold the Politics," *New York Times*, March 30, 2004). Incidentally, Bellafante does list Korda as the image's author.

27. Novoa, interview with author.

28. Ales Erjavec, "Neue Slovenisches Kunst—New Slovenian Art: Slovenia, Yugoslavia, Self-Management and the 1980s," in *Postmodernism and the Postsocialist Condition* (Berkeley: University of California Press, 2003), 147–48.

29. According to Medea Benjamin, Robaína was "said to be a 'reformer,' to have differences with the Party leadership, including Fidel Castro, and to have the guts to express these differences openly. He did not express them to me. He did admit, however, that the 'old guard'—those over 50 who fought in the Sierra with Fidel Castro—have had a hard time transferring power to the next generation. . . . he said the revolution skipped the middle generation, those from about 35 to 50, and only recently has the leadership realized that new leaders must be cultivated" (Benjamin, "Soul Searching," in "Cuba: Facing Change," special issue, NACLA *Report on the Americas* 24, no. 2 [1990]: 29).

30. As the Cuban American writer Alma Guillermoprieto confessed on hearing Fidel speak, "For more than three hours I lost myself in a rapture that was produced not so much by the speech as by the sonorous undulation of his words and his expression of pain" (*Dancing with Cuba: A Memoir of the Revolution* [New York: Pantheon, 2004], 108–9).

31. Glexis Novoa, in *Carlos Rodríguez Cárdenas: Artista de Calidad* (Havana: Galería Habana/Fondo Cubano de Bienes Culturales, 1988), unpaginated.

32. Gerardo Mosquera, untitled text, in *Carlos Rodríguez Cárdenas*.

33. Jorge Mañach, *La crisis de la alta cultura en Cuba: Indagación del choteo* (Miami: Ediciones Universal, 1991).

34. Ibid., 75, 84.

35. Cinto Vitier, *Lo cubano en la poesía* (Havana: Instituto Cubano del Libro/Colección Letras Cubanas, 1970), 340–41, quoted in Tonel, "The Key to the Gulf and How to Use It" (part 10, excerpted in Veigas et al., *Memoria*, 31).

36. Fernando Ortiz, *El Pueblo Cubano* (Havana: Editorial de Ciencias Sociales, 1997), 55 (written between 1908 and 1912).

37. Mañach, *La crisis de la alta cultura en Cuba*, 66 (hereafter cited in the text).

38. March through October.

39. Alejandro Aguilera, e-mail to author, August 19, 2004.

40. Among the shows closed during 1988 were *A tarro partido II* (The broken horn: work by Tomás Esson), *Nueve alquimistas y un ciego* (Nine alchemists and a blind man: organized by Arte Calle and Grupo Imán), and *Artista de calidad* (solo show by Carlos Rodríguez Cárdenas), while in 1989 both the exhibitions by Ponjuán and René Francisco, and by ABTV, were censored within the Castillo de la Fuerza exhibition project.

41. Walter Kerr, *Tragedy and Comedy* (New York: Simon and Schuster, 1967), 199.

42. Nelly Richard, "Cultural Peripheries: Latin America and Postmodernist De-centering," in John Beverley, José Oviedo, and Michael Aronna, eds., *The Postmodernism Debate in Latin America* (Durham, N.C.: Duke University Press, 1995), 220.

43. Novoa used the term in titling an exhibition documenting the 1980s performance works *La consagración de la jodedera.* The term itself means to live by your wits, or to do anything to survive, but related terms in Spanish indicate that its meaning is perhaps more ample and indistinct than that: *jodedora* refers to a "happy woman," with obvious pejorative connotations, and *jodedor* suggests a "big prankster," again with nasty undertones. Novoa's title might therefore be read as "The Consecration of Fucking People Up."

44. While the group's membership changed somewhat over time, those identified as members of the group in their self-produced video documentary are Aldito Menéndez, Pedro Vizcaíno, Erick Gómez, Iván Álvarez, Ernesto Leal, Ofill Echevarría, Leandro Martínez, and Ariel Serrano.

45. Tonel, "Acotaciones al relevo," 61, reprinted in Veigas et al., 94.

46. Ernesto Leal, interview with author, Havana, March 18, 2002.

47. This one-night event was staged at the Galería L, on January 11, 1988.

48. According to Leal, "The idea was this notion of an opening, where people go to have a drink and so on; so what we did was buy a lot to drink and get everybody drunk, that was more or less the idea" (interview with author).

49. Novoa, interview with author.

50. Aldo Damián Menéndez, "Art Attack: The Work of ARTECALLE," in Fusco, *Corpus Delecti,* 277.

51. Leal, interview with author.

52. Galería L, Havana, October 13, 1987. Participating artists included Vizcaíno, Gómez, Hugo Azcuy, Álvarez, Leal, Max Delgado, Alán González, Echevarría, and Serrano (the "nine alchemists"): "the blind man" was "the people."

53. The title quotes from a patriotic poem by Mirta Aguirre, which suggests that Che should not be reduced to history or to conveniently edited aspects of his revolutionary work, meanwhile leaving aside the ethical demands that he set as his revolutionary example.

54. Frency Fernández Rosales has blamed this provocation on the Group on Human Rights headed by Ricardo Bofill in "La vocación inconclusa: Notas sobre Arte Calle," in *Enema 2 y 3* (Havana: Instituto Superior de Arte, 2000), 49. In a video clip of the event, the audience is seen walking carefully around the edges of the painting on the floor, not on it (http://www.youtube.com/watch?v=MlzP3iUZ2pE).

55. Editorial de la redacción de la cultura, "Arte es huir de lo mezquino, y afirmarse en lo grande," *Juventud Rebelde,* October 1987.

56. "Ud. se equivocó de exposición" (unpublished typescript, October 1987), 4. Signed by Azcuy, Álvarez, Delgado, Echevarría, Gómez, González, Leal, Serrano, and Vizcaíno.

57. Grupo Provisional is identified by Camnitzer as consisting primarily of Novoa, Carlos Rodríguez Cárdenas, and Segundo Planes, with Planes as a much less active partner. In fact, Planes does not list Grupo Provisional activities on his résumé (the reference here is to the catalog for his major exhibition in 1993 at the Galería Ramis Barquet). According to Novoa, the group was formed by him, Cárdenas, and Francisco Lastra.

58. Novoa, interview with author.

59. February–March 1988. Sites for the installation included the National Museum of Fine Arts, the Castillo de la Fuerza, Casa de las Américas, Galería Haydée Santamaría, and Habana Club.

 As though anticipating criticism of the project from an anti-imperialist position, Roberto Fernández Retamar (the president of Casa de las Américas and a leading official intellectual figure) went to some lengths to justify its importance in his text for the exhibition brochure "Rauschenberg, American Artist": "It is understandable that a man who incorporates so much [referring to Rauschenberg's work with assemblage] goes around the planet to show his wares in the most distant sites, and also to enrich those sites with new visions, born in those sites. Of course: one should not look in those visions for the spirit of the people in those places, but instead for that of Rauschenberg, heir to the pedigree including those North Americans who, like Whitman or Hemingway, brought together in their work, in the manner of vast collages, that which the world requires to express itself: in order to express the best of a community of energetic pioneers, who we cannot confuse with those responsible for other adventures" ("Rauschenberg, Artista Americano," in *ROCI [Rauschenberg Overseas Cultural Exchange]* [ROCI International: Universal Limited Art Editions, 1988]). Rauschenberg visited and worked in ten countries overall for ROCI—Venezuela, Mexico, Cuba, China, the German Democratic Republic, Japan, Tibet, Malaysia, Chile, and the Soviet Union—in a quixotic bid to advance international understanding through contemporary art.

60. Novoa, interview with author.

61. Glexis Novoa, "La consagración de la jodedera" (unpublished typescript).

62. Art-De consisted of an artist (Juan-Sí González), a lawyer specializing in human rights (Jorge Crespo Díaz), and a filmmaker (Eliseo Valdez).

63. At first these events were held in the Coppelia park in Vedado every Wednesday afternoon (March 2, 9, 16, 23): permission to use that site was then withdrawn, and the group moved to the park at the corner of 23 and G, also in Vedado (April 6, 13, 20, 27, May 18). The group was then prohibited from working further in public.

64. Untitled video documentary, 1988.

65. Novoa explains it thus: "They said you were mediocre, they didn't include you in any important exhibitions, you didn't travel abroad, and when foreign curators came to Cuba they never took them to see you. That segregated you. That's what the Cuban government knew how to use, that implacable silence that separates you and dissolves you as an artist" (interview with author).

66. Untitled video documentary, 1988.

67. In fact, members of Art-De did have contact with Amnesty International representatives.

68. Participants included Abdel Hernández, Quintana, Hubert Moreno, Arnold Rodríguez (Peteco), Rafael López Ramos, Saavedra, Alejandro López, José Luis Alonso Mateo, Luis Gómez, and Nilo Castillo.

69. Leal, interview with author.

70. According to Los Lirios del Jardín, participating artists included Alonso Mateo, Castillo, Gómez, Hernández, Alejandro López, López Ramos, Hubert Moreno, Peteco, Teresa Ortíz, Quintana, and Saavedra (http://losliriosdeljardin.blogspot.com/2008/07/meditar.html).

71. As Leal explains, "There was a newspaper called *Novedades de Moscú* ('News from Moscow'), and we bought it every time it came out, because there was a lot of information about perestroika and discussions about how they were handling it, the process—and that influenced us a lot. Besides, we didn't want to know how to change the society into a kind of capitalism or something like that, but how to make a type of socialism that was real and radical" (interview with the author).

72. Interview with author.

73. While there were apparently two "teams," the Red team (Rafael López, Novoa, de la Nuez, Alejandro Frometa, Saavedra, René Francisco Rodríguez, Vizcaíno, Toirac, Juan Pablo Ballester, Mosquera, Llopiz, Garciandía, Silveira, David Palacios, Buergo, Azcano) and the Blue team (Castillo, Aldito Menéndez, Tonel, Ponjuán, Gómez, Abdel Hernández, Hubert Moreno, Ermy Taño, Cárdenas, Gómez, Victor Manuel, Alejandro Aguilera, Esson, Nicolás Lara, Pedro Álvarez, Alejandro López, Robaldo Rodríguez, Rubén Mendoza, Ángel Alonso), most accounts of the game stress that anyone who wanted to play did, such that the fact of there being two "teams" did not actually mean very much: it was more like everyone playing together. The game was played to the accompaniment of the rock bands Zeus and Takson.

74. Aldito Menéndez, "La revolución del arte y no el arte de la revolución" (unpublished typescript).

75. Rubén Torres Llorca, "Oral History Interview with Rubén Torres Llorca," by Juan Martínez, Miami, January 31, 1998, Smithsonian Archives of American Art, http://artarchives.si.edu/oralhist/torres98.htm.

76. The Biennial was organized under the theme of *tradición y contemporaneidad en las artes plásticas y en el ambiente del Tercer Mondo* (Tradition and contemporaneity in the plastic arts and in the conditions of the Third World). Among the Cubans included in the main exhibition, *Tres Mundos*, were Pepe Franco, Garciandía, Marta María Pérez, Brey, Torres Llorca, and Soto, and Bedia had a solo show, *Final del centauro*, in the Castillo de la Fuerza. The segregation of generations was not across the board, and among the younger artists also included in the main exhibition were Aguilera, Buergo, and Esson.
The humor exhibition included Tonel, Quintana, Novoa, Cárdenas, and Saavedra.

77. Delgado was in prison from May 10 to December 7, 1990, as punishment for the work, titled *La esperanza es lo último que se está perdiendo,* which was declared to be a "public scandal." He was twenty-four at the time.

78. Glexis Novoa, e-mail to author, November 10, 2003.

79. Tonel, "I Am Not a Performance Artist," interview with David Mateo, in *Tonel: Lessons of Solitude* (Vancouver: Morris and Helen Belkin Gallery, 2000), 46.

80. *Humor: Chago y Tonel,* Galería del Cerro, Havana, 1982.

81. Unsigned text, "Desangramientos de Chago," in *Nace el topo: Las remoras de egolo* (Havana: Espacio Aglutinador, 1995), unpaginated.

82. The image is not unusual for Tonel: as Dannys Montes de Oca notes in her essay "Crossroads: Graphic, Conceptual, and Environmental Intersections in the Work of Tonel," his work has "an abundance of cut-off arms, stumps, faces without eyes, bruised torsos, vomit, vaginas with parasites, and penises as enormous as they are useless" (quoted in *Tonel: Lessons of Solitude,* 17).

83. Quoted in Montes de Oca, "Crossroads," 16. In fact the show's opening (it was part of the "Artist of the Month" series at the Castillo de la Fuerza) was delayed for two weeks as a result of the concern that it provoked among cultural administrators: when it finally opened, a warning note was placed at the entrance to the gallery. Similar problems arose in 1991, and, consequently, Tonel staged his *Happiness* exhibition in the confines of the house he shared with his wife and parents, rather than in the Casa del Joven Creador, where it had been scheduled to coincide with the fourth Havana Biennial (artist biography, in *Tonel: Lessons of Solitude,* 90–91).

84. Tonel, "I Am Not a Performance Artist," 44.

85. Soto, interview with author. While the education at ISA was rigorous, it was also extremely academic, an unhappy convergence of nineteenth-century academic traditions and Soviet pedagogy (Guevara had once referred to the Soviet manuals as "bricks"), a prolongation of the dreary technical preparation that the young artists had encountered in their earlier schooling. In much of his early writing about these artists, Mosquera emphasized the importance of their education "within the revolution," weaving a protective camouflage around them by identifying them as the legitimate products of the revolutionary process and tracing their iconoclastic work to roots in their training. In fact there was a fundamental irony to that claim, since for the most part the students were extremely critical of the pedanticism and senseless discipline, and their resistance to it was probably a crucial element in their development. As Garciandía put it, "that I emerged as I did was despite the curriculum. . . . and so in that sense the instruction was indeed very important. Because it's important what you fight against, what you struggle with" (interview with author). Official attitudes toward the students were probably mixed, on the one hand, trusting of them as the first total products of the Revolution and, on the other, wary of them as young people and, worse, artists.

86. In fact the curriculum that Garciandía developed was a direct refutation of the Cuban Constitution's distinction between form and content, structured around "On the Manner of Addressing Clouds," an article by Thomas McEvilley that he had run across in *ArtForum.* In the essay, McEvilley elaborates a system of reading artworks based in the premise that "all statements about artworks involve attributions of content, whether acknowledged or not" ("On the Manner of Addressing Clouds," *ArtForum International,* Summer 1984,

61–70). As Garciandía tells the story, he found the article during a trip to Canada and stole the magazine to bring it back to Havana. "As I was reading, I realized it had tremendous pedagogical potential, from the thirteen categories that McEvilley establishes for how to read the content in a work of art" (Garciandía, interview with author).

87. In addition to Garciandía's accumulated clout and credibility, there were two factors that made it possible for him to so radically challenge the pedagogical model at ISA. First, ISA was an "amorphous object" in institutional terms, under the dual purview of the Ministry of Culture and the Ministry of Education: the slippage between the two bureaucracies and two sets of dictates was exactly the kind of "crack" that provided a workable space. Second, a new set of national curricular structures had recently been approved that added the option of "Plan C," under which it was up to the professor to devise a program to address general learning objectives, in whatever way they saw fit. This was a significant departure from the general rule in which not only objectives but also step-by-step lesson plans were centrally dictated.

Most educational institutions, however, remained on Plan B, and ISA was therefore highly suspect in many people's view. According to Saavedra, "There were people who wouldn't hear any talk of ISA. . . . it was considered to have ideological problems, it was always seen that way, considered that people there were not clear, were not clearly defined in political terms" (interview with author).

88. In the absence of formal diplomatic relations, both the U.S. and Cuban governments maintain "Interests Sections" in each other's capitals.

89. Interview with author.

90. Andrés Oppenheimer, *Castro's Final Hour* (New York: Touchstone/Simon and Schuster, 1992), 121.

91. Ibid., 407.

92. Francisco's blindness was concurrent with an epidemic of neuritis in Cuba, which was blinding thousands of people.

Perhaps it is not a coincidence that works about fictional blind artists dot the history of late-twentieth-century art of the USSR. See, in particular, the 1973 Nikolai Buchumov series by Komar and Melamid and *Primakov Sitting in a Closet* (1972) by Ilya Kabakov. Komar and Melamid invented Buchumov, a Russian painter born in 1891. A metaphysicist who hated humanity and adored nature, his mission was to remove from himself the "human" aspects that distanced him from the beauty and transcendence of Nature. According to Buchumov's detailed "autobiography," he was an impoverished child from the countryside who, arriving in Moscow to study painting, lost his left eye in a fistfight with a classmate, "in an argument about art." Returning to his native village, Buchumov eventually resumes painting and produces a series of small cardboards, each one a landscape idyll with the image of the artist's nose along the left edge. As Buchumov explains: "I prepared my brushes myself. A marble board, which formerly held a clock, carefully preserved by me, a gift of my late benefactor Petukhov, has faithfully served me until now. On it I rubbed in the juices of every manifestation of nature. In this connection, I would like to add that in the rubbings mixed with oil, each earthly creature gives its own color. I am painting from a single spot, where, as they say, my late mother gave birth to me while working in the fields.

Here, I hope, they will bury me" (Melvyn B. Nathanson, ed., *Komar/Melamid: Two Soviet Dissident Artists* [Carbondale: Southern Illinois University Press, 1979], 12–13).

93. Rosa Lowinger, "Francisco and I: A Conversation with Fernando Rodríguez," *Sculpture* 20, no. 9 (2001): 23.

94. Milan Kundera, *The Art of the Novel* (New York: Harper Perennial, 2000), 125.

95. Ibid., 105.

96. The Havana police force was increased substantially during the Special Period, the new officers mostly recruited from the rural eastern provinces, a zone where the population is largely black and where support for the government remained strong. The new police were largely held in contempt by the cosmopolitan *habaneros.*

97. Mañach, *La crisis de la alta cultura en Cuba,* 82–83.

98. Cienfuegos, "the man best loved in Cuba after Castro," mysteriously disappeared at sea in a small plane crash in 1960. According to Hugh Thomas, "Foul play was immediately suspected. Was not Cienfuegos anti-Communist? Had he been killed by Raúl Castro personally in a fit of jealousy?" (*Cuba: Or the Pursuit of Freedom,* rev. ed. [New York: Da Capo, 1998], 1247–48.)

99. This was the beginning of a series of works later featured in the 1993 film *Fresas y Chocolate,* religious figures pierced by sickles that attract the friendly attention of "an embassy" and precipitate the political downfall of the sculptor and a friend who helps him. That film was another strategic time-fracture: set in 1979, its narrative of repression and censorship could thus be read as complaining about historical, rather than current, problems.

100. Regarding the ladder: Cuba's slaveholding society had lived in constant fear of losing its control. Spontaneous slave uprisings took place in 1832, 1835, 1837, and 1838, and in 1843 two different slave conspiracies spread among dozens of plantations to hundreds of slaves and thousands of whites and free people of color. Spanish authorities responded brutally: according to one contemporaneous account, "Slaughterhouses . . . were established in Matanzas and Cárdenas, where the accused were subjected to the lash to extort confessions. . . . A thousand lashes were in many cases inflicted on a single negro; a great number died under this continual torture." The prisoners were tied to ladders for the floggings, giving the conspiracy its name of "La Escalera," one of the grisliest episodes in Cuba's history (Louis A. Pérez, *Cuba: Between Reform and Revolution* [New York: Oxford University Press, 1995], 100).

101. "Bettina Funcke Talks with Peter Sloterdijk," *Bookforum,* February–March 2005, 28.

102. Ibid.

103. There had always been a perverse aspect to the interdependency among artists and state. By permitting artists to make critical works financed by the government, the regime dampened the artists' credibility. The works are applauded abroad, which is good publicity for the Cuban system. At the same time, while all of this allows artists to test the limits of government censorship, the government in turn gets an intimate sense of the mood of the nation's intellectuals. Saavedra recalled that, "in 1987 or 1988 what is now called Fototeca

was created, spaces were created for debate where the members of all the groupings or those who did not belong to any group went and had discussions. It began with a small group but it grew, and at a certain point the fact of the meetings bothered somebody high up, and they sent a social psychologist to investigate the concerns of young people, to make inquiries into what was being said there, to find out about our motivations" (interview with the author).

104. The designation comes from Desiderio Navarro, referring to comics themselves, "vanguard" art citations of comics (e.g., Roy Lichtenstein), and Quintana (Navarro, e-mail to author).

105. Rubén de la Nuez, "Muriendo libre: La encrucijada humor de Lázaro Saavedra," *La Gaceta de Cuba,* no. 5 (September–October 1988).

106. Tonel, "A Tree from Many Shores," *Art Journal,* Winter 1998, 65.

107. De la Nuez, "Muriendo libre."

108. Accounts of the deal varied at the time. According to one artist, the Ministry took 70 percent of all sales, with the other 30 percent going to the dealer or broker. The artist then received some amount in pesos. At a meeting at the Fondo de Bienes Culturales artists, complaining about this split, were told that it was their patriotic duty to submit: a crisis with the country's insulin supply required the artists to sacrifice so that diabetics could survive.

What happened with Peter Ludwig and the Düsseldorf show, according to this source, was that, although the work was already in Germany, Cuban officials insisted on shipping it back to Cuba so that Ludwig would have to return to the island to negotiate. In this way they hoped to induce him to buy even more work. Miraculously, it worked, and subsequently officials hoped to do this with everyone.

109. Luis Camnitzer, e-mail to author, March 15, 2005.

110. "Camello" was the nickname of the new, improvised buses made by welding together two different vehicles such that the resultant one had two long "humps," prompting the reference.

111. Members of Eighties SA included Eric Rojas, Omar Copperi, Félix Ernesto Pérez, Max Delgado, and Roberto Diago Durruthy.

112. Félix Ernesto Pérez, *Super Eighties Game* (Havana: Instituto Superior de Arte, Asociación Hermanos Saíz, 1994), unpaginated.

113. Ibid.

114. Joel Rojas, interview with author, Havana, March 22, 2002.

115. Rojas was still in Havana at the time of this writing, but subsequently emigrated to the United States: he now lives and works in Miami.

116. This was pointed out by Gerardo Mosquera (e-mail to author, July 7, 2002).

117. During the so-called *Habanazo,* hundreds ran through the streets of central Havana in protest both of economic conditions and of lack of liberty. Fidel himself took to the street to talk to the protesters: at the sight of him the protesters dropped their rocks and bricks and broke into applause. Castro's arrival was covered extensively on state TV, which also

neglected to mention the cause of the protests or to show the size of the crowd and disturbance. The *Habanazo* erupted after a couple of events in which people attempting to leave the island had been stopped by the Cuban Coast Guard: in one of those events, in mid-July, the Coast Guard had capsized a tugboat, causing the deaths of over forty women and children: the incident was recounted widely by survivors. Tensions had also risen in the wake of a government announcement that, because of a lack of hard currency reserves, the island would not be receiving the petroleum supply for August, and therefore most nonessential activities, including most industry and services, would be paralyzed for the month. A wave of violence and vandalism swept the city, much of it directed against government offices and buildings, and anti-Castro graffiti appeared.

118. For a more extended discussion of the Biennial, see my "Visions, Valves, and Vestiges: The Curdled Victories of the Havana Bienal," *Art Journal*, Spring 2007.

119. De la Nuez, "Muriendo libre."

120. The exhibition was ancillary to, and not formally part of, the Biennial.

121. As of March 2006, the *Detector* was hanging in the museum, after having been included in a solo show of Saavedra's work there in September 2003.

122. Roughly translated, this could mean someone engaged in disruptive or subversive activity.

123. The penalty for black-market meat sales was as much as six months on a work farm.

124. E-mail press release, forwarded to the author by Glexis Novoa, February 26, 2005.

125. Mañach, *La crisis de la alta cultura en Cuba,* 94.

INTERLUDE

1. Ambrosio Fornet, "La crítica bicéfala: un nuevo desafío," *La Gaceta de Cuba,* January–February 2002, 20.

2. Margarita Mateo Palmer, "Signs after the Last Shipwreck," in "From Cuba," ed. John Beverley, special issue, *boundary 2* 29, no. 3 (2002): 152.

3. "As humiliating as it was to have U.S. accusations of Cuban drug dealing turn out to be true, Ochoa's motives were more disturbing still. Had the revolution lost all meaning for him? . . . Ochoa's trial statements reveal little on this point. . . . In his later, more suggestive remarks, he commented on being tired, on having lost his way. In a country whose exceptionalism rests on its revolutionary commitment, Ochoa's actions and words must have been painful for many, a frightening reflection of cynicism at the top" (Elizabeth Quint, "Ochoa's Legacy," in "Cuba: Facing Challenge," special issue, NACLA *Report on the Americas* 24, no. 2 [1990]: 30).
 Medea Benjamin also cites strong reactions among her friends: "You can imagine how we felt when we discovered some of those accusations were true! And Cuba is not like the United States, where you can separate individuals from the government because the government changes every four years. Here those individuals are the government, and their activities reflect on the system as a whole." Another friend put it more graphically: "For me, drug dealers are the scum of the earth. To find a top revolutionary leader involved in

drugs is like catching your father in bed with your wife. It makes you question your whole belief system" (Benjamin, "Soul Searching," in "Cuba: Facing Challenge," special issue, *NACLA Report on the Americas* 24, no. 2 [1990]: 24).

4. The turn of phrase is from Osvaldo Sánchez ("15 Artistas cubanos o del muro que nunca existió," 43).

5. Earlier defeats of leftist regimes in the region, including Jamaica (1980), Guatemala (1982), and Grenada (1983), made the loss of Nicaragua decisive in terms of regional politics.

6. Between 1975 and 1991 approximately 377,000 Cuban troops had rotated through Angola; in the preceding three years alone, 50,000 combatants had returned home to a Cuba with no jobs for them and no patriotic triumph.

7. U.S. Department of State, Chronology of Cuban Affairs (1958–1998), January 12, 1998; *Christian Science Monitor,* January 9, 1992.

8. The economic collapse cannot be entirely blamed on the sudden withdrawal of trade and subsidies by the USSR and the East bloc; however, those events were catastrophic. When trade relations collapsed, 84 percent of Cuba's trade was with the Soviet bloc. Dissolution of the CMEA meant, among other things, the loss of supply of fertilizer, chemicals, and spare parts. Sugar production plunged in the early 1990s to around 50 percent of what it had been previously.

The economics of the moment appear much the same even in the sympathetic account provided by Haroldo Dilla Alfonso. According to Dilla, by 1998 ordinary Cubans had to purchase, in dollarized markets, 60 percent of their protein needs, 50 percent of edible oils, and 30 percent of their caloric intake (Dilla, "Cuba: The Changing Scenarios of Governability," in "From Cuba," ed. John Beverley, special issue, *boundary 2* 29, no. 3 [2002]: 65). Thus many of the most important gains of the Revolution had been sharply set back. What had remained constant was the vulnerability to fluctuations in the world price of sugar and a perennial energy shortage.

9. "Fifteen percent of individuals interviewed in Havana consider themselves 'extremely needy,' while only 4 percent claim to have no unmet material needs at all. Of the unmet needs mentioned by the individuals interviewed, those most frequently mentioned were economic necessities associated with declining living standards. Insufficient wages, the high costs of daily life, inadequate transportation and housing—in that order—were the dissatisfactions indicated by over half the respondents" (Guillermo C. Milán, "Inequality and Anomie in Cuba," "Inside Cuba," special issue, *NACLA Report on the Americas* 32, no. 5 [1999]: 34–35).

10. The bicycles were sold to students for 60 pesos and to workers for 120.

11. Susan Eckstein, "From Communist Solidarity to Communist Solitary," in Aviva Chomsky, Barry Carr, and Pamela Maria Smorkaloff, eds., *The Cuba Reader: History, Culture, Politics* (Durham, N.C.: Duke University Press, 2003), 621. The conference cited was held in 1993. The unfamiliarity of bicycle traffic, along with the lack of helmets and lights, accounted for the high rate of accidents and injuries: in 1995, 2,175 bicycle accidents were reported in Havana alone, and 479 traffic fatalities nationwide involving bicycles

(Joseph L. Scarpaci, Reoberto Segre, and Mario Coyula, *Havana: Two Faces of the Antillean Metropolis* [Chapel Hill: University of North Carolina Press, 2002]: 243, 270).

Cuba's first postrevolutionary bicycle factory was actually opened in 1964, in Caibarién, and was inaugurated by Che Guevara himself. Bicycles never took off as a popular means of transportation, however, and by 1990, it was still the country's only bicycle manufacturer, producing only around 5,000 bikes per year. Four new factories were built in 1991, however, and by 1994 the country was producing 200,000 units per year (Richard Schweid, *Che's Chevrolet, Fidel's Oldsmobile* [Chapel Hill: University of North Carolina Press, 2004], 205).

12. Already in 1991 a change had been made to Cuban finance laws, allowing foreign companies to buy a 50 percent share of new hotels and run them single-handedly.

13. Eckstein, "From Communist Solidarity to Communist Solitary," 620.

14. According to José Quiroga, "The state tried to address potential armed forces restlessness by involving them in joint ventures with foreign capital. In order to facilitate that, in 1988 it formed the Gaviota Tourism Group SA, an umbrella association that managed all sorts of foreign contacts. The state was assured of the army's loyalty and felt free to create a new class of military entrepreneurs after condemning to death in 1989 Arnaldo Ochoa—the highest ranking and most decorated hero of the Angolan campaigns—as well as Antonio de la Guardia, Amado Padrón and Jorge Martínez. The military ended up managing the most critical sectors of the economy—going as far as to control the TRD subsidiary—(the Tienda de Recaudación de Divisas), stores that collect hard currency" (*Cuban Palimpsests* [Minneapolis: University of Minnesota Press, 2005], 7).

Joseph Scarpaci, Roberto Segre, and Mario Coyula put Gaviota's birth earlier, in the 1960s, and note that the company was charged with managing recreational centers for Soviet advisers. Noting the downsizing of Cuban armed forces since the advent of the Special Period, they quote the Cuban economist Julio Carranza, who said that "the armed forces are trying to generate enough foreign exchange so as to be able to sustain themselves as a military force without being a load on the state or a burden on the rest of the economy" (Scarpaci, Segre, and Coyula, *Havana,* 295–96).

As a major conduit for hard currency the tourism sector was a natural site for corruption, and the military's assumption of control was in part directed against those developments. As Janette Habel notes, "The main tourist operators have a heavy commercial and financial punch and run several hundred venues. Last year Juan José Vega del Valle, chairman of Cubanacán, was fired, along with other top executives, for "serious management errors." He rebutted allegations of embezzlement, supposedly uncovered after foreign exchange controls were set up for Cuban companies in 2003; but the tourism minister also stepped down. The Cubanacán executives were replaced by the military, who manage the state tourism business Gaviota.

"The main Cuban economic power lies with the Revolutionary Armed Forces, increasingly involved in tourism, agriculture, industry, transport, communication and electronics. The military also hold key posts in the government and in the Cuban Communist party (PCC), where they sit on the political bureau. A military man, Colonel Rolando Alfonso, heads the ideological department of the party's central committee, and another, Colonel Ernesto López, runs the Cuban radio and television institute.

"This generation of officers, who have had capitalism-inspired business training, are behind market reforms and the greater independence now given to state companies in the hope of boosting their profitability and efficiency" ("Cuba: What Will Happen after Castro?" *Le Monde Diplomatique,* June 2004, http://mondediplo.com/2004/06/13cuba).

15. *Museo de la Revolución,* 58.

16. The status of these new NGOs has often been shaky when they resulted from initiatives other than that of the state: for example, the Pablo Milanés Foundation, started in 1993 by the recording star to help young Cuban artists and independent cultural institutions through profits from record sales in Latin America, was taken over by the Ministry of Culture in 1995: the government accused Milanés of embezzlement after he protested the seizure (Mark Falcoff, *Cuba: The Morning After* [Washington, D.C.: American Enterprise Institute for Public Policy Research, 2003], 202).

Scarpaci, Segre, and Coyula note that "Raúl Castro delivered a very controversial report on March 23, 1996, to the Central Committee of the Cuban Communist Party. He emphasized that the Cuban concept of civil society is not the same as that in the United States, and he claimed that some foreign NGOs in Cuba 'attempt to undermine the economic, political and social system freely chosen by [the Cuban] people . . . [and] whose only aim is to enslave [Cuba].' Raúl Castro's remarks stem from the official Cuban reaction that many international and Cuban NGOs ideologically undermine the revolution through the controversial Torricelli Track Two Law in the United States, which provides sanctions against Cuba while also promoting cultural exchanges" (Scarpaci, Segre, and Coyula, *Havana,* 165).

17. Writing in the leftist publication NACLA *Report on the Americas,* Guillermo C. Milán reports the following results of a survey conducted between 1994 and 1998: "Perceptions expressed about how one achieves success in life fell into two distinct groups: one in which respondents gave priority to individual efforts and one in which they emphasized the political and economic conditions of the country. Significantly, among both groups, only a third of those surveyed expressed any optimism about their own future. About half of all expectations of improvement were based on individual solutions like self-employment, overcoming professional barriers and individual effort. This indicates that at the psycho-social level, a sense of life based on the individual, the career and the family is becoming increasingly legitimate. . . . These results reveal a perception among some sectors that some sort of dysfunctionality exists in Cuban society which prevents individuals from achieving some sense of self-fulfillment. This perception presumably underlies the fact that around 30% of the respondents said they valued capitalism as the social alternative which would allow one to develop as an individual. One of the social consequences of the current economic crisis is that values associated with individual economic struggle are increasingly gaining acceptance among the Cuban population. . . . In this sense, we can verify a trend toward a reorientation of psycho-social identity and of moral and ideological values that broadly corresponds with societal transformations" ("Inequality and Anomie in Cuba," 35).

18. Antonio José Ponte, "The Supervised Party," in "From Cuba," ed. John Beverley, special issue, *boundary 2* 29, no. 3 (2002): 217. Prostitution, a primary symbol of Cuba's degradation as "playground" for tourists, was outlawed in 1961, and a support system of daycare, schools, and jobs was created to support the "rehabilitation" of former prostitutes. The elimination of prostitution (or more precisely, the avowed intention to eliminate it) was

seen as a fundamental part of the Revolution's commitment to the dignity of every Cuban, along with the creation of systems of universal health care and education.

19. State involvement and sanction is suggested in a variety of sources, including Achy Obejas (*Days of Awe* [New York: Ballantine, 2002], 204) and Andrés Oppenheimer (*Castro's Final Hour,* 287). Susan Eckstein explains it in the following terms: "Three of the main Cuban organs that operate resorts—Cubatur, Cubanacán, and Cimex—hosted a Playboy trip around the time the Special Period was launched. The government allowed the magazine to feature an article on 'the girls of Cuba,' contingent on coverage of the island's tourist facilities. Even the Ministry of Tourism began to run advertisements abroad featuring string bikini-clad sexy Cuban girls" ("From Communist Solidarity to Communist Solitary," 614).

20. "In a survey taken in 1997 among a small but in some respects representative sample of residents of Havana, Milán found that 20 percent of the respondents demonstrated a total lack of confidence in the capacity of the prevailing political system to resolve the national problems, while another 26 percent had exactly the opposite opinion. Even more significant is the fact that 47 percent preferred to locate the solution of these problems in individual efforts without reference to the political system as such. On this basis, it is possible to suggest the following hypothesis: Cuban society is beginning to experience a process of polarization of attitudes and behaviors. At one extreme is an atomized minority opposed to the system, while the other extreme is yet another minority, but in this case one that is effectively organized and characterized by an active ethos of consensus. In the center, the majority is made up of those persons who have opted for individual solutions, who are more nervous about an uncertain change than the vicissitudes of the present situation and at the same time are seduced by the expectations of enrichment that the market always brings with it, although very few have or will have adequate access to these opportunities" (quoted in Dilla, "Cuba: The Changing Scenarios of Governability," 70).

21. For example, in the first years of the 1990s, *Cuadernos de Nuestra América,* a well-respected review in the field of international studies, began to dedicate increasing attention to domestic issues. By early 1996, however, the government had taken control of the Center for Studies on the Americas, which published *Cuadernos,* and disbanded and dispersed its staff.

22. According to Debra Evenson, "In March, the Communist Party (pcc) issued a call for widespread discussion in preparation for the fourth party congress to be held in the first half of 1991. . . . It did not offer the Cuban Politburo's agenda for resolving the nation's problems, but rather solicited public analysis and debate of alternative policies. . . . At first many were skeptical of the party leadership's sincerity. To some, the call was a public relations strategy to buy time. An even more cynical interpretation suggested that the debate would be used to identify potential troublemakers. Indeed, individuals and small groups who declared their opposition to socialism or to Cuba's one-party system found no tolerance of their political views; some were even arrested. Many others, unfamiliar with public discussion where opposing views are encouraged and respected, were unsure how to respond. This combination of fear, cynicism, and inexperience turned the first round of meetings in April into an unmitigated disaster. 'The meetings of provincial party and national mass organizations involved several thousand delegates and typically lasted from eight to fourteen hours each, portions of which were televised. A fascinated public watched and

listened almost daily to sharp criticism of dysfunctional economic institutions, stagnant bureaucracies, ineffective political structures, and policies that impede creativity and responsiveness. As the discussion proceeded, problems were detailed with increasing specificity and the debate became bolder and more dynamic'" ("Channeling Dissent," in "Cuba: Facing Change," special issue, NACLA Report on the Americas 24, no. 2 [1990]: 26).

23. Ibid., 64–65.

24. In fact, according to Dilla, "generally speaking, widespread corruption in daily life is encouraged by a permissive environment that is, frankly, alarming." ("Cuba: The Changing Scenarios of Governability," 71). Nonetheless, Castro clad it in the heroic symbols of the nineteenth-century independence struggle, portraying it as one more in a long history of struggles for national independence. Over and over, Castro declared the very independence of the country (not merely socialism, not merely the Revolution) to be at stake.

25. Regarding the ubiquity of the *doble moral*, Benjamin provides the following commentary: "Every day almost every Cuban I know does something illegal just to get by," remarked a European friend who has been living in Cuba for twenty years. "They may buy black market coffee or shoes for their kids, call in sick at work so they can have time to shop for food, swipe supplies from the office to use at home, or get their toilet fixed by a plumber working illegally. They might be members of the Communist Party or staunch supporters of the revolution, but they break the law as a matter of course. And since everyone sees everyone else doing it, it becomes part of the game. But deep down, it creates a kind of double standard that flies in the face of the mores this revolution stands for. In some ways, Cuba has created a nation of hypocrites and liars" (Benjamin, "Things Fall Apart," 20–21).

26. Valdés, "Mirror of Desire," 107.

27. Cuba's suicide rate is high. According to Louis Pérez Jr., who has written a book-length study on the subject, "For more than 150 years, the rate of suicide in Cuba has been among the highest in the world. It has long been the highest in all of Latin America. From the late colonial period into the early republic, under capitalism as well as socialism, men and women in Cuba have killed themselves at a higher rate than in almost all other countries" (*To Die in Cuba: Suicide and Society* [Chapel Hill: University of North Carolina Press, 2005], 5).

As Scarpaci, Segre, and Coyula point out, Cuba's suicide rate during the Special Period was twice that in the United States, and affected young people and men most heavily. They go on to clarify, however, that while Cuba's suicide rate is far higher than that of any other country in the Western Hemisphere, those statistics may be misleading, since in other Latin American countries "vital rates registration is not as developed as in Cuba and Roman Catholic values lead to an underreporting of suicides" (*Havana,* 261).

28. A tragic strain infuses Cuban national symbols: "La Estrella Solitaria" is the national flag, and the national bird is the Tocoloro, known for dying in captivity. See Pérez, *To Die in Cuba,* 324.

29. The incident recounted was part of a Varadero hotel cabaret show, New Year's Eve 2000. Che mania has advanced even farther since then. A whole travel industry has been spawned, in part, by the success of the film *The Motorcycle Diaries,* based on Guevara's youthful sojourn through South America. According to the *New York Times,* for example, a

"Che Trail" was opened in October 2004 by the Bolivian Ministry of Tourism in cooperation with CARE International: the trail allows visitors to follow the path of Guevara's last march before he was captured in La Higuera (Rachel Dodes, "On the Trail of the Young Guevara," *New York Times,* December 19, 2004).

30. Although the departure of the artists was dramatic, it is worth keeping in mind that it was minor in comparison with the thousands of others who floated desperately across the Florida Straits in the first years of the 1990s, cresting in the *balsero* crisis in August 1994. In fact, fewer artists and intellectuals have gone into exile in both the current and the 1980 exodus than workers from other sectors. (See Arturo Arango, "To Write in Cuba, Today," in "Bridging Enigma: Cubans on Cuba," ed. Ambrosio Fornet, special issue, *South Atlantic Quarterly* 96, no. 1 [1997], 122–23.)

Furthermore, the exodus of artists was not as unitary as the term would suggest: there was not a sole reason for leaving, or a sole idea of the terms of that leaving. Motives ranged from dissatisfaction with living and working conditions, to the uncertainty that future exit permits would be issued, to disillusionment and/or exhaustion. Political problems were probably only rarely the cause, although of course there is a limit to how much the economic can be meaningfully separated from the political reasons.

Bedia was not only one of the earliest to depart, but also one of the best equipped for survival abroad owing to an already well-developed career. According to him, the decision to leave was "spontaneous," smoothed by the fact that Mexico was an easy adjustment culturally and linguistically, and artists did not have to break decisively with Cuba to live there. "My generation," he said in 1994, "isn't resentful or full of rancor. We're only full of the frustration of failure. Everything that they promised us, that they inculcated in us; they didn't give any of it, and it didn't look like they were going to. We only contemplated a situation that was a kind of perpetually comatose state. It's not the innocent reproach of a child to his father: 'You said you wouldn't do this, but I saw you do it.' No, it's something closer to skepticism, to disenchantment" (Alfredo Torres, interview with José Bedia, *Brecha* [Montevideo], November 11, 1994, 25). Bedia's contemporary, Arturo Cuenca, provides a somewhat different narrative. Cuenca had been increasingly frustrated in Cuba: although an avowed Marxist and an interesting artist, he was largely sidelined because of his angry, volatile, and confrontational manner. He was often left out of the group shows that were being organized with greater and greater frequency and that were establishing the dominance of certain artists. Cuenca decided to emigrate during a trip to Mexico in July 1989: being outside Cuba was unexpectedly catalytic. "I wasn't thinking at all about staying," he told Luis Camnitzer some years later. But "then the Ochoa affair happened, a little while later the blocking of Glexis, that year I felt superbad, I saw what happened in Nicaragua. . . . a bunch of things like that that made me very sad but also made me reflect—that is, they made me grow up. I had already become totally disillusioned with what was happening in Cuba but, well, from outside I could see things more clearly. I saw the reality, that I had been formed by a system, I had been made to believe that it was one thing, but it was another . . . and so for me that was tremendous" (Arturo Cuenca, undated interview with Luis Camnitzer).

Some, including Tomás Esson, were apparently encouraged to leave and not come back (according to Alejandro Aguilera, "in fact when Tomás left for the exhibition in Boston, the police in the airport grabbed him and said, 'And if you want to, go ahead and stay there'"

[Alejandro Aguilera, interview with author, Atlanta, March 8, 2003]), and some, like Juan-Sí González, were put onto planes by security officials, shorn of the right to return.

31. Eugenio Valdés Figueroa, "Trajectories of a Rumor: Cuban Art in the Postwar Period," in Holly Block, ed., *Art Cuba: The New Generation* (New York: Abrams, 2001), 18.

32. Acccording to Lupe Álvarez, "The complacency shown by cultural institutions over the emigration of key figures of the art movement was . . . common talk in intellectual circles. The intention of eliminating them from the game seemed to prevail, to neutralize the centers of conflict that they had provoked" ("Reflexión desde un encuentro," in Tania Bruguera, ed., *Memorias de la Postguerra,* no. 2, 1994, 18).

Osvaldo Sánchez notes that, "in less than a year, more than thirty painters had obtained letters of invitation [to Mexico] in order to avoid the inertia of an Island that doesn't move anymore. . . . Among the new regulations of migration, the Cuban authorities intuited the convenience of giving exit permits with the purpose of giving the damn youth some time to go get refreshed outside, to crash with the reality of competition, far away from the planned support, to exercise their criticism from zero, without any advantages" ("15 Artistas cubanos o del muro que nunca existió," 45).

Beatriz Aulet, who was well positioned to know the internal logic of the cultural apparatus, concurs: "There was a coincidence of the beginning of the Special Period and tremendous limitations in every kind of things. That is to say that, independently of that, the situation in the country got very tense, very difficult. . . . And so they gave the possibility to all those artists, so they could leave, do you understand what I mean? . . . And so the policy was right on the mark, I think, to give them the possibility to leave, without having to . . . you know? That they'd go, they'd come—a special status, in other words. To me it seems like a very intelligent policy" (Aulet, interview with author, Havana, March 25, 2002).

Diplomatic arrangements were made to allow the artists to settle in Mexico for a while (according to *Newsweek,* the Cuban authorities chose Mexico because "there's a big Cuban embassy there, Cuban functionaries . . . could operate freely there and Mexico offered no political asylum to wayward artists" [Peter Plagens, "The Next Wave from Havana," *Newsweek,* November 30, 1992, 77]). The situation was precarious: a developing economic crisis in Mexico, among other things, led the Mexicans to threaten tighter entry restrictions, and Cuban diplomats made surprise visits to artists' studios in Mexico City and Monterrey to monitor the content of their work. Diplomats also frequented the openings at Nina Menocal's gallery in Mexico City (the first to exhibit the work of these artists regularly), boasting about Cuban cultural achievements and openness. According to knowledgeable sources, the unspoken deal was that as long as the artists did not make antiregime comments, their visas would be extended. According to one rumor, after a while the Cuban embassy pressured the Mexicans for more control over the Cuban émigrés (a competing version locates the source of the pressure in the United States), and so the Mexicans resolved the problem by not renewing the visas and forcing the artists to leave.

Conspiracy theories circulating in Cuba attributed the emigration to Mexico as part of a governmental plot to earn hard currency, and parallel theories in Miami concluded that it was part of a clandestine political infiltration into the Miami exile community. According to the Cuban American art collector Ramón Cernuda, "at the end of the 1980s the situation in Miami became extraordinarily politicized, and there were those who thought they were living a political moment in which the Castro government was making an 'offensive'

to penetrate Miami culturally and ideologically, and that art and painting was part of that offensive, concretely playing a role, that those Cuban painters had not abandoned the country, hadn't denounced the Cuban government, which had followed them here, promoted them here, when in reality in Cuba all those painters were forgotten, they had absolutely no interest in them. But in any case that was an argument that developed, and there were those who pressured the local authorities to initiate a process of persecution against those who we were patronizing and promoting, stimulating Cuban Art" (Juan Martínez, "Oral History Interview with Ramón Cernuda, March 28, 1998," www.aaa.si.edu/oralhist/cernud98.htm).

33. In interviews in 2001 and 2002, many people commented on the fact that the 1990s "generation" was declared to exist from the very beginning of the decade, long before the contours of a coherent grouping could legitimately be discerned. The critical recognition of them as an identifiable, and promotable, cohort, indicated the extent to which even criticism had shifted its sights toward the commercial promotion of the new Cuban art. The topic surfaces repeatedly in the discussion organized by Magaly Espinosa and published in *Temas* as "Controversia: Algo Nuevo en la plástica de los 90?" Participants included Magaly Espinosa Delgado, Janet Batet González, Corina Matamoros Tuma, David Mateo Núñez, Lázaro Saavedra González, and José Toirac Batista (*Temas,* nos. 12–13, October 1997–March 1998, 163–76).

34. Palmer, "Signs after the Last Shipwreck," 152.

35. Jacques Rancière, *On the Shores of Politics,* trans. Liz Heron (London: Verso, 1995), 3.

36. Eugenio Valdés Figueroa, "Art of Negotiation and the Space of the Game: Coitus Interruptus of Modern Cuban Art," in *Cuba Siglo XX,* 388.

37. Antonio Eligio (Tonel), "The Art of Passion, A Reckoning: About Visual Arts in Cuba and Their Context in-between Two Centuries," in Marijo Dougherty, ed., *Passionately Cuban: Nine Artists from Havana* (Albany: University Museum, State University of New York, 2001), 34.

3. MUSEUM

1. Desiderio Navarro describes this as an ongoing aspect of cultural administration in Cuba: "In each period there is an attempt to erase (minimize or veil) from the collective cultural memory everything related to the intellectual's critical activity of the preceding period, whether it be the memory of the forms it assumed, the channels that it used, the spaces in which it developed, and the specific personalities who practiced it, or the memory of how it was fought, repressed or supressed, and who its antagonists were. . . . It is not by chance, then, that the 1980s critical interventions struggled to rescue the memory of their 1960s precedents as an interrupted tradition" ("In Medias Res Publicas," 366).

2. Corina Matamoros, interview with author, Havana, March 22, 2002.

3. Ibid. Marta Arjona, one of Matamoros's predecessors, was perhaps more candid when, after 1959, she noted that she had removed the works of exiles because they had "never managed to fit into a genuine revolutionary commitment." Those excised from the galleries

included Guido Llinás, José Ignacio Bermúdez, Viredo (Viredo Espinosa), Hugo Consuegra, Rafael Soriano, José María Mijares, and Salvador Corratje (Ileana Fuentes, "Profetas por conocer," *Encuentro en la red,* September 10, 2003, http://www.cubaencuentro.com/cultura/20030228/897ae3050b396d5cae8b310d5a1b46bb/1.html).

4. Matamoros, interview with author.

5. Ibid.

6. Margarita González, Tania Parson, and José Veigas, eds., *Déjame que te cuente: Antología de la crítica en los 80* (Havana: Artecubano Ediciones/Consejo Nacional de las Artes Plásticas, 2002).

7. *Havana Journal,* http://havanajournal.com/culture_comments/A2690_0_3_0_M/).

8. Old Havana was declared a World Heritage Site in 1982, but it was only in the 1990s that the restoration began in earnest, facilitated not only by governmental will but also an influx of foreign capital.

9. *London Sunday Times,* August 24, 2003. A November 2005 three-page spread in the *New York Times* took a more sexualized approach, perhaps in part because the article shared the Travel section with splashy coverage of the Art Basel Miami Beach Art Fair. The front page features a large color photo of a young black man standing on the rocks along the Malecón seawall in Havana in wet swim trunks, with a brooding sky behind him. Havana is, in this text, "virgin territory," "seductive," "tantalizing," and "forbidden fruit," among other things. Besides sex, art is featured as a prominent local attraction, taking "a prominent place . . . just about everywhere in Havana. . . . Paintings and sketches hang in corridors, in rooms, in hotel lobbies" (Luisita López Torregrosa, "Waiting for Havana," *New York Times,* November 27, 2005).

The 2004 edition of *TimeOut Havana,* on the other hand, provides a contemporary art shopping guide, with listings of artists' home-studios along with descriptive blurbs about their works, contact information, and tips on tax and export regulations ("Stu-stu-studio," in *TimeOut Havana* [London: Penguin Books, 2004], 149), and on a flight from Havana to Miami in March 2006, instructions on how and where to stow paintings were included as a part of the routine preflight safety demonstration.

10. *The Lennon,* by José Villa, was inaugurated on December 5, 2000, in the park at Seventeenth and Sixth streets, in Vedado, in a ceremony presided over by Minister of Culture Abel Prieto—"longhaired himself," as Scarpaci, Segre, and Coyula note, "clos[ing] a thirty year span that ranges from Lenin Park to Lennon Park" (*Havana,* 371).

Scarpaci, Segre, and Coyula note that the following rehabilitation and erection of monuments occurred in Havana during 1999–2000: "Monuments to generals from the Independence Wars Antonio Maceo and Calixto García (rehabilitation and reposition of the statue of Gómez that had been removed in the 1960s for political reasons). Construction of a new monument to Simón Bolívar on G Street and rehabilitation of the Villalón Park. Rehabilitation of the monument to El Quijote, on J at 23rd Street. Construction of a monument to the Mexican composer Agustín Lara on Almeda de Paula, Old Havana" (ibid., 343).

11. Carlos Garaicoa, "Japanese Garden 1997," in Roca, *Carlos Garaicoa,* 111.

12. Orlando Hernández, "Habana zen: Breve ensayo sobre jardinería de ruinas," in *Jardín japonés/Jardín cubano* (Havana: Centro Wifredo Lam, 1997), unpaginated.

13. Ibid. A 1995 study of building conditions in Havana conducted by the city's Assembly of Popular Power reported that, of 557,179 buildings housing the approximately 2.2 million inhabitants, about 52 percent were in good condition, 25 percent were marginal, and the remaining 23 percent were in "bad" condition—meaning, in danger of collapse (José Bella Lara, ed., *Cuba in the 1990s*, trans. Lisa Makarchuk [Havana: Editorial José Martí, 1999], 150, quoted in Ben Corbett, *This Is Cuba: An Outlaw Culture Survives* [Cambridge: Westview, 2004], 112).

14. "En las hierbas del verano . . ." was commissioned as part of *Proyecto Memorias Intimas-Marcas*, April 1997.

15. Virginia Pérez Rattón, "Carlos Garaicoa: Proyectar un paisaje (una conversación con Virginia Pérez Rattón)," in *Paisaje: Carlos Garaicoa* (San José, Costa Rica: TEOR/ética, 1999), 6.

16. Gerardo Mosquera, "Arte a través de la ciudad," in *Carlos Garaicoa: El espacio decapitado* (Faubourg du Lac: Centre PasquART, 1995), 44.

17. Valdés, "Mirror of Desire," 102.

18. See, for example, *Proyecto La Casa Brillante* (1992), in which Garaicoa made a new casting of a rusty, corroded metal plaque that marked the location of a prerevolutionary-era jewelry store.

19. José Ignacio Roca, "Ruins; Utopia," in Roca, *Carlos Garaicoa,* 96.

20. Carlos Garaicoa, quoted in Amei Wallach, "Below the Surface: Daydreams of Havana, and Other Cities Too," *New York Times,* May 19, 2005.

21. "In this series I try to interpret the phenomenon of the Cuban migration from an existentialist point of view, different to that of the political or economic reasons" (artist's statement, untitled CD dossier).

22. In one installation of the series Piña set up the images specifically to "reproduce the tension that comes from contemplating the sea (or the idea of what you'll find on the other shore) in a situation of *isolation*" (artist's statement, untitled CD dossier).

23. *Historia* (2000).

24. Ernesto Leal, e-mail to author, January 22, 2004.

25. Francis Acea (b. 1967) and Diango Hernández (b. 1970). Ernesto Oroza (b. 1968) was also a member of the group, until 1997, though this is generally not reflected in the subsequent materials published on their work.

26. Gerardo Mosquera, "Los híjos de Guillermo Tell," in Veigas et al., *Memoria*, 109.

27. Sugar water was a staple of the subsistence diet that many survived on during the Special Period.

28. For a fuller discussion, see Camnitzer, *New Art of Cuba,* 303–5.

29. A *New York Times* review of Alberto Casado's first solo show in the United States is a good indicator of how the visual appeal of the new Cuban art was ascendant over its content, especially in the case of foreign readings. The artist, writes Ken Johnson "just might be on the threshold of an international career." Casado's technique is the first item of interest in the review, and much is made of the fact that he developed it from a folk art technique typically used to make "cheap simulations of precious religious objects." Now, Johnson notes, Casado makes "expensive simulations of cheap simulations." On the other hand, "the social and political significance of those works will be lost on viewers not steeped in Cuban art history," but this is not fatal. In fact, Johnson figures that even Casado is not too sure about what that history means, noting that "whether Mr. Casado meant to mock avant-garde fatuousness, celebrate its heroism or memorialize its failure remains teasingly ambiguous."

As the years have passed since the heyday of the new Cuban art, the Cuban bureaucracy has come to understand that even though some people abroad will be looking for political controversy in Cuban art, mostly they will be content to read it just like the *Times*: the image of Fidel appears, it must mean something, but we don't know what, nor do we particularly need to. "The political import of this work [a portrait of Fidel] is veiled," Johnson says, "but it is easy to suspect it of satiric motives.... There are relatively few overtly political images in Mr. Casado's show, however—hardly anything that would tell you what his politics are. What runs deeper than politics in Mr. Casado's work is religion" ("Beer Cans Bridge the Gap between Global Pop Art and Cuban Kitsch," *New York Times,* April 20, 2005).

30. Yoan Capote, interview with author, Havana, December 27, 2001.

31. On the question of competition among artists, a note about the earlier situation in Havana may be helpful. *Volumen Uno*'s friendly collectivity has been romanticized over the years, especially as a type of reprimand to the more individualized production that gradually become the norm later on. It is therefore important to note the particular socio-economic circumstances within which that work was done, and which enabled an artistic practice based not only in a cooperative, rather than competitive, social structure but one that also was characteristically process-oriented, gestational, discursive, and investigative rather than product-oriented—a fact that can be attached quite directly to the condition of not depending on their artwork for economic survival. Those conditions were propitious for collective-based working processes that are, among other things, notoriously time-consuming and therefore difficult to maintain under the pressures of a market-driven production. The groups of the 1980s, then, can be understood not only in terms of an inter-subjective ethic but also as the fruits of a rare exemption from the pressures of market and livelihood. Until the radical economic changes that began around the end of the 1980s, artists could live, albeit modestly, without financial pressure, and work without taking the future sale of what they were making into consideration.

32. Gerardo Mosquera, "Arenas Movedizas," in *Arenas Movedizas* (Havana: Centro de Conservación, Restauración y Museología, 1995), unpaginated.

33. Orlando Hernández, in *Permanecer Nuestra Colectiva* (Havana: Espacio Aglutinador, 2000).

34. Fernando Rodríguez, interview with author, Havana, December 17, 2002. Cuauhtémoc Medina writes of a similar situation in Mexico. Throughout the 1990s many artists in

Mexico "fell prey to the notion of contemporary art as a means of escaping the ideologies of 'national culture' as well as the oppressive seduction of 'the international.' Peripheral artists (and by extension their fellow travelers) have to perform a trick, which consists in de-identifying themselves and abusing, distorting, parodying or sometimes even deconstructing their assigned roles as their nation-states' virtual civil servants" (Cuauhtémoc Medina, "Mutual Abuse," in Klaus Biesenbach, *Mexico City: An Exhibition about the Exchange Rates of Bodies and Values* [New York: PS1 Contemporary Art Center, 2002], 38).

35. Fernando Rodríguez, statement on *Puramente formal* exhibition invitation, quoted in Héctor Antón Castillo, "La otra vision de Francisco de la Cal," in *Noticias de artecubano* 2, no. 11 (2002): 5.

36. Iván de la Nuez, "Una mirada de la nueva barbarie," in *Visión del dolor* (Havana: Centro de Desarrollo de las Artes Visuales, 1991), unpaginated.

37. "Art for me is a little that, a trick, and it has to do with this very common idea, you see it a lot in Hollywood Westerns of the guy who goes in his wagon and sells whisky in place of medicine, saying that it's medicine that will cure everything. For me art is kind of like that, the artist is kind of like that, a guy who sells things that don't exist. Selling dreams, supposedly, which will cure the people, which is a lie, it isn't going to cure anything" (Luis Gómez, interview with author, Cojimar, December 26, 2001). Gómez has remained quite consistent in this view over the years and had the following to say in 1995: "What saves the work is pure spirituality. I don't agree with the idea that . . . art is a medium to eliminate traumas. What you get from it is pure energy. Pure essence, pure spirituality. A tormented guy will keep on being that way, whether he makes art or not. . . . art increases life, it doesn't cure, although you understand things through the work, and it helps you know yourself. But that doesn't imply that you're going to change" (Gómez, quoted in Erena Hernández, "El 'tramposo' Luis," in *Arenas Movedizas*).

38. Gerardo Mosquera, "El llanto de dios," in *Todo acerca del alma* (Havana: Espacio Alternativo, Centro de Desarrollo de las Artes Visuales, 1994), unpaginated.

39. Juan Antonio Molina, "Persistencia del silencio II," in *Work in Progress: Luis Gómez Armenteros* (Havana: Espacio Aglutinador, 1995).

40. Members of DUPP, interview with author, Havana, March 19, 2002.

41. A *solar* is a Havana tenement, in many cases an old mansion fallen into disrepair and cut up into many smaller dwellings.

42. René Francisco Rodríguez, "La casa nacional" (unpublished document, July 1990).

43. Ibid.

44. Marta María Pérez, Pérez Monzón, Fors, Tonel, Brey, Castañeda, and Ceballos were among the participants.

45. These projects, perhaps, were done with genuine spirit, especially early on, but always mixed with a dose of pragmatism. As Garciandía recalls, "For me always, I . . . I don't believe in the Bauhaus role, for example, and never have. . . . I believe that design is design and art is art, really. . . . They are two things that hardly touch one another. But the Ministry of

Culture prefers, naturally, that the artists be designers: more than anything else, it's like a sort of diversion. I always saw it as a sort of diversion, an instrument of diversion, of the institutions in relation to the artists. And nobody believed much in that, but everybody participated. Why? Because it was a way of staying on good terms with the institution and later to be able to say, well, you know I've been in all those events, please give me a space to put on an exhibit. . . . they are going to feel some obligation to us when we needed another type of support. And that's more than anything else the way I saw it. But on the other hand, very funny things happened because, for example the business of *Telarte*. . . . it was a way to clothe the whole family" (Garciandía, interview with author).

Tonel, expressing a less cynical view, has described these projects as important, encouraging a collectivist atmosphere among the artists and, fundamental to the events of the 1980s, establishing a "mutual understanding of artists and institutions for a good part of the decade, even though in other respects they were in conflict" ("70, 80, 90 . . . ," 417).

46. Cristina Vives, "¡Bases llenas!, . . . o, el arte en la calle," in *Revista del Instituto de Cultura Puertorriqueña: Edición Especial: Trienal Poli/Gráfica de San Juan: América Latina y el Caribe* 5, no. 10 (2004): 99.

47. *Proyecto Hacer* worked between 1988 and 1991: the group included, at various points, Hernández, Leal, Alejandro López, Saavedra, Nilo Castillo, Julio Fowler, Alejandro Frometa, Evel González, Alejandro López Marrero, Hubert Moreno, David Palacios, Sonia Pérez González, and the journalist Eric Splinter.

48. Unattributed author's note, in Veigas et al., *Memoria,* 293.

49. Ibid., 212.

50. The Pilón project took place during 1988 and 1989. The participants were Hernández, Saavedra, Castillo, López, Moreno, and the musician Alejandro Frómeta.

51. Lázaro Saavedra, interview with author, Havana, March 20, 2002.

52. Ibid.

53. Paidea, "Objetivos, tareas y programa" (unpublished typescript).

54. Lázaro Saavedra, interview with author, Havana, December 12, 2002.

55. Hart's support of the project was both strong and visible: "He went to Santiago de Cuba for the 20th of October, which is the Day of Cuban Culture and he made an official appearance in Pilón, in the Hotel Marea de Portillo; he sponsored a luncheon and we went and had a meeting with Armando Hart, in that place" (Saavedra, interview with author).

56. Saavedra, interview with author.

57. Ibid.

58. Saavedra noted, in an unusually cryptic formulation: "Look, the group that went to Pilón might have been a homogenous group, but it would be interesting to investigate some day what the points of contact were among the five and what were the contradictory points" (interview with author).

59. Lázaro Saavedra, interview with author, Havana, December 12, 2002.

60. Navarro, "Lectura de un testimonio," 50–51. The text, although only published in 2003, was actually written in 1970.

61. Unnamed reviewer, "La Época: Intervención DUPP en un espacio público," *Arte Cubano,* no. 2 (1999): 93.

62. Yuneikis Villalonga and Elvis Fuentes, "A Timely Introduction," in *Waiting List: Time and Transition in Contemporary Cuban Art* (Ljubljana: Mestna Galerija, 2006), unpaginated.

63. There have been three separate DUPP groups, working during the following intervals: January–June 1990; January–June 1992 ("Departamento de Debates y Exposiciones"); 1997 ("Galería DUPP"). The group did not actually use its acronym as a name until the third manifestation, in 1997: nonetheless, the name "DUPP" is now generally used in reference to all three groups.

64. Rodríguez, "La casa nacional." Saavedra, but also Ponjuán, Toirac, Bruguera, Miranda, Douglas Pérez, Lupe Álvarez, and others also counted among those who taught at ISA during those lean years.

65. Interview with author, Havana, March 19, 2002.

66. Ibid.

67. Edward Said, *On Late Style: Music and Literature against the Grain* (New York: Pantheon Books, 2006), 14.

68. Ibid., 92.

69. Ibid., 148.

70. Ibid., 160.

71. Peter Bürger's observation on this question is helpful: "If the twofold character of art in bourgeois society consists in the fact that the distance from the social production and reproduction process contains an element of freedom and an element of the noncommittal and an absence of any consequences, it can be seen that the avantgardeistes' attempt to reintegrate art into the life process is itself a profoundly contradictory endeavor. For the (relative) freedom of art vis-à-vis the praxis of life is at the same time the condition that must be fulfilled if there is to be a critical cognition of reality. An art no longer distinct from the praxis of life but wholly absorbed in it will lose the capacity to criticize it, along with its distance" (*Theory of the Avant Garde,* trans. Michael Shaw [Minneapolis: University of Minnesota Press, 1984], 50).

72. The term is from Ibis Hernández Abascual, a cofounder of the Centro Wifredo Lam (which organizes the Biennial), in "Mutuas Transferencias: De lo cotidiano al arte, del arte a lo cotidiano," *Revista del Instituto de Cultura Puertorriqueña: Edición Especial: Trienal Poli/Gráfica de San Juan: América Latina y el Caribe* 5, no. 10 (2004): 69–75.

73. "Programas de la Batalla de Ideas vinculados a la cultura," Ministerio de Cultura Web site, http://www.min.cult.cu/informe/batalla_ideas.html. Similar to the Rectification program in the 1980s, the Battle of Ideas is largely a purification program aimed at curing internal ills. Jon Lee Anderson quotes a Castro speech in November 2005 to this effect:

"This country can self-destruct, this revolution can destroy itself.... They [the Americans] cannot destroy it, but we can. We can destroy it, and it would be our fault" ("Castro's Last Battle," *New Yorker*, July 31, 2006, 47). "Battalions" of *trabajadores sociales* ("social workers") have been assembled to advance the Battle of Ideas: comparison to the social work agenda of the new "art of social insertion" seems inevitable.

74. Fernando Luis Rojas, "Sobre batallas y caballeros de los 90," *El Caimán Barbudo*, http://www.caimanbarbudo.cu/caiman327/especiales327.htm.

75. While it seems to have formed quite spontaneously, it cannot be forgotten that Enema convened once DUPP had already proved itself to be a successful pedagogical model and vehicle for visibility.

76. Tania Bruguera's reenactment of works by Ana Mendieta in 1986–87 is an important precedent for Enema's reperformances. By Bruguera's account, the gesture was in part a way to return Mendieta to her native Cuba, at a time when it was officially anathema for those who had left to maintain any perceptible presence on the island. Bruguera's performances were an homage to Mendieta, while Enema's re-creations were much less focused on the originating artists and more concerned with the resignification of the performed acts through repetition, translation, and translocation.

77. Performed in March 2001.

78. Linda Montano and Tehching Hsieh's work, "Art/Life One Year Performance," was a work with a sharper sting than Enema's re-creation: for one thing, although the two artists were tied (and padlocked) together for an entire year, they also did not touch each other during that time. C. Carr provides an interesting summary of the issues at play in their piece: "Committed together to this arduous performance, they found they didn't agree on what it meant to be doing it.

"I told them that when I pictured myself in the ropes, it felt like strangling in total dependency and lack of privacy.

"Tehching said my reaction was just personal. Just emotional. Here, we were talking about Art.

"Linda said Tehching thought the performance was subsumed by the Art. But she was interested in issues like claustrophobia, and ego and power relationships—Life issues. They were as important as Art.

"No, Tehching said, that was too personal. The piece was not about him with Linda. It was about all people" (C. Carr, *On Edge: Performance at the End of the Twentieth Century* [Hanover, N.H.: University Press of New England, 1993], 4–5).

79. These included curricula that had been developed by Garciandía and Osvaldo Sánchez for ISA.

80. Hanoi Pérez (member of Enema), interview with author, Havana, December 23, 2002.

81. The plaza was built in December 1999, reputedly at a cost of US$2 million.

82. Banks of folding chairs were routinely set up for the thousands brought in for the incessant Friday afternoon rallies that went on weekly for more than six months, organized around a variety of themes—one week, grandmothers would be convened to coincide with

Elián's grandmothers' visit to Washington, another week it would be thousands of *pioneros* marching in synch with the visit by Elián's classmates to the United States, and so on. Mass rallies and marches were staged during this time in every city and town on the island, roundtable discussions were convened nightly on television, Elián T-shirts were produced in large quantities, billboards were erected, and school lessons were developed so that children would "understand" what was happening. Of course, the Elián demonstrations in Miami were no less melodramatic or staged.

83. The show was organized as part of the launch of the second edition of their journal, *Enema 2/3*.

84. Tanya Angulo, Juan Pablo Ballester, José Ángel Toirac, and Ileana Villazón, untitled text, *"Homage to Hans Haacke,"* July 1989, note 21, unpaginated.

85. Marco Castillo Valdés points out that "our formative period as artists took place at the same time as the avalanche of the process of restoration of colonial Havana" (Los Carpinteros, interview with Eugenio Valdés, "Hablando por si mismo: Haciendo memoria desde un interior habanero," *Arte Cubano* [February 1999]: 65).

86. Kapcia, *Havana*, 184.

87. Ibid., 185.

88. The Focsa building (Fomento de Obras y Construcciones, SA) went up in the heart of the Vedado district of Havana between 1954 and 1956, an object of wonder for being one of the largest reinforced concrete structures in the world: it is one of the most important monuments to modernism in the city. It, along with other major building projects of the time (Hotel Habana Hilton, Hotel Riviera, Tropicana Cabaret), was built with private investment during the heyday of the gambling, whoring, dictatorial time of Fulgencio Batista's rule: it was, in other words, the output of exactly the business class that Batista was keeping Cuba safe for.

But Focsa has an even wider set of associations and affiliations, stretching beyond those of the rich period of modernity in Havana and its complicated and tense relation with the modernity brought by revolution. Once the Revolution came, Focsa was used as lodging for thousands of students on scholarships, hundreds of foreign technicians, and cadres of Cuban doctors, nurses, and other health specialists, "before they left to provide their collaboration to other lands of the world." Focsa was also, notoriously, made home for the many Soviet specialists brought/sent to the island and who, as Carmen Carro notes, actively contributed to the building's premature dereliction (http://www.cubafreepress. org/art2/cubap020408cc.html [accessed March 12, 2007]).

89. "Oposición y defensa de la tesis de los Carpinteros," *Loquevenga* 2, no. 1 (1995): 19, quoted in Valdés, "Art of Negotiation and the Space of the Game," 385. A decade later, Alexandre Arrechea provided the following explanation for the game: "After we exhibited *Interior habanero* there were people very interested in buying the work. But it so happened that they were collectors from Miami, where many of the richest Cuban exiles settled, after they abandoned their houses in the early sixties. When we developed our thesis project for graduation, we took advantage of this interest. We created a fake letter from a collector in Miami, who wrote why he loved our work and wanted to buy it. Everyone thought it was

real, and *Art Nexus* published a news item about how all our works were bought by a Miami collector, but it was a fake" (Margaret Miller and Noel Smith, "Conversation/Interview with Los Carpinteros," in *Los Carpinteros* [Tampa: Institute for Research in Art, Contemporary Art Museum/Graphicstudio, in collaboration with National Museum of Fine Arts, Havana, 2003], 122).

90. Los Carpinteros, interview with Eugenio Valdés, in "Hablando por si mismo," 65.

91. Interview with author, Havana, January 2, 2002.

92. *Paisaje Popular Cubano*, collateral to the fourth Havana Biennial, Centro de Arte 23 y 12, 1991. Both the materiality and method of these works owed much to Elso. Kcho's affinity for natural materials was attributed at the time to his rural roots rather than to any anti-art impulse. Mosquera's essay in the brochure compares Kcho to Elso and Mendieta, observing that, while they were urban artists working with a sensibility for natural materials, Kcho was working with the materials that he grew up surrounded by. Not only is Kcho's pastoral youth sometimes romanticized, so is the fact of his family's "artisan tradition": his father was a carpenter, and his mother was a potter (Amalina Bomnin, "Kcho: He Who Makes the Trick, Does the Trick," *Art Nexus* 3, no. 3 [2004]: 58).

93. Untitled installation at the Bienal de São Paulo.

94. Acosta is modestly described on the jacket of his 2001 book of essays *El signo y la letra: Ensayos sobre literature y arte* as an academic and author. The citation reads as follows: "Doctor en Ciencias Históricas, Investigador Titular y Profesor Titular Adjunto del Instituto Superior de Arte, recibió en 1994 el premio Annual de Investigaciones del Ministerio de Cultura. Ha publicado, entre otros, los ensayos *Los signos al infinito, Avidez de la palabra,* y *Los silencios quebrados de San Lorenzo,* y los poemarios *Profecía del vino, Puertas oscuras* y *Fractura del tiempo*" (*El signo y la letra* [Havana: Centro de Investigación y Desarrollo de la Cultura Cubana Juan Marinello, 2001]).

95. Rafael Acosta de Arriba, "Tatlin, Lam y la Nueva Jungla," in *La jungla* (Havana: National Museum of Fine Arts, 2001), 5, 10.

96. Ibid., 9, 10. The *New York Times* upped the ante in its preview of Kcho's first U.S. gallery show by noting that he had "not been allowed a studio in Cuba" ("denied a studio at home," confirms the photo caption) (Susan A. Davis, "Up and Coming: Kcho; Art Is a Cuban's Vessel to Freedom," *New York Times,* March 17, 1996). That is a misleading claim, since it suggests that Kcho was refused a studio for political reasons, rather than for a lack of available real estate. In any case, just a few years later, he had a lovely studio on a boat and a deluxe protocol house in one of the most exclusive areas of the capital, and Castro himself stood as best man at the artist's wedding.

97. As Mosquera has noted: "Since the [1980s], censorship has become more cynical, and some officials even discuss with artists what is allowed in their works—almost as if it were a technical problem. This is what I call the 'You Know Who' [*quién tu sabes*] syndrome. This phrase is used in Cuba to criticize the 'Maximum Leader' without mentioning his name. It puts the responsibility for identifying him on the other person, not on the one speaking. In the end both know what the work refers to, but both are protected in an

unusual alliance between censor and censored" (Gerardo Mosquera, "New Cuban Art Y2K," in Holly Block, ed., *Art Cuba: The New Generation* [New York: Abrams, 2001], 13).

98. In an interview with the Uruguayan newspaper *Brecha,* the Cuban economist Ángel Morales noted that the country had "possibilities of a natural, cultural, educational and social nature, and we already have some knowledge in those areas" ("There's No Other Country That Can Straighten Out Its Finances Like Cuba Can," *Brecha,* January 17, 2003).

99. José Ángel Toirac, "Valen Todos" (unpublished typescript, 1993–94), 44. As members of Enema put it, "Of course the artists, as a group, as a social organism—like any species on the planet—conserve defensive memories. And so without even determining to, they know perfectly well what kinds of things they can get away with, and what kinds of things will get them in trouble. A kind of mechanism of self-regulation has evolved . . . the structure of galleries, the places that present art know perfectly well what kinds of things will make trouble for them. And they'll tell you no, right away. So, what happens? The mechanism between artists and the people working in the institutions that are supposed to keep track of all the latest developments in art, it's a different kind of relation, a little more viable— there's more relation" (Enema, interview with author, Havana, December 29, 2001).

100. Iván de la Nuez and Juan Pablo Ballester, "El post-exilio y la post-guerra," in Tania Bruguera, ed., *Memorias de la postguerra no. 2* (1994), 10.

101. In fact, the Havana Biennial (which in any case has been less and less focused on engaging a nonspecialist, much less Cuban, audience in recent years) was bumped off the calendar at the end of 2002 by the first annual Havana Auction, replacing even that tepid commitment to public culture with an event whose sole purpose was to move artworks into private circulation.

102. Quoted in Pérez, *To Die in Cuba,* 349.

103. This is according to Esterio Segura (interview with author, Havana, December 16, 2002). Another noteworthy effect of this spree is that, in its wake, artists have generally stayed home during the Biennial in subsequent versions, waiting for the collectors' knock at the door: this means that they are no longer out at the Biennial, meeting other exhibiting artists, going to compatriots' openings, and so forth.

104. Maria Finn, "Visions of Dollars Dance before Cuban Artists' Eyes," *New York Times,* November 23, 2003.

105. Rancière, *On the Shores of Politics,* 8.

106. Eugenio Valdés, "Hablando por si mismo: Haciendo memoria desde un interior habanero," *ArteCubano,* no. 2 (1999).

107. Among the critics who rose in visibility during the 1990s were Juan Antonio Molina, Rufo Caballero, Janet Batet, Dannys Montes de Oca, and David Mateo; additionally, Magaly Espinosa, Eugenio Valdés, Magda González, and Lupe Álvarez became increasingly visible on the international level.

108. Not coincidentally, the return to visuality paralleled the growth of a market for Cuban art and also a booming international market overall in the 1990s, which shared that

renewed interest in the visual and/or "beautiful," as opposed to "conceptual" and anti-aesthetic approaches to art making. In these terms, "beautiful" art was art that held value within itself, not a self-sacrificial art intent only on transforming what lay outside it.

109. Mosquera was censored at the end of the 1980s and thereafter was almost entirely unable to publish in Cuba; Osvaldo Sánchez left for Mexico; and Orlando Hernández and Desiderio Navarro pretty much withdrew.

110. As ABTV note in their *"Homage to Hans Haacke"* text, this problem had even been recognized by the Consejo Nacional de Artes Plásticas itself, quoting the document "Notas para un diagnóstico de las promociones más recientes en las artes plásticas cubanas" (CNAP, May 3, 1989) that "there predominates, in our most important press organs . . . the absence of critique, or of the opinions exercised by those few who could contribute." The group further notes, "For example, during 1988 the journalist Soledad Cruz, without being a specialist (as she herself recognizes in her article published by *Juventud Rebelde* on Thursday, June 23, 1988), became—from the pages of *Juventud Rebelde*—the most active polemicist about plastic arts."

111. Among critics, for example, Valdés writes: "During the eighties Cuban art had the utopian aim of posing itself as the critical conscience of society, which is to say, as the arbiter of knowledge and judgment. This prompted a reactivation of the contradictions between political and artistic discourse. Art became circumstantial. It adopted an almost journalistic character. The art gallery became an area of confrontation that involved the public in a debate on its role in social movements. According to Gerardo Mosquera, the art gallery became a kind of 'tolerance zone.' The aspirations of art to have a wide impact on the public inevitably led to a somewhat romantic outlook" ("Art of Negotiation and the Space of the Game," 385).
 The artist Erik García, who was a member of Arte Calle, later made the following, characteristic statement: "To me it doesn't make sense, it's like restricting yourself, falling into the same vicious cycle, to refer always to the situation we're living. What interests me more is to express universal values, in the most universal manner possible, in the manner that the most people in the world, from the most diverse cultures, can understand. What happens is that when you use those national symbols . . . it seems to me that then circumstances crush you doubly, they crush you because you're living them and they crush you again because you re-create them in order to sell them. . . . We all have political concerns, but they don't have to pass in such an overwhelming way into your work" (interview with author, Havana, March 12, 2002).

112. Gerardo Mosquera, "Arte preso," in *Ángel Delgado: 1242900 (Parte I)* (Havana: Espacio Aglutinador, 1996), unpaginated.

113. Orlando Hernández, "Ángel Delgado: espuma en la boca," *Bomb,* December 2002.

114. There is a distinguished history in Cuba of independent cultural publications. For Valdés, *Memoria de la postguerra* evoked "the impact made thirty years earlier by the tabloid *Lunes de Revolución.* Bearing in mind the contrasts and temporal distance that separate these papers, we can also note some important connections. Both newspapers ended up becoming the ephemeral action that brought some hope to a vanguard group of intellectuals and stimulated cultural debate; both had their genesis in periods of intense

contradiction and profound uncertainty; and in both cases the printed product, the artistic gesture, and the cultural responsibility of the collaborators were accompanied by a rumor that later was harvested as a legend, as the mythology of a tangible event. . . . these papers are linked by an important historical phenomenon: after the dissolution of *Lunes* and the collapse of intellectual debate that came later in the 1960s, an exodus of intellectuals took place that was no less significant than the one of 1989–93, which directly preceded the first issue of *Memoria*. [Luis Camnitzer wrote of it,] 'What is noteworthy is the fact that at a time of unprecedented economic crisis in which distances have grown almost *ad infinitum* due to the lack of transport and the international dispersion of artists, *Memoria* has not only assembled ideas but has helped maintain a sense of coherence. . . . [It is] a primary vehicle of communication'" (Valdés, "Trajectories of a Rumor," 19).

115. Rafael López Ramos, special assignment to *Memoria de la postguerra*, "La guerra ha terminado afirma joven artista cubana," *Memoria de la postguerra*, no. 1, November 1993, 5.

116. Tania Bruguera, "Ni todo, ni todos: La voz," *Memoria de la postguerra*, no. 1, November 1993, 1.

117. A third issue, planned but never realized, was to have been on the theme of reconciliation: at one point Bruguera was thinking of formatting it as a "live" version, distributed via rumor and gossip circuits rather than paper and ink, which would have not only conformed to the way that most news circulates on the island but also considerably lessened the risks of further retribution against it. A version of that third issue was declared retroactively in 2005 when Bruguera republished the brochure from her 2003 exhibition at the National Museum of Fine Arts: originally, the brochure was to have consisted solely of political slogans, but the museum curator appended a restorative personal reminiscence. In a 2005 catalog published on the occasion of her participation in the Venice Biennale, Bruguera edited out the curator's text and titled the remaining text "Memoria de la postguerra III" (*Tania Bruguera*, 52). She also republished the first two volumes of the newspaper, including the one that had incited such harsh official response.

118. "Interview," conducted by RoseLee Goldberg, in *Tania Bruguera*, 29, published on the occasion of Bruguera's participation in the fifty-first Venice Biennale (2005).

119. Ibid.

120. Tania Bruguera, interviewed by Jens Hoffman, *Flash Art*, no. 225 (July–September 2002).

121. Bruguera, *Tania Bruguera*, 185.

122. Eating dirt also recalled the suicides, by the same method, of thousands of indigenous people on the island in protest of their treatment by the Spanish conquistadors. According to Louis A. Pérez, citing sixteenth-century accounts, "perhaps as many as 30,000 Indians— almost one-third of the total pre-Columbian population of Cuba—perished as a result of suicide during the early days of European conquest and colonialization. They chose death by way of hanging. They ingested poison. They ate dirt in order to die" (*To Die in Cuba*, 3–4).

123. Earlier in its history, apparently, the space had served as a prison cell.

124. To read the work as "humanizing" the icon of Fidel coincides with the meaning suggested by the artist at the time. More recently, she has suggested a more ambivalent

intonation: the audience "go toward the light, [the video was the only light source in the work] and the light is Fidel! And gradually, while their vision gets used to the darkness, they notice that nearby are several naked Cubans, and the realization is, 'Oh my God, I have been so seduced by power that I didn't even realize what was going on around me'" ("Interview," 27).

125. Ibid., 31.

126. Tania Bruguera, "Cátedra Arte de Conducta," in *Tania Bruguera,* 47.

127. Technically the *Taller* is part of ISA but meets at the artist's home.

128. Eduardo Ponjuán, interview with author, Havana, January 5, 2002.

129. Glenda León, "DUPP: Un fénomeno psicoactivo," *Noticias de Arte Cubano* 1, no. 2 (2000): 7.

130. Interview with author, Havana, December 28, 2001.

131. "La Intermitencia Visual." León explains the work as follows: "Every time the eye closes there was a fade to black and then it opened again. It was about the blink, it was the intermittence, like a reflection: as though when you close your eyes in a certain way you interrupt what you're seeing. . . . It's not important, but they're like the little things in life, that you never stop to think about" (interview with author).

La Jetée (1962), the work that Marker is perhaps best known for, is a film about memory composed entirely from still photographs except for a few breathtaking seconds that show a sleeping woman's eyes flutter awake. In that moment—her silent, breathing flicker—the revolution by which pictures became cinema is instantly felt, the special affinity for passing time, for change and evanescence, for memory.

132. Javier Marimón, "Glenda León: Jenny Holzer + cirugía estética," *La Gaceta de Cuba,* no. 3 (2002): 59.

133. Ibid.

134. Andrés Isaac Santana, "Arturo Montoto: Museo de América, Madrid," *Art Nexus* 3, no. 57 (2005): 133. Montoto studied in Moscow on a scholarship for six years at the State Institute of Arts "V.I. Súrikov," where he earned an MFA in mural painting.

135. Javier Marimón, "Una exhibición *dumb* de James & Wilfredo," in *La Gaceta de Cuba,* no. 6 (2000): 61–62.

136. *Art Nexus* 3, no. 55 (2005).

137. Wilfredo Prieto, interview with author, Havana, January 12, 2002.

138. Monroe Denton, "Art Review: The Eighth Bienal," *The Antiquer,* http://www.theantiquer.net/article/articles.htm?theAntiquer_article_646.htm.

139. Jean Baudrillard, interviewed by Catherine Franchlin, in *Art and Philosophy* (Milan: Giancarlo Politi Editore, 1991), 11–12.

140. Pierre Nora, "The Reasons for the Current Upsurge in Memory," Tr@nsit online, Nr. 22/2002 (Transit—Europäische Revue), http://www.iwm.at/index.php?option=com_content&task=view&id=285&Itemid=463.

141. All quotes are from Nora, "Reasons for the Current Upsurge in Memory."

EPILOGUE ON THE HORIZON

1. Marc Augé, *Oblivion,* trans. Marjolijn de Jager (Minneapolis: University of Minnesota Press, 2004), 67.

INDEX

humor, in Cuban art, 76–78, 87, 110–18, 147–50; political iconicity and, 120–38; withdrawal from, 162–63. *See also choteo* (Cuban cultural tradition)

hyperrealism: Cuban artists and, 36–37

"Imperfect Cinema" (Espinosa), 14

Individual and His Memory, The (6th Havana Biennial), 145

individualism: artists' withdrawal to, 160–61

institutional identity: artists' withdrawal from, 162–65

Instituto Superior de Arte: *choteo* and, 108, 116; collectives and, 209, 211; cultural legacy of, 278n.85, 296n.64, 297n.79; DUPP and, 204; new Cuban art and, 136–37, 279n.87; politics and, 161, 303n.127; Special Period and, 216

interiority in Cuban art, 22–29

International Conference of Young Creators, 31

internationalism: Cuban national identity and, 3–13

interventionist trend: Battle of Ideas and, 208–11

Investment Time (Barroso), 222

Isaroko exhibition, 208

Japón (Japan) (Grupo Provisional performance), 98–100

Jardín Japonés/Jardín Cubano (Japanese garden/Cuban garden) (Garaicoa Manso), 176

Jarry, Alfred, 24

Jesus: artists' depictions of, 42, 43

jodedera (performance art), 94–108, 275n.43

John Paul II (Pope), 170–72, 225

Johnson, Ken, 293n.29

Jóvenes Artistas: Retrospectiva (exhibition), 257n.17

jóvenes más joven (the younger young ones) (ISA), 139

Juego de pelota (Enema collective), 210–11

Jugete para niño africano (Toy for an African child) (Bedia work), 17

"Julito 26" (Chago character), 77

Kádár, Janos, 253n.5

Kapcia, Antoni, 213

Kcho. *See* Leyva Machado, Alexis

Kelley, Mike, 45–46

Kerr, Walter, 76, 92

Kiko Constructor (Kiko the Builder) (Soto work), 31

kitsch: *Arte en la fábrica* exhibit and, 199; *choteo* and, 89–90; by Cuban artists, 34–38, 48, 77–78; *Metáforas del templo* exhibit and, 186; political iconicity and, 120–22; proliferation in Special Period of, 156–57

Klein, Yves, 179

Komar, Vitaly, 279n.92

Korda. *See* Díaz Gutiérrez, Alberto (Korda)

Kosuth, Joseph, 14

Kuba OK exhibition, 58, 74, 132, 227

Kundera, Milan, 17, 89–90, 122

La casa nacional exhibit, 197–99, 203–8

La consagración de la jodedera performance exhibition, 275n.43

La crisis de la alta cultura en Cuba: Indagación del choteo (The crisis of high culture in Cuba: Inquiry into the *choteo*) (Mañach), 87–88

ladder imagery in Cuban art, 128, 263n.57, 280n.100

La diestra (The right hand) (Segura Mora), 126

La Época department store exhibition (DUPP), 203–7

La escultura de Toirac (Toirac's sculpture) (Casado), 85

prostitution in Cuba, 122–23, 155–57, 285n.18, 286n.19

Proyecto Hacer, 199–200, 295n.47

Proyecto La Casa Brillante (Garaicoa Manso), 292n.18

Proyecto Pilón, 199–200

Psychiatric Exam of a Post-War Artist (Ceballos), 232

public opinion in Cuba: impact of Special Period and, 153–57, 283n.8, 285n.17, 286n.20, 286n.22, 290n.33

Puertas al infinito (Doors to infinity) (Chago), 79

Puramente formal (Purely formal) (Rodríguez series), 192–93

Puré expone exhibition, 48–49

Quevedo, Alberto, 4

Quiet Room (Gómez), 194, 195

Quinquenio Gris (Five Gray Years), xiii

Quintana, Ciro, 48, 132, 268n.115, 277n.68, 277n.70, 277n.76, 281n.104

Quiroga, Jorge, 284n.14

quotidian current in Cuban art, 22, 30–44, 48

racism in Cuba, 155–57

Rákosi, Mátyás, 253n.5

Ramos Lorenzo, Sandra, 128–29, 131, 207–8

Rancière, Jacques, 161, 222

Rauschenberg, Robert, 81, 99–100, 276n.59

Rectificar es crear, es buscar lo nuevo (To rectify is to create, to search for the new) (Cárdenas), 57

Rectification period (Cuba), 79–80, 272n.11

Recuerdos de nuestro bebé (Memories of our baby) (Pérez work), 26, 28–29

Refranes (Proverbs) (Garciandía series), 39, 86

Regata (Regatta) (Leyva Machado [Kcho]), 131, 216–17

religious traditions: Cuban art and, 13–20

Reproducción prohibida (Reproduction prohibited) (Ponjuán/Francisco Rodríguez), 92

Retablo Familiar (Family altar) (Soto work), 31–32

Reviva la revolu . . . (Menéndez), 104–5

revolutionary ideology: Cuban art and, xii–xv, 10–13, 52–53, 268n.126; Elso Padilla's challenge to, 61–69; ruralism and, 4–5, 256n.9; in Soto's work, 30–33

Richard, Nelly, 92, 94

Rimbaud, Arthur, 44, 49

Ritual (González street performance), 59, 60

Robaína, Roberto, 85, 103–4, 274n.29

ROCI–Cuba (Rauschenberg Overseas Cultural Exchange–Cuba), 99–100, 276n.59

Rock Campesino, 96, 97

Rodríguez, Arnold (Peteco), 277n.68

Rodríguez, Eduardo Luis, 270n.134

Rodríguez, Emilio, 258n.22

Rodríguez, Fernando, 119–22, 127, 132, 185, 190–93

Rodríguez, Luis Felipe, 256n.12

Rodríguez, René Francisco: DUPP and, 196–98, 204, 277n.73; everyday art and, 47; exhibitions by, 92, 134–35, 157, 186, 239

Rodríguez Álvarez, José Mariano Manuel (Mariano), 22, 46, 263n.30

Rodríguez Cárdenas, Carlos: biennials and, 277n.76; censorship of, 75, 280n.100; exhibitions by, 55–58, 107–8, 110, 169, 271n.1, 274n.40, 277n.73; Grupo Provisional and, 276n.57; kitsch and, 90–91; *Kuba OK* exhibit and, 132, 134; *MEDITAR* collaboration and, 105; revolutionary ideology and work of, 85–86, 146–48; social space in work of, 119

Rodríguez de Armas, José Luis, 271n.146

Rojas, Eric, 281n.111

Rachel Weiss is a writer, curator, and educator
who has been traveling to and writing about Cuba since 1986.
She is professor of arts administration and policy
at the School of the Art Institute of Chicago and has published
extensively on contemporary art.